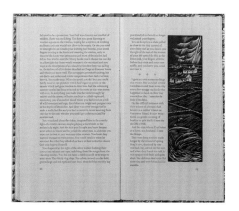

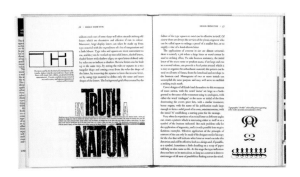

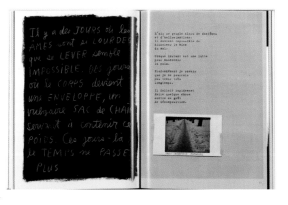

The Surface of Meaning

Books and Book Design in Canada

Robert Bringhurst

The Atkins Library · C C S P P R E S S

CANADIAN CENTRE FOR STUDIES IN PUBLISHING PRESS

- Simon Fraser University
 515 West Hastings Street
 Vancouver, B.C.
 V6B 5K3

- www.ccsp.sfu.ca

LIBRARY AND ARCHIVES CANADA CATALOGUING IN PUBLICATION

Bringhurst, Robert, 1946–

 The surface of meaning : books and book design in Canada / Robert Bringhurst

(The Atkins library)
Includes bibliographical references and index.
ISBN 978-0-9738727-2-9

 1. Book design – Canada – History.
 2. Books – Canada – History.
 3. Oral tradition – Canada.
 4. Publishers and publishing – Canada – History.
 I. Title.
 II. Series: Atkins library

Z483.B74 2008 686.0971 C2008-901493-6

Printed in Canada

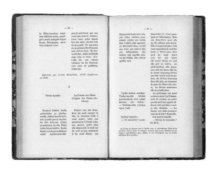

for Don Atkins

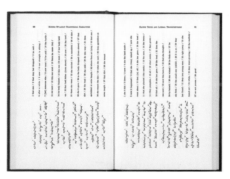

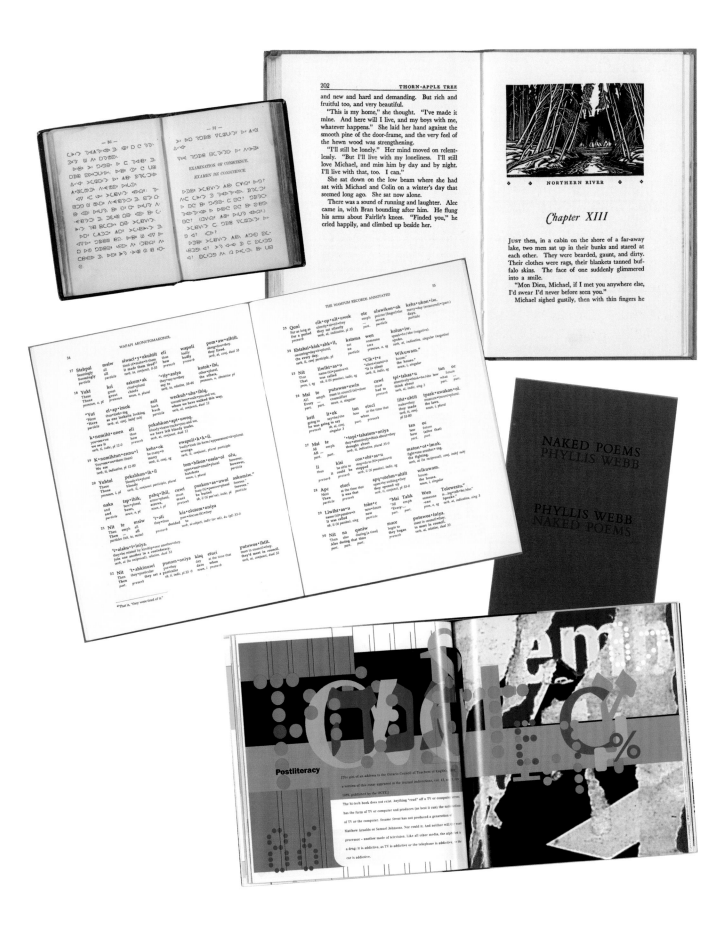

Contents

✳ Acknowledgements · **9**

■ PROLOGUE: WHAT'S A BOOK – AND WHY?

 Transparency, tangibility, complexity, and culture · **11**

■ THE INVISIBLE BOOK

 Literary structures before, beneath, and beside
 the European colonization · **15**

■ THE ECHO OF TANGIBILITY

 Constructing culture from the Second World War
 to the Digital Divide · **47**

■ STILLS FROM THE TYPOGRAPHIC MOVIE

 Canadian books from 1980 to the present day · **93**

✳ Appendices

 1 *Winners of the Alcuin Design Awards 1981–2006* · **207**
 2 *Winners of the Malahat Awards 1981–1984* · **227**
 3 *Frequency of Mention in Appendices 1 & 2* · **228**

✳ Bibliography · **229**

✳ Index · **237**

Book page (top left, numbered 36)

36

The first drops of rain fell on the hearse that was carrying Vera's third husband into Big Indian. The wind had fallen off toward morning, the waiting men had lowered the corpse with long ropes. The tall, gangling stranger from the road gang was hardly more than a bag of bones, he'd been so dehydrated, so perfectly dried. He was for a moment kind of dried flower in Vera's arms.

Mr. Aardt, surprised by the rain, swerved, hit the ditch, swung back onto the road. He missed Marvin Straw by inches; Marvin was waiting in a stand of last year's cattails, his dirt-rimmed eyes feverish with love, feverish with renewed hope at the sight of the loaded hearse.

As the clouds thickened, moving eastward, they robbed the powerline poles of their shadows. Liebhaber, by this time, was lying on the deck of his boat; the boat was resting on dry land, where the river once had run. He'd been looking up at the sky for three hours ... once ran. He felt the first drop of rain ... His back ...

Book page (top middle-right column)

was almost still, the wind had almost ceased from its endless blowing. And more there came, now, the weighing of dark cloud onto the radiance of sky.

A drop of rain hit him and he knew it would be a flood. At last, his marriage time had come. He had remembered the future correctly: there would be a flood, a joy of rain, his battle won, his ark floating. Let the doubting bastards drown, he would saw whom he pleased. He shook his head, wiped a drop of rain from his forehead, got to his feet.

Liebhaber drove Vera's Essex back to the farm. The few drops had become a drizzle by the time he got there. "It's going to rain cats and dogs," he shouted, hardly up the steps and onto the porch. It was not Tiddy, but Vera who first came to the door. Liebhaber didn't bother to look at her Essex, returned, finally, from wherever Liebhaber had taken it. She said nothing of his theft, ... conspiring to unhinge the world; he might have been, for ... attention, innocent.

And then, only then, did Liebhaber notice: here at ... with the falling drops of rain, fell a bee. Here and there ... Tiddy came to the door, now, and with her, Rose. Rose, ... as she had always been, her shoes not tied, her dress ... tied, whose dress did not quite fit. But the older ... there too. Theresa O'Holleran, so beautiful, in the ... young breasts, in the defiance of her blue eyes, ... tugged at a corner of his mustache, for a moment ... his mouth.

Anna Marie came out onto the porch, with the ... saw the rain, knew that her hair, in a matter of ... frizzy, unmanageable. Her youngest daughter ... porch and took the comb from her mother, ... own dark hair, watching all the time the wea... was there too, dressed in her Hutterite garb, no makeup on ... pale face ... quite hiding her heavy black shoes. She ... hand ...

Poetry page (top right)

Insect murmur clots the peartree: emblem

so castigates rome's green ruin. We lunch

nevertheless among reinvention

Legend page (far top right)

LEGEND

episode NURSES
Party Scene
Greeting
...Her Pants to No End
How to Joke
...in Thirty Party
Then Joe Vein in the Fatal Dart and Finance Last
Earth Money: "Where is the Flower I Must Spit?"
As if the World's a Punctured Chit

interlude
Virgil's Bastard Daughters Sing
Some Pom-poms
...

episode MAJORETTES
Crossing the Adanac
March: Thespians Against Knowledge
Battle Cry
Envoy

appendix DEBBIE'S FOLLY

throu[gh]

Introduction page (middle left)

CLICK

Intro duction

LYNN CROSBIE

Women and girls rule my world.
– Tom Jones

Not to mention delight laughter feminism
upon which I keep insisting
– Erin Mouré, "Human Bearing"

BRA ASHES
– inscribed on an urn on my mother's shelf, circa 1975

IN RECENT MONTHS I have heard hyper-
masculine men, ranging from gangster rap-
pers to uniformed members of the 'World
Wrestling Federation,' refer to themselves and their cronies as "cliques"
(pronounced "clicks"). This particular choice of word, in my mind, re-
calls feminism's pluralistic nature and suggests that, finally, aggressive
men have come to bite off feminism for fast and frightening images
of strength.

It was Gloria Steinem who used the term click to describe that mo-
ment of feminist self-awareness, the quick epiphany that has a private
and public resonance: the click of high heels on sidewalks or tapped
together in a ruby glitter; two fingers snapping; scissor blades closing;
the release of a gun's safety; the flick of a light switch; a catch in the
machinery; the clatter of nails on a typewriter; a lock yielding to a key.

In the late 1980s, feminists made this sound every time they flicked
open a lighter to torch a bra, or pounded the pavement in protest.
When I began asking women to contribute to this collection, I wasn't ...

Title pages (middle right)

Man in Love · Richard Outram

Rural Night Catalogue

Michael deBeyer

The Porcupine's Quill, Inc.

Open book (bottom left)

By genetic memory maybe ...
our minds have the ability to think laterally.
Isaac Ash Pokiton, Cree/Chipewyan artist

Hypertext is very different from more traditional forms of text ...
Reading, in hypertext, is understood as a discontinuous or non-linear process
which, the thinking, is associative in nature,
as opposed to the sequential process envisioned by conventional text.
Idris Matia, computure researcher

A Note on the Structure of the Text

This study has been conceived as a 'trickster discourse,' to use the term coined by
the American mixed-blood Anishinaabe writer, Gerald Vizenor (1989, 9). It is a dis-
course among tricksters, about tricksters, and even as trickster, in the sense that
the 'trickster is a comic discourse, a collection of utterances in oral tradition'
(Vizenor 1989, 187). At once open-ended, unfolding, evolving, incomplete, the dis-
course is imagined in numerous verbal and visual narratives and a multiplicity of
authoritative voices. Charged with a playful spirit and what architect Robert
Venturi calls a 'messy vitality' (1966), it finds expression in multilayered commu-
nication and simultaneous conversation, in surprise connection and 'narrative
chance' (Vizenor 1989, 9). It defies univocal representation.

In the following pages quotations and notes are used extensively to disburse the
narrative voices and reflect the intertextual nature of the discourse. Neither quota-
tion nor note should be considered a secondary or subordinate text. At various
points in the conversation, other voices interrupt and/or subordinate text, in
space where texts can talk to each other' (Babcock 1984, 127) non sequitur, song,
poem, prose, and personal anecdote enrich and enliven the discourse. In some
instances notes take the form of extended annotation and include illustrations. In
this they constitute a kind of hypertext or hypermedia, forms of non-sequential
writing and visualizing that until recently were primarily associated with literary
studies and computer science (Delany and Landow 1991). Most important, the text
honours and participates to some degree in a non-linear process of representation
shared by many of the artists interviewed.

More than invocations of authority, the quotation and the footnote
are the means of transforming a monological performance into a dialogue,
of opening one's discourse to that of others.
They are also the literary way of interrupting and commenting on one's own text,
of acknowledging that reading and writing, like any cultural performance,
involve appropriating, absorbing, and transforming the texts of others.
Barbara Babcock, anthropologist

These pivotal questions set this study in motion and led to a series of animated
and illuminating conversations across Canada from January 1990 to November
1991 with various members of the extended 'Art Tribe,' as well as with Native elders,
linguists, actors, performance artists, curators, and art historians.[2] Emerging from
these conversations was the conviction on my part that there was indeed a sensi-
bility, a spirit, at work and at play in the practice of many of the artists, grounded
in a fundamentally comic world view and embodied in the traditional Native
North American trickster.

In fact, several artists cited the Trickster as a direct influence on some aspect of their
work. Most also agreed that a distinct comic and communal attitude does exist that
can legitimately be labelled 'Native humour.' Transcending geographical bound-
aries and tribal distinctions, it is most often characterized by frequent teasing,
outrageous punning, constant wordplay, surprising association, extreme subtlety,
layered and serious reference, and considerable compassion. These qualities are
amply illustrated in the words and images gathered together in this book under
the headings of self-identity, representation, political comol, and global presence.

2 The artists whose work is featured in this book are primarily Canadian. The ques-
tions posed and themes addressed are, however, reflective of a sensibility found
throughout Native North America. Several significant national and international
events anchor historically the period during which this initial research was con-
ducted. Their presence is registered in both the conversations excerpted and the
works reproduced in this study. Among the more notable are Elijah Harper's stan-
ding defeat of the Canadian government's March Lake Accord; the Mohawk stand-
off at Oka, Quebec; the war in the Persian Gulf; the 1992 Canadian constitutional
referendum; the sweeping victories of the film Dances with Wolves; and the 1992
Columbus quincentenary celebrations that precipitated the exhibition Indigena:
Perspectives of Indigenous Peoples on Five Hundred Years at the Canadian Museum
of Civilization, Hull, Quebec, and Land Spirit Power: First Nations at the National
Gallery of Canada in Ottawa, Ontario, to which several of the artists who were
interviewed contributed.

Included as well in the book are excerpts from later interviews, with Métis artist Bob
Logan in January 1995 and Plains Cree artist George Littlechild in November 1996.

Bottom right page (with image)

THUNDERBIRD: And even ('I take what I want.
Dangerous, threatening poise. While still looking at Foodbird)
THUNDERBIRD: [cont.] ... Yes, Quikulik! (pause slowly to take hunt) Stay in this camp. ()

Quikulik starts his glance, then looks down as if considering it, from the corner of his eye he casts his stare
you want to.

Quikulik meets his glance, then looks away as ...
Foodbird.

EXTREME CLOSE-UP of Foodbird's eyes ...
DISSOLVE: slowly. Casual.

QUIKULIK: Yes, of course ... Just me I'm leaving tomorrow for a caribou hunt ... say that way

...

THUNDERBIRD: [under] ...

VANESSA: [under her breath] My husband's ...

...

EXTERIOR CAMP NEXT DAY
CLOSE-UP of Quikulik bending over. He sets a bow assembly of ...

Assembling this book has been in some respects more like curating an exhibition of sculpture and painting than like anything in the normal round of editing and publishing. Art exhibitions are notorious for the amount of co-operation and patience they require as well as for the volume of largely invisible and intangible labour involved. Exhibitions also tend to put considerable strain on human relationships, yet they almost always testify to the presence of large reserves of faith and good will.

This book would not exist without the generosity, determination, and patience of Don and Barbara Atkins, nor without the public spirit and generosity of Victor L. Marks.

It would also not exist without the skill, dedication, and apparently incurable good cheer of Ernst Vegt, a master of fine-art photography, who is responsible for nearly all the photographic images.

Nor would it exist without the help of Eric Swanick, head of the Special Collections and Rare Books department at Simon Fraser University Library, who contributed immense amounts of professional expertise, made the research a pleasure, and went far out of his way to enable us to photograph books from the SFU collection. I am grateful to other librarians too, including Ralph Stanton at the University of British Columbia, Vancouver, and Valerie-Anne Lutz and Charles Greifenstein at the American Philosophical Society Library, Philadelphia.

Roberto Dosil, at CCSP, has been a delight to deal with throughout the process. Leah Gordon very generously provided the information contained in appendix 1. Hilary Hannigan undertook the sizable task of negotiating reprint permissions. The redoubtable Jim Douglas, Mark Stanton, Rowland Lorimer, and Mary Schendlinger have also all contributed to the project behind the scenes.

Rod McDonald of Lake Echo, Nova Scotia, who designed the type you are reading, introduced several subtle modifications and improvements especially for this book. Peter Cocking, Joe Kotler, Arden Ogg, and Ingrid Paulson very kindly helped me identify some types they had used themselves, and Andrew Steeves improved the book by pointing out the close connection between maple leaves and fig leaves.

I am grateful to the many Canadian publishers who have allowed me to reproduce in this book pages from some of theirs. I'm particularly grateful to Ron Scollon, a lifelong scholar of Chipewyan language and oral literature, who allowed me to use a significant excerpt from his work in progress on an important Canadian author, François Mandeville.

It is still occasionally said that "no one appreciates book designers" and that "nothing has been written about Canadian book design." The bibliography included here is, in my eyes, proof enough that both these sentiments are false. Several recent studies in the field – notably those by Randall Speller, Brian Donelly, Robert Stacey, and Dean Allen – have been particularly helpful to me and will, I think, be helpful to many others.

The writers, artists, storytellers, type designers, typographers, printers, and publishers whose work is displayed and discussed in this book are my colleagues. Many, whether they know it or not, have also been my teachers. I'm pleased to say that many are also my friends. Like anyone mounting an exhibition, I have included nothing at all that I myself do not find interesting and instructive, and nothing that I do not in some sense admire. But I could not include more than a fraction of what I admire, and the absence here of any particular book, or of any designer, author, publisher, or printer, is not an implicit sign of the absence of admiration. Every book and type designer in Canada, every alert Canadian publisher and librarian, and everybody anywhere who enjoys Canadian books, will be able to think of other books and people that might have been or ought to have been included. I have such a list myself. I suspect, in fact, that my list is longer than most – and it has not stopped growing.

Quadra Island, British Columbia
April 2008

Prologue: What's a book – and why?

It is an old and venerable rule that the typography of books should be transparent, like a window or a wineglass in which the text is held.[1] No printed page or drinking glass is actually invisible, but both can seem to disappear in favour of their contents. Both can also reappear as things in themselves and as mirrors of their surroundings. Individual readers and whole societies can and do see themselves reflected in their printing, whether or not they are conscious of it as such. The design and manufacture of books can tell us as much about a people or a culture as the condition of its grain fields, pasture lands, and gardens, the social climate of its streets, and the architecture of its buildings.

And what is a book? Most of us think of books as physical objects: words and sometimes images written or printed on a thin, flexible surface which has usually been folded, cut, and bound. But if books were merely that, then a telephone directory or mail-order catalogue would qualify as much as *Don Quixote* or the *Canterbury Tales*. To those who know and love them, books are recognizable, as forests are, and cities, by their structure (branching and rebranching), their complexity (enormous), and their size (big enough to get lost in). A book is usually something we can carry in one hand, yet if it is a real book it is also larger than we are: a city or forest of words that can feed us and swallow us up and transform us. A book is not a catalogue or list; it has to make more sense than that. It is not a stack of cordwood but a tree: a branching, leafing, flowering structure, unfolding in the mind, where it can find the space it needs.

In oral cultures, books are indeed invisible – but in every healthy and mature oral culture, books are present. Oral books that occupy no shelf space can and do unfold to epic size in storytellers' voices – and can retain that size, and that complexity, in a thoughtful listener's mind. The voice can be as palpable, and as seemingly transparent, as the printed page.

In electronic cultures, books can emerge in a similar way from a smidgin of disk space and flash across a screen, in a fleeting and unstable imitation of the printed page. It remains to be seen whether books in this form can interact as fruitfully with human attention and memory.

In cultures possessing fluent scripts, paper, and printing, books have acquired a stable material form. Those quiet, reliable, portable, legible objects are the benchmark incarnation of the book for most of us now, yet we know that, to be real, a book must be more than a physical object. What makes the tangible form of a book rewarding is that it stands for an intangible reality alive in the heart and mind.

1 The classic statement of this view is an essay by Beatrice Warde, "The Crystal Goblet," which began life as a lecture given in London in October 1930 under the title "Printing Should Be Invisible." For a printed version, see the bibliography, p 229.

The design of books has meaning because it gives visible form to those invisible realities. The book designer is an interpreter, drawing meaning to the surface where its shape can be revealed. That, however, is not all a book designer does. The printed page is a surface where things inside the book and things outside it intersect and interact with one another. The book designer deals with both of these, revealing in the process something about the text that has been written and something about the conditions in which it may be read.

Between 2004 and 2007 a large, three-volume study entitled *History of the Book in Canada* was published by the University of Toronto Press, and its twin in French, *Histoire du livre et de l'imprimé au Canada*, by les Presses de l'Université de Montréal. It is the work of over a hundred professional scholars orchestrated by Patricia Lockhart Fleming and Yvan Lamond, and it is a model of modern book design and production. This monumental work is full of interesting and useful information, but it troubles me in two respects. First, it is systematically devoid of any intellectual or literary sense of what might really constitute a book or why books matter to the human species. Second, despite its insistence that all books have material form, it exhibits no more interest in the visual and sculptural aspects of Canadian books than in their intellectual and literary role.[2]

The true subject of the *History of the Book in Canada* is the complex sociological phenomenon known as print culture: the effect, in other words, of giving human language an independent material life. This is a worthy subject, to be sure, and it substantially overlaps the history of the book – but the two are not the same. The *History of the Book in Canada* has much to say about newspapers, broadsides, calendars, hymn sheets, government bulletins, and even the printing of money – though these things are not books in any intelligent sense of the word. In an effort to reach out to Native culture, it also fastens upon wampum belts, petroglyphs, pictographs, and totem poles – but these are not books either. What they are is sumptuous counterparts of the library catalogue card: tokens confirming the fact that oral books exist and providing a highly abbreviated, skilfully coded summary of some of the things they contain.

Typography and design, though they are crucial to the life of printed books, are forms of art, not dimensions of sociology, and the *History of the Book in Canada* has remarkably little to say about them. Yet so richly is it filled with statistical analysis and gossip concerning the role that print has played in human affairs that, to stay within three volumes, it stops in 1980, leaving the last thirty years and the entire digital age out of account.

I have concentrated here on things the *History of the Book in Canada* glances over or leaves out: Canada's wealth of Aboriginal traditions, in

2 The third volume, edited by Carole Gerson and Jacques Michon, which covers the period 1918–1980, is on both counts a significant improvement on the previous two.

which the books are still primarily oral; the visual and sculptural coming-of-age of the Canadian printed book; and the explosion of books produced in the last few decades. Canadian society has changed in many ways since 1980, and so have our methods of type design, typesetting, book design, and production. These social and technological transformations are palpable in our books, which on the whole, since 1970 or 1980, have grown visually much richer, literarily more varied, and sculpturally poorer.

As luck would have it, a Vancouver-based group of Canadian bibliophiles, the Alcuin Society, founded a national book design competition in 1981. It was dormant in 1982 and 1983 but then grew steadily to international prominence. As further luck would have it, the poet Robin Skelton, through his literary quarterly *The Malahat Review*, founded another such competition, also in 1981. The Malahat Awards for book design ceased in 1984, but they started with great verve (like all things in which Skelton was involved), and they conveniently overlap the period when the Alcuin Awards had not quite found their feet. I am not a great believer in prizes and competitions, artistic, literary, or otherwise, but I suspect that the accumulated results of these two competitions over a quarter of a century are self-correcting enough to tell us a few things that an individual medal could not. I have therefore included the roster of these awards, and a brief analysis, in three appendices to this book.

There have been (and are) other graphic design competitions in Canada, but in these competitions books have played a minimal part.[3] (Most graphic designers, in Canada as elsewhere, have never designed a book, and most are neither temperamentally inclined nor technically qualified to do so.) And this is a book about books, not about advertising or packaging – not even about the packaging of books.

Unlike their usually glossy, sometimes garish, covers and jackets, printed books are three-dimensional objects. Their pages bend and turn, flowing into the spine and back out. Opened near the middle, they tend to have a different width as well as a different thickness than when opened near the front or back. In letterpress books – which are still alive and well in Canada – the lettershapes themselves are *in*, not *on*, the paper, so the page is a flexible sculpture in low relief. And the paper itself has weight, grain, fragrance, colour, and texture, as well as a partially fixed and partially mutable shape. There is more in a book than meets the eye, and consequently more than any camera can reach.

Thus it happens that printed books, like oral books, cannot be fully reproduced in the pages of other books, any more than marble sculptures or oil paintings can. It is possible, of course, to give some hints, and there is much more to be learned from a good reproduction than from a poor one. A lot of professional care and expertise has gone into making the

3 The Society of Graphic Designers of Canada 1970 catalogue (including work from 1966–68) is typical in this respect. It devotes two pages to the nine entries for book design (and in six of the nine cases focusses purely to the covers). Four pages are devoted to the thirteen entries for magazine and newspaper design, and forty-four pages to 116 entries under the heading Printing for Commerce (calendars, shopping bags, posters, and so on). Another eight pages are devoted to fifteen entries under the three headings Package Design, Exhibit Design, and "Experimental and Student Work." The notorious Graphic Design issue of the journal *Canadian Art*, published in 1960, offers a similar perspective.

reproductions in this book, but the measure of their success will be the degree to which they leave you uncontented with any reproduction and eager to encounter the originals instead.

Books exist because we want and need them. Many people want them nearly as much as they want children, and for closely related reasons. Humans, like all mammals, bequeath what they can to their offspring in two forms: natural and cultural, or genetic and nongenetic. Neither is sufficient on its own. Books, whether oral or written, are among the most powerful means we have for transmitting nongenetic heredity. Idolizing them brings with it certain problems. Societies that worship particular books have a worrisome record of aggravated self-righteousness. But worshipping a book is incompatible with genuinely *reading* it. And books, for all their failings – and their writers' and readers' failings too – seem to be crucial to human culture. Books – not writing or printing, but books in the deeper sense – may be part of our basic identity as a species. As basic as nests to birds.

Most of what we write and print, like most of what we say, has no such grand importance. What makes a book a book, in the fullest sense of the word, is its plausible claim to be a fairly self-contained component of the essential human legacy. We test words for that quality every time we read.

In the middle of Boris Pasternak's great novel, Yuri Zhivago sits in an upcountry library watching Larissa, the woman he loves, as she immerses herself in a book. He thinks to himself,

She reads as if that were not the highest human activity but something very simple, within the powers of a draft animal. As if she were carrying water or peeling potatoes.[4]

Not long afterward, he sees her bringing water from the well and thinks to himself, *It's the other way too: she carries water as if she were reading, lightly, without effort.*[5]

Real books encourage that kind of relationship between reading and the rest of life, and it is just that kind of reading – or so it seems to me – that allows us to recognize real books and to make use of them.

4 *Doctor Zhivago* § 2.9.12: Она читает так, точно это не высшая деятельность человека, а нечто простейшее, доступное животным. Точно она воду носит или чистит картошку.

5 § 2.9.13: И наоборот, воду она носит, точно читает, легко, без труда.

The Invisible Book

Humans have evidently been telling stories for about as long as there have been humans. That would be at least a hundred thousand years. We have been writing them, however, for fewer than four thousand years, and printing them for no more than twelve hundred.[1] Reading and writing did not become the predominant method of sharing information until the spread of universal compulsory schooling, which is much more recent than printing. It has lasted for less than one half of one per cent of the lifetime of our species.

There is clear evidence that writing developed in southern Mexico around three thousand years ago, independently of its origins in Mesopotamia, Egypt, and China. Like their Asian and Middle Eastern counterparts, the early Mesoamerican scripts involve large numbers of complex characters, uniting symbols for sounds with symbols for meanings. This kind of writing is too cumbersome for casual or universal use, and therefore difficult to export. Indigenous Mexican and Guatemalan writing systems endured for many centuries, but so far as we can tell, they were only used by professional priests or scribes and rarely employed beyond the boundaries of the empires which produced them.

At least two early visitors to Canada claimed to have found hieroglyphics. A soldier, Louis-Armand de Lahontan (1666–c.1715), claimed they were used by Iroquoians. A missionary, Chrestien Le Clercq (1641–c.1705), said he had seen them among the Micmac – and claimed to have built his own apparatus of hieroglyphic prayer on that foundation. There is no reason to doubt that these two men had seen indigenous meaningful symbols, but a set of symbols (ownership marks, heraldic crests, religious emblems, or warning signs, for instance) is not the same as writing. To be able to *write* means to be able to transcribe, with some precision, anything one can say in a human language.

Runic alphabets[2] were widely used in Scandinavia throughout the Middle Ages, and they are no more difficult to learn than other alphabetic scripts. Given the presence of Norse settlers in Newfoundland around the tenth century, it is possible that runic script was used on the Canadian east coast for writing short messages a millennium ago. Runic script also exerts a potent romantic attraction on some imaginations, so people have looked hard for North American runic inscriptions. Yet in spite of diligent searching, proof of the early use of runic script in North America has never yet been found. Canadian runes may still turn up, but when and if they do, they may not tell us a great deal. Even in northern Europe, where they

1 The oldest known printed book is an edition of the Diamond Sutra printed in China from hand-carved wooden plates in 868 CE. (A copy, found along the Silk Road in 1907, is now in the British Library, London.) Briefer texts were printed by similar methods under the patronage of the Empress Wǔ Zétiān (武則天), who died in 705. Printing from moveable metal type was also known in China and Korea at an early date – more than three centuries before Gutenberg.

2 The term *rune* has several senses. Any syllabic or alphabetic script written with straight, stiff strokes, in which the glyphs are not connected to each other, might be loosely known as runic. Such scripts are found in Italy, Turkey, North Africa, and elsewhere. The runic scripts of northern Europe are alphabetic, and their alphabetic order generally begins with the letters FUÞARK. (That third letter is *thorn*, pronounced like *th*.) These scripts are therefore known to specialists as *futharks*.

ALGONQUIAN	PENUTIAN
Abenaki	Nisgha
Atsina	Tsimshian
Blackfoot	
Cree	SALISH
Innuaumin	
Maliseet	Comox
Micmac	Halkomelem
Munsee *	Klallam
Ojibwa	Lillooet
Potawatomi	Lummi
	Nlakapamux
ATHAPASKAN ‡	Nuxalk
	Okanagan
Beaver	Pentlatch †
Chilcotin	Sechelt
Chipewyan	Shuswap
Dakelh	Squamish
Dogrib	
Gwichin	SIOUAN
Han	
Kaska	Lakhota
Nicola †	
Sarsi	WAKASHAN
Sekani	
Selkirk	Haisla
Slavey	Heiltsuk
Tagish †	Kwakwala
Tahltan	Nitinaht
Tanana	Nootka
Tsetsaut †	Uwekyala
Tutchone	
Wetsuwetin	XHAAYDAN
ESKALEUT	Haida
Inuktitut	UNCLASSIFIED
IROQUOIAN	Beothuk †

IROQUOIAN	
Atiwendaronk †	*Languages marked
Cayuga *	with an asterisk
Huron †	were brought to
Kwedech †	Canada after 1600
Mohawk*	by native speakers
Oneida*	leaving what is
Onondaga*	now the USA.
Seneca*	
Tuscarora*	† Languages marked
	with a dagger are no
KOLOSHAN ‡	longer spoken.
Tlingit	‡ Both Athapaskan
	and Koloshan belong
KUTENEIAN	to the Nadene-
	Yeniseian phylum.
Kutenai	

thrived, runic alphabets have rarely or never been used for extended texts. In Canada as in Europe, the runic *book* remains confined to the realms of antiquarian forgery and pseudohistorical fiction.

Bookish writing first came to Canada in the trim, familiar form of the Latin alphabet, transplanted here by French and English colonists and missionaries, beginning in the sixteenth century and spreading, often slowly and superficially, over the land. There were no printing presses here before the middle of the eighteenth century, and when they arrived they were used for printing small newspapers, calendars, government notices, and mercantile handbills, not for books. There was no Canadian paper mill until 1805, and no foundry casting type for a quarter century after that. There were no presses designed and built in Canada until the late 1830s, nor any printing type of Canadian design until after 1840. When Native Canadian type was at last produced, it was used for many decades solely for the purpose of printing texts from elsewhere.

But books were here already, in profusion, with no need of an alphabet in which they could be written nor of paper, type, and a press with which to print them.

When European adventurers began to come to Canada, perhaps sixty indigenous languages were spoken here. None of those languages had a script, but each one had a literature: a library ranging from proverbs and songs to wide-ranging cycles of interconnected stories. As ethnographic linguists learned to work together with Native Canadians, much of this literature found its way into manuscript, then into print. It was translated, in other words, from its original, dynamic, oral form, in which stories were mapped against the landscape, into the static form of writing, where the text was fixed securely to a page that could travel intact through time and space. In print, such works have often been supplied with English or French translations, but in these translations, many features of the original, including subtle allusions and references to places, plants, and animals, are frequently obscured.

One of the best of those linguists, John Reed Swanton, was able to see clearly how the oral book could function in Native Canadian societies. In the spring of 1901, after eight months' work in two Haida villages, he wrote to his mentor, Franz Boas, who was teaching in New York City:

I have written nearly three thousand pages in Haida and have translated most of the same.... Another thought that my studies this year have awakened is that in commonly supposing scriptures to be things of comparatively recent historical development we are exactly wrong. It seems to me that, although unwritten, the entire life of an ancient Haida was referred to nothing but scriptures or what may fairly be called such.[3]

Until 1960, most editions of Native Canadian texts were designed and printed abroad, yet they are Canadian in a way few other books are. They were all dictated in Canada by native-born Canadians speaking Native Canadian languages. They embody a truly Canadian heritage, and their literary structures are deeply homegrown. As such, they pose distinctively Canadian problems of typographic design. Any comprehensive study of Canadian books which ignores them is, I think, ignoring the truth in some of its richest, most interesting forms.

The first outsiders to make a formal study of Native Canadian languages were not ethnologists but missionaries. Many of them were fascinated by language. Far fewer, alas, were seriously interested in Native Canadian literature. They had the book to end all books and had come to preach that this was so. Friderik Baraga is an eminent example. He was born in 1797 in a Slovene-speaking part of the beleaguered Austrian Empire. He studied law in Vienna, theology at Ljubljana, and in 1823 was ordained a Catholic priest. After seven years in parishes near his war-torn home, he volunteered for duty in Ohio. Except for a couple of fundraising journeys to Europe, he remained in North America from 1831 until his death in 1868. At the height of his career, he was Bishop of Upper Michigan with a seat at Sault Ste. Marie and a territory including both the north and south shores of Lake Superior.

Language was Baraga's weapon, and he handled it with skill. He published devotional and historical works in Slovene, German, and French, linguistic works in English, and other religious works, including a volume of sermons, a collection of prayers and hymns, a guide to the Old Testament, and a biography of Jesus, all in Ojibwa. The sermons were much admired by his colleagues, who eventually translated them into Cree. His Ojibwa grammar (first published in Detroit in 1850) and his dictionary (published in Cincinnati in 1853) were later issued in revised Canadian editions by Beauchemin & Valois in Montreal.

Baraga's grammar is one of the finest nineteenth-century studies of a Native Canadian language. It is modelled, nevertheless, on grammars of Latin and Greek and sometimes seems, despite its best intentions, compelled to describe Ojibwa in Indo-European terms. It is filled with Algonquian words and phrases,[4] yet it looks like a European book because that is the only kind of book its author or printer had ever seen.

Émile Petitot, a French Oblate missionary some thirty years younger than Baraga, left a legacy of a different kind. Petitot arrived at Great Slave Lake in 1862. When he returned to France in 1883, he had accumulated a large collection of texts in four Native Canadian languages and shorter samples in two more. He published this collection, with parallel French translations, at Alençon in 1888. This was the first printed anthology of

3 Swanton's letter is dated 12 May 1901. The original is in the Anthropology Archives, American Museum of Natural History, New York. For the context, see chapter 8 in Robert Bringhurst, *A Story as Sharp as a Knife* (Vancouver: Douglas & McIntyre, 1999).

➤ Baraga: pp 26–27

4 Algonquian is the name of a language family – the one to which Oijbwa, Cree, and all of their close relatives belong. Algonquian is in turn part of a larger language phylum known as Algic. (Incidentally, every language, and almost every family, listed on the facing page has more than one name. The names given here are inevitably not those which everyone prefers.)

➤ Petitot: pp 28–29

➤ Boas, Swanton, Hewitt, Sapir,
 Bloomfield, Rasmussen, etc:
 pp 32–45

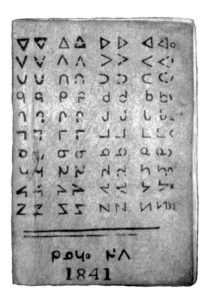

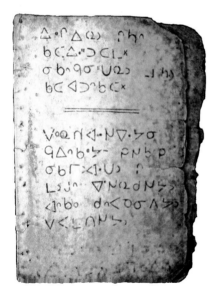

The first Canadian typeface, as printed by James Evans, Rossville, Manitoba, 1841. FACING PAGE: Some of Evans's original metal type.

Native Canadian literature. Far longer and better texts were transcribed between 1890 and 1940 by Boas, Swanton, J.N.B. Hewitt, Edward Sapir, Leonard Bloomfield, Knud Rasmussen, and others. For more than a century it has been feasible to make another multilingual Aboriginal anthology like Petitot's but bigger, broader, better. No one has yet done so.

Baraga probably knew nothing of Petitot. He almost certainly heard stories of a nearer neighbour, the Methodist missionary James Evans, who was born in England in 1801 and immigrated to Canada in 1822. From 1834 to 1839, Evans worked among the Ojibwa on the St. Clair River, at the other end of Lake Huron from Sault Ste. Marie. He was particularly keen that his parishioners should learn to read and write, and he came to think that the Latin alphabet hindered them from doing so. Evans had little graphic talent (his manuscripts, at the University of Western Ontario, make this clear), but he had mechanical and conceptual ability. He was much intrigued by Pitman shorthand, which he had learned in England as a boy, and he was interested in efforts then underway in England and France to create a simplified script for the blind. (The system invented by Louis Braille in 1829 was at that time only one of many contenders.) Evans supposed that such an approach would also help the sighted. He invented a script in which a simple geometric shape corresponds to each consonant and the *orientation* of the shape expresses the following vowel. For instance, in this system, ∟ = *ma*, ˥ = *me*, Γ = *mi*, and ⌐ = *mo*. Ignoring a few complexities (such as the critical distinction between short and long vowels, and the fact that a consonant can occur at the end of a syllable, without any following vowel), Evans first hoped that as few as nine basic symbols might suffice to write the essential sounds of Ojibwa.

He had just begun refining the system, adding signs for long vowels and final consonants, when he was transferred, first to Guelph and then, in 1840, to Norway House and Rossville, at the north end of Lake Winnipeg. The language spoken there was Cree, but Cree is close enough to Ojibwa that both Evans and his script could readily adapt.

In Manitoba, Evans started to experiment with methods of making type. Early in 1841, he succeeded in carving matrices from bur oak and casting some rough letters, getting his type-metal from musket balls and the linings of Hudson's Bay tea chests. He made his own press from a fur trader's press (intended for flattening pelts into bales), made his own ink from lampblack and fish oil, and tried printing on deer hide and birch bark as well as on paper.

Evans's Algonquian syllabics were the first Canadian script and became the first Canadian typeface. They were scoffed at by many, but over the next half century they were adopted and adapted enthusiastically by many other missionaries as well as Native people.

Evans's first, utterly homespun publication, completed late in 1841, was a sixteen-page booklet of hymns in Cree. After his early death, in 1846, his colleagues continued printing at Rossville Mission, and better fonts were professionally cut, both in London and in Montreal. By 1862 a complete Cree Bible had been printed in syllabics for the British and Foreign Bible Society, London. None of this early printed material is Canadian in content, but native speakers of Cree and Ojibwa saw that the script had other uses. They employed it to write letters, to leave messages for friends along the trapline, and for gravestones and graffiti.

Two Anglican missionaries, John Horden (1828–93) and Edwin Arthur Watkins (1827–1907), adapted Evans's system to Inuktitut. A third, Edmund Peck (1850–1924), used their script for his Inuktitut translation of the Bible and brought syllabics into general use in the eastern Arctic. Another Anglican, John Tims (1857–1945), created a variation of the script for writing Blackfoot. The Oblate fathers, beginning around 1850 with Henri Faraud (1823–90) and Alexandre Taché (1823–94), were the first to tackle the harder task of adapting the system to Chipewyan and its Athapaskan relatives.[5]

Athapaskan languages have a more elaborate array of consonants and vowels than Algonquian languages and cannot be unambiguously written without a larger set of symbols. Modified versions of Latin script actually work very well for this purpose, but the idea of a new and indigenous script exerted a strong attraction for missionaries and native speakers both. There are, however, many northern Athapaskan languages, each with its surprises. Francophone Catholic missionaries and their Anglican competitors worked on these difficult problems separately, and of course native speakers introduced innovations of their own. As a result, many variants of syllabic script came into local use. By no means all these variants were cut and cast as metal type, but Canadian syllabic fonts still multiplied – and found their way to print shops from backwoods British Columbia to Bruges.

One of the most avid syllabic printers was Émile Grouard (1840–1931), an energetic Oblate missionary who used his Belgian-made syllabic type to print devotional materials in Chipewyan, Slavey, Gwichin, and Beaver as well as Cree. Indeed, the first books printed in Alberta were printed by Grouard at Lac La Biche, beginning in 1878, in Athapaskan and Algonquian syllabics.

The most fully developed of all Canadian syllabic scripts was created in 1885 by another Oblate, Adrien-Gabriel Morice (1859–1938), for yet another Athapaskan language, Dakelh, spoken in northern British Columbia. Morice's system is based on those of Faraud, Grouard, and their colleagues, but Morice's comes much closer than the others to full

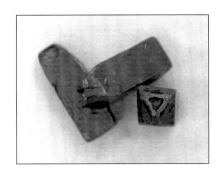

5 The first known publication in Athapaskan syllabics is a substantial volume entitled *Prières, cantiques et catéchisme en langue montagnaise ou chipeweyan* / ᑌᐅ ᐧᕿᐣ ᐣᐧᑊᕁ, published in Montreal in 1857 by Louis Perrault. (There are three later editions, published at Montreal, at the Lac La Biche Mission in Alberta, and at Bruges.) The Oblate motto (LJC&MI) on the title page and the certificate of ecclesiastical approbation leave no doubt that the compiler/translator was one of the Oblates of Mary Immaculate serving under Alexandre Taché, Bishop of St. Boniface. Taché himself and his colleague Henri Grollier probably contributed to the book, but the one Oblate competent to edit the whole work at that date was Henri Faraud. Thanks to an old and widely copied cataloguing error, nearly every institution in the world holding a copy of this book has for years misidentified the compiler as Charles-Ovide Perrault (1809–1837), the publisher's elder brother. Nothing in the book or elsewhere supports that attribution. Charles-Ovide Perrault was a Montreal lawyer and MPP for Vaudreuil. His brief life is well documented. It is certain that he was never an Oblate missionary and probable that he never heard or wrote a word of Chipewyan. Since he died on 24 November 1837, it is also certain that he was not acquainted with Canadian syllabic script in any form.

► Morice: pp 30–31

6 A detailed study of Morice's writing system, written by the linguist William Poser, is listed in the bibliography.

► Examples of Cree and Inuktitut texts published in syllabics since 1960: pp 79, 144–45, 174–75, and 178–79.

Initial	vowel			(final)
	i	u	a	
—	△	▷	◁	
p	∧	>	<	˂
t	∩	⊃	⊂	˂
k	ρ	d	b	ᑳ
ɣ / g	ᒉ	⅃	∟	ᒐ
m	Γ	⅃	∟	ᒪ
n	σ	ᣟ	ᕓ	ᐢ
s / h	ᒉ	ᒉ	ˎ	ˎ
l	⊂	⊃	⊆	ᒪ
j / y	ᐅ	ᐊ	ᐅ	ᐟ
v	ᐊ	ᐅ	ᐊ	ᐊ
ẏ / r	ᒉ	ᑉ	ᒋ	ᒋ
q	ˢρ	ˢd	ˢb	ˢb
ŋ / ng	ᵊᒉ	ᵊᒍ	ᵊ∟	ᵊ
ŋŋ / nng	ᵊᵊᒉ	ᵊᵊᒍ	ᵊᵊ∟	ᵊᵊ
ł / lh	ᒉ	ᒍ	ᒋ	ˎ

THE INUKTITUT SYLLABARY, *titirausiq nutaaq* (ᑎᑎᕋᐅᓯᖅ ᓄᑖᖅ), in the form now commonly used in Nunavut. In Nunavik (northern Quebec) a fourth orientation is widely used to write the diphthong *ai*: ▽ = *ai*, ∨ = *pai*, ∪ = *tai*, ᖅ = *kai*, etc.

and accurate representation of all the vowels and consonants involved. It also demonstrates, as few of the world's writing systems do, a subtle understanding of relations among the different sounds. And Morice alone among syllabic printers had three different sizes of type, cut and cast to his specifications in 1889 in Montreal. A font of Morice's Dakelh syllabics includes two hundred characters, where Evans's fully developed Cree syllabic script has ninety – but both systems still unfold from just nine basic shapes.[6]

What these missionary printers all have in common is that they were rendering foreign texts in Native Canadian languages, not intentionally aiding Canadian voices to find typographic forms of their own. But in this welter of translation, syllabic scripts matured into useful indigenous instruments. After 1940, as English and French swept over the land, the syllabic scripts receded from view. But dozens of syllabic fonts have been made in digital form in recent years, and most of the world's personal computers now come pre-equipped with more than 600 Canadian syllabic glyphs (all the established Inuktitut, Algonquian, and Athapaskan characters) in a font called Euphemia, produced in 2004 by the Canadian type designer William Ross Mills.

Creating a script for an unwritten language is one thing; finding typographic forms for an unwritten literature is something else. Early publications of Native Canadian texts uniformly treat the songs as verse and the oral narratives as prose, though the prose is often printed as a constellation of words or even individual syllables, teased apart for painfully literal translation. In the 1950s, the American linguist Dell Hymes began to study the structure of Native North American oral narrative and to demonstrate conclusively that it was something quite different from prose. The structures Hymes discovered are not "verse" in the conventional sense of that word, but it seems they are best represented by arranging the texts in lines and stanzas. These lines and stanzas are primarily units of meaning, not units of sound, and they embody fractal patterns which echo at different scales, from the tiniest narrative episode to the story or story cycle as a whole.

Hymes and others have shown that related structures are present in oral literature worldwide, and that they vary in wonderful ways from culture to culture. In European literature, however, it has long been the custom to mask or erase such semantic structures in prose and to replace them with acoustic patterns in poetry. European typography is (or was until recently) wedded to that convention and unprepared for Native North American literary forms. Though many Native Canadian texts have been published since Petitot's anthology of 1888, very few have been presented in a way that clarifies their structure.

Perhaps it will be useful to see how a text can change when its oral narrative structure *is* allowed to take visible shape on the page.

François Mandeville (1878–1952) is a Native Canadian author of some distinction. He was born at Fort Resolution, on the southern shore of Great Slave Lake. His father, Michel Mandeville, worked for the Hudson's Bay Company as an interpreter from 1891 until his death in 1910. François was fluent from childhood in Chipewyan and French. Later he picked up English. Like his father, he joined the HBC as a young man. He was stationed for a time at Hay River, where he learned Slavey, then at Arctic Red River, where he learned Gwichin. In 1917, he moved to Fort Rae, where he spoke Dogrib – a language he had learned already from his wife. In 1925, he retired to Fort Chipewyan, Alberta. This remained his home until his death in 1952, though he made many trips elsewhere, including a long visit to Wood Buffalo in 1940, where he learned some Cree. He could write but was not a writer. He had a great reputation as a mythteller instead. He never left northern Canada, yet when asked his nationality, he routinely replied that he was French. His French, not his Chipewyan, name is the one he chose to use.

In 1928, a linguist by the name of Li Fang-kuei (李方桂) called on Mandeville and asked if he would dictate a few stories. Six days a week for the next six weeks, Mandeville told long tales of Datsą́tthí (ᑕᑊᕁᐟ, Raven Head), Thatthẹlí (ᒍᐟᒉᐟ, Old Axe), Łuri (ᑊᑕᑎ, Scabby), Edełkali (▽∪ᔅᑫ∩, Spread Wings), and other characters. He knew very well what a book was, knew that he was making one, jotted notes to himself about episodes to include, and took great pains with the dictation. He also took great interest in the Latin-based technical alphabet used by Li Fang-kuei.

If Mandeville's book had been published locally and promptly, it would have made good sense to print it in Canadian syllabics. Instead, it rested in Li's notebooks for nearly fifty years. The work was finally published in 1976 – and unusually for an important Canadian book, it was issued in Taiwan. It has no Chipewyan title (nor a French one), but in English it is *Chipewyan Texts* and in Mandarin 赤坡巖語故事集 [*Chìpōyén yǔ gùshì jí*, "Red-slope-cave Language Legend Collection"]. All the stories are printed as prose, laboriously typed on a golfball-style typewriter in Chipewyan and English by Li's student, Ron Scollon.

Recently, Scollon returned to these stories to make a fresh and structurally sensitive translation. A small part of one story is shown on the following pages in three forms: (1) Li's field notes of 1928; (2) the published typescript of 1976; (3) a structural setting of the original with Scollon's new translation, made in 2007.

· Oral vowels *without* leading consonant:

a	e/ε	i	o/u
◁	▽	△	▷

· Nasal vowels are marked with grave:

ą	ę/ε̨	į	ǫ/ų
◁̀	▽̀	△̀	▷̀

· Oral vowels *with* leading consonants:

Initial	vowel				(final)
	a	e/ε	i	o/u	
ʔ	″◁	″▽	″△	″▷	
h	ˈ◁	ˈ▽	ˈ△	ˈ▷	
w	◁·	▽·	△·	▷·	o
b	<	∨	∧	>	ı
g, k	ᗷ	ᕪ	ᕞ	ᗡ	\
k'	ᗷˈ	ᕪˈ	ᕞˈ	ᗡˈ	
l	ᑐ	ᑌ	∩	ᑐ	ˢ
ł	ᶜᑐ	ᶜᑌ	ᶜ∩	ᶜᑐ	ˢ
dl, tł, tl'	ˈᑐ	ˈᑌ	ˈ∩	ˈᑐ	
m	ᒺ	ᒥ	ᒦ	ᒧ	ᴄ
n	ᑫ	ᑬ	ᓂ	ᓄ	ᗡ
s	ᒡ	ᒢ	ᒣ	ᒤ	ᑎ
ts, ts'	ˈᒡ	ˈᒢ	ˈᒣ	ˈᒤ	
sh / c	Ɛ	ɯ	ᗰ	ᴈ	
dj, tc, tc'	ˈƐ	ˈɯ	ˈᗰ	ˈᴈ	
d, r	ᑕ	∪	∩	ᑐ	/
t	ᑕ̵	ᑌ̵	ᗅ	ᗉ	
t'	ᑕˈ	∪ˈ	∩ˈ	ᑐˈ	
tθ'	∈	∪̵	⋒	϶	
θ, ð	ᑐ	ᕪ	ᒥ	ᑌ	h
tθ, dð	ˈᑐ	ˈᕪ	ˈᒥ	ˈᑌ	
x, γ	ᒧ	ᕯ	ᕝ	ᕲ	z
y	ᒾ	ᒿ	ᕀ	ᕁ	+
z	ᓄ	ᓇ	ᓈ	ᓉ	
dz	ˈᓄ	ˈᓇ	ˈᓈ	ˈᓉ	

One among many versions of the CHIPEWYAN SYLLABARY, typical of those used at Fort Chipewyan in the late 19th and early 20th centuries. This script would have been familiar to François Mandeville.

THIS PAGE: Pages 16–21, notebook 8, from the Chipewyan notebooks of Lǐ Fānggùi (Li Fang-kuei), written at Fort Chipewyan, Alberta, during the summer of 1928. 127 × 203 mm (5″ × 8″). This is one of a set of ten handwritten volumes, now part of Ms Coll 119, American Philosophical Society Library, Philadelphia.

FACING PAGE: Part of the same excerpt, as printed in Fang Kuei Li [Li Fang-kuei] & Ronald Scollon, *Chipewyan Texts / Chìpōyén yǔ gùshì jí* (Nankang, Taipei: Institute of History & Philology, Academica Sinica, 1976). 190 × 260 mm (7½″ × 10¼″). Undesigned. The author of the texts is François Mandeville.

12. The Story of the Man Who Became a Wolf
25)

1. There was a man called Spread Wings. It is said that man became a wolf. It is said that when he became a man again after being a wolf, he became like a young man. Three times he lived until old age and became a (young) man. So it is told about how once again he became a wolf.

2. At that time, he having become very old again, a wolf said to him, "If you wish to live on the earth yet, you must live with us again. If you do that, you will live for a long time in the future," it told him. Then Spread Wings thought, "I won't be a wolf again." But the wolf told him, "If you do not become a wolf again, it will not be long until you die," he told him. Spread Wings said, "I wish to live on the earth yet, so I'll become a wolf," he said. At once he became a wolf.

12. dene nʉniye ʔenadlɛ· beɣǫ honi

1. ʔįɬéɣį dene ʔedeɬkali húlye. ʔeyi dene nʉniye henadlɛ sni. ʔeyi nʉniye ɣįlé-tɛ'ę́ɣę dene henaθdlį-dé tcilekuyi láʔǫt'e ʔanat'ɛ́ sni. ta ʔoteyé hʉ́tɬ'éðɛ́ nɛ́únįɬθer hots'én dene ɣįlɛ́ sni. ʔekú· ʔįɬá nʉniye naɣedlɛ· hoɣǫ holni.

2. ʔekú· ʔoteyé nɛ́únįɬθer nadlįú nʉniye ʔayɛɬni. ʔǫtʉ̌· nɛ́ hok'e náɣwasθer yenįðen-dé nuhwe-xéɬ nánanedðer. ʔekwáʔanedjá-dé yʉ·naθɛ́ θá ɣįna-ixa, yéɬni. kú· ʔedeɬkali, nʉniye naɣwasdlɛ́-hílɛ yenįðen. kúlú nʉniye ʔayéɬni, nʉniye henaθįdlį-hílɛ-dé neðiyé-ixa θá-hílɛ, yéɬni. ʔedeɬkali ʔadi, ʔǫtʉ̌· nɛ́ hok'e náɣwasθer yenesθen ʔeyit'á nʉniye ɣwasɛ́, héni. dedǫnɛ́ nʉniye heθelį.

3. Then he found out that the wolf that was talking to him was an old woman. Then as soon as Spread Wings had become a wolf, the old woman said to him, "My Grandson, there are probably many caribou to the North. Now we'll start out that way," she said. Then they started to the North.

4. That wolf was old, but since she went fast, she went to the end of the big lake in no time. And so doing they finally came again to the barren ground. Then suddenly they saw caribou tracks. His grandmother said to him, "My Grandson, we are hungry now. (This which left these) tracks which we are looking at is meat. Now since I am old it is impossible for me, but you are a young man. Therefore I suppose it is not impossible for you. You go after it. Then I'll start after you. If by chance you have killed the caribou, I will come to you," she said.

3. kú· ʔeyi t'ahi nʉniye yets'én yaɬtei-nį nʉniye ts'éɣąkuyi ʔeyi ʔadi-hik'é. kú· ʔedeɬkali nʉniye heθelį dedǫnɛ́ nʉniye ts'éɣąkuyi
51)
ʔayéɬni, sʉnaɣį, yʉ·tθɛ́ ʔɛtθén ɬą-lesǫ́. dʉhú ʔekozɛ́ hʉ·t'ás, héni. ʔekú· yʉ·tθɛ́ hɛ̌·ð'az.

4. ʔeyi nʉniye nɛ́únįɬθer, kúlú nálɬɬa-hit'á tu netcá kúlú hóðʔą-hílɛ yek'é tθ'ánalguih. ʔekwáɬ'į-hįt'ǔ· ʔets'ɛ́naθɛ́ hozuɛ́-k'e nįhįt'az. ʔekú· ʔet'axą ʔɛtθén-keɣɛ́ ʔahu·ɣɛʔį. betsʉnɛ́ ʔayéɬni, sʉnaɣį, ʔekú· bér-ba hɛ́·dðer. diri bɛkeɣɛ́ nɛ́lʔį ʔeyi bér ʔǫt'e. ʔekú· si nɛ́únįɬθer-hit'á sa dʉ́yɛ́, kúlú nen tcilekuyi nɛlį. ʔeyit'á na dʉ́yé-hílɛ-lesǫ́. nen bɛk'éniye nįgaɬ. ʔekú· si nɛk'éniye tusâ· ʔet'axą ʔɛtθén ɬɛɣɛ́nįɬθer-dé ʔeyer neɣǫ níni·ya-ɣwalį, héni.

► OVERLEAF: The same text passage, retranscribed and retranslated by Ron Scollon in 2007.

dεne nų́niyε ʔεnadlíi bεɣą honi

ᑌᑕ ᓄᑊᘁ "ᐁᐧᐅᐠᐱᑊ ᐁᐧᐅᓄ

François Mandeville, transcribed by Li Fang-kuei

[PROLOGUE]

¶ ʔįɬáɣį dεne ʔεdεɬkali húlyε.

ʔεyi dεne nų́niyε hεnadlí
sni.

ʔεyi nų́niyε ɣįlέ-tɬ'áɣą
dεne hεnaθdlį-dέ
tcilekuyi láʔątʼε ʔanatʼį́
sni.

ta ʔoteyέ hútɬ'έðέ nį́únįɬθer hots'én dεne ɣįlέ
sni.

ʔεkúú ʔįɬá nų́niyε naɣεdlέε hoɣą holni.

[SCENE 1]

ʔεkúú ʔoteyέ nį́únįɬθer nadlįú nų́niyε ʔayεlni.

«ʔąɫų́ų́ nį́ hokʼε náɣwasθer yεnįðen-dέ
nuhwε-xέɬ nánanεdðer.
ʔεkwáʔanεdjá-dέ yų́ų́naθέ θá ɣįna-ixa,» yέɬni.

kúú ʔεdεɬkali,

«nų́niyε naɣwasdlέ-híle yεnįðen.»

kúlú nų́niyε ʔayέlni,

«nų́niyε hεnaθįdlį-híle-dέ nεðiyέ-ixa θá-híle,» yέɬni.

ʔεdεɬkali ʔadi,

«ʔąɫų́ų́ nį́ hokʼε náɣwasθer yεnεsθen
ʔεyitʼá nų́niyε ɣwasɬέ,» héni.

dεdąné nų́niyε hεθεlį.

THE STORY OF THE MAN WHO BECAME A WOLF

ᒧ ᓇᐤᑎ ᐅᑊ ᒧ ᐸᑊ ᑊᐸ ᐱᑕᐨ ᐊ ᐅᐧᔅᑊ

François Mandeville, translated by Ron Scollon

[PROLOGUE]

¶ *There was a man called Spread Wings.*

From time to time he became a wolf.
This is what they say.

After he has been a wolf,
when he becomes a man again,
he becomes a young man.
This is what they say.

Three times he has lived to be an old man.
This is what they say.

This is the story he told about becoming a wolf again.

[SCENE 1]

When he was very old, a wolf spoke to him,

"If you wish to live longer on the earth,
you must live with us again.
If you do that, you will live for a long time."

Spread Wings thought,

"I won't be a wolf again."

But the wolf said,

"If you don't become a wolf again, you'll die soon."

Spread Wings answered,

"I want to live longer on the earth,
so I will become a wolf again."

He immediately became a wolf.

kúú ʔɛyi t’ahi nųniyɛ yɛts’én yałtei-nį
 nųniyɛ ts’éyąkuyi ʔɛyi
 ʔadi-hik’ɛ́.

kúú ʔɛdɛłkali nųniyɛ hɛθɛlį dɛdąné
nųniyɛ ts’éyąkuyi ʔayéłni,

 « sųnaɣį,
 yųųtθɛ̨́ ʔɛtθén łą-lɛsą́.
 dųhú ʔɛkozį́ huút’ás, » héni.

[SCENE 2]

ʔɛkúú yųųtθɛ̨́ hɛɛ́ðʔaz.

 ʔɛyi nųniyɛ nį́únįłθer, kúlú náltła-hit’á
 tu nɛtcá kúlú hóðʔą-hílɛ yɛk’ɛ tθ’ánalguih.
 ʔɛkwát’į-hįt’uú ʔɛts’ínaθɛ́ hozué-k’ɛ nįhįt’az.

ʔɛkúú ʔɛt’axą ʔɛtθén-kɛɣɛ́ ʔahuuɣɛʔį.

betsųné ʔayéłni,

 « sųnaɣį,
 ʔɛkúú bér-ba hídðer.
 diri bɛkɛɣɛ́ nílʔį ʔɛyi bér ʔąt’ɛ.

 ʔɛkúú si nį́únįłθer-hit’á sa dúyé,
 kúlú nen tcilekuyi nɛlį.
 ʔɛyit’á na dúyé-hílɛ-lɛsą́.
 nen bek’éniye nįgał.

 ʔɛkúú si nɛk’éniye tusáa
 ʔɛt’axą ʔɛtθén łɛɣánįłθer-dé
 ʔɛyɛr nɛɣą́ níniiya-ɣwalí, » héni.

ʔɛkúú ʔɛdɛłkali ʔɛtθén-k’éniye tédya.

 hozué-k’ɛ nį́hįnįʔaz-nį
 kúlú ʔą́lųų ʔą́łk’ɛ dɛtcin-yaze dáréðla.
 ʔɛyi-ta ʔɛtθén hełkáł.

tɛðɛ ʔɛldziné nįðá ʔɛtθén nį́niłk’ɛ hozué-k’ɛ …

Then he realized that the wolf
 who was speaking to him
 was an old woman.

As soon as Spread Wings had become a wolf
the old woman said to him,

 "Grandson,
 there are probably many caribou up North.
 Let's go that way."

[SCENE 2]

They started North.

 Although the wolf was old, she went fast,
 so they came to the end of the big lake in no time.
 And doing so they finally came again to the barren ground.

Suddenly they saw caribou tracks.

His grandmother said,

 "Grandson,
 we are hungry now.
 These tracks we are seeing were left by meat.

 I am old, and so it is impossible for me,
 but you are a young man.
 It is not impossible for you.
 You go after it.

 I'll start after you.
 If you kill a caribou,
 I will come to you."

Spread Wings started after the caribou.

 They came to the barren ground,
 but there were still small pockets of woods.
 He tracked the caribou among them.

He tracked a long way in the moonlight on the barren ground …

[25]

Friderik Baraga, *A Theoretical and Practical Grammar of the Otchipwe Language*, 2nd ed. [revised by Albert Lacombe] (Montreal: Beauchemin & Valois, 1878). 127 × 185 mm (5″ × 7¼″). Designer unnamed.

The first edition of Baraga's Ojibwa grammar, published in Detroit in 1850, is 576 pages long. The Montreal edition of 1878 is described by its self-effacing editor as "a mere reprint" – but one in which "nevertheless we have thought it proper to make a few alterations … in order to save printing expenses." By paring down the number of examples, the length was reduced to 434 pages.

One Canadianism introduced in the Montreal edition is the use of the circumflex to mark long vowels. (The first edition marked them with acutes and graves, using the circumflex for nasals.) Though it is dropping out of use now in Ojibwa, the circumflex remains the normal Canadian way of marking long vowels in Ojibwa's sister language Cree, when it is written in Latin letters instead of syllabics.

A 19th-century printer, speaking in French, would have called the text face in this book *classique anglais,* but in English he would have called it *modern.* To an art historian, it is an Anglo-American Romantic face. All these terms point to the same things: the sharp contrast between the thick and thin strokes, the sharpness and thinness of the serifs, the ball-like terminals on letters such as *c, f, g, j, r,* and the insistently vertical emphasis or *rationalist axis* of the letters.

As in many 19th-century books, the title page is a collection of faces at hand: eight different fonts from six different families. And as usual with handset type, there are some wrongfont characters – letters from one font accidentally mixed into another. (On the left-hand page, for example, the fourth N in the *First Person* column and the P in the heading of the *Third Person* column are unintentionally different. Even the circumflexes can vary from line to line.)

[*See also pp 17–18*]

— 152 —

III. CONJUGATION.

To this Conjugation belong the *intransitive* or neuter verbs, that end at the third person singular, present, indicative, in *in* or *on;* and they likewise end so at the first person.

Here are some of the verbs of this description.

First Person.	*Third Person.*
Nin dagwishin, I arrive ;	*dagwishin.*
Nin pangishin, I fell ;	*pangishin.*
Nind âpitchishin, I fall hard ;	*âpitchishin.*
Nind agôdjin, I hang, or I am on high ;	*agôdjin.*
Nin jingishin, I am lying ;	*jingishin.*
Nin minoshin, I lie well ;	*minoshin.*
Nin twâshin, I break through the ice ;	*twâshin.*
Nind ojâshishin, I slide or glide ;	*ojâshishin.*
Nind osâmidon, I speak too much ;	*osâmidon.*
Nin danânagidon, I talk ;	*danânagidon.*
Nin mishidon, I have a long beard ;	*mishidon.*

AFFIRMATIVE FORM. NEGATIVE FORM.

INDICATIVE MOOD.

PRESENT TENSE.

Nin dagwishin, I arrive, *	*Kawin* si,
ki dagwishin,	" si,
dagwishin,	" si,
*dagwishin*im, one arrives,	" sim,
they arrive, (on	
arrive,)	
*nin dagwishin*imin, †	" simin,
*ki dagwishin*im,	" sim,
*dagwishin*og,	" siwag.

* See *Remark* 4, p. 96. † See *Remark* 3, p. 95.

IMPERFECT TENSE.

*Nin dagwishin*inaban, I arrived,	*Kawin* sinaban,
*ki dagwishin*inaban,	" sinaban,
*dagwishin*oban,	" siban,
*nin dagwishin*iminaban,	" siminaban,
*ki dagwishin*imwaban,	" simwaban,
*dagwishin*obanig,	" sibanig.

PERFECT TENSE.

Nin gi-dagwishin, I have arrived,	" si,
ki gi-dagwishin,	" si,
gi-dagwishin,	" si,

Etc., as above in the *present* tense, always prefixing *gi–*, to the verb.

PLUPERFECT TENSE.

*Nin gi-dagwishin*inâban, I had arrived,	*Kawin* sinâban,
*ki gi-dagwishin*inâban,	" sinaban,

Etc., as above in the *imperfect* tense, always prefixing *gi–*, to the verb.

FUTURE TENSE.

Nin ga-dagwishin, I will arrive,	*Kawin* si,
ki ga-dagwishin,	" si,
ta-dagwishin,	" si,
*ta-dagwishin*im,	" sim,
*nin ga-dagwishin*im,	" simin,
*ki ga-dagwishin*im,	" sim,
*ta-dagwishin*og,	" siwag.

SECOND FUTURE TENSE.

Nin ga-ji-dagwishin, I shall have arrived,	*Kawin* si,
ki ga-gi-dagwishin,	" si,
ta-gi-dagwishin,	" si,

Etc., as above.

A THEORETICAL AND PRACTICAL

GRAMMAR

OF THE

OTCHIPWE LANGUAGE

FOR THE USE OF

Missionaries and other persons living among the Indians

By R. R. BISHOP BARAGA.

A SECOND EDITION, BY A MISSIONARY OF THE OBLATES.

MONTREAL:
BEAUCHEMIN & VALOIS, Booksellers and Printers
256 and 258, St. Paul Street.

1878

Émile Petitot, *Traditions indiennes du Canada nord-ouest: textes originaux et traduction littérale*. (Alençon: Renaut de Broise, 1888). 138 × 216 mm (5½″ × 8½″). Designer unnamed.

Petitot transcribed these texts in northern Canada between 1862 and 1880, travelling widely from his base at Great Slave Lake. There are some pages in Cree and in Inuktitut, but the great majority of the book is in northern Athapaskan languages – Chipewyan, Dogrib, Gwichin, and Slavey – all with parallel French translation. The principal authors include François Beaulieu and Ekunélyel in Chipewyan, Sylvain Vitœdh in Gwichin, and Lizette K'atchodi in Slavey.

Petitot dealt with the rich parade of Athapaskan consonants by adding two Greek letters, χ and ρ (*chi* and *rho*), to his French roman alphabet, and by writing digraphs and trigraphs (e.g., *kh, kk, tt, tts*) to represent other speech sounds seldom heard in western Europe. (In this book, his printer replaced the Greek χ with a Latin cursive *x*.) Shifts of pitch or tone, which are common in Athapaskan languages, are marked by adding graves or acutes to the vowels. Nasalization is marked as in French, by adding an *n*. The distinction between long and short vowels, also important in Athapaskan languages, is not reliably recorded.

[*See also pp 17–18*]

la. Ekhu kuntl'on : inniétton Inkfwin-wétay nandigal'é, sendi, dukkρala Nigosi koρon Bénégunlay naxéttsen kokenté wéré.

çais (1) arrivèrent par eau avant que nous le savions ; étant toute petite depuis lors ma mère souvent cela de m'a parlé. Or ma mère en sa présence les Français sont arrivés donc. Et souventes fois : Jadis au Zénith assis créa la terre, m'a-t-elle dit, pas encore Créateur du les Français avec nous ils parlèrent, avant que.

Racontée par Lizette Khatchoti, vieille jongleuse, en 1870.

II

Ttséku-kρunhé.

La Femme aux Œufs.
(Origine des Peaux-de-Lièvre).

Yennènè l'adétté béella yédawétchu yu yéttchaninilla, inttiéri-kotchô ayinlaw, kρunhi yan yé naρwet, tsé kkè kwé-yan éyizou yéρanintchu, bé ella. Ekhu éyitta béρon tsédété. Kρulu béella yéρa kρon nadékkρon sundi. Ayétiwondé-ullé.

Femme une son beau-frère lui avait couvert la tête, le vêtement d'elle il avait écarté, toute nue grandement il l'avait mise, une maison petite dans elle demeurait, le seuil sur de nerf un peu seulement il lui avait donné, son

Ekρagontté kρulu kwè kha-
xoë inkρa ninihon yéρa-
déïndi, eyixhé xoë taékli,
kha l'adétté yillu agodatti,
yé khé-tchiré ékρa, eyixhé
xoë wési, xoé entl'on kha
ρon tadayaéklun, kha
entl'on ensi nayéllu, kha-
wé-hié déklin, kha entl'on
agullay ensi.

Uyellé bédènè nadékhé.
Ttséku-kρunhè détchin
tρatchinnéρolé, déti, eyikkè
tawétay xhé étchin :
— Ttsékukρunhé yérinkρa
inyay ? adu.

Bédènè dzédatl'a :
— Su nanutchu ? yendi.

beau-frère (1). C'est pour-
quoi on l'abandonna. Mais
son beau-frère pour elle
du feu alluma sans doute.
Elle n'en pouvait plus. Cela
étant cependant, le nerf des
lacets à lièvre pour faire
qu'il lui avait laissé
avec lui des lacets
elle tressa, lièvre un seul
elle prit ça arriva, ses
pieds-tendons elle tressa,
avec cela des lacets elle fit,
de lacets beaucoup lièvres
aux elle tendit sous les ar-
bres, de lièvres beaucoup
donc elle prit, un vêtement
de peau de lièvre elle tres-
sa, les lièvres nombreux
elle les rendit donc.

Au printemps son mari
revint en canot. La Femme-
œufs de poisson un arbre
penché sur l'eau, appelé, là-
dessus était perchée et avec
ça elle chantait : — La
femme aux œufs pourquoi
viens-tu la voir ? disait-elle.

Son mari tressaillit :
— Dois-je te reprendre ?
lui dit-il.

(1) Toutes ces phrases sont à double sens, et caractérisent l'état de la première femme après sa création, n'ayant pour toutes facultés que les organes reproducteurs kρon, ékkwé, et son intelligence qui la rendit maîtresse de sa position.

A 19th-century French printer would have called the type in Petitot's book *classique français* — the term then used for any French Romantic text face. What makes this type Romantic (or *classique*) is primarily the consistently vertical axis and sharp contrast between the thick strokes (*les pleins*) and the thin ones (*les déliés*). The almost circular bowl of lowercase roman *a* and the vertical tail of lowercase roman *y* are borrowed from the proprietary designs of Pierre Didot (1761–1853), but this type lacks other eccentricities which Didot introduced into his own fonts. The face was used by a number of French periodicals as early as 1840 — and Petitot's book began as a special issue of a learned periodical, the *Actes de la Société philologique*.

The smaller (8-point) font used for footnotes is quite different, with lower contrast and more gradual transitions between the thick and thin strokes, a teardrop-shaped bowl in the lowercase *a*, and a conventional sloped tail on the lowercase *y*. This type is *classique anglais* instead of *français*.

Adrien-Gabriel Morice, ꓭꜱꓭꜱ ▽ᵛ꓾ꓔ ꓷꞀᶻꓷꞄ / *Carrier Prayer-Book / Livre de prières à l'usage de la tribu des Porteurs* ([Fort Saint James, B.C.]: Stuart's Lake Mission, 1901). 98 × 140 mm (4″ × 5½″). DESIGN & PRESSWORK: Adrien-Gabriel Morice.

The book has title pages and prefaces in the Athapaskan language Dakelh (also known as Carrier), in English, and in French. Titles and subheads throughout are usually in English, French, Latin, or some combination of these. The main text, however, is entirely in Dakelh.

FAR RIGHT, FACING PAGE: Phonemic values of a few sample characters.

Morice designed the writing system itself as well as the type in which this book is printed.

[*See also pp 19–20*]

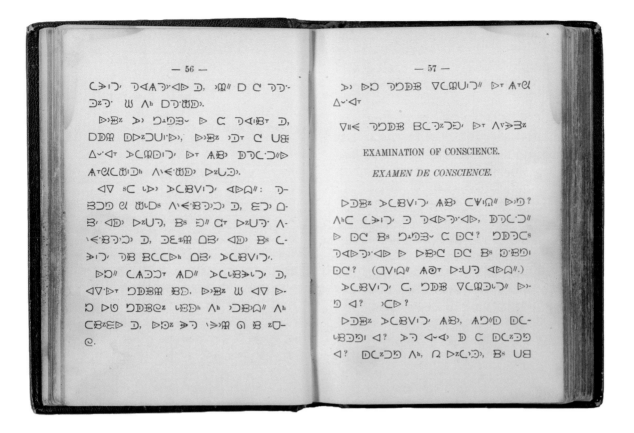

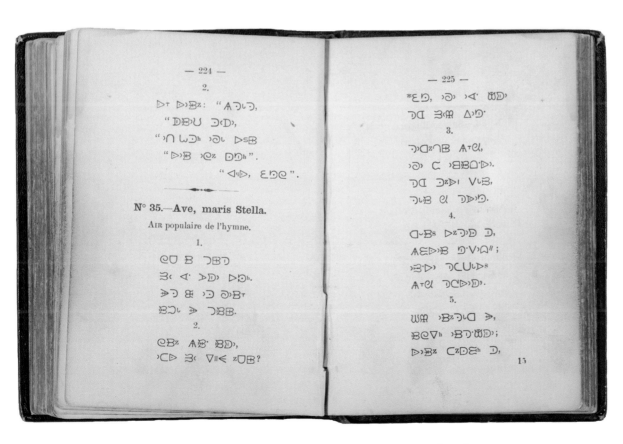

ꕷ	=	ta
ꕷ	=	tʌ
ꕷ	=	te
ꕷ	=	ti
ꕷ	=	to
ꕷ	=	tu
ꕷ	=	t'a
ꕷ	=	t'ʌ
ꕷ	=	t'e
ꕷ	=	t'i
ꕷ	=	t'o
ꕷ	=	t'u
ꕷ	=	ka
ꕷ	=	kʌ
ꕷ	=	ke
ꕷ	=	ki
ꕷ	=	ko
ꕷ	=	ku
ꕷ	=	k'a
ꕷ	=	k'ʌ
ꕷ	=	k'e
ꕷ	=	k'i
ꕷ	=	k'o
ꕷ	=	k'u

The vowel "ʌ" is like "a" but farther back in the mouth.

Consonants written with apostrophe are ejective (glottalized).

Franz Boas, *Tsimshian Texts*. Bureau of American Ethnology Bulletin 27. (Washington, D.C.: BAE, 1902). 196 × 286 mm (7¾″ × 11¼″). Designer unnamed.

These texts were dictated to Boas in the Nisgha village of Kincolith, on the Nass River, British Columbia, in November 1894 by Moses Bell and Philip Latimer. At the time, Boas was under the impression that Nisgha and Tsimshian were two dialects of a single language, so he called these "Tsimshian Texts," though he knew full well that they were dictated by Nisgha speakers. Linguists now know what native speakers knew all along: that Nisgha and Tsimshian are sister languages, like German and Dutch or Spanish and Italian, not dialectical variants of each other.

hîhî!" When he had said so, he hit the Deer's head. "O, my poor brother-in-law!" he said when the Deer died. Then he took the Deer into his canoe. He broke some mussel shells and stuck them into his body, saying that they were arrowheads. Then he paddled back to the village singing (?) (?) (?). Then the Deer's wife went down, and Txä'msEm showed her where the arrow points were sticking in the Deer's blanket. The woman believed him. They carried up the Deer which Txä'msEm had murdered. Then he killed the Deer's wife also. He stayed at the house and ate them. He had killed them for this purpose.

17. Then he came to the house of Smoke-hole. The house was at the foot of a mountain. He entered. The chief said to his grand-

1. Sa-ba'xL hē'tg·ê, k·'ēt ia'tsL t'Em-qē'sL wan. "Aiawa's
 It was finished he said, then he hit the head of the deer. "Oh,

2. q'aLā'nēE gua'!" dēya' aL La nô'ôL wa'ng·ê. K·'ēt lôgôm-gō'ôL
 my brother-in-law! Oh, poor one!" he said at (perf.) died the deer. Then into he took

3. wa'ng·ê aL ts'Em-mā'l. K·'ē dôqL q'am-g·usgua'sEm hā'gun.
 the deer in in the canoe. Then he took only broken large mussels.

4. KⁿLē-ax·'â'yit. K·'ēt lō-ma'ksaant aL LEpLa'nt. Ma'LdEL hawu'l
 All he struck it. Then in he stuck it in his body. He told that arrows were

5. lâ'ôt. K·'ē hwäx·t aL lō-ya'ltkⁿtg·ê: "Max-Lig·itwä'ltkⁿ
 in it. Then he paddled while he returned: "All

6. t'ēn wulä'kdEm qans dä'mxLē. Hē'i, hi'i, hi'i." K·'ē
 and my friend. Hē'i, hi'i, hi'i." Then

7. iaga-iē'L nak·sL wa'ng·ê. K·'ēt gun-g·a'adEs Txä'msEm
 down went the wife of the deer. Then made her see Txä'msEm

8. hwîl lō-ma'qskⁿL wun hawu'l aL gula's lEp-nē'tg·ê.
 where in struck the points of the arrows in his blanket himself.

9. K·'ē sEm-hō'tkⁿsL hana'qg·ê. K·'ē bax-gō'dEL wa'ng·ê. La
 Then believed him the woman. Then up they took the deer. (Perf.)

10. su-g·a'dEs Txä'msEm. K·'ē huX dē-dza'kⁿL na'k·stg·ê. K·'ē
 murdered Txä'msEm. Then also he killed his wife. Then

11. huX tq'al-lō-dzô'qst aL hwî'lpg·ê, aL yô'ôxk"t, qan
 also against he stayed at the house, and he ate, therefore

12. hwî'ltg·ê.
 he had done it.

13. 17. HuX hwä'iL hwîlps Am'ala'. HētkⁿL hwî'lpg·ê aL
 Again he found the house of Smoke-hole. It stood the house at

14. dēp-sqanē'st. K·'ē ts'ēnL lâ'ôt. K·'ē hē'tg·ê: "Qâ'ôL, qâ'ôL,
 the foot of a mountain. Then he entered in it. And he spoke: "Go for him, go for him,

¹ This sentence is in Tsimshian dialect.

children, "Attack him, because he steals all the good things he sees."
Txä′msᴇm took off the bark of an alder and chewed it. Then he entered
the house of Smoke-hole, intending to steal his bow, which was orna-
mented with abalone shells. He transformed himself into a raven and
took the bow. Smoke-hole said to his door, "Shut, Door!" Then
Txä′msᴇm was unable to leave the house. They tried to catch him,
intending to kill him. He cried, "Qa, qa, qa, qa!" Smoke-hole said
to his smoke hole, "Shut!" and the smoke hole caught Txä′msᴇm's
neck. He was dead, and his body was hanging in the smoke hole.
Txä′msᴇm pretended to be dead. Then Smoke-hole made a fire. Then
Txä′msᴇm took his own voice and put it in the woods, in a bluff behind
Smoke-hole's house. There it made an echo, crying, "Miserable chief,
what are you doing? You are a chief and you eat the excrements of a

dᴇm	lē′lukst	aʟ	am′ä′ma	līg·i-hwî′lʟ	g·a′atg·ê."	Nʟk·′ē	1		
(fut.)	he steals	of	good	things	he sees."	Then he			
k·s-qä′ôqt	sä-gō′dᴇʟ	mäsʟ	lōx·,	at	qē′ᴇntg·ê.	Nʟk·′ē	huX	2	
first	off took	the bark of	alder	and	chewed it.	Then	again		
ts′ēnt	aʟ	hwîlps	Am′ala′.	K·′ēt	k·si-dᴇ-ba′xʟ	ha-Xda′kⁿ	3		
he entered	at	the house of	Smoke-hole.	Then he	out with ran	the bow			
txa-bᴇlä′da.	K·′ēt	lō-ʟô′ôtkⁿʟ	qäk,	ʟat	gō′uʟ	ha-Xda′ks	4		
all abalone shell.	Then he	transformed himself into	the raven,	he (perf.)	took	the bow of			
Am′ala′g·ê.	"Hä′k′waxan,	ä′dz′ᴇp!"	dēya′s	Am′ala′.	Nʟk·′ē	5			
Smoke-hole.	"Shut so that it can not be moved	door!"	thus said	Smoke-hole.	Then				
aqʟ-k·si-yô′xkⁿs	Txä′msᴇm.	K·′ē	hwîl	k·′ē	lō-tk·o-yô′xkⁿt	aʟ	6		
without to go out	Txä′msᴇm.	At once		in around	he in followed				
hwî′lptg·ê	aʟ	dᴇm	dzakⁿt.	K·′ēt	lō-ʟô′ôtkⁿ·s	Txä′msᴇm	qäq	7	
his house	to	(fut.)	kill him.	Then	transformed himself	Txä′msᴇm	raven		
aʟ	hē′tg·ê:	"Qa,	qa,	qa,	qa."	K·′ē	a′lg·îxs	Am′ala′:	8
and	said:	"Qa,	qa,	qa,	qa."	Then	said	Smoke-hole:	
"Ha′kⁿwaxan,	gan-ala′!"	K·′ēt	hä′tsᴇʟ	t′ᴇm-lä′nîx·s	Txä′msᴇm	9			
"Shut,	boards smoke of hole!"	Then	hit	the neck of	Txä′msᴇm				
gan-alä′g·ê.	K·′ē	nô′ôs	Txä′msᴇm.	Lō-d′ᴇp-iax′ia′qʟ	g·a′dᴇt	aʟ	10		
the boards of the smoke hole.	Then	was dead	Txä′msᴇm.	In down hung	his body	in			
ts′ᴇm-ala′.	Hîs-nô′ôtkⁿʟ,	hwî′ltg·ê	Txä′msᴇm.	K·′ēt	sᴇ-mē′ls	11			
in the smoke hole.	He pretended to be dead,	he did	Txä′msᴇm.	Then	he burn made				
Am′ala′ʟ	lakⁿ.	K·′ēt	gōs	Txä′msᴇm	lᴇp-a′lg·îxt.	K·′ēt	12		
Smoke-hole	a fire.	Then	took	Txä′msᴇm	his own speech.	Then			
qaldîx·-ma′gat	aʟ	ts′ᴇm-biä′qʟ	qaq′alä′ns	Am′ala′g·ê.	At	13			
to the rear he put it of the house	at	in bluff	behind the house of	Smoke-hole.	He				
sᴇ-gul′ä′datg·ê:	"Qä′gᴇm	tsᴇ	dē-lᴇbᴇlt-hwî′lᴇnᴇstä′,	tedē	14				
made echo:	"Miserable	when	also against you do,	when					

The alphabet used here is an early attempt to create a stringent technical alphabet adaptable to any human language. Boas tested and revised it countless times between 1890 and 1935. In this version, the following rules apply:

1 A dot following a consonant means that it is palatalized (i.e., pronounced with a y-like glide, so *g·ê* = *gyê*).

2 A dot beneath a consonant means that it is uvularized (pronounced farther back in the throat).

3 An apostrophe following a consonant means that it is ejective (glottalized).

4 Cap X is a velar fricative, as in German *ich,* and lowercase *x* is its uvular counterpart.

5 The *q* is like *k* but uvular.

6 Small cap L is the sound now written λ or *tl*: a voiceless alveolar lateral affricate.

7 A macron indicates a long vowel.

8 The prime (′) is intended to indicate stress (which in these transcriptions is often confused with length).

9 In the vowels, diacritics and small caps are used to mark varieties of inflection which a native speaker would probably not have bothered to note. (In linguistic terms, these variations are phonetic, not phonemic.)

For a note on the type in which this book is set, see pp 36–37.

came in. Twenty sat down at the right side of the cradle, and twenty sat down at the left side of the cradle. Two men took hold of the right side of the cradle, and two of the left side, and the four men rocked the cradle; and thirty-six men said, "Hä⁸x̣ᵘ, hä⁸x̣ᵘ!" Then the girl stopped crying.

gwiлēda q!u'lsq!ulyakwē mō'sgEmg·ustâ-⁸laēda bē'bEgwanEmē. Wä, lā'⁸laē ma-⁸łtsE'mg·ustâwēda la k!us⁸ā'lїł lāx hēł-k·!ōtagā'wa⁸lїłasa xaā'p!ē. Wä, lā'⁸laē ma⁸łtsE'mg·ustâwēda la k!us⁸ā'lїłEla lā'x gEmxāgā'wa⁸lїłasa xaā'p!ē. Wä, lā'⁸laē dā'x·⁸īdēda ma⁸łō'kwē bē'bEgwanEm-xa hēłk·!ōtaxdzE⁸yasa xaā'p!ē. Wä, lā'⁸laē ma'luxᵘ⁸Emxaē'da lä'xat! dā'x·-⁸īdxa gEmxā'xdzE⁸yasa xaā'p!ē. Wä, lā'⁸laē yā'ł⁸īdēda mō'kwē bē'bEgwanEm-xa xaā'p!ē. Wä, lā'⁸laēda mā'musgEm-g·ustâlāsa q!aл!ō'kwē bē'bEgwanEm la ⁸nē'k·a: "Hä⁸x̣ᵘ, hä⁸x̣ᵘ." Wä, lā'⁸laē л!Ex⁸ī'dēda ts!ā'ts!adagEmē.

Then Food-Giver spoke, and said, "O brother! I am going to pull into my canoe some of the chiefs of the tribes, for that is what I was born for by my mother, my dear, — to make slaves of the chiefs all over the world." Thus spoke Food-Giver to his brother.

Wä, lā'⁸laē yā'q!eg·ałē л!ā'л!axwasdē. Wä, lā'⁸laē ⁸nē'k·a: "⁸ya, ⁸nE'mwōt, la-⁸mEn lāł nē'xEmxsElāł lā'xōx g·ī'g·aga-ma⁸yaxsa lē'lqwalaлēg·a⁸, qaxg·în hë'-⁸mēk· lā'g·iła g·āx mā⁸yuлEms, ā'dä, qEn lē q!ā'kwīlaxōx g·ī'g·agama⁸yaxsa awī'-⁸stäxsEns ⁸nā'lax," ⁸nē'x·⁸laē л!ā'л!axwas-dē lā'xēs ⁸nE'mwōtē.

———————

Then Head-Winter-Dancer spoke. He questioned Real-Chief, and said, "O son! are there not other tribes seen by your people on either side of you?" Thus he said to his son. Real-Chief spoke at once, and said, "O father! sometimes I see smoke at the other side." Thus he said, pointing to X̣ulkᵘ, the village of the ⁸nE'mgēs.

Wä, lā'⁸laē ē't!ēd yā'q!eg·ałē Ts!ä'-qama⁸ē. Wä, lā'⁸laē wuлā'x ⁸nā'x̣ᵘ⁸naxu-⁸la. Wä, lā'⁸laē ⁸nē'k·a: "⁸ya, xunō'k·ᵘ, k·!eâ'saē dō'gułtsōs g·ō'kulōtaqōs lāx ō'gu⁸lä lē'lqwalaлē lā'xwa, wā'x̣ᵘsē л!a-yā'qōs," ⁸nē'x·⁸laēxēs xunō'kwē. Wä, hë'x·⁸idaEm⁸lā'wisē yā'q!eg·ałē ⁸nā'x̣ᵘ-⁸naxu⁸la. Wä, lā'⁸laē ⁸nē'k·a: "⁸ya, ā'dats, â'naxwa⁸mEn dō'qulaxa kwā'x·iła lā'xa qwē'sōtē," ⁸nē'x·⁸laēxs la⁸ē ts!E'ma-łax X̣u'lkwē lāx g·ō'kwa⁸lasasa ⁸nE'm-gēsē.

Food-Giver wished at once to go and see them, and he asked Real-Chief to lend him forty able-bodied men. Then Real-Chief called his tribe, and told them that Food-Giver wanted forty able-bodied men; and he also told them

Wä, hë'x·⁸idaEm⁸lā'wisē л!ā'л!axwasdē ⁸nēx·· qa⁸s lē dō'x̣⁸wīdEq. Wä, lā'⁸laē axk·!ā'lax ⁸nā'x̣ᵘ⁸naxu⁸la qa лē'k·ōmasē-sēs mō'sgEmg·ustâ â'lak·!En bē'bEgwa-nEm lāq. Wä, hë'x·⁸idaEm⁸lā'wisē ⁸nā'x̣ᵘ-⁸naxu⁸la лē⁸lalaxēs g·ō'kulōtē. Wä,

FACING PAGE: Franz Boas &
George Hunt [Q'ix̌itasu'], *Kwakiutl
Texts*, vol. 1. Jesup North Pacific
Expedition 3.1 / Memoirs of the
American Museum of Natural
History 5.1 (New York: AMNH,
1902/1905). 273 × 347 mm
(10¾″ × 13¾″). Designer unnamed.

Nearly everything in this large
book was transcribed by Boas's
Canadian colleague Q'ix̌itasu',
a native speaker of Kwakwala,
between 1895 and 1900, in the
vicinity of Fort Rupert, B.C. Many
of the speakers are unnamed,
but some of the best can be
identified. They include Galgax̌ala,
T'sox̌t'sais, Wała'las, and X̌anyus.
The photograph shows part of
an 80-page story of a character
named T'saqame (Head Winter
Dancer), told by T'sox̌t'sais.

Here the superscript inverted 3 (ᶜ)
represents a glottal stop. Ejective
consonants are marked with an
exclamation.

THIS PAGE: John Napoleon Brinton
Hewitt, *Iroquoian Cosmology. Part 1.*
Bureau of American Ethnology
Annual Report 21 (Washington,
D.C.: BAE, 1903). 195 × 282 mm
(7¾″ × 11″). Designer unnamed.

The main text of this volume is
a creation story dictated by the
Mohawk elder Dayodakane (Seth
Newhouse) at the Grand River
Reserve, Ontario, in 1896 and 1897.

Mohawk, like other Iroquoian
languages, is rich in nasal
vowels. Here these are
written with ñ and
superscript n.

For a note on the
types in which
these two books are
set, see pp 36–37.

dogs licked the mush from her body. If she had flinched to the point
of refusing to finish her undertaking, it is also certain that he would
have said: "It is of course not true that thou desirest that thou and I
should marry."

And when his two beasts had finished eating, he then, it is said,
showed her just where his food lay. Thereupon she prepared it, and
when she had completed the preparation thereof, they two then ate
the morning meal.

It is said that she passed three nights there, and they two did not
once lie together. Only this was done, it is reported: When they two
lay down to sleep, they two placed their feet together, both placing
their heads in opposite directions.

Then, it is said, on the third morning, he said: "Now thou shalt
again go thither to the place whence thou hast come. One basket of
dried venison thou shalt bear thither on thy back by means of the fore-

Franz Boas & George Hunt, *Ethnology of the Kwakiutl*, vol. 1. Bureau of American Ethnology Annual Report 35 (Washington, D.C.: BAE, 1921). 193 × 283 mm (7½″ × 11″). Designer unnamed.

The entire book – two thick volumes – was written in Kwakwala by Q'ix̱itasu' (known in English as George Hunt), who also provided the illustrations and a literal English translation. Boas edited the work in both languages. In the printed version, pride of place is given to the translation because there were only a few hundred speakers of Kwakwala and very few of those were able to read the language. (There are now more readers but even fewer speakers.)

The alphabet used here is much like those shown on pp 32–34. Small cap L is the sound now written λ or *tl*; with a dot beneath (ʟ̣), it represents the voiced counterpart, now written λ or *dl*. The letter ł (barred L) is a voiceless L, now often written *hl* or *lh*. Superscript epsilon (ᵋ) represents a glottal stop.

CFGJQRST
CFGJQRST

TOP ROWS: Monotype Series 7 Modern Extended, used in the BAE publications of Native Canadian texts. BOTTOM ROWS: Old Style No. 2, used in the Jesup volumes.

abcd, efg? joprst
abcd, efg? joprst

136 ETHNOLOGY OF THE KWAKIUTL [ETH. ANN. 35

1 **Cedar-Bark Basket (1).**—Now the flat-bottomed basket is finished. | Then the woman takes cedar-bark and puts it down at the place where she is seated, | not far from the fire of the house, so that the | heat of the fire just strikes it. She measures the cedar-bark with her hand ‖
5 and cuts off a length of five spans | with her fish-knife. When the cedar-bark has been cut, | she splits it so that it is one | finger-width wide in the middle, in this manner: [figure] | This will be the
10 bottom of the cinquefoil-basket. As [figure] soon as all ‖ the cedar-bark has been split in the middle, the woman who makes the basket takes cedar-sticks | and splits them in square pieces half the thickness of the | little finger, and she measures them so that each is two spans | long. Then she breaks them off. | When this has been
15 done, she takes a narrow strip of ‖ split cedar-bark, and she takes the two | cedar-sticks that have been measured and places them together crosswise, in this way: [figure] Then she | ties them together with the narrow split cedar- bark. As soon as this has been finished, she | takes another one of the cedar-sticks that have been measured and puts it | on the other end of those that have
20 been tied together, and she [figure] ties it on with narrow ‖ split cedar-bark, in this manner: [figure] After this has been done, she | takes up another one of the cedar-sticks that have been measured, and she puts it | on the ends of the two sticks, and she ties

1 **Cedar-Bark Basket (1).**—Wä, laᴇmʟ̣a gwäla ʟᴇq!ᴇxsdē lᴇxaᵋya; wä, laxaēda ts!ᴇdāqē ăxᵋēdxa dᴇnasē qaᵋs ăxᵋälilēs läxēs k!waēlasē läxa k·!ēsē âlaᴇm qwēsaʟa läx lᴇgwīlasēs g·ōkwē qa âᵋmēsē hēlâlē ʟ·lēsᵋala-ēnaᵋyasa lᴇgwīlē läqēxs laē mᴇnmᴇnts!älaxa dᴇnasē. Wä, laᴇm
5 bäłᵋītsēs q!wäq!wax·ts!änaᵋyē läq. Wä, sᴇk·!ap!ᴇnk·ē bäʟaᵋyasēxs laē t!ōts!ᴇntsēs xwäʟayowē läq. Wä, g·îlᵋmēsē ᵋwīᵋla la t!ōt!ᴇts!laa-kwa dᴇnasaxs laē dzᴇdzᴇxsᴇndᴇq qa ᵋnälᵋnᴇmdᴇnēs läxᴇns q!wä-q!wax·ts!änaᵋyēx yîx âwâdzᴇwasas yîxa nᴇgᴇdzâᵋyas g·a gwäłēg·a (*fig.*) yîxa ōxsdēʟasa ʟᴇg·ats!ēʟē ʟ·läbatēlasōᵋs. Wä, g·îlᵋmēsē ᵋwīᵋla
10 la dzᴇxoyᴇwakŭxs laēda ʟ·läbätēlaēnoxwē ts!ᴇdāq ăxᵋēdxa k!wax-ʟāwē qaᵋs xôx̣ᵋwīdēq qa k·!ēk·!ᴇwᴇlxᵋunēs. Wä, lä k·!ōdᴇn läxᴇns sᴇlt!ax·ts!änaᵋyēx yîx âwâgwidasas. Wä, lä bäłᵋīdᴇq qa maēmałp!ᴇn-k·ēs âwâsgᴇmasasa mōts!aqē läxᴇns q!wäq!wax·ts!änaᵋyaxs laē k·ōx·sᴇndᴇq. Wä, g·îlᵋmēsē gwäłᴇxs laē ăxᵋēdxa ts!ēłts!ᴇq!astowē
15 dzᴇxᴇkᵘ dᴇnasa. Wä, laxaē ăxᵋēdxa malts!aqē läxa mᴇnēkwē k!waxʟāwē qaᵋs k·ak·ᴇtōdēs ōbaᵋyas g·a gwäłēg·a (*fig.*). Wä, lä yäʟōtsa ts!ᴇq!adzō dzᴇxᴇkᵘ dᴇnas läq. Wä, g·îlᵋmēsē gwäʟᴇxs laē ēt!ēd ăxᵋēdxa ᵋnᴇmts!aqē mᴇnēkᵘ k!waxʟāwa. Wä, laxaē k·atbᴇnts läx äpsbaᵋyasa lä yäʟᴇwakwa qaᵋs yîłᵋaʟᴇlōdēs yîsa ts!ᴇq!ädzowē
20 dzᴇxᴇkᵘ dᴇnas läq; g·a gwäłēg·a (*fig.*). Wä, g·îlᵋmēsē gwäʟᴇxs laē ēt!ēd ăxᵋēdxa ᵋnᴇmts!aqē mᴇnēkᵘ k!waxʟāwa qaᵋs k·ak·ᴇtbᴇndēs läx ōbaᵋyasa malts!aqē. Wä, läxaē yäʟᴇmg·aaʟᴇlōts wax·sbaᵋyasēs

[36]

it to both ends. | She just ties it on with narrow split cedar-bark. 23
Now | it is this way, and it is the stiff bottom of the clover-
basket, for ‖ that is what the cedar-sticks tied together 25
are called. Therefore all the | clover-baskets are of the
same size when they are made by the basket-makers. One
is neither | bigger nor smaller than another, for the bottoms
are measured. | When this is done, the woman takes the cedar-
bark that has been split | and measured off, and she
splits it again down to one end, ‖ in this manner: Then she 30
takes the stiff bottom and places it | on the
middle of the cedar-bark, in this way: and she
weaves it like a mat in | coarse weaving,
so that it is of the same size as | the stiff
bottom. Now it is woven | in this
way, and it is called | "the bottom
woven in broad strips;" namely, the bottom woven
in ‖ split cedar-bark. When the stiff bottom has 35
been covered, | the woman splits the cedar-bark
into narrow strips, starting from the | edge of the
stiff bottom, in this way: After | she has
split it, she takes a long strip of narrow split |
cedar-bark, puts the end through the cor-
ners of the stiff bottom into the ‖ woven bottom 40
of the basket, and she ties the | two ends to the

āłEm k·at!aLEloyâ yîsa ts!ēq!adzowē dzExEkwa dEnas laq. Wä, lä 23
g·a gwälaxs laē gwälēda L!āxaxsdēLāsa LEg·ats!ēLē L!ābata (*fig.*)
qaxs hëᵋmaē LēgEmsa yāLEwakwē k!waxLāwa lāg·iłas ᵋnEmālasa 25
LEg·ats!ē L!ābataxs laē k·!îtasEᵋwa yîsa L!ābatēlaēnoxwē k·!eâs
ᵋwālats. Wä, lāxaē k·!eâs ămäs qaēda mEnyayowēxa L!axExsdaᵋyē.
Wä, g·îłᵋmēsē gwälExs laēda ts!Edāqē ăxᵋēdxa mEnmEnts!aakwē
dzExōyewakᵘ dEnas qaᵋs dzExᵋēdē ēt!ēdxa dEnasē lābEnd lāx ăpsba-
ᵋyas, g·a gwälēg·a (*fig.*). Wä, lä ăxᵋēdxa L!āxExsdaᵋyē qaᵋs ăxdzō- 30
dēs lāxa nEgEdzâᵋyas g·a gwälēg·a (*fig.*). Wä, lä k·!îł!ēdEq qa
äwâdzolīdEkwēs. Wä, hëᵋmis qa ᵋnEmādzowēsēs k·!îtaᵋyē LEᵋwa
L!axExsdaᵋyē. Wä, laEm g·a gwälē k·!îtaᵋyasēg·a (*fig.*). Wä, hēEm
LēgadEs k·!ît!ExsdEᵋyē äwâdzolīdEkᵘ, yîxa ōxsdEyē, yîxs laē gadzE-
qałēda dzExEkwē dEnasa. Wä, g·îłᵋmēsē hamElg·îdzōwa L!āxExs- 35
daᵋyaxs laēda ts!Edāqē hēloxᵘsEnd dzEdzExsEndxa g·äg·iLEla lāx
ēwŭnxaᵋyasa L!axExsdaᵋyē qa ts!ēłts!Eq!astowēs (*fig.*). Wä, g·îł-
ᵋmēsē gwał dzEdzExsᵋālaq laē ăxᵋēdxa g·îlstowē ts!ēq!adzō dzExEkᵘ
dEnasa qaᵋs nēx·sōdēs lax k·!ēk·!ōsäsa L!āxExsdaᵋyē hēx·sâla lāx
äwâdzolīdEkwē k·!ît!ExsdEndēsa L!ābatē. Wä, lä mōkŭmg·aaLElōts 40
wäx·sbaᵋyas lāxa k·!ēk·!ōsäsa L!āxExsdaᵋyē g·a gwälēg·a (*fig.*). Wä,

The Native Canadian texts published in the USA and Canada during the early 20th century came from a few specialized publishers and were set and printed in a few specialized plants using the same or similar type. The books shown on pp 32–33, 35–43, and 45 are all set in what the Victorians called a "modern" (i.e., Romantic) face – usually Monotype Series 7 Modern Extended. For subheads a bolder Clarendon type was sometimes used.

Books in the American Museum of Natural History's Jesup series (see p 34) look different from the others because they were set and printed in Leiden by the firm of E.J. Brill. The type used for volumes in that series is what 19th- and early 20th-century printers called *old-style*. These types are not Romantic but Baroque, often with strong Neoclassical elements. The transitions from thick stroke to thin stroke are gradual; the axis of some letters is oblique rather than vertical; the aperture in letters such as C and e is larger; the upper serifs are more wedge-shaped, and the terminals of letters such as r and f are teardrop-shaped, not round. The earliest Jesup volumes, published in 1898–99, were handset in a Dutch face of this kind. From 1900 on, they were set on a Monotype machine in a face called Monotype Old Style No. 2.

(The Brill firm, founded in 1683 by Jordaan Luchtmans, specialized in oriental and scholarly printing, publishing, and bookselling. When its fortunes declined in the mid 19th century, it was bought, renamed, and rejuvenated by Evert Jan Brill. For the next hundred years, it had the reputation of being able to set and print "anything in any language." Toward the end of the 20th century the firm abandoned its fields of expertise – typography, printing, and bookselling – and retreated into "information management.")

A Story Told to Accompany Bear Songs

[Told by Job Moody of the Witch people]

A man began to set deadfalls. His son was always with him. Whenever he went out to see them he found that in some way or another they had got away from the deadfalls. And he now became angry. He became angry with himself because he could not get the black bears. Now he began fasting.

After eight nights had passed he became weak. In the ninth night his son lay by him, and some time before daylight he pushed against his father with his feet. Then his father did not move, and he looked at his father. He was already dead. He saw foam piled up in front of his mouth.

Now, although his father was dead, he went to see his father's deadfalls. There was one in the first deadfall he looked into. Then he pulled the bear out of the deadfall. He laid it face up to skin it. Now, when he took his knife the bear's body began to sing through him:

> Chief,[1] chief [that I am], be careful how you pull your grandfather around.
> Be careful how you pull around your grandfather as you sit beside him.
> I am too much of a boy for you (i. e., too old). Chief, chief [that I am].

After he had skinned it he looked at one (a deadfall) farther inland. One also lay in that. He pulled it out to skin it. Now he took his knife. [It then sang through him]:

> Chief, chief [that I am], I am already far away.
> At the cliff, coming from my passage through the mountains,[2] I hold up my head grandly.
> Chief, chief [that I am], I am already far away from it.
> From my blue mountain I am now far away.
> On the island I travel, led about proudly. From it I am far away. Chief, chief [that I am].

He started for one still farther inland. One was also in that. He pulled it out. When he laid his hand on his knife to skin it, that one also sang through him:

> Chief, chief [that I am], they say [that I have] green mountains.
> They say [that I went into the creek I own which stretches its length afar.[3]
> Chief, chief [that I am].

His younger brother having disappeared, Marten traveled around this island rapidly.[4] He then heard people singing [these songs]. And he sent word back quickly. He said: "The human beings have already finished singing." He immediately turned his marten skin upside down and held his beating stick to dance for his younger

A Story Told to Accompany Bear Songs

Nañ ī'łiña hao sqā'badax.idag.an. L' gī'tg.a ī'łiña la gi L.'dadjag.an. Uiê'dhao l' daot!agā'ñgas k!iał lā'g.a sqā'baga-i lā'g.a LguxA'n+ ga ī'sdagañas. Giê'nhao uiê'dhao l' st!exag.ia'lag.an. Giê'nhao q!enA'ñ hao l' st!ē'xag.ia'lag.an tana'-i g.adō' lA g.etsgia'si g.aga'n A. Uiê'dhao aga'ñ la g.e'idax.idag.an.

La gi g.ā'la-i stā'nsiñxag.ea'lga-i L.ū l' qada'og.ā'xag.ia'lag.an. G.ā'la-i LAAłī'ñgīsg.oa'nsiñgao g.ala'-i'g.a l' gī'tg.a la at tā'-idaiyag.an, giēn sī'ñgaL.an sta g.adjī'ñag.ela-i L.ū g.ō'ñg.añ la Lg.adā'ñag.an. Giēn gam l' g.ō'ñg.a hiłdAg.A'ns giēn xA'ñgusta ū la qea'ñagan. L' g.ō'ñg.a LL.ū'xan k!otwä'las. Xēłag.e'ista sqol q!a'-idjuL!xadies lA qea'ñag.an.

Uiê'dhao g.ō'ñg.añ k!otulā'gas sk!iä'xan g.ō'ñg.añg.a sqabaga'-i lA qiñgai'yag.ani. Uiê'dhao sqā'ba la qēnLā'gañas g.a xAn nañ g.a q!ä'dag.adai'yag.an. Uiê'dhao sqā'baga-i g.e'ista tā'na-i lA dAñL.stai'yag.ani. Uiê'dhao l' L!staga'-i g.an xA'ñagi lA la dag.ag.ā'wag.an. Uiê'dhao sqawa'-i la g.an lA qagī'ga-i L.ū tā'na-i k!ō'da la g.ei sg.alA'ñL!xax.idaiyag.an.

| : | :"O'ho hâ hâlī'x.ia'â: | gū'stalasxa'n ła tcī'nañ dAñL.g.ō'skinAñ.
　　　　Chief (in bear　　　　be careful　　　　　your　　　　[you] pull around.
　　　　language)　　　　　　　　　　　grandfather

　　"Gū'stalasxa'n ła tcī'nañ g.eiL.g.ō'sginAñ,
　　　Be careful　　　your　　[you] pull him around
　　　　　　　grandfather　sitting beside him.

　　" DAñ g.a dī g.axā' g.e'ida,: | :o hâlī'x.iêâ: | :â hâlī'x.ias: |
　　　You　for I　am too much of a　　chief　　　chief
　　　　　　　　boy

[Â hâlī'x.ias was sometimes replaced by Suwayē'.]

Uiê'dhao lA la Lstagī'ga-i L.ū didax.ū'sta lana' ī'siñ lA qea'ñgag.ealag.an. La g.a ī'siñ nañ L.'g.odi la ē'siñ L!staga'-i g.an lA dAñL.stai'yag.an. Uiê'dhao sqawa'-i la g.an lA g.agī'gag.an.

| :"Â hâlī'x.ias　sā'hâhaiyē,: | :hâ sta dī gai'xâägīwañ: |
　　　Chief　　　　from　I　　am already far away
Ldag.a'oxē'lagañ sta stAls gu ł A'ndjudala-i | :â hâlī'x.ias: |
My passage through　from cliff　at　I hold up my head　chief
　the mountains　　　　　　　greatly
A'hao sta dī q!aixā'gīwañ Ldag.a'o g.ō'lg.alg.A'ñ sta
Now　from　I　am far away　my mountain　blue　from
A'hao sta dī q!aixagī'wañ gwa-is gut ł A'ndjudala-i | :hâ sta dī
Now　from　I　am far away　island　upon I　travel about　from　I
　　　　　　　　　　　　　　　　　proudly
q!aixā'gīwañ: | | :hâlī'x.ias.: |
am far away　　　chief.

Hao ī'siñ dī'dA nañ īdja's g.a lA qā'x.iagît. La g.a ī'siñ nañ ga q!adag.ā'di. La ī'siñ wa g.e'ista lA dAñL.'stAL!xa. La ī'siñ L!staga'-i g.an sqawa'-i lA qagī'ga-i L.ū ī'siñ ga g.ei sg.alA'ñL!xa,

John Reed Swanton, *Haida Texts and Myths, Skidegate Dialect.* Bureau of American Ethnology Bulletin 29 (Washington, D.C.: BAE, 1905). 145 × 235 mm (5¾″ × 9¼″). Designer unnamed.

Swanton transcribed these texts, in the Haida language, at Skidegate in Haida Gwaii (the Queen Charlotte Islands) during the autumn of 1900. The first draft of the English translation was also made in the Haida country, by Swanton and his bilingual Haida colleague Henry Moody. The principal authors are Skaay, Ghandl, Kilxhawgins, and Sghaagya.

The alphabet Swanton used for Haida is similar to that which his teacher Franz Boas used for Kwakwala, but here ñ = ng (as in *song*); uvular g is written with a period beside (g.) instead of a dot below, and the voiced affricate dl is likewise written with a period beside ("L." instead of "ḷ"). The x followed by a period is a velar instead of uvular fricative. (Confusingly, then, "x." is higher in the throat than "x", but "g." is lower in the throat than "g", while "L." and "L" are both pronounced in the same position.) These oddities were not Swanton's preference; they stem in part from attempts by his employer, the Bureau of American Ethnology, to reduce the costs of printing.

[*See also p 16*]

a as in *father.*
e open as in *met.*
i as in *in.*
ī close as in *pique.*
o open as in *on;* occurs rarely.
ō close as in *note.*
ū as in *rule.* ·
û as in *but.*
a̧, ȩ, i̧, o̧, u̧ are a, e, ī, ō, and ū as described above, but nasalized.
y as in *yes.*
w as in *will.*
m as in *met.*
n as in *net.*
ñ as *ng* in *sing.*
l as in *let.*
ł a surd lateral spirant; the breath escapes between the teeth and the back of the tongue.
ł' the last described sound with glottal affection.
z sonant as in *lizard.*
s surd, nearly as in *sit* but sometimes approaching *c.*
j sonant as z in *azure.*
c as *sh* in *shall.*
γ a sonant palatal spirant similar to the sound of *g* in *Tage* as spoken in Northern Germany. In a few instances it may have been confused with *g.*
x a surd palatal spirant as *ch* in German *nach.*
h as in *hit.*
b as in *bit;* rare, probably connected with *m.*
d an intermediately sonant dental stop; that is, sonant in the latter portion only.
t a very strongly aspirated surd dental stop.
t' a glottally affected surd dental stop.
g a sonant palatal stop. It frequently occurs in the texts but is found in few separate etymological elements. In some cases it may have been misheard for either γ or ġ.
ġ intermediately sonant palatal stop.
k a strongly aspirated surd palatal stop.
k' a glottally affected surd palatal stop.
dz, dj; ts, tc; and ts', tc' are sonant, surd, and glottally affected affricatives akin in sound to a combination of the simple sounds composing them.
ʻ is used to denote especial aspiration after a vowel.
ᵋ is used for the glottal stop.

300

TŪMAXALE, A CULTURE HERO.[1]

ī ła dī ōñ ke dī łū dûγ γū γīn li̧ tin da zō' ke γût t'ac
Once two brothers were. Just alone they two were going about.

2 in t'ī zō łe tc'ûn nō γût łe he kū γût dī ī ła t'ī tū na tcī' ʻin-
Suddenly, "We will separate," they thought. "One lake large on each side

da dji ma maiʻ ʻin da djī ya wō t'a jī kū γût dī
its shore on each side we will go," they thought.

4 a dū wût te tōn t'e djī dī e jai de dûn ne tûn ne wō li̧ kō-
Not very far when he had gone person's trail was there. He came there.

nai ya gū ye a k'e heʻ γai yał k'a djū xic γa za tū na tcī'
Along there he walked. Again between mountains lake large

6 ke na de tûn na gū e xa k'a heʻ na des ya in da djeʻ tū ya
road came to the water again. Along there he went. On either side water sky

ē dō t'e ī k'e djiʻ tcaʻ ī leʻ ke tcin na γes dai lo̧ ai ye dī tc'e ġû
was to be seen. Along there beaver dam he crossed. There woman

8 mō gō ne le' ce nī γûn nī tī ya ᵋī ûs dī etc da na t'û ōn t'e
pretty dressed he saw. "My sister, what are you doing is it?"

ye' dī dûn ne γai ya le e t'e ût tsûk as de djī yī wō' a din dī
he said. Man immediately coming, she cried. "My sister for what do you—
 make a noise?"

10 dī tca na tcī djo na de dûn ne ma tc'e tes da e dī zō
"This beaver large here lives. People when they give to him only then

ke ne le ai yī ga ca γin ti̧ ī ye heʻ dū xa γa tceʻ ya γī xic
he is glad. That one they gave me to. Then, 'This evening over there mountain

12 ca na γa ya la djeʻ ī dī la łin ta tī djī e dō wō t'e heʻ ca
large right half way there sun goes down there

γa nī nût dûs tī la a cī ye' dī as detc tcaʻ a lōn t'e mō es dai
I will get you again,' he said." "My sister, beaver it is I will sit for him.

14 dī e djiʻ xōn na datc ye' dī ya γa xic kai he caʻ a deʻ ī e dī lo̧
When does he come out?" he asked. "Over there above the mountains sun
 if it is then

ī na dûs te le ce ye' dī xa mō es dai ya γī xic na wō djeʻ
I will get you,' he said." "Well, I will sit for him over there mountain
 on top,"

16 ye dī a t'ī ī e dī djō cût da γa cin da ye' dī ī e dī nī ye ti̧
he said it was there. "Here for me wait," he said. There he put her.

[1] Told by Louisçon, a man about 40 years of age who has maintained unusual interest in the myths of his people. The words and phrases in this text were later traced on the Rousselot apparatus from Louisçon. The transcription in this text is therefore believed to be fairly accurate.

Pliny E. Goddard, *Beaver Texts.* Anthropological Papers of the AMNH 10.5 (New York: American Museum of Natural History, 1917). 158 × 240 mm (6¼″ × 9½″). Designer unnamed.

Goddard transcribed these texts – dictated by three storytellers known as Ambroise, Ike, and Louisçon – on the Peace River near Vermilion, Alberta, in the summer of 1913.

Beaver – also known as Dunneza or Tsattine – is an Athapaskan language spoken in northern British Columbia and Alberta. Like other Athapaskan languages, it has a wonderfully elaborate system of vowels: long and short, oral and nasal, level and raised in pitch. Goddard recorded some of these distinctions but not all. Almost alone among professional field linguists, he also clung to the widespread amateur habit of writing Native American words and phrases as disconnected monosyllables.

Report of the Canadian Arctic Expedition 1913–18, vol. 13: *Eskimo Folk-lore* (Ottawa: King's Printer, 1926). 165 × 248 mm (6½″ × 9¾″). Designer unnamed.

Though transcribed by Diamond Jenness, a Canadian anthropologist, and published in Ottawa as part of the report of a Canadian expedition, nearly all of these texts were dictated in northern Alaska. Most of the stories were told by a woman named Qapqana from the Colville River country on the Beaufort Sea. The longest and most complex tale in the book (part of which is shown here) was dictated by Itaqluq and Alfred Hobson – two men from Barrow, Alaska – based on a story they had heard shortly before from a man named Ugiarnaq, from Cape Prince of Wales on the Bering Strait. The language is Inuktitut – primarily the Alaskan and Mackenzie Delta dialects of Inuktitut, which are generally known as Iñupiaq.

Jenness borrows Greek letters freely for sounds unfamiliar in English. He uses γ (*gamma*) for a voiced velar fricative (the *g* of German *Sagen*), and λ (*lambda*) for the voiceless alveolar lateral affricate, usually written *ł* (or *hl* or *lh*). The Latin *c*, in his system, represents a sound like *ch* in English *cheese*. The Greek vowels α, ι, ε (*alpha, iota, epsilon*) represent lax varieties of *u, i*, and *e* (as in *but, bit, bet*). The letter ɔ (*open o*, which looks like a rotated *c*) represents a lax variety of *o* (as in *nor*). The letter ŋ (*eng*) represents the sound *ng* (as in *sing*). A raised dot after a letter is a sign of increased length.

iγλaulakcɪn·aqλutɪk lɪkɪt·cuk tävräni
travelling every little while nevertheless | they arrived | then | they being

ɪtpiaγäluaqotɪk aŋayuqakmɪɣni kɪvγɪt·cut tamna uʷɪŋa
really for a time | at their parents | there were messengers | he | her husband |

ire·λaq kɪvγɪt·kat ana·k oqalaktuk ire·λaq nuliaqaiyunait·cɔq
IreIaq | they invited him | his parents | said | Irelaq | probably will cease

 acɪnʸ oqalaliγɪt·cut äλ·ät mälɪɣmɪγman
to possess a wife | well | they said again | others | when he followed also |

tɪŋmiaŋata ɪnʸupqalainmɪvλuγɪkλu mälɪkpan acɪnʸ
their bird | causing them two to be killed also | if he followed | well | the runners also |

aqpat·aqcγαptauq ɪnʸuit ɪtqänaiyaqcirut tapkwakλi ire·λatkuk
the men | they went to begin to get ready | yet those two | Irelaq and his

 ɪtqänaiyaqmiuk ɪtiγamɪŋ aulaγut
wife | went to get ready also | when they rose in the morning | they departed |

aulaqamɪŋ ɪnʸuit tamäγ·a qamuktoaqλutɪŋ ire·λam nuliani
when they departed | the men | here | hauling on the sled | Irelaq | his wife |

iλ·ɪvλuγo uniämɪnʸun aulaqtɔq qamukλuγɪt·li uniani
placing her on it | on his sled | he departed | but he drawing it | his sled | and

uciaγλuγolu nuliani iγλauγäluaqamɪŋ lɪkɪt·cut
loading her on it | his wife | when they had travelled for a while | they reached |

ku·kmun ɪmnalɪkmun civuλɪt° aqulɪγoqtut ire·λatkuk
to a river | to a place with a cliff | the front men | went behind | Irelaq and his

 aquλiγoqtuk ɪnʸuit tävra pɪc·uaqλutɪŋ ätqaγaqtut
wife | fell behind | the men | thereupon | walking | they descended one after the

 iλoqaqmɪŋ taina ätqaγaqtut ire·λatkuk
other | all of them | in this way | they went down one after the other | Irelaq and

 acɪnʸ aquλirni tɪkɪnmaγnɪk nutqaqtuk äλ·ät
his wife | then | in the rear | when they arrived | they stopped | the others |

mäγ·a nutqalaitcuλ·uni ku·kun tamäγ·a pɪc·uaqcɪn·aqλutɪŋ
here | not wishing to stop | through the river | here | walking one after the

 ikaγaqtut acɪnʸ pɪc·uaqcɪn·aqλutɪŋ mayuaqλutɪŋ
other | they crossed over | well | walking one behind the other | climbing up |

tɪkɪyacɪkamɪŋ qaŋanun nɪvɪŋacɪvλutɪŋ
when they had almost reached | to the top | beginning to lean back | they

pɪc·uaqtut mayuanɪk·amɪŋ aŋotɪt ikayɔγiaγat
walked | when they had completed the ascent | the men | they began to help

 ire·λaq tɪkɪnʸamɪŋ tamna aγnaq cikcγat
him | Irelaq | when they arrived | she | the woman | the sled-cover | to its

iλuanun naqilaγγutɪvλuγo ätgautiaqciγat akλunan·ɪk
inside | lashing her | they proceeded to lower her down | some ropes | holding

tɪγumicɪqλutɪŋ ätqaqcirut cukailaqλutɪŋ ätqatɪpqauγaγat
on to them | they proceeded down | going slowly | they with difficulty low-

 ku·kmun tɪkɪnʸamɪŋ εqγoqλuγo
ered her down | to the river | when they reached | carrying her on their shoulders |

ikaγotɪλiγɪt·kat mayuaqcɪλiγɪt·cut taina
they carried her across | they began to ascend again | in this way | when they

iγλauγäluaqamɪŋ qamotɪt qaŋataqtauγaqmatun iλ·iγaγaqtut
had travelled for a while | the sled | as if rising into the air | it gradually became|

ɑŋataqtauɣaqmatun | ιtkäluaɣami | kιc·εma | ɑŋata·piaqpɔq
as if rising into the air | when it was for a time | finally | it really rose up |

qiλ·iɣιn·un | tätpɑm·a | ikiɣaqtut | taina
upon the sled | there on top | they placed themselves | in this way | when they

iɣλauɣäluaqamιŋ | qamotιŋi tutqatalιqcut | tunmata
travelled for a time | his sled | they touched ground again | when they touched

iɣλaulaqcιn·aqλutιŋ | nutqaqtut | acιnᵛ ho·q | kιc·iän
ground | travelling nevertheless a little way | they rested | well | hoq | only |

nipiɣιλiɣιtᶜkat | naqitaɣotιλιtᶜkat | iɣλaupiɣäluaqotιŋ
they uttered it | they lashed her on again | travelling along really for a while |

ku·kmun | tιkιλiɣιtᶜcut | taina | culi | cirλιqiλiɣιt·cut
to a river | they reached again | in this way | again | they pulled harder again |

civuλιqtun | aɣlan | cirλιqipiäŋιt·cut | mayaqamιŋ
as at first | but | they did not really pull harder | when they ascended | they

naqitaɣotιλiɣιtᶜkat | iɣλauyuɣäläkλutιŋ | cua | ιpkwa
lashed her on again | continuing to travel on for a time | behold | those yonder |

ιn·ιt | ιnᵛuit | taika | ätoqpaucianιkniqcut | tιkιnᵛa
dwellings | people | over there | were already engaged in singing | when

maɣλaktotirut | qaɣiɣιmi | ire·λam
rived | they exchanged presents with them | in the dance-house | *Irelaq*

maɣλakmaɣoli | kimιnᵛi ιnᵛuit | aviɔrut | ιnᵛu
he gave presents to him however | his host | the people | shouted | the

oqalaɣaqtut | akιqcɣainᵛivλuɣo | maɣλaktoɣιqamιn
kept saying | there being nothing equivalent | when they had finishe

ιnᵛuit | aiyarut | ire·λatkukλi | airuk
presents | the people | went back home | but *Irelaq* and his wife | ret

kimιŋmιŋnun | ciɣoaqciqamιŋ | ire·λam aɣ
to their host | when it was becoming bed-time for them | *Irelaq* | hi

qoicuiqcaɣiaqtɔq | qoipqaqλuɣo | cua | una | nιviaqciaqa
went outside | after she had finished | behold | that one | a little girl

tιkιcanιkniqλuɣo | tiɣuvλuɣo | taima | oqalaktɔq | än
act of coming up to her | taking hold of her | then | she said | m

ɑm·a | piɣatιn | cuälaɣukλutιn | ɑm·
mother | she yonder | summons you | something wishing with you | she

piɣatιn | qain | qiλamιk | kinatakäpcak·äluaqtιλ·uɣo
she summons you | come | quickly | while she held back unwillingly h

noqιn·iaɣaqciɣa | picuŋιlakäluaɣami
she was going to keep dragging her along | when she was rather unwilli

kιc·εma | mäliaqciva | ku·k | mälilaqλuɣo aula
ever | finally | she proceeded to follow her | the river | following it | she t

tιkιt·cuk | mɑniɣauɣamun | cicitun | ιn·ιqcuamιk
away | they reached | to a low mound | like a cave | having a dwelling

upkwaqaqtuämun | icιqtuk | icιqniälaqmιk | nai
place that had a door | they entered | they being about to enter | she

auqcuknimιk | icιqmaŋnik | cua | una | utkucιk
something with blood | when they entered | behold | it | a pot | t

qalauqtoaq | auktun | ιt·uamιk oɣaɣaqnιqcuaq | anaɣoaq
boiling | like blood | being | what it contained | cooking | the ol

It appears that the Windigo was very angry at having eaten his grandmother. Now she was running down-hill; as she climbed the next rise, there down below was the iron house. When she looked behind her, already she saw the Windigo coming; then really she fled with all her might. When she reached it, she forgot the instruction she had been given by the old woman whom she had killed.

"Open the door for me! Both-Side-Eyes wants to kill me, big brother!" she cried.

Although she called in all manner of ways, he was even about to seize her, when she remembered what the old woman had told her.

"Big brother," she cried again, "open the door for me!" she cried; "Both-Side-Face wants to kill me!" she cried.

The door of the iron house swung open. She went in. She saw those who had their dwelling inside there, a young woman and a young man.

Then the young woman said to her, "Sister-in-law, sit down!"

Soon with noise the Windigo arrived outside.

"Open for me, Iron-House-Dweller!" he cried.

Then the young man opened the door and chopped off the Windigo's head.

Then the young woman stayed there. For that young woman and that man were very good to her. Then in time, they gave her something to keep in the bosom-fold of her garment, to give her manitou power. And really, she had great strength; she too had now manitou power. Then they made men's clothes, which she put on, * * * * * * * * * Then really, she went about hunting.

Then at one time they said to her, "Your brothers miss you very much. They are suffering greatly; you ought to try to see them," they told her; "Now, not far from here you will come to a hill. There you will see a very large tipi. He who lives there is intent on tormenting people; he builds a nest from which he jumps on people. That place is full of people who suffer from all kinds of injuries, since that evil person who lives there breaks different parts of their bodies as he comes down on them," they told her; "This is the only difficulty, but, after all, he takes only young women; he pays no attention to men. As soon as he sees you, he will say to you, " *" they told her; "That is what he will say to you."

When the young woman had been instructed, she went out of the house, taking provision for the journey. She set out. Presently, just as the day had reached noon, she saw the place. Although she walked far round to avoid it, she must have been seen by that evil man who all day jumped down on young women, taking pleasure in tormenting them.

When he had come and met her, he said to her, " * * * * * * "

So it seemed he was her cousin. * * * * * * * * * * * * *

" 'My male cousin,' I have been calling her; why it is Burnt-Stick!"

Thereupon she secretly took up a stick of saskatoon wood; she used it as a cane. He led her home by the hand and took her into his tipi. And there she saw nothing but young women whose bodies were broken in every way from having been jumped upon.

These young women said, "Only to think that we, too, were as beautiful as this young woman!" Thus spoke those crippled ones.

CANADA

DEPARTMENT OF MINES

HON. CHARLES STEWART, MINISTER; CHARLES CAMSELL, DEPUTY MINISTER

NATIONAL MUSEUM OF CANADA

W. H. COLLINS, ACTING DIRECTOR

BULLETIN No. 60

ANTHROPOLOGICAL SERIES, No. 11

Sacred Stories of the Sweet Grass Cree

BY

L. Bloomfield

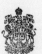

OTTAWA
F. A. ACLAND
PRINTER TO THE KING'S MOST EXCELLENT MAJESTY
1930

Then, when he had placed a seat, and had climbed up on a tree which stood there, she took that stick which she had picked up.

"Let it turn into iron!" she said; "When he comes leaping, let him impale himself!" she said.

And truly, as he jumped, he impaled himself, that evil man who used to kill the young women. So Burnt-Stick killed him; she killed that evil man.

She went to where she had left her brothers when she departed.

What did she see, they were weeping, mourning for her, and all the while saying, "Our little sister was eaten by the Windigo!" Thus spoke her brothers as she listened to them.

"Enough; cease weeping, brothers! I have come!" she said.

Those young men were very glad. She had picked out ten of the women she had restored to life, and taken them for her brothers. Then those men were very glad to have wives.

Then at one time, "I am not really a human being," said the young woman; "And now my father wants me. So I shall turn into a deer. I have completed my benefaction to all of you, in giving you young women."

(26) The Thunderer's Brother-in-Law

Louis Moosomin

nāh-namiskwākāpaw.

 kītahtawä yāhkih mīna mitātasiwak nāpäwak.

 āsay mīna tapasīwak, " usām kika-mästsihikunaw awa wīhtikōw," äh-ītwätsik äsah.

 päyak uskinīkiskwäsisah sipwähtahäwak, usīmisiwāwa. nikwatis äsa ntawih-usīhtāwak wīkiwāw. äkwah äkutä ay-ayāwak. äkwah kinwäs äkutä äsah uy-ōhpikihäwak ōhih usīmisiwāwa. piyisk ispimihk äsa mistikwah tsimahäwak, äkutah äh-mānukawātsik, äh-watsistwanihkätsik, itah äh-uwīkiyit. kītahtawä kahkiyaw käkway äsah pawätam awa kanāts-ōskinī-kiskwäw. äkwah kītahtawä kā-kiskäyihtahk kitah-pimihāt. äkwah kutakah nāpäsisah minah usīmisiw äsah awa uskinīkiskwäw.

 äkwah ōmisi k-ätāt usimisah : " niwīh-ntāmisun," itwäw äsah.

 " nimisä, tānitäh māka kä-kīh-miskaman mīnisah? pipun ōma," itwäw äsah awa nāpäsis.

 " nisīmis, namuya nika-kīh-pwātawihtān," itwäw äsah ; " ayisk nika-pimihān," itwäw äsah awa uskinīkiskwäw.

 äkwa tāpwä wawäyīw, ä-sipwähtät, kutak askiy äy-isi-pimihāt awa uskinīkiskwäw. tāpwä äkutä äh-takuhtät akāmaskihk, mātsi-mawisōw katisk äsah äh-āpihtā-kīsikāyik äkutä takuhtäw. āsay mātsi-mawisōw misāskwatōminah. päyak mwähtsi ä-sākaskinahtät umawiswäkan, āsay mīna kutak äh-atih-sākaskinahtāt, kītahtawä piyäsiwah kā-pähtākusiyit. kayahtä nāspitsi-sākimik. äh-pākupayit, kayahtä kā-wāh-waniskānikut uskinīkiwa. mistah äkwah äkutah miywäyihtam. māh-māsihitōwak ; uwītsimusiw ōhi uskinīkiwa.

 äh-utākusiniyik iyikuhk, kīwäw. tāpwä mīnisah kīwähtatāw. wīki-wāhk äh-takuhtät, mātsih-kīsisam ōhih mīnisah. mistah äkwah miywäyih-tamiyiwa ustāsah ä-kīsisamōwāt.

Leonard Bloomfield, *Sacred Stories of the Sweet Grass Cree.* National Museums of Canada Bulletin 60 (Ottawa: Department of Mines, 1930). 160 × 240 mm (6¼″ × 9½″). Designer unnamed.

Bloomfield transcribed these stories, in Cree, on the Sweetgrass Reserve, Saskatchewan, during the summer of 1925. Most of the texts were dictated by three older men, Kâ-kîsikâw-pîhtokêw (Coming Day), Sâkêwêw (Adam Sakewew), and Nâh-namiskwêkâpaw (Louis Moosomin). "Sacred Stories" is Bloomfield's translation of the Cree term *âtayôhkêwin*.

During the summer of 1925, while he was transcribing these often long and complex stories from dictation, Bloomfield also hired several Sweetgrass people to *write* stories in Cree. Those stories (which have never been published) are all written in Cree syllabics rather than Latin letters. Most members of the band knew the syllabic script, but writing, for the Sweetgrass people, had not become a literary activity. None of the written stories has the literary richness and fullness – the *bookishness,* you could say, in the best sense of that dubious word – found in most of the oral stories.

The Cree vowel now written *ê* is *ä* in Bloomfield's alphabet. The other long vowels are marked with a macron, not the more idiomatic circumflex.

While he published the complete Cree text of these stories, Bloomfield omitted from his translation even the subtlest and most sidelong references to sex and to excretion. These excisions are marked in the English with asterisks.

Knud Rasmussen, *Iglulik and Caribou Eskimo Texts*. Report of the 5th Thule Expedition 7.3 (Copenhagen: Gyldendal, 1930). 180 × 270 mm (7″ × 10¾″). Designer unnamed.

These Inuktitut texts were dictated in 1922, most of them by a man named Ivaluardjuk, at Naujat (Repulse Bay) in Nunavut.

Rasmussen uses a right-tailed *n* (ŋ) instead of eng (ŋ) for the sound *ng* (as in *sing*) and the letter *esh* (ʃ) for the sound *sh* (as in *ship*). Barred *b* (ƀ) here is a voiced bilabial fricative – or as Rasmussen describes it, a sound midway between *b* and *v*. Barred *g* (ǥ) is a voiced velar fricative – the sound that Jenness writes with a gamma (γ). The open o (ɔ) is lax o, as in English *nor*. A raised dot following a letter is a sign of increased length.

The type is a French Romantic face, first imported to Denmark in the 1890s and widely used there for the next several decades. The barred *b* (ƀ) – a symbol much used by early Indo-Europeanists – belongs to the same font, and an inverted *c* is used for open o (ɔ), but the esh, right-tailed *n*, and barred *g* are borrowed and do not match.

Edward Sapir & Morris Swadesh, *Nootka Texts: Tales and Ethnological Narratives, with Grammatical Notes and Lexical Materials* (Philadelphia: Linguistic Society of America, 1939). 173 × 254 mm (6¾″ × 10″). Designer unnamed.

Nootka Texts appeared sixty years after the Montreal edition of Baraga's *Grammar of Otchipwe*. In that interval, the Linotype and Monotype machines had come into common use, and many fine new types had been designed, but the text face employed for publications of this kind remained effectively unchanged.

The texts in this book were dictated in 1910 and 1913–14 in the Nuuchahnulth village of Ts'uuma'as near Port Alberni, B.C. Most of the texts – dictated by Saayaach'apis, Qiiẋa,

Wiḥa'is, and others, were transcribed by Edward Sapir, who was then chief anthropologist of the National Museum of Canada. An important section was also dictated by Saayaach'apis's son Siixuuhlmiik (Douglas Thomas) and transcribed by Siixuuhlmiik's son, Hiixuq'in'is (Alex Thomas), who had learned from Sapir how to write his native language. The passage shown here was dictated by Wiḥa'is (Frank Williams).

Sapir uses a rigorous technical alphabet in which increased length is marked by a following dot, uvular or pharyngeal shift by a dot below, and glottalization by an apostrophe above. The letters č and š represent *ch* and *sh* (as in *cherish*). Barred lambda (λ) is the affricate *tl*. The gelded question mark (ʔ) is a glottal stop. The discombobulated semicolon (ʕ) represents a pharyngealized or swallowed glottal stop.

and new and hard and demanding. But rich and fruitful too, and very beautiful.

"This is my home," she thought. "I've made it mine. And here will I live, and my boys with me, whatever happens." She laid her hand against the smooth pine of the door-frame, and the very feel of the hewn wood was strengthening.

"I'll still be lonely." Her mind moved on relentlessly. "But I'll live with my loneliness. I'll still love Michael, and miss him by day and by night. I'll live with that, too. I can."

She sat down on the low beam where she had sat with Michael and Colin on a winter's day that seemed long ago. She sat now alone.

There was a sound of running and laughter. Alec came in, with Bran bounding after him. He flung his arms about Fairlie's knees. "Finded you," he cried happily, and climbed up beside her.

❖ ❖ NORTHERN RIVER ❖ ❖

Chapter XIII

Just then, in a cabin on the shore of a far-away lake, two men sat up in their bunks and stared at each other. They were bearded, gaunt, and dirty. Their clothes were rags, their blankets tanned buffalo skins. The face of one suddenly glimmered into a smile.

"Mon Dieu, Michael, if I met you anywhere else, I'd swear I'd never before seen you."

Michael sighed gustily, then with thin fingers he

Grace Campbell, *Thorn-Apple Tree* (Toronto: Collins, 1942). Wood engravings by Franklin Carmichael. 140 × 200 mm (5½″ × 8″). DESIGN: Franklin Carmichael.

Campbell's novel is set on the Canadian frontier, but the type (set on a Linotype machine) is a deliberate and relatively faithful imitation of the letters of John Baskerville, an English Neoclassical designer. The texts that Baskerville had uppermost in mind when he drew these forms were Virgil's *Georgics* and the *Aeneid*. Here the type is set with half-em spaces between the words and a full em quad between sentences. (An em quad is a space as wide as the type is tall.) This is a practice found routinely in 19th-century publications.

[*See also p 48*]

The Echo of Tangibility

In Asia and Europe, where printing emerged from a long tradition of scribal practice, typography has always tended to differ from language to language and country to country. In the rest of the world, there has been much less creative exchange between typography and local forms of writing, and print more often looks like the colonial importation or imitation that it is. Even when type is locally made, under these conditions, it may look like borrowed clothing. The printing press arrived in the USA more than a century before it came to Canada, yet no distinctively American typography evolved before the end of the nineteenth century. Canada, with its smaller population and much less fervent sense of itself as an independent nation, was understandably still slower to develop a typography it could call its own.

There is nothing in principle wrong with second-hand clothes. But throughout the nineteenth century, as European colonial dominance reached its peak, European typographic art was in a slump. Inescapably, typography in the colonies slumped along with it. Paper was frequently poor[1] and design often pretentious or insipid. The printing types in common use were flaccid. It was customary to set them with fat spaces between the words and even fatter ones between the sentences, as if readers might need to catch their breath after every marriage of subject and predicate. Numerals tended to be the size of capitals, making a page of historical narrative look like a swollen column of classified ads. If special care were lavished on the title page, it might sport tuberous or vegetal hand lettering, blurring the vital distinction between linguistic and pictorial information. In Canadian books, the type might well be cast in Canada, but outside of a few books in Canadian syllabics, the letterforms themselves were always imported. Nor was there anything Canadian in the way these letters were placed on the page. Typographic conventions had the unquestioned authority of ancient institutions – even though the ties between these conventions and their foundations had largely rotted away.

European typography was born and raised in the Renaissance, nourished on trim and rapid penstrokes made by lively, well-trained human hands – but in conquering the world, becoming all things to all readers, typography had lost not only its local freshness but much of its intellectual and physical vitality. At the end of the nineteenth century, the forms of the Latin alphabet were begging to be reborn. Over the next several decades, they would in fact be reincarnated many times, but these renewals also came to Canada second-hand. The revival of humanist

1 There are many ways to ruin paper while making it, but the two favourites are by adding chlorine or ground wood fibre into the pulp. The use of chlorine became a problem soon after chlorine bleach was introduced, in France in 1789. The use of mechanical wood pulp was pioneered in the 1840s by at least two people working independently: Friedrich Keller in Germany and Charles Finnerty in Nova Scotia.

a a

Renaissance letterforms (ABOVE) tend to be *structures* growing naturally out of the pen nib. Victorian letterforms (BELOW) have for the most part disintegrated into *shapes*. They are as a rule *allusions to structures,* drawn, not written.

a a

scribal practice, forcefully begun when the self-taught calligrapher Edward Johnston began to teach in London in 1899, had immediate transformative effects in England and Germany. But Johnston's teaching came to Canada only in 1927, in watered-down form. Here its impact was much less.

There were signs even before the First World War that some people wanted to make better books. For years, the painter Tom Thomson (1877–1917) and several members of the Group of Seven made their living producing images for commercial reproduction. In 1912, before the Group as such was formed, these artists moved en masse from Grip, a Toronto advertising agency, to the printer/publisher Rous & Mann. After the war, Edwin Holgate (1892–1977), the belated eighth member of the Group of Seven, taught graphics in Montreal and experimented with books. In Winnipeg, Walter Phillips (1884–1963) turned from watercolour to woodcut, and then to wood engraving, issuing portfolios of images and illustrating a few books.

➤ Carmichael: p 46

J.E.H. MacDonald (1873–1932), eldest of the Group of Seven, took a keen interest in book illustration. His son, Thoreau MacDonald (1901–89), became a specialist in the field – but both men still saw letterforms merely as shapes, not structures, and neither pursued a serious interplay of text and illustration. Franklin Carmichael (1890–1941), youngest of the original Seven, had fewer ambitions in this domain, but his books are more nearly integrated wholes.

Better printing types at last began to appear, from American sources, just before the First World War; after the war, they were produced in greater numbers, in Europe and the USA alike.[2] Several Canadian printers and publishers – including Clarke & Stuart and Roy Wrigley in Vancouver, the Herald Press in Montreal, and Rous & Mann in Toronto – along with the revered Toronto typesetters Cooper & Beatty, acquired several of these fonts and learned how to use them.

Yet books were barely part of Canada's new self-image. Rous & Mann, under its enlightened CEO, was in much the same position as its artist employees. Proof that the things it produced were good in themselves was not enough to keep it alive; it had to claim that what it produced would help others make money. Most of its own publications were pamphlets, not books. What it printed for others, though well made, was for the most part trivial in content and ephemeral in nature. But if visual art *as art* was hard to sell, at least its existence was recognized. The National Gallery of Canada – named by a hopeful governor general in 1880 – had to wait until 1913 for Parliament to ratify its mandate, but the country went without a national library until 1953. (In the United States, by contrast, the Library of Congress mutated into a national public library before the end of the nineteenth century, but there was no National Gallery until 1937.)

2 For example: Frederic Goudy's Kennerley (1911); Morris Benton's Cloister (1913–25); Bruce Rogers's Centaur (1914); the revivals by ATF, Lanston, and Monotype (1918–22) of types by Jean Jannon (all misidentified as the work of Claude Garamont); Monotype Poliphilus & Blado (1923); the Stempel Foundry's Stempel Garamond (1924); Monotype Fournier (1925); Goudy's Deepdene (1927); Eric Gill's Gill Sans (1927); Paul Renner's Futura (1927); Linotype Granjon (1928); ATF Bulmer (1928); Monotype Bembo (1929); Gill's Perpetua (1929) and Joanna (1930); Linotype Estienne (1930); W.A. Dwiggins's Electra (1935); and Monotype Van Dijck (1937).

It was not until the 1960s that the Canadian book was convincingly reinvented in tangible form, yet with the luxury of hindsight we can see the pattern forming in many separate, simple events just after the Second World War. In 1946, a young man named Jack McClelland (1922–2004) started to work at his father's staid Toronto publishing firm. He would take control of the company, McClelland *&* Stewart, in 1961 and become the flamboyant prince of Canadian publishing. In 1947, an even younger man by the name of Frank Newfeld (born in Brno in 1928) visited Canada briefly, liked what he saw, and then headed for Jerusalem, where a more urgent cultural renaissance seemed ready to unfold. He would return in 1954, after training in London, to become the most productive and creative of all Canadian book designers.[3] In 1948, a quiet and passionate youngster named Roland Giguère (1929–2003) entered the recently formed École des Arts Graphiques in Montreal. Over the next twenty years, under the imprint of Éditions Erta, he would establish the *livre d'artiste* as a Québécois institution. In Vancouver in the late 1940s, another student, Robert Russell Reid (born in Medicine Hat in 1927), was teaching himself typography and printing. He would soon become an itinerant master typographer, stretching the bounds of commercial and academic publishing in Montreal and Toronto as well as Vancouver. And Reid would share his intense love of letterpress with the artist Takao Tanabe (born in Prince Rupert in 1926). Tanabe, far more than Reid, also had a keen ear for contemporary literature and would soon design and print some books as pure and spare as his later landscape paintings.

Remove any one of these people from the mix and the modern history of the book in Canada would be noticeably different and less interesting than it is. But many others enriched the broth in many ways. There was Antje Lingner, who in 1954 left her job as a designer of type specimens at the Bauer Foundry in Frankfurt, came to Canada on a whim, and was offered (perhaps also on a whim) a full-time job at the University of Toronto Press as in-house designer of books. She was the first person in Canada to hold such a position – and she retained it for forty-two years. There were other talented designers, including Allan Fleming (1929–77) and Harold Kurschenska (1931–2003), who were also both employed at times by the University of Toronto Press. There was a brilliant linocut artist, George Kuthan (1916–66), who worked with Reid on several projects in the early 1960s in Vancouver. There were serious private presses, sometimes printing genuine books. Two significant examples, both in Toronto, are George McDonagh's Roger Ascham Press, founded in 1964, which ran for two decades, and Will Rueter's Aliquando Press, founded in 1962, which is running still.

Canada's most celebrated typographer in the 1950s and 1960s was

➤ Newfeld: pp 52–61

3 Two useful studies of Newfeld's work, both written by Randall Speller, are listed in the bibliography.

➤ Reid: pp 64–65, 70–75

➤ Tanabe: pp 64–69

➤ Lingner: pp 84–85

➤ Fleming: pp 80–84; Kurschenska: pp 62–63

➤ Dair: pp 76–77

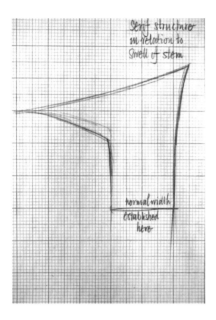

ABOVE: "Serif structure in relation to swell of stem": one of Dair's initial sketches for Cartier. BELOW: The 1967 version of Cartier roman, as used by Glenn Goluska in 1978.

Reader, Lover of Books, Lover of Heaven ⸿ABC DEFGHIJKLMNOPQRS TUVWXYZabcdefghi jklmnopqrstuvwxyz:

A catalogue based on an exhibition of the book arts in Ontario compiled by David B. Kotin ❧ with a checklist of Ontario private presses by Marilyn Rueter and an introduction by Douglas Lochhead ❧❧ Willowdale ❧ North York Public Library 1978

Carl Dair (1912–67), who spent most of his career doing ad work in Toronto and Montreal. He designed too few books – the craft was still too poorly paid – but he undertook to fill a void by designing the first Canadian alphabetic typeface. He christened it Cartier.

Dair was new to designing type, and the work went slowly. He initially imagined that Cartier might be cut by hand in metal, but technology was changing all the while. In the end, the face was rushed into production in phototype form, for use in the Canadian centennial of 1967. A few months later, its overworked designer was prematurely dead and could edit it no more. As initially issued, Cartier was a first draft. The roman was well drawn but available only in a display weight, too light for normal text. The italic was so spidery and cramped that it could scarcely be used at all. Accoutrements such as small capitals, needed for book work, were missing altogether. Only in the final years of the twentieth century (as we shall see in the next chapter) did the country's first alphabetic type attain a finished form.

Apart from some pleasantly zany initials, Frank Newfeld has never designed any type, but he has shown particular artistry in playing type and illustration off against each other, interweaving and interlocking the two. In a series of books that he designed for McClelland & Stewart in the early 1960s, illustrations are broken down into components which are reused in different contexts, as letterforms are. Square flowers (typographic ornaments normally used to print borders and patterns) are worked into illustrations, while freehand patterns are coaxed into scribal forms. The texts glide freely through this carnival, uninfringed and unperturbed. The illustrations are there to be looked at – *and that takes care of looking*; it satisfies that need. Pure reading is what's left – and the texts are set with that in mind.

You might not guess it, looking at these volumes, but at this point in its history, the typographic book was undergoing a major change. For five centuries in the European tradition, the printed page had been a three-dimensional object, created by pressing sculpted forms into thick but flexible paper.[4] As it transferred ink to the paper, the press also *changed the paper's shape.* In the early 1960s, type for books was still routinely set in metal – usually on a Linotype or Monotype machine – but increasingly, this type was used only to print proofs. First proofs were read and the type corrected; then final proofs were cut, pasted, and photographed. The resulting *image* of the type was printed by the *photo-offset* process, together with the illustrations. The end product was flat: two-dimensional text and images resting *on*, not *in*, the paper. The printing machine was still called a press, but it no longer left any *impression*. It changed the paper's colour but not its shape.

Within a few years, type design and typesetting were themselves turned into photographic processes, and the typical printed book became a kind of slow, heavily subtitled, manually operated cinema instead of a sinuous river of visible language in bas-relief.

In the midst of this unplanned and inarticulate transformation sat a bemused but highly articulate academic named Marshall McLuhan (1911–80). He joined the faculty of the University of Toronto in 1946 as an unknown and almost unpublished specialist in English Renaissance wordplay. By the early 1960s, he was the lionized author of *The Mechanical Bride, The Gutenberg Galaxy,* and *Understanding Media: The Extensions of Man.* Embracing another medium – oral tradition, manuscript, print, radio, or television, for instance – *reproportions our sensibilities*, said McLuhan, and this alters the way we think and behave. Bookish though he was, he was widely misunderstood to be prophesying the end of printed books and even relishing their demise.

In the age of the internet, McLuhan seems more prophetic than ever before, but the printed book (as he fervently hoped) has also survived. So has letterpress printing, with all its implications concerning the tangibility and three-dimensionality of meaning.

Newfeld, Dair, Fleming, and others who worked in trade and academic publishing went with the economic and technological tide, but they infused the new technology with their knowledge of the old. Reid held out a short while longer, producing magnificent letterpress work at McGill until his cheerful disregard for budgets and cost controls caught up with him. Charles Morriss (1907–83), an itinerant printer from Winnipeg, settled in Victoria in 1950 and started printing books there in 1953. Letterpress remained his chosen medium, and he ran his shop in the prairie spirit, using one text face (it was Intertype Baskerville) for everything. Bev Leech (born in Regina in 1935), who had studied with Reid in Vancouver in the early 1960s, then worked with him for years in Montreal, joined Morriss as staff designer in 1970 and presided over hundreds of books that were modern and old-fashioned, luxuriant and spare at the same time.

At his studio in New Westminster, B.C., Jim Rimmer (born in Vancouver in 1934) has been more old-fashioned yet, cutting and casting type in metal as well as in digital form. He has cut not only his own designs but also a 14-point version of Dair's Cartier and a 14-point Cree syllabic for hand composition in metal. New apprentices come to him yearly, keen to learn the ancient trade.

4 Printing in Asia goes back thirteen centuries rather than five, but early printing in Asia was generally on thin, translucent paper, printed one side only, and the image was often transferred to the paper by burnishing rather than pressing. The surface of the printing plate was sculpted in three dimensions, but under these conditions it rarely left a discernibly three-dimensional mark.

➤ McLuhan: pp 62–63

➤ Leech: pp 86–89

➤ Rimmer: pp 90–91

He cutteth out rivers among the rocks—JOB

Ralph Gustafson, *Rivers among Rocks* (Toronto: McClelland & Stewart, 1960). Illustrations by Frank Newfeld. 146 × 208 mm (5¾″ × 8¼″). DESIGN: Frank Newfeld.

Preceding the title page are four leaves of translucent paper printed on both sides, in three colours, with rocky and watery abstractions. Showing through the paper as they do, the three colours appear to be five. The text and remaining illustrations (three two-page spreads, marking the three main sections of the book) are printed in two colours rather than three, on paper with greater opacity.

The type is Pilgrim – the Linotype adaptation of Eric Gill's Bunyan, designed in 1934. The large initials are Michelangelo, designed by Hermann Zapf in 1950. The book was printed letterpress, using zinc engravings for the linocut illustrations. Subsequent books in the series (reproduced here on pp 54–61) were printed by photo-offset, though the type was still set in hot metal.

[*See also pp 49, 50, & 51*]

32 ❁ QUEBEC WINTERSCENE

And the snow trodden round the yard,
Soiled with boots and fetched cordwood,
Straw ravelled near the barn–
The long snow of the fourfold land.
At dusk, acres clamped cold,
Threshold and clearing everywhere white
To the distant scribble of alders, across
The frozen field snakefence
Like charred music; sky only harvest
Helps over, buckled, with taste of tin
Dipper icy a man drinks gasping,
Sweat of warm barn-work a hazard
Once out, door-to, headed for house.

 At eight, night now pitch, the train,
Halted for mailsacks at the swung
Lantern–the far horizontals
A moment, a history happening
The hills–alongside, pants, monstrous,
Pistons poised. Then pulls past.

At the cutting, heard warning

 whose only
Answer is the local heart.

O flesh, flesh, how art thou fishified! SHAKESPEARE

33 ❀ ON SUCH A WET AND BLUSTERY NIGHT

On such a wet and blustery night as this
May each man have his flame and house and food,
From pain his freedom now, as Mercy is,
And in his natural thought to count his good.
The street is wild and from the harrying north
The wind and rain beat down the lamps and walls,
The water glistens, swirls, all hate is forth;
Envy no man can who is not false.
On such a night as this King Lear went out
His head without a cover from the rain;
Owen waited in the Flanders mud
Drawing the shelter his greatcoat gave;
Soil loosened down the hill of Mozart's grave
Bewildered Constanze could not find again.

Marie-Claire Blais, *Tête blanche*, translated by Charles Fullman (Toronto: McClelland & Stewart, 1961). Illustrations by Frank Newfeld. 133 × 208 mm (5¼″ × 8¼″). DESIGN: Frank Newfeld.

The type is Linotype Electra, designed in 1934 by William Addison Dwiggins. It is a face inspired primarily by the work of the 18th-century French typographer Pierre-Simon Fournier.

As in many of Newfeld's books from this period, the title page has enlarged to occupy three spreads. Only a normal book paper is used, and only one colour of ink, but the extended title page again relies on the effect of images showing through from recto to verso and vice versa.

BLAIS

TÊTE BLANCHE

Translated from the French

by

CHARLES FULLMAN

BLAIS : TÊTE BLANCHE

A kite is a victim you are sure of.
You love it because it pulls
gentle enough to call you master,
strong enough to call you fool;
because it lives
like a desperate trained falcon
in the high sweet air,
and you can always haul it down
to tame it in your drawer.

A kite is a fish you have already caught
in a pool where no fish come,
so you play him carefully and long,
and hope he won't give up,
or the wind die down.

A kite is the last poem you've written,
so you give it to the wind,
but you don't let it go
until someone finds you
something else to do.

A kite is a contract of glory
that must be made with the sun,
so you make friends with the field
the river and the wind,
then you pray the whole cold night before,
under the travelling cordless moon,
to make you worthy and lyric and pure.

1

Darkness makes
 a home for the world
The serpents
 rise swanlike from the water
hurl their narrow tongues
at the iron hulks
of the dreaming tethered ships

If there are humans left like me
 along this natural shore
they do not dare cry out
My coat is the colour
 of the ruined sky
my fingers
 of the soft blue sand

Go by brooks, love,
Where fish stare,
Go by brooks,
I will pass there.

Go by rivers,
Where eels throng,
Rivers, love,
I won't be long.

Go by oceans,
Where whales sail,
Oceans, love,
I will not fail.

Beneath my
your small b
are the upturned bellies
of breathing fallen sparrows.

Wherever you move
I hear the sounds of closing wings
of falling wings.

I am speechless
because you have fallen beside me
because your eyelashes
are the spines of tiny fragile animals.

I dread the time
when your mouth
begins to call me hunter.

When you call me close
to tell me
your body is not beautiful
I want to summon
the eyes and hidden mouths
of stone and light and water
to testify against you.

63

Leonard Cohen, *Spice Box of Earth* (Toronto: McClelland & Stewart, 1961). Illustrations by Frank Newfeld. 148 × 209 mm (5¾″ × 8¼″). DESIGN: Frank Newfeld.

The type is Linotype Caledonia, designed in 1937 by W.A. Dwiggins. The typographic ornament, used in many ways in different colours and sizes throughout the book, was set in 18-point metal in repeating groups of four, proofed, and then photoenlarged in both positive and negative form. In the trade, this ornament is known as a Monotype N° 1310 corner piece.

The large, hand-held and hand-drawn letter facing the first poem in the book is Hebrew *kaph*, the initial letter of כהן *kohen*, or Cohen.

[*See also pp 49, 50, & 51*]

THE CHEQUERED

SHADE

POEMS BY ROY DANIELLS

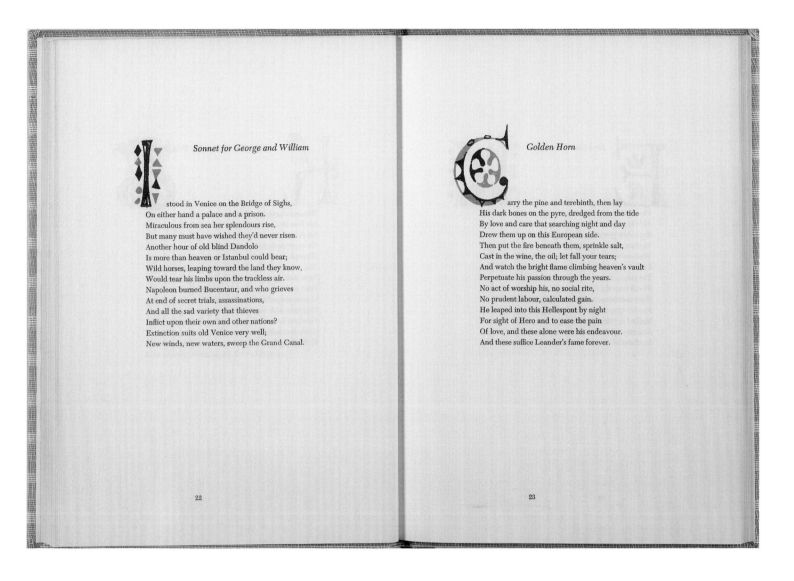

Sonnet for George and William

I stood in Venice on the Bridge of Sighs,
On either hand a palace and a prison.
Miraculous from sea her splendours rise,
But many must have wished they'd never risen.
Another hour of old blind Dandolo
Is more than heaven or Istanbul could bear;
Wild horses, leaping toward the land they know,
Would tear his limbs upon the trackless air.
Napoleon burned Bucentaur, and who grieves
At end of secret trials, assassinations,
And all the sad variety that thieves
Inflict upon their own and other nations?
Extinction suits old Venice very well;
New winds, new waters, sweep the Grand Canal.

22

Golden Horn

Carry the pine and terebinth, then lay
His dark bones on the pyre, dredged from the tide
By love and care that searching night and day
Drew them up on this European side.
Then put the fire beneath them, sprinkle salt,
Cast in the wine, the oil; let fall your tears;
And watch the bright flame climbing heaven's vault
Perpetuate his passion through the years.
No act of worship his, no social rite,
No prudent labour, calculated gain.
He leaped into this Hellespont by night
For sight of Hero and to ease the pain
Of love, and these alone were his endeavour.
And these suffice Leander's fame forever.

23

Roy Daniells, *The Chequered Shade* (Toronto: McClelland & Stewart, 1963). Hand lettering and initials by Frank Newfeld. 169 × 235 mm (6¾″ × 9¼″). DESIGN: Frank Newfeld.

Unlike Cohen and Gustafson, Daniells is now understandably seldom remembered as a poet, but his book remains a durable example of the book designer's art.

The type is again Linotype Caledonia, designed by W. A. Dwiggins. This is based on the so-called Scotch Roman fonts whose first known appearance is in Edinburgh in 1808.

Newfeld drew a full 26-letter font of these decorative initials and gave it the name Laurentia, but it was never manufactured as a typeface.

[See also pp 49, 50, & 51]

A

BESTIARY OF THE GARDEN FOR
CHILDREN WHO SHOULD KNOW BETTER

on & between the blades of grass
the shining Ant-hordes flow & pass
from morning dew to evening mist
beloved of the fabulist:
 these virtue-hoarders, honey-misers
 timesavers, grasshopper-despisers
 late-to-bedders, early-risers
i think they need some tranquillizers

the Bee's another body busy
buzzing till he drives me dizzy
always in a tearing tizzy
rather striped & kind of frizzy
not very personable izzy?

Cicada's a sting
of sound
never found
on the ground
or on the wing
his noise tears
crossgrain on the dry
blue jaw of the sky
like an electric razor that needs repairs

the Dandelion is frowsy & raggedy
his blossom is yellow, his leaf is jaggedy
his name implies you may well keep distant
but he isn't fierce, though he is insistent
his greens are edible & from the flower
you may brew some wine if you like it sour

28

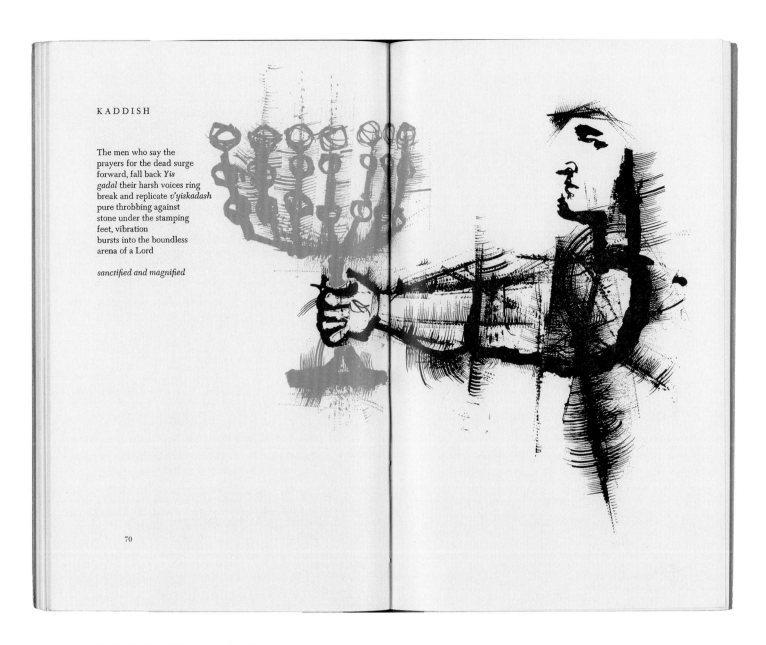

KADDISH

The men who say the
prayers for the dead surge
forward, fall back *Yis
gadal* their harsh voices ring
break and replicate *v'yiskadash*
pure throbbing against
stone under the stamping
feet, vibration
bursts into the boundless
arena of a Lord

sanctified and magnified

70

Phyllis Gotlieb, *Within the Zodiac* (Toronto:
McClelland & Stewart, 1964). Illustrations
by Frank Newfeld. 144 × 232 mm
(5¾″ × 9″). DESIGN: Frank Newfeld.

The type is Dwiggins's Linotype Caledonia.

itself in the mechanization of writing and what followed long before Gutenberg, "the advance in quantification which medieval logic exhibits is one of the chief differences between it and the earlier Aristotelian logic." (p. 72) And quantification means the translation of non-visual relations and realities into visual terms, a procedure inherent in the phonetic alphabet, as was shown earlier. But with Ramus in the sixteenth century it is not enough to make trees and schemes of knowledge:

For at the heart of the Ramist enterprise is the drive to tie down words themselves, rather than other representations, in simple geometrical patterns. Words are believed to be recalcitrant insofar as they derive from a world of sound, voices, cries; the Ramist ambition is to neutralize this connection by processing what is of itself nonspatial in order to reduce it to space in the starkest way possible. The spatial processing of sound by means of the alphabet is not enough. Printed or written words themselves must be deployed in spatial relationships, and the resulting schemata thought of as a key to their meanings. (pp. 89–90)

Confronted with the numerous relationships between Ramus and "applied knowledge," Father Ong has published an article, "Ramist Method and the Commercial Mind,"[50] which makes an admirable approach to the obsession with quantification in the Renaissance:

One of the persistent puzzles concerning Peter Ramus and his followers is the extraordinary diffusion of their works during the sixteenth and seventeenth centuries. The general pathway of this diffusion has been well known since Waddington's *Ramus* in 1855. It proceeds chiefly through bourgeois Protestant groups of merchants and artisans more or less tinged with Calvinism. These groups are found not only in Ramus' native France, but especially in Germany, Switzerland, the Low Countries, England, Scotland, Scandinavia, and New England. Perry Miller's work, *The New England Mind: the Seventeenth Century*, is the most detailed study of Ramism in any such group. Such groups were moving into more openly influential positions socially and were improving themselves intellectually, and Ramism appeals to them as they move up. Ramus' works thus enjoyed particular favor not in highly sophisticated intellectual circles but rather in elementary or secondary schools or along the fringe where secondary schooling and university education meet . . .

What is necessary to understand here is that the key to any kind of *applied* knowledge is the translation of a complex of relations into explicit visual terms. The alphabet itself as applied to the complex of the spoken word translates speech into a visual code that can be uniformly spread and transported. Print had given an intensity to this latent process that was a virtual educational and economic take-off. Ramus, with the whole scholastic drive

[50]*Studies in the Renaissance*, vol. VIII, 1961, pp. 155–72.

behind him was able to translate it into the visual "humanism of the new merchant classes." Such is the simplicity and crudity of the spatial models promoted by Ramus that no cultivated mind, and nobody sensitive to language, could be bothered with them. And yet it was this crudity that gave him his appeal to the self-educated and to the merchant classes. Just how large a section of the new reading public these were has been demonstrated in the great study of *Middle-Class Culture in Elizabethan England* by L. B. Wright.

Typography tended to alter language from a means of perception and exploration to a portable commodity.

✳ As for the mere stress on use and practicality, it is not only Ramus but the entire humanist corps that insists upon that. From the Sophists to Cicero training in language and oratory had been accepted as the road to power and top executive action. The Ciceronian program of encyclopedic knowledge in the arts and sciences came back with printing. The essentially dialogue character of scholasticism gave way to a more extensive program in languages and literature for the training of the Courtier and the Governor and the Prince. What we have come to consider as an impossibly genteel curriculum of authors, languages, and history was in the Renaissance held necessary for the statesman, on one hand, and the study of Scripture, on the other. Shakespeare presents (I, i) his Henry the Fifth as combining both:

> Hear him but reason in divinity,
> And, all-admiring, with an inward wish
> You would desire the King were made a prelate;
> Hear him debate of commonwealth affairs,
> You would say it hath been all in all his study;
> List his discourse of war, and you shall hear
> A fearful battle rend'red you in music;
> Turn him to any cause of policy,
> The Gordian knot of it he will unloose,
> Familiar as his garter: that, when he speaks,
> The air, a charter'd libertine, is still,
> And the mute wonder lurketh in men's ears,
> To steal his sweet and honey'd sentences;
> So that the art and practic part of life

161

Marshall McLuhan, *The Gutenberg Galaxy: The Making of Typographic Man* (Toronto: University of Toronto Press, 1962). 154 × 235 mm (6″ × 9¼″). DESIGN: Harold Kurschenska.

The book is composed as a large constellation of short, aphoristic articles. Each has a headline instead of a title, and the articles are so short that at least one headline appears on almost every spread. The type is Linotype Times, a newspaper face, and the text is set — as newspapers commonly are — with lining numerals (digits the same size as the capital letters) instead of numerals that fit with the lower case. The text, however, is highly literate and chock-a-block with historical and literary references and quotations. It is also equipped with a lengthy prologue, epilogue and bibliography. Evidently there are reasons why it ought to keep on looking like a book, as well as alluding to newspaper format.

[*See also pp 49 & 51*]

NEWLOVE

THE PRIVATE PRESS OF ROBERT REID & TAKAO TANABE. VANCOUVER. MCMLXII.

'This place
and spouse had seen her growing old
and ugly: some women look better with time:
she drank and loved too much for that: so
with a young fool she'd fool herself
to youth again.
 And then I thought
I was rid of the bitch; but
a stolen wife's no honor.'

 c.

 'It was
for love we did it all; not
even our own love: but yours.
 Because we could not see our baby
hurt. What a thing is love!
 It
seemed no heavier than feathers
but sank like iron in our hearts
and killed us all.
 Son,
I think we are in hell.'

John Newlove, *Grave Sirs* (Vancouver: Private Press of
Robert Reid & Takao Tanabe, 1962). Woodcut by Takao
Tanabe; presswork by Robert Reid and Ib Kristensen.
155 × 299 mm (6¼″ × 11¾″). DESIGN: Takao Tanabe &
Robert Reid.

The text face – a deliberately plain, unstylish, even
antistylish, letter designed in New York in 1908 – is
Morris Fuller Benton's ATF News Gothic Extended,
printed from the metal. The titling face is Futura. Tanabe
used the same News Gothic for other poets published
by his own Periwinkle Press in the early 1960s.

[*See also p 49*]

from
AN
OLD
STORY

A.

'Dazed by days' disease, we tell
a different story now than first
was told.

 Before, we spoke according
to reputed facts.

 We are no longer
sure. If they could hear us
we might say that some detailed
doubt nags us like a pregant wife.'

B.

 'What a temper that woman
was always in:
 because the food
was not correctly spiced, or someone
hadn't changed her bed, or she was
bored;
 as if the war were not enough
she brought her tongue along.'

 'At least, in bed or in the bath,
mine tickled me with fingers,
not a knife.'

 'Perhaps I was not wholly wise; but love
is always right; she had a wart or two:
what's that to love?'

 'Nothing.'

 'Perhaps
she was no longer so beautiful
as she had been: every moon
wanes.
 Nonetheless, a mature
love, surely . . . and I was so young:
quite young, and lost — eighteen —
you see, I'd never been in love before,
really in love some neighings
at the moon perhaps, not really.
 Only screwed by kitchenmaids
and other smelly sluts.
 Perhaps
she twisted me a bit?'

SPEECH TO THE RUMP PARLIAMENT

Your withered buttocks, crone! no muscle
there: to get a bum-belch out
's tremendous labor; such a lank-shank
as can't sit for fear
of chipping hip-bones:
still, still,
you keep asking for another drink.

canadien-français. Aucune œuvre n'est, plus que la sienne, près de la vie; sa poésie a les vertus du journal intime, de même que son *Journal* est œuvre de poète. Comme l'a écrit Robert Elie: "L'œuvre de Saint-Denys-Garneau a cette beauté et cette noblesse des témoignages vrais, et je n'en connais pas de plus émouvant ni de plus loyal." Saint-Denys-Garneau est mort à l'âge de 31 ans, d'une crise cardiaque, au manoir familial de Sainte-Catherine-de-Fossambault.

Une critique particulièrement attentive aux détails de forme pourrait déceler dans sa poésie des imperfections, des marques d'inachèvement; d'autant que plusieurs poèmes des "Solitudes" demeurent des ébauches, que Saint-Denys-Garneau aurait reprises si le temps et la force lui en avaient été donnés. Il n'a pu satisfaire à l'égard de tous ses poèmes cette exigence de qualité dont nous savons qu'il était pourvu à un très haut degré. Mais il s'agit d'accepter le poète tel qu'il est; avec ses quelques déficiences; avec surtout cette profusion de richesses <u>neuves</u>, jaillies d'une âme sans cesse présente à elle-même. Il est au Canada-français des poésies plus accomplies que la sienne; il n'en est pas qui aient ouvert tant de routes à la fois, proféré avec tant de justesse et de gravité la plainte de l'homme mal accordé à son existence.

L'œuvre d'Anne Hébert par contre, et bien qu'elle soit loin d'être terminée, nous offre déjà une poésie qui accomplit totalement ses promesses. Anne Hébert publia d'abord *Les Songes en Equilibre* (1942), d'une poésie fraîche et indécise, qui n'était pas sans rappeler les "Regards et jeux dans l'espace". Mais c'est par une œuvre de prose, *Le Torrent* (1950), que l'écrivain devait prouver la maturité de ses dons. Le conte admirable qui donne son titre au recueil, écrit dans une langue somptueuse, chargée d'harmoniques, et nous entraînant au plus secret de l'aventure intérieure, demeure l'un des plus beaux textes de prose qui se soient écrits au Canada-français. Avec *Le Tombeau des Rois,* publié trois ans plus tard, Anne Hébert devint, selon le critique André Rousseaux, "un des grands poètes contemporains de la langue française". Dans une forme sévère, dépouillée jusqu'à l'os, où chaque mot doit porter le poids entier de l'espoir et de la sur-vie, le poète y propose le cheminement d'une âme dans sa vie concrète, allant des gouffres de l'abandon à l'aurore d'une véritable communication. Les poèmes qu'Anne Hébert a écrits après "Le Tombeau des rois"—et qui ont été réunis, avec ce recueil, dans un livre paru à Paris: *Poèmes*—signalent un profond renouvellement, mais dans la prolongement immédiat des victoires acquises. Le rythme s'est élargi, les formes et les couleurs se jouent avec une abondance et une liberté que ne permettait pas la dure interrogation du *Tombeau des Rois*. En prose, Anne Hébert a également donné un beau roman poétique, *Les Chambre de Bois* (1958), et une pièce de télévision publiée dans *Les Ecrits du Canada français* (1958). Elle travaille actuellement à une pièce de théâtre, en plus d'écrire de nouveaux poèmes.

6

CONTENTS

5 PREFACE

9 TRANSLATOR'S NOTE

ST-DENYS GARNEAU

CAGE D'OISEAU 13 BIRD CAGE

ACCOMPAGNEMENT 15 ACCOMPANIMENT

RIVIERE DE MES YEUX 15 MY EYES A RIVER

UN MORT DEMANDE A BOIRE . . . 17 A DEAD MAN ASKS FOR A DRINK

SPECTACLE DE LA DANSE 19 SPECTACLE OF THE DANCE

COMMENCEMENT PERPETUEL 21 PERPETUAL BEGINNING

AUTREFOIS 23 AT ONE TIME

LE JEU 25 THE GAME

POIDS ET MESURES 29 WEIGHTS AND MEASURES

ANNE HEBERT

LA FILLE MAIGRE 33 THE LEAN GIRL

EN GUISE DE FETE 35 AS IF FOR A HOLIDAY

VIE DE CHATEAU 37 MANOR LIFE

LA CHAMBRE FERMEE 39 THE CLOSED ROOM

IL Y A CERTAINEMENT QUELQU'UN 41 THERE IS CERTAINLY SOMEONE

LES DEUX MAINS 43 THE TWO HANDS

LE TOMBEAU DES ROIS 45 THE TOMB OF THE KINGS

SAISON AVEUGLE 49 BLIND SEASON

NEIGE 49 SNOW

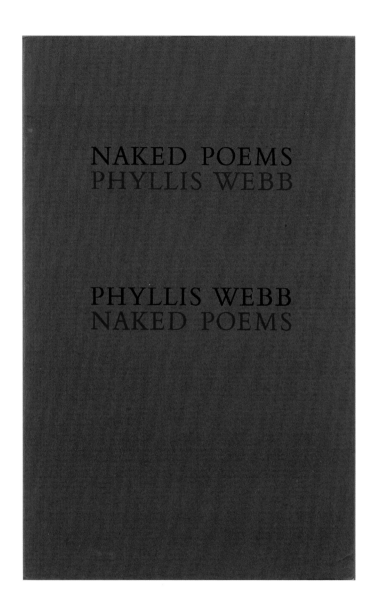

Hieratic sounds emerge
from the Priestess of
Motion
a new alphabet
gasps for air.

We disappear in the musk of her coming.

I hear the waves
hounding the window:
lord, they are the root waves
of the poem's meter
the waves of the
root poem's sex.
The waves of Event
(the major planets, the minor
planets, the Act)
break down at my window:
I also hear those waves.

Suite II

The sun comes through
plum curtains.
I said
the sun is gold
in your eyes.
It isn't the sun
you said.

Phyllis Webb, *Naked Poems* (Vancouver:
Periwinkle Press, 1965). 140 × 230 mm (5½″ × 9″).
DESIGN & PRESSWORK: Takao Tanabe.

"A new alphabet / gasps for air," Webb's poem
says. To make this statement clear, Tanabe has
set the text in a type as familiar and plain as any
that exists: Times Roman. But this is the original
Monotype Times New Roman, printed from the
metal – different indeed from the shabby replicas
of the same name found nowadays in countless
cheaply made books and on every personal
computer. The type on the cover is something
much more statuesque: Monotype Bembo.

[*See also p 49*]

Eric McLean, *Le Passé vivant de Montréal / The Living Past of Montreal* (Montreal: McGill University Press, 1964). Illustrations by Richard D. Wilson. 149 × 200 mm (6″ × 7¾″). DESIGN: Robert Reid.

The type is Monotype Bembo, one of several Renaissance revival faces produced in the first half of the 20th century. It was cut in England in 1929 under the direction of Stanley Morison, based on a roman font cut in Venice by Francesco Griffo in 1495 and an italic designed in Venice in the 1520s by Giovanni Tagliente.

The illustrations in this book are particularly satisfying – in part because they are printed by gravure, which gives a softer and more continuous image than the conventional halftone process. But the text (set in metal) is *also* printed gravure, which renders the letterforms soft and fuzzy. (What you see here, however, is only a halftone image of the gravure in the original publication.)

[*See also pp 49 & 51*]

Rue de la Capitale: maçonnerie ancienne et réseau d'échelles de sauvetage. On a peine à croire que cette rue fut autrefois l'une des plus animées de la ville. Sous l'ancien régime, elle abondait en tavernes que fréquentaient les rudes trafiquants de pelleterie auxquels succédèrent, après l'arrivée des Anglais, les *raftsmen* et les endiablés pionniers irlandais. Fleury de Mesplet y fixa son imprimerie où il tira le premier numéro de la *Gazette de Commerce et Littéraire* en 1778, l'ancêtre de la présente *Montreal Gazette*. Mesplet était venu de Philadelphie avec Benjamin Franklin quand l'armée révolutionnaire américaine occupa Montréal. Franklin espérait gagner les Canadiens à la cause américaine; les pamphlets bilingues de Mesplet devaient y contribuer. L'armée américaine battue à Québec, Franklin retourna prudemment à Philadelphie. Mesplet fut fort embarrassé. Comment ramener du jour au lendemain son encombrante et coûteuse presse à imprimer aux Etats-Unis! Il se ravisa et décida de rester chez les *British*. Il fut arrêté, interrogé, déclaré inoffensif et relâché quelques jours après. Il s'efforça pendant de nombreuses

The confusion of old masonry and fire-escapes along the eastern part of rue de la Capitale has little in it to suggest that this was one of the liveliest streets in the city. During the French regime it housed several taverns which were patronized by some of the rougher types in the fur trade, and after the arrival of the English the tradition was continued by the raftsmen and the irrepressible Irish pioneers. It was here that Fleury de Mesplet set up his printing press and turned out the first copy of *La Gazette de Commerce et Littéraire* in 1778, a paper which was later to become quite simply the Montreal *Gazette*. Mesplet had been brought from Philadelphia by Benjamin Franklin when the Army of the Continental Congress occupied Montreal. Franklin hoped to persuade the Canadians to join the American cause, with the aid of pamphlets turned out in both languages on Mesplet's press. When the Americans were defeated at Quebec, Franklin thought it prudent to return to Philadelphia. Mesplet, however, could not make arrangements to cart back his heavy and costly printing press on such short

The Lawrence Lande Collection of Canadiana in the Redpath Library of McGill University, edited by Lawrence Lande (Montreal: Lawrence Lande Foundation for Canadian Historical Research, 1965). Presswork by Ib Kristensen. 260 × 350 mm (10¼″ × 13¾″). DESIGN: Robert Reid.

FOLLOWING SPREAD: two more pages from the same work.

The type – printed from the metal – is Monotype Bulmer, which is based on a set of fonts that William Martin cut and cast for the Shakspeare Press, London, in 1790.

FOREWORD

GENERALLY SPEAKING ONE CAN DEFINE Canadiana as anything relating to Canada. For me it includes books, pamphlets, broadsides, maps, manuscripts, and letters relating to Canada, mainly before Confederation. It also includes material on Western Canada up to the beginning of this century. For the purpose of this bibliography I have divided my collection into three main sections; each section is arranged alphabetically by author, or by title if the author is not known. Periodicals are listed by title.

The first section, Basic Canadiana, includes fundamental works dealing with the history, geography, and economic resources of early Canada. It contains accounts of the French regime and of the exploration and discovery of our land as far west as the Prairies. Military campaigns, general legislation, religious institutions and their history (including material pertaining to the Clergy Reserves), and matter concerning early immigration, land, and elections have been categorized in this section. Here also you will find essays of substance, serious periodicals, the more classical travel accounts, the biographies, correspondence, and trial reports of public figures.

The second section, Canadiana on the West and the North, is made up of publications which fall into one or the other of these two geographical areas; this division of the collection is a very natural one, and the only material that might otherwise have appeared in the first or the third section is an occasional poem (there are some by Louis Riel), or some natural history (such as a pamphlet on winter birds in the pamphlet series by the Manitoba Historical and Scientific Society). Works include exploration, settlement, and legislation on the West and the North, government reports and debates, material pertaining to the Arctic, the Hudson's Bay Company, the Red River Settlement, and the Riel Rebellion, maps, immigrant and tourist guides, city directories, dictionaries of colourful slang and of Indian languages, as well as some non-Canadian subjects which were printed in western Canada.

The third section on Cultural and Supplementary Canadiana contains material which is of inestimable value as far as our national cultural life — in the fullest sense of the term — is concerned, as well as works which supplement the theme of the first section. Thus I have collected here poetry, drama, fiction, music, and philosophy. I have included the literary periodicals, juvenile literature, literary curiosities, and maps. Here also are the almanacs, text books, works on education, books on medicine and agriculture, sermons, speeches, and articles on religion, such as liturgies. Finally, there are biographies of literary figures and public figures of lesser importance than those appearing in the first section, directories, fishing and hunting guides and sporting journals, the later travel accounts, records of shipwrecks, reports of criminal trials, and works having no more direct relation to our

1209　　Halkett, John

STATEMENT RESPECTING THE EARL OF SELKIRK'S SETTLEMENT OF KILDONAN, UPON THE RED RIVER, IN NORTH AMERICA; ITS DESTRUCTION IN THE YEARS 1815 AND 1816; AND THE MASSACRE OF GOVERNOR SEMPLE AND HIS PARTY. *London, [printed by J. Brettell, n.d.].*

2 p.l., 125, lxxxix p. • fold. map • 8vo • half-leather • uncut.

CF. PEEL 42; TPL 1092.

1210　　Hall, Edward Hepple

HO! FOR THE WEST!!! THE TRAVELLER AND EMIGRANTS' HANDBOOK TO CANADA AND THE NORTH-WEST STATES OF AMERICA, FOR GENERAL CIRCULATION CONTAINING USEFUL INFORMATION ON ALL IMPORTANT POINTS, GATHERED DURING A RESIDENCE OF EIGHT YEARS IN BOTH COUNTRIES; COMPILED FROM THE LATEST AUTHENTIC SOURCES AND DESIGNED PARTICULARLY FOR THE USE OF TRAVELLERS, EMIGRANTS AND OTHERS. *London, Algar & Street, 1856.*

64 p. • 8vo.

CF. CAN. ARCH. I 2743.

1211　　Hall, Edward Hepple

LANDS OF PLENTY IN THE NEW NORTH-WEST. A BOOK FOR ALL TRAVELLERS, SETTLERS AND INVESTORS IN MANITOBA AND NORTH-WEST TERRITORY. *Toronto, Hunter, Rose & Co., [1880].*

129 p. • sm. 8vo • orig. cloth.

PEEL 408.

1212　　Hall, Mary Georgina Caroline

A LADY'S LIFE ON A FARM IN MANITOBA. BY MRS. CECIL HALL. *London, W. H. Allen & Co., 1884.*

2 p.l., 171, [1] p. • 8vo.

PEEL 554.

1213　　Ham, George Henry 1847-1926

THE NEW WEST. EXTENDING FROM THE GREAT LAKES ACROSS PLAIN AND MOUNTAIN TO THE GOLDEN SHORES OF THE PACIFIC. WEALTH AND GROWTH. MANUFACTURING AND COMMERCIAL INTERESTS. HISTORICAL, STATISTICAL, BIOGRAPHICAL. *Winnipeg, Canadian Historical Publishing Co., 1888.*

[viii], [9]-205 p. • lg. 8vo • orig. printed wrappers.

PEEL 774.

1214　　Hamilton, James Cleland 1836-1907

THE PRAIRIE PROVINCE; SKETCHES OF TRAVEL FROM LAKE ONTARIO TO LAKE WINNIPEG, [ETC.]. *Toronto, Belford Brothers, 1876.*

vii, 259 (i.e. 255) p. • sm. 8vo • orig. cloth.

PEEL 346.

1215　　Hargrave, Joseph James 1841-1894

RED RIVER. *Montreal, printed for the author by John Lovell, 1871.*

xvi, [17]-506 p. • 8vo • orig. cloth.

PEEL 261.

1216　　Harmon, Daniel Williams 1778-1845

A JOURNAL OF VOYAGES AND TRAVELS IN THE INTERIOR OF NORTH AMERICA, BETWEEN THE 47TH AND 58TH DEGREES OF NORTH LATITUDE, EXTENDING FROM MONTREAL NEARLY TO THE PACIFIC OCEAN [ETC.]. *Andover, [Vt.], Flagg and Gould, 1820.*

xxiii, [25]-432 p. • 8vo • contemp. calf.

PEEL 63; TPL 1171.

1217　　Harvey, Arthur 1834-1905 COMP.

A STATISTICAL ACCOUNT OF BRITISH COLUMBIA. *Ottawa, G. E. Desbarats, 1867.*

41 p. • 8vo.

SMITH 4136; TPL 4589.

1218　　Haultain, Theodore Arnold 1857-1941

A HISTORY OF RIEL'S SECOND REBELLION AND HOW IT WAS QUELLED. *Toronto, Grip Printing and Publishing Co., 1885.*

44 p. • Parts I and II • folio • At head of title: The souvenir number of the Canadian Historical and Illustrated War News.

PEEL 603.

1219　　Hazlitt, William Carew 1834-1913

BRITISH COLUMBIA AND VANCOUVER ISLAND; COMPRISING A HISTORICAL SKETCH OF THE BRITISH SETTLEMENTS IN THE NORTH-WEST COAST OF AMERICA; AND A SURVEY OF THE PHYSICAL CHARACTER, CAPABILITIES, CLIMATE, TOPOGRAPHY, NATURAL HISTORY, GEOLOGY AND ETHNOLOGY OF THAT REGION; COMPILED FROM OFFICIAL AND OTHER AUTHENTIC SOURCES. WITH A MAP. *London, G. Routledge & Co., 1858.*

viii, 247, [1] p. • map • 12mo • orig. glazed pictorial boards.

SMITH 4272; TPL 3818.

1220　　Hearne, Samuel 1745-1792

A JOURNEY FROM PRINCE OF WALES'S FORT IN HUDSON'S BAY, TO THE NORTHERN OCEAN. UNDERTAKEN BY ORDER OF THE HUDSON'S BAY COMPANY, FOR THE DISCOVERY OF COPPER MINES, A NORTH WEST PASSAGE, ETC. IN THE YEARS 1769, 1770, 1771, & 1772. *London, printed for A. Strahan and T. Cadell, 1795.*

xliv, 458 p. • fold. chart, plans, views • lg. 4to • tree calf • L.P.

We owe the publication of this *Journey* to the celebrated French navigator, La Pérouse, who captured Fort Albany on Hudson Bay and found Hearne's manuscript. The fort was

afterwards surrendered to the British, but La Pérouse insisted on the publication of this work by the Hudson's Bay Company, and his stipulation was honourably fulfilled in this beautiful volume. The author was the first white man to gaze on the Arctic or Frozen Ocean from the northern shores of the continent of America.

Financed by the Hudson's Bay Company, Samuel Hearne set out in 1769 to find a western exit from Hudson Bay, and to examine the country for the coppermines that the Indians had reported. Failing not once but twice, this determined English-man reached the Coppermine River in December 1770 and followed it to its mouth. He gives much attention to the natural history and to the Indian tribes of the region. On his return journey he discovered Great Slave Lake. The negative result of this journey was the proof that there was no possibility of finding the Northwest Passage through Hudson Bay.

SABIN 31181; TPL 445.

1221 Hearne, Samuel

VOYAGE DE SAMUEL HEARNE, DU FORT DU PRINCE DE GALLES DANS LA BAIE DE HUDSON, À L'OCÉAN NORD, ENTREPRIS PAR ORDRE DE LA COMPAGNIE DE LA BAIE DE HUDSON, DANS LES ANNÉES 1769, 1770, 1771 ET 1772, ET EXÉCUTÉ PAR TERRE, POUR LA DÉCOUVERTE D'UN PASSAGE AU NORD-OUEST. TRADUIT DE L'ANGLAIS. [Paris], Imprimerie de Patris, An VII, [1799].

2 v.: lviii, 373 p., 2 fold. maps, 2 fold plates.; 2 p.l., 332, xxix p., 1 l., 3 fold maps, 2 fold plates., fold maps, fold. ill. • 8vo • orig. boards.

GAGNON II 974.

1222 Hector, James

ON THE PHYSICAL FEATURES OF THE CENTRAL PART OF BRITISH NORTH AMERICA AND ON ITS CAPABILITIES FOR SETTLEMENT. (FROM THE EDINBURGH NEW PHILOSOPHICAL JOURNAL, NEW SERIES, FOR OCTOBER 1861.) Edinburgh, printed by Neill and Co., 1861.

1 l., 35 p. • 8vo • wrappers unopened. • The work supplements Palliser's explorations of 1857.

1223 Henderson's Directory

HENDERSON'S DIRECTORY OF THE CITY OF WINNIPEG AND TOWN OF ST. BONIFACE. CONTAINING AN ALPHABETICAL DIRECTORY OF THE CITIZENS, A STREET DIRECTORY OF THE CITY OF WINNIPEG, A SUBSCRIBERS' CLASSIFIED BUSINESS DIRECTORY, AND A MISCELLA-NEOUS DIRECTORY. FOR THE YEAR 1884. [Winnipeg], The Winnipeg Directory Publishing Co., [1883 ?].

390 p. • 8vo • orig. boards.

CF. PEEL 373A.

1224 Henry, Alexander 1739-1824

TRAVELS AND ADVENTURES IN CANADA AND INDIAN TERRITORIES, BETWEEN THE YEARS 1760 AND 1776. New York, I. Riley, 1809.

vi p., 1 l., 330 p., 1 l. • 8vo • contemp. calf • In Part I, the author relates the incidents of his life as a fur trader among the Indians on the shores of the upper Great Lakes, of the massacre of the garrison of Fort Michilimackinac, of his narrow escape and his capture. His narrative of the details of his long captivity gives an account of the domestic habits of the northern Indians. Part II is a narrative journal of travels through the Indian countries.

PEEL 29; TPL 484.

1225 Hering, Rudolph

REPORT ON A FUTURE WATER SUPPLY FOR THE CITY OF WINNIPEG, MANITOBA, SEPTEMBER, 1897. [Winnipeg, McIntyre Bros. printers, 1897?].

56 p. • plates • 8vo • orig. printed wrappers.

1226 Hewson, M. Butt

THE CANADIAN PACIFIC RAILWAY. Toronto, Patrick Boyle, 1880.

56 p. • fold. map • 8vo • orig. printed wrappers • pres. copy signed by author.

PEEL 409.

1227 Hibben, Tertius Napier

A DICTIONARY OF THE CHINOOK JARGON, OR INDIAN TRADE LANGUAGE, OF THE NORTH PACIFIC COAST. Victoria, B.C., T. N. Hibben & Co., [1871].

29 p. • 8vo • orig. green wrappers.

CF. SMITH 4403.

1228 Hibben, Tertius Napier

GUIDE TO THE PROVINCE OF BRITISH COLUMBIA, FOR 1877-8. COMPILED FROM THE LATEST AND MOST AUTHENTIC SOURCES OF INFORMATION. Victoria, T. N. Hibben & Co., Publishers, 1877.

xii, 410 p. • 8vo • black boards.

SMITH 3930.

1229 Hibben, Tertius Napier

DICTIONARY OF THE CHINOOK JARGON; OR, INDIAN TRADE LANGUAGE OF THE NORTH PACIFIC COAST. Victoria, B.C., T. N. Hibben & Co., 1887.

23 p.

CF. SMITH 4406.

seldom-used cases of some shops will often unearth striking old letters which are decorative and effective if run in colour. Moreover, large display letters can often be made up from type material with the expenditure of a bit of imagination and a little labour. Type rules and squares are most convenient to use, and they can be worked up into solid letters, shaded letters, shaded letters with shadow edges, or open letters defined only by rules cut to indicate a shadow. Reverse letters can be built up in the same way, by setting the rules or squares in a rectangular shape and cutting away from the rules the shape of the letter, by removing the squares to leave the reverse letter, or by using type material to define only the outer and inner shapes of the letters. The background grid effect created by the

The device used by the Institute of Contemporary Art, London, defines only the outer and inner shapes of the letters with simple rules. Below, an advertisement by THEO DIMSON, Toronto, exploits strong contrast of size and texture, and vigorous opposition of vertical and horizontal.

IN TRUTH A NATION

"Something moves as it has never moved before in this land, moves dumbly in the deepest runnels perhaps of a collective mind, yet by sure direction toward a known goal. Sometimes by thought, more often by intuition, the Canadian people make the final discovery. They are discovering themselves. That passion of discovery which once sent birchbark canoes down unmapped waters, pushed railways across the Rockies, and dragged men to the frozen seas turns inward to explore a darker terrain. The nation labors in the travail of self-discovery and, by this labor, proves that it is in truth a nation, the home of a people." This advertisement, commemorating the completion of the St. Lawrence Seaway and Power Project, and its official opening by Her Majesty, Elizabeth Ii, is published by THE TORONTO-DOMINION BANK

From "Canada: Tomorrow's Giant" by Bruce Hutchison Published by Longmans, Green and Company

lower case CAPITALS

which is easier to read?

There have been many attempts to secure a generalized answer to this question, and there are partisans who defend one or the other with passion, if not with intelligence. Even scientific testing has come up with conflicting answers; the simple fact of the matter is that it is primarily the appearance of the word or words that counts. Since we tend to read the upper third of a line of type and judge the word by its 'skyline' it stands to reason that letters which have their main characteristics below this recognition line are going to be confused with similar letters, and legibility will be reduced. The first panel on the next page shows how four groups of capitals resemble each other's contours; panel two shows six areas of lower-case confusion. All of these letters require that the reader's eye penetrate the letter, go to the foot of the letter, or even search below the line to identify the letter. The presence of too many confusing letters in a word, such as COFFEE in panel three will dictate using lower case for better recognition; however, the word 'hillbilly' gains in legibility when set in capitals. Let the nature of the word dictate the form.

12

1

UNI

2

bh pn oce
gqa vy ij

3

COFFEE coffee
HILLBILLY hillbilly

Typographic "doodles" achieved by photo-typsetting at the studio of ALBERT HOLLENSTEIN in Paris.



The text that appears on the reproduced book page reads:

DESIGN WITH TYPE | 57

failure of the type squares to meet can be effective in itself. Of course there are always the services of the photo-engraver who can be called upon to enlarge a proof of a smaller face, or to supply a zinc of a hand-drawn letter.

The applications of contrast in size are almost universal; there is scarcely a job where a large letter or word cannot be used to striking effect. To take business stationery, the initial letter of the main name or product name, if set large and run in a second colour, can provide a focal point around which it is easy to organize the subordinate material; this pattern can be used on all sorts of forms, from the letterhead and envelope to the business card. Monograms of two or more initials can accomplish the same purpose and may well serve to establish a striking trade mark.

Cover designs of all kinds lend themselves to this treatment of mass: menus, with the word 'menu' set large as a background to the name of the restaurant using it; catalogues, with either the word 'catalogue' or the name or initial of the firm dominating the cover; price lists, with a similar treatment; house organs, with the name of the publication made large enough to form a solid panel of its own; announcements, with the initial 'A' establishing a starting point for the message.

Very often the repetition of an initial letter at different angles can create a pattern which is interesting either in itself or as a symbol of the business indicated. But each problem calls for the application of ingenuity, and it is only possible here to give fictitious examples. Effective application of the principle of contrast of size can only be made if the designer studies his copy for the clue that will indicate what letter or word can take this distortion and still be effective both as a design and, if possible, as a symbol. Sometimes a little doodling on a scrap of paper will help an idea come to life. At this stage the type indication does not have to be meticulous, so long as a contrast is there to start images of all sorts of possibilities flashing across the mind.

ABOVE: Carl Dair, *Design with Type*, 2nd ed. (Toronto: University of Toronto Press, 1967). 175 × 204 mm (7″ × 8″). DESIGN: Carl Dair.

LEFT, ON THE FACING PAGE: Volume 2 (1965) of Dair's pamphlet series *A Typographic Quest* (New York: West Virginia Pulp & Paper, 1964–68). 133 × 228 mm (5¼″ × 9″).

ABOVE RIGHT: A specimen of Dair's 1967 Cartier roman phototype.

The type in *Design with Type* is Monotype Bembo, cleanest of all 20th-century Renaissance revival faces. Dair also experimented here with the use of a short vertical bar for marking hyphenated line breaks. (Part of the broken word *rec-tangular*, from the left-hand page above, is shown in the magnified excerpt.) This edition of *Design with Type* was the first Canadian book ever included in the American Institute of Graphic Arts annual "Fifty Best Books" exhibition – a fact that pleased Dair greatly.

[See also pp 50 & 51]

ABC
abcd
efghi
jklm

...tters, shaded le...
...pen letters defined only
...verse letters can be built
... rules or squares in a rec...
...om the rules the shape of
...o leave the reverse letter,
...ly the outer and inn...
...ffect created b...

nĭⁿðae' nĕkǫ̆mǫ́'ᵃtę̆'ti'²

ahę̆ⁿhǫ̆ǫ́' hú³ⁿᵈgeⁿðĭ'⁴ ŭnę́'⁵ ăwa-
wĭ'⁵cę̆he'⁶ tsaˑtę̆'tu'⁷ nǫmǫ́'ᵃ⁸ⁿðe'⁹ ăhę̆ⁿhǫ̆ǫ́'
ᵈiⁿgǫ́'ᵃwic¹⁰ ðinǫmǫ́'ᵃⁿðe¹¹

ðǎe'nǫmǫ́'ᵃⁿðe'¹² tŭsǎhǎte'¹³ ðucàˑrǎˑkwat¹⁴
nę̆ⁿðǎe'¹⁵ nǫmǫ́'ᵃⁿðe'¹⁶ usǎǎ'tǎraˑkwat¹⁷
nĕkǫmǎǫ́'tę̆'ti'¹⁸

nę̆'¹⁹ kĕtǫ̆skwa'ye'²⁰ tŭhǎˑᵃweˑt²¹ yǎhaˑwiˑ²²
uⁿðàˑrǫ́ˑt²³ nǫⁿðĕˑk²⁴ à'uⁿǫ́ˑt²⁵ ⁿðekǫmǫ́'
tę̆ˑti'²⁶ nǫⁿðĕˑk²⁷ kĕtǫ̆ˑskwa'ye'²⁸

ayę̆hǫ̆ǫ́'²⁹ kĕˑce'³⁰ ɛˑcĕtsĭkĕˑⁱtra'k³¹
ðĕˑcitaˑra'³² ⁿǫⁿðǎĕˑ'³³ ĭyęⁿⁿǫⁿðĕˑk³⁴ ðĕwàˑtǫˑ³⁵
cetsĭkĕˑⁱtra'³⁶ nǫⁿðĕˑ'³⁷ ðǎiyę̆'³⁸

1 that one / 2 that they her dropped / 3 he said /
4 after a while / 5 now / 6 our strength is ebbing /
7 [let] someone else / 8 now next / 9 he said / 10 the turtle /
11 me next / 12 this one next / 13 there he came (to) /
14 his body floated / 15 this one /16 next / 17 her body held
up / 18 that had fallen (from above) / 19 now / 20 the toad /
21 there she went / 22 she carried / 23 a mouthful / 24 of dirt /
25 she it gave / 26 to the body dropped (from above) / 27 that
dirt / 28 the toad / 29 she said / 30 do this way / 31 thou
sprinklest at arms length / 32 where thou art lying / 33 that one /
34 she meant the dirt / 35 what she said / 36 thou sprinklest at
arms length / 37 that dirt / 38 she meant

kǎtaˑᵃyáˑre'¹ kǎhá'² nę' ăwǎtǫ̆ˑmę̆-
tsǫ́ˑ¸ga'⁴ nę' ăwáˑtǫ'⁵ ðutǎwǎˑkę̆'⁶

nakwĕⁿǫ̆mę̆'⁷ ðǎˑwéˑti'⁸ à'uⁿǫ́ˑt⁹ ðe-
katǫ̆ˑskwaˑyę̆'¹⁰ ða'yǎę̆ⁿkwa'¹¹ ðunę̆ˑhaˑ¹² ðŭ-
yáˑrĕsa'¹³ hŭⁿǫ́ˑca'¹⁴ tĭwà'¹⁵ nĕ'yǎⁿðáˑre'¹⁶ ⁿðę̆-
kwa's¹⁷ ðǎˑewéˑti'¹⁸ à'uⁿǫ́ˑt¹⁹ ⁿkĕtǫ̆ˑskwaˑyę̆'²⁰

nę̆ⁿðĕⁿǫ̆ma'ᵃⁿðĕ'²¹ nę̆ⁿðǎę̆ⁿðĕˑka'ᵃ²¹
ða'wéˑhǫ̆ⁿgáˑati'²³ yǒmahǎˑᵃraˑ²⁴ ǎˑréˑhǫˑ²⁵
ahǎjá'ᵃtǎˑrę̆ˑhǫ'²⁶ ðeˑⁱjaˑǎha'²⁸

aˑ'yǎtuˑyę̆'²⁹ ǎhǎˑyŭmaˑtŭˑrę̆ha'³⁰ ðe
hĕⁱjaˑǎhǫ'³¹ taˑ'kė̆ˑtu'³² awǎhę̆ˑtĕ̆ha'³³ tĕthŭ-
nę̆ⁿtuˑⁿðĭhǎˑke'³⁵ nesǎǎˑtat³⁶ ǫⁿtĕˑrǫ̆mé'³⁷
tǎwǎˑsti'³⁸

1 she it did / 2 there / 3 now / 4 she the land made /
5 now it happened / 6 that she (was) raised up / 7 now she
went about / 8 that (is) all / 9 she her gave / 10 the toad /
11 that she planted (the seeds) / 12 the corn / 13 the beans /
14 (the) pumpkin / 15 all / 16 what exists / 17 that grows /
18 that all / 19 she her gave / 20 the toad / 21 then the
one next / 22 now this here is / 23 that she thought /
24 by herself / 25 she wished / 26 he finds me / 27 he
me finds / 28 the small one (child) / 29 It is so / 30 they
her found / 31 they two young ones / 32 right away / 33 she
found out / 34 while / 35 they were growing / 36 the onebody /
37 no not person / 38 good

These stories were dictated in Oklahoma in 1911 by descendants of Huron speakers from southern Ontario. The original texts are reproduced photographically from Barbeau's handwritten transcript, while the English renderings are typeset. The prefatory matter is set in the normal way, but the main text of the book must be rotated 90° in order to be read.

The text face is Linotype Excelsior, a newspaper face designed in 1931 by Chauncey Griffith. The titling face is Stellar bold, a Ludlow face designed in 1929 by Robert Hunter Middleton. The type was set in metal but printed by photo-offset.

Ayaruaq's autobiography – published shortly before the author's death at the age of 62 – was probably the first book to be written (instead of dictated) in Inuktitut. It was also the first book published by an individual Inuk writer. But even in the country of its origin, syllabic type was a good deal harder to find in 1968 than in 1868 or 1880. The skilled hand-compositors who had trained themselves in setting it were also gone, yet digital syllabic fonts (and the new generation of mostly self-taught computer compositors they inspired) were still some fifteen years away. Ayaruaq's book was therefore typed out on a government-owned justifying typewriter and printed directly from typescript. The only parts of the book that are set in type are the page numbers.

Economic Atlas of Ontario, edited by William G. Dean. (Toronto: University of Toronto Press, 1969). Cartography by Geoffrey J. Matthews. 330 × 460 mm (13″ × 18″). DESIGN: Allan Fleming.

To the considerable amazement of its designer (who had not had very much room in which to design) this atlas was awarded the grand prize at the 1970 Leipzig International Book Fair and subsequently advertised as "the most beautiful book in the world."

The text face – poorly fitted, insufficiently leaded, and a little too light in weight – is Adrian Frutiger's Univers, chosen by the cartographer. The type used by Fleming for the title spread and running heads is Hermann Zapf's Optima, first issued in 1958 as a metal foundry type but here set photographically.

The circles are proportional to the number of employees in manufacturing in incorporated centres of 1,000 population and over in 1961. Most of the data represent employment in the summer and fall of 1965. In a few cases it was necessary to use 1964 to 1961 data. A few centres have been omitted because of the total absence of data, e.g.: Rodney, West Lorne, Beamsville.

Les cercles sont proportionnels au nombre d'employés dans l'industrie manufacturière des centres constitués de 1,000 habitants et plus en 1961. La plupart des données indiquent l'emploi durant l'été et l'automne 1965. En quelques cas, il fut nécessaire d'utiliser des données relevées entre 1961 et 1964. Quelques centres furent omis à cause de l'absence totale de données, ex.: Rodney, West Lorne, Beamsville.

Metro Toronto 243,228 Hamilton, 63,703

Oshawa 23,159
Windsor 20,229
Copper Cliff 17,301
10,000—14,999
5,000— 9,999
2,000— 4,999
1,000— 1,999
600— 999
300— 599
150— 299
0— 149

Number of employees in manufacturing by place of work, 1965

Nombre d'employés dans l'industrie manufacturière par lieu de travail, 1965

ECONOMIC ATLAS OF

ONTARIO

ATLAS ÉCONOMIQUE DE

L'ONTARIO

W.G. DEAN Ph.D.
Editor

G.J. MATTHEWS
Cartographer

Department of Geography
University of Toronto

W.G. DEAN Ph.D.
Directeur

G.J. MATTHEWS
Cartographe

Département de géographie
Université de Toronto

Published for the Government of Ontario by the University of Toronto Press

Publié pour le gouvernement de l'Ontario par l'University of Toronto Press

A high, narrow, vaulted Gothic chamber

FAUST *sitting at his desk, restless*

Look at me. I've worked right through philosophy, right through medicine and jurisprudence, as they call it, and that wretched theology too. Toiled over and slaved at it and know no more than when I began. I have my master's degree and my doctor's and it must be ten years now that I've led my students by the nose this way and that, upstairs and downstairs, and all the time I see plainly that we don't and can't know anything. It eats me up. Of course I'm ahead of these silly scholars, these doctors and clerics and what not. I have no doubts or scruples to bother me, and I snap my fingers at hell and the devil. But I pay the price. I've lost all joy in life. I don't delude myself. I shall never know anything worth knowing, never have a word to say that might be useful to my fellow men. I own nothing, no money, no property, I have no standing in the world. It's a dog's life and worse. And this is why I've gone over to magic, to see if I can get secrets out of the spirit world and not have to go on sweating and saying things I don't know, discover, it may be, what it is that holds the world together, behold with my own eyes its innermost workings, and stop all this fooling with words.

Oh if this were the last time the full moon found me here in my agony. How often have I sat at this desk among my books watching for you in the deep of night till at last, my melancholy friend, you came. Oh to be out on the hilltops in your lovely light, floating among spirits at some cavern's mouth or merging into your meadows in the dimness. Oh to be clear, once and for all, of this pedantry, this stench, and to wash myself in your dew and be well again.

But where am I? Still a prisoner in this stifling hole, these walls, where even the sunlight that filters in is dimmed and discoloured by the painted panes, surrounded from floor to ceiling by dusty, worm-eaten bookshelves with this sooty paper stuck over them, these instruments everywhere, these beakers, these retorts, and then, on top of that, my family goods and chattels. Call that a world?

Is it any wonder that your heart should quail and tremble and that this ache, this inertia, should thwart your every impulse? When God created man he put him in the midst of nature's growth and here you have nothing round you but bones and skeletons and mould and grime.

Up then. Out into the open country. And what better guide could I have than this strange book that Nostradamus wrote. With its help I shall follow the movement of the stars. Nature may teach me how spirits talk to spirits. It is futile to brood drily here over the magic signs. You spirits, hovering about me, hear me and answer. *He opens the book and sees the sign of the macrocosm*

What a vision is this, flooding all my senses with delight, racing through my nerves and veins with the fire and the freshness of youth. Was it a god who set down these signs that hush my inner fever, fill my poor heart with happiness, and with mysterious power make visible the forces of nature

about me. Am I myself a god? Such light is given to me. In these pure lines I see the working of nature laid bare. Now I know what the philosopher meant: 'The spirit-world is not closed. It is your mind that is shut, your heart that is inert. Up, my pupil, be confident, bathe your breast in the dawn.' *He contemplates the sign*

Oh what a unity it is, one thing moving through another, the heavenly powers ascending and descending, passing the golden vessels up and down, flying from heaven to earth on fragrant wings, making harmonious music in the universe. What a spectacle. But ah, only a spectacle. Infinite nature, how shall I lay hold of you? How shall I feed at these breasts, these nurturing springs, for which I yearn, on which all life depends? When these are offered, must I thirst in vain? *He turns the pages angrily and sees the sign of the Earth-spirit*

How differently this sign affects me. You, Earth-spirit, are closer to me, warming me like wine and filling me with new energy. I'm ready now to adventure into life, endure the world's joy and the world's pain, wrestle with its storms, and not lose courage in the grinding shipwreck. See, the room is clouded, the moon is hid, the lamp goes out, vapours rise, redness flashes, terror comes down on me from the vaulted roof. You spirit that I have sought, I feel your nearness. Reveal yourself. My whole being gropes and struggles towards sensations I never knew. My heart goes out to you. Reveal yourself. You must, though it costs me my life. *He seizes the book and spells out the mysterious sign, a red flame flashes, and the spirit appears in the flame*

SPIRIT
Who calls?

FAUST *with face averted*
Appalling.

be somebody, else why should there be devils at all?

IDEALIST
Imagination in my sense has gone too far this time. Truly, if I'm a part of all that, I'm off my nut.

REALIST
These goings-on are a torment, they're more than I can take. For the first time I don't know where I stand.

SUPERNATURALIST
I'm happy to be here and enjoy this company. I can reason from devils to good spirits.

SCEPTIC
They're tracking out the little flames and think they're near the treasure. Doubt goes with devil, d with d. This suits me entirely.

CONDUCTOR
Frog in the leaves and cricket in the grass. You cursed dilettantes. Fly's snout and midge's nose, what musicians!

OPPORTUNISTS
This host of merry creatures is called sans-souci. We can't walk any longer on our feet, so we walk on our heads.

THE NE'ER-DO-WELLS
We've scrounged many a meal so far, but now God help us. We've danced right through our shoes and we're down to our bare feet.

WILL-O'-THE-WISPS
We come from the swamp where we were born. But here we rate at once as shining gallants.

SHOOTING STAR
I came from high up in the starry light. Now I lie sprawling in the grass. Who'll help me on to my feet?

THE CRUDE ONES
Make way, make way. We tread down the grass. Spirits can be heavy-footed too.

PUCK
Don't stamp so, like baby elephants. Let Puck be the heaviest of us.

ARIEL
If nature or the spirit gave you wings, follow my light tracks to the rosy hill-top.

ORCHESTRA *pianissimo*
Clouds and mist are lit from above. A breeze in the trees and wind in the reeds, and everything vanishes.

scene 23 DULL DAY. A FIELD

Faust. Mephistopheles

FAUST
An outcast, driven to despair. Wretchedly wandering the wide earth and now at long last a prisoner, a condemned criminal, locked in a dungeon, exposed to the cruellest torture, the dear girl so ill-fated. Had it to come

scene 23 DULL

Faust. Mephistopheles

FAUST

An outcast, driven to now at long last a ...osed to the cr...

Johann Wolfgang von Goethe, *Faust*, translated by Barker Fairley (Toronto: University of Toronto Press, 1970). Illustrations by Randy Jones. 172 × 249 mm (6¾″ × 9¾″). DESIGN: Allan Fleming.

The text face is Linotype Palatino, designed in 1948 by Hermann Zapf. The blackletter used on the title page is Fette Fraktur, based on the work of the 19th-century German typefounder Johann Christian Bauer.

This book was printed photo-offset (as most books were by 1970), and Linofilm Palatino (the phototype version of the face) had been available since 1963 – but Zapf had redesigned the face in adapting it to phototype, and the new type had been issued in a stunted version. Fleming therefore had the whole text of *Faust* set in metal.

GOETHE'S **Faust**

TRANSLATED BY BARKER FAIRLEY

UNIVERSITY OF TORONTO PRESS

Losers confesses his love and his need for the composite Catherine Tekakwitha-Edith figure, destroyed by the system or excluded from the public life of society. He would find her, not in heaven but on earth, not in church on Sundays only but everywhere in his daily life. He would ask her for the most ordinary everyday things. "Phrase-book on my knees, I beseech the Virgin everywhere."[41] He writes out little dialogues, like those in a Berlitz language course, in which he would ask her for all the little things he needs. He would beseech her in the Wash House, in the Tobacconist's, in the Barber Shop, in the Post Office, at the Bookseller's. "O God, O God," he concludes, "I have asked for too much, I have asked for everything! I hear myself asking for everything in every sound I make. I did not know, in my coldest terror, I did not know how much I needed. O God, I grow silent as I hear myself begin to pray."[42] The final prayer is a list of phrases in Greek and in imperfect English of the type that might be used by a man asking for things at the druggist's.

L'uomo universale, it would seem, has discovered that he is not self-sufficient, that his ideal itself is inadequate, that Creation is too large to be contained in his laws, or in the laws of the Creator he conceived and served. He discovers that he must learn from the medicine man a new language of prayer.

CHAPTER FOUR

The Problem of Job

I wish I had been born beside a river
Instead of this round pond
Where the geese white as pillows float
In continual circles
And never get out.
 JAMES REANEY, "The Upper Canadian"

Beside us frocked and righteous men
Proclaimed their absolutes as laws.
They kept their purity of creed
By twisting facts that showed the flaws.
 F. R. SCOTT, "Eclipses"

And this planet dancing about Apollo,
the blood drying and shining in the sun ...
 IRVING LAYTON, "Seven O'Clock Lecture"

When Edmund Clark in Grove's *The Master of the Mill* opposes his father in a scheme to automate the great flour mill and monopolize the economy, he justifies himself by saying:

"It was the Victorian attitude, and it was yours and your generation's, to mistrust the future as you mistrusted me. So they fought the coming of that future with laws and guns; and finally, seeing that they could not shoot holes into a tide, they fought it with concessions to the rabble designed to retard the coming of the tide. They were intent on saving their skins. They did save them, for the moment. But what was their answer to the question asked by the centuries, the question asking for justice? Their answer was the *status quo*. But, hold on to the *status quo*, and you strangle life."[1]

This book

was designed by

ANTJE LINGNER

under the direction of

ALLAN FLEMING

and was printed by

University of

Toronto

Press

D.G. Jones, *Butterfly on Rock: A Study of Themes and Images in Canadian Literature* (Toronto: University of Toronto Press, 1970). 140 × 234 mm (5½" × 9¼"). DESIGN: Antje Lingner / Allan Fleming.

The type is Monotype Baskerville. This is a Neoclassical face, but it is used here in an un-Neoclassical manner. The running heads, chapter heads, and quotations are asymmetrically positioned, and the prose is set ragged rather than justified.

[*See also p 49*]

Jacopo Bannisio

Andreas BALENUS of Balen, d 10 February 1568
Frequently called Balenus, Andreas van Gennep of Balen, forty kilometres east of Antwerp, was probably born about 1484. He may have received one of the scholarships in the College of the Castle, Louvain, which were reserved for young men from his district. He did not matriculate until 27 May 1516 and appears to have attended the lectures of Matthaeus *Adrianus and Jan van *Campen at the Collegium Trilingue. After receiving his MA he began to study medicine; subsequently he was often praised by his contemporaries for his knowledge of medicine, botany, and physics. He pursued a career as a physician, which he did not entirely abandon when on 26 February 1532 he succeeded Jan van Campen as professor of Hebrew at the Trilingue, accepting two-thirds of the regular professor's wages. Although he suffered from a nervous illness at the turn of 1543–4 and had to take a leave, he brought the attendance of Hebrew courses to such a level that students began to demand daily lectures and the old opponents of the Trilingue in the faculty of theology recognized the excellence of the program.

Balenus had such famous students as the theologian Gulielmus Lindanus and the oriental scholar Andreas Masius, who became a correspondent and close friend. Balenus recommended his pupil Lambert *Coomans as a suitable servant for Erasmus (Ep 3037). Coomans proved satisfactory and, thanks to a bequest from Erasmus, returned to Balenus' house to continue his studies at Louvain. Erasmus sent greetings to Balenus in 1535 (Ep 3052) and apparently wrote him soon after (Allen Ep 3130).

Balenus wrote two treatises, 'De accentibus hebraicis' and 'De consensu editionis Vulgatae cum hebraica veritate,' both mentioned in the *De optimo genere interpretandi scripturas* of his pupil Lindanus. Another book, 'De investigatione thematis in hebraico sermone,' existed in manuscript about 1760. He married Roberta van Duerne, who died on 17 December 1567. Balenus himself died two months later and bequeathed all his possessions to the poor students of Louvain.

BIBLIOGRAPHY: Allen Ep 3037 / de Vocht CTL III 208–19 and passim / *Matricule de Louvain* III-1 530

CFG

BALTHASAR AUSTRIACUS See *Balthasar von KÜNRING*

Jacopo BANNISIO of Korčula, d 19 November 1532
Jacopo Bannisio (Banisius, de Bannissis) was born on the Island of Korčula, (Curzola) in Dalmatia. His father was Paolo Bannisio, perhaps of the lower nobility. In 1493 or 1494 Bannisio entered the service of the Emperor *Maximilian I and by 1502 was an imperial secretary. He was rewarded with a number of lucrative benefices, including the deanery of Trent in 1512 and that of Antwerp in 1513, and several parishes. He received holy orders in 1514.

Bannisio took part in numerous diplomatic missions and was especially prominent in efforts to ally with England. In August of 1513 he was in the English camp at Tournai after *Henry VIII defeated the French in the battle of the Spurs. From 1515 to 1522 he was frequently in contact with English emissaries, who saw him as a partisan of their cause at the imperial court. In 1521 Bannisio was at Worms and

helped draft the edict against *Luther. Although he continued intermittently to be involved in the diplomatic service of the Hapsburgs, in 1522 he went to live at Trent, where he later died. Between 1523 and 1527 he engaged in a mission to return Francesco II *Sforza to Milan and for his services was rewarded with an annual income. He renounced his ecclesiastical benefices in favour of his nephew and in 1530 was permitted to appoint substitutes for his missions in the imperial service.

Bannisio was a friend and patron of artists and humanists. In 1520 he met Albrecht *Dürer at Brussels and Antwerp, where he had a residence, and helped extend a pension first paid to the artist by the Emperor Maximilian. Dürer later drafted a coat of arms for Bannisio and perhaps also a portrait sketch.

On 3 November 1517 (Ep 700), Erasmus wrote to Bannisio to apologize for not seeing him at Brussels and to express anger at *Pfefferkorn's attacks on all men of learning. Erasmus suggested that he might write to Maximilian so that the madness of Pfefferkorn could be suppressed 'not by books, but by the club of Hercules,' (Ep 709) that Pfefferkorn was best left to his own devices. Later, on 21 May 1519 (Ep 970), Erasmus wrote to Bannisio to praise the level of learning attained by Henry VIII and England.

BIBLIOGRAPHY: Allen Ep 700 / DBI V 755–7 / LP II and III passim / Erwin Panofsky *Albrecht Dürer* (Princeton 1943) II nos 382, 1075 / *Deutsche Reichstagsakten* Jüngere Reihe (Gotha-Göttingen 1893–) I 185 and passim

TBD

Theobald BAPST of Guebwiller, 1496/7–4 October 1564
A native of Guebwiller, Upper Alsace, Bapst was already in orders when he matriculated at the University of Freiburg on 12 January 1515. He graduated MA in 1517–18 and began to teach, while at the same time studying law with Udalricus *Zasius. Bapst was a free-wheeling youth, and there are records of a lively evening in the company of Bartholomaeus *Latomus which led to some embarrassment for the faculty of arts (1519). He settled down, however, and was elected rector for a term in 1522 (Ep 1353) and for thirteen more terms between then and 1552. Between 1525 and

1528 he had to leave Freiburg to supervise a relative at the University of Dole. On 29 March 1530, during one of Bapst's terms as rector, Zasius presided at his solemn doctoral graduation. In the Freiburg faculty of law he held the chair of the codex from 1535 until 1542, when he was promoted to the senior chair of civil law; he was also dean for fourteen terms. His legal opinions were in great demand throughout the Breisgau and Alsace, and he was councillor to the Hapsburg administration in Ensisheim, but he was not a publishing scholar. Although Bonifacius *Amerbach had been his fellow-student at Freiburg, a regular correspondence between them did not begin until the 1540s. Bapst died of the plague, leaving one half of his fortune, or 10,800 florins for the foundation of a college at Freiburg named after him.

BIBLIOGRAPHY: Allen Ep 1353 / *Matrikel Freiburg* I 218–19 and passim / Schreiber *Universität Freiburg* II 332–5 / Winterberg 15–16 / Clausdieter Schott *Rat und Spruch der Juristenfakultät Freiburg i. Br.* (Freiburg 1965) 64–6 and passim / AK VI–VIII passim / BRE Ep 270 / Öffentliche Bibliothek of the University of Basel MS G² II 66 f 6: a letter from Bapst to J.U. Iselin, Freiburg, 17 September 1562

PGB

Hieronymus BARBA (Ep 2721 of [September-/October 1532])
Hieronymus Barba, a Dominican who associated with Ambrosius *Pelargus at Freiburg, has not been identified.

Ermolao (I) BARBARO of Venice, 1453/4–c July 1493
Ermolao Barbaro gained much of his early education away from his Venetian home in the company of his father, Zaccaria, an active politician and diplomat. He studied first in Verona with his uncle, also named Ermolao Barbaro, and from 1462 in Rome, with *Pomponius Laetus and Theodorus *Gaza. His reputation grew rapidly; in 1468 he was again in Verona, this time to receive the poet's laurel crown from *Frederick III. During the 1470s he worked sporadically but intensively at Padua, taking his doctorate in the arts on 23 August 1474 and in civil and canon law on 27 October 1477. By this time a political career was beginning to open to him. He entered the

Contemporaries of Erasmus: A Biographical Register of the Renaissance and Reformation, vol. 2, edited by Peter G. Bietenholz (Toronto: University of Toronto Press, 1986). 168 × 247 mm (6¾″ × 9¾″). DESIGN: Antje Lingner.

The type is Hermann Zapf's Palatino, used here in its digital Linofilm form. (It was the Linofilm or phototype version of the face that was digitized, not the foundry nor the Linotype-metal version.)

With the switch from metal to phototype, typographic refinements such as true small caps and old-style figures (which fit with the lowercase letters) rapidly vanished from printed books. Legibility suffered accordingly. As phototype matured into digital type, the old refinements were sometimes reintroduced. This incarnation of Linofilm Palatino – available to Lingner in 1986 but not to Allan Fleming in 1970 – will stand comparison with its metal predecessors.

...rkorn was b... Later, on 21 May ... us wrote to Bannisio ... ing attained by Henry ... LIOGRAPHY: Allen Ep 7... III passim / Erwin Pa... (Princeton 1943) II ... Reichstagsakten

Two of the many differences between the Linofilm and Linotype-metal versions of Palatino are that the Linofilm descenders are longer and the Linofilm italic is narrower. (The Linotype-metal version of Palatino is shown on p 82.)

Robin Skelton, *Musebook* (Victoria,
B.C.: Pharos Press, 1972). Illustrations by
Herbert Siebner. 230 × 305 mm (9″ × 12″).
DESIGN: Bev Leech.

As in all the books printed in Victoria by
Charles Morriss, the text type is Intertype
Baskerville. The titles are handset in
Emil Rudolf Weiss's Weiss Series II. The
text is printed from the metal, and the
illustrations are coloured by hand.

[*See also p 51*]

WAITING FOR A LETTER

Tomorrow I may hear.
Of course!
But till tomorrow
I am caught
between the wish
to send you love
and that to ban
such dangerous thought,

being aware,
(as are we both),
of love's absurdity,
its greed,
its tyranny,
and, too, unsure
that love's what either
of us need,

yet being also
most aware
that for a little while
we two
released that great
imprisoned prince
and found what love
revealed may do,

and found, moreover,
that the text
within love's book
is falsely glossed,
for lovers also
may be friends
and prize affection
over lust.

11

ROBIN SKELTON

MUSEBOOK

HERBERT SIEBNER

THE PHAROS PRESS

1972

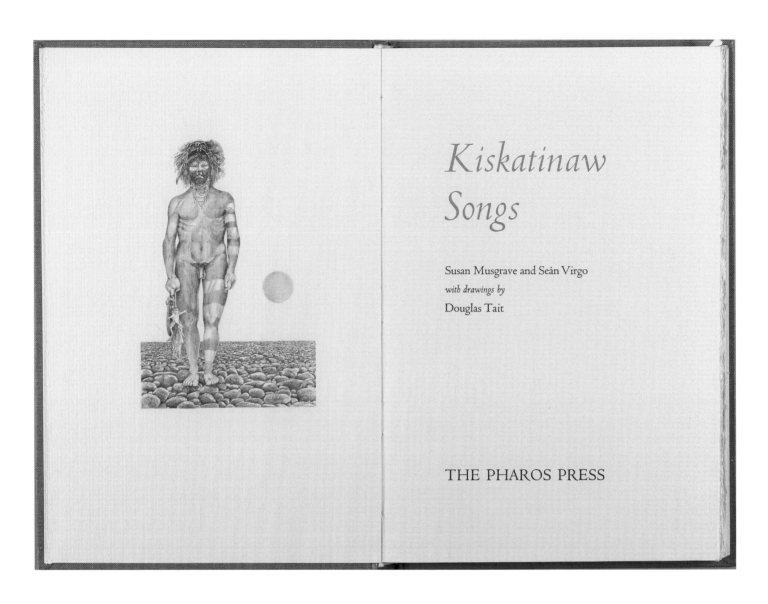

Kiskatinaw
Songs

Susan Musgrave and Seán Virgo
with drawings by
Douglas Tait

THE PHAROS PRESS

Susan Musgrave & Seán Virgo, *Kiskatinaw Songs* (Victoria, B.C.: Pharos Press, 1977). Drawings by Douglas Tait. 170 × 240 mm (6¼″ × 9½″). DESIGN: Bev Leech.

The text face is again Intertype Baskerville, but the title page and titles are handset in Frederic Warde's Arrighi italic and Bruce Rogers's Centaur roman. These are printed from the metal. Like all the Pharos Press books, this was printed by Charles Morriss.

[*See also p 51*]

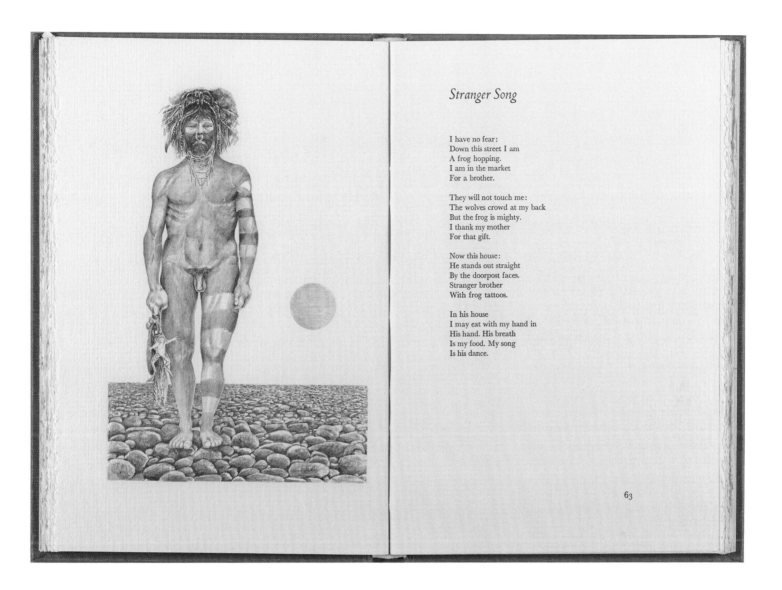

Stranger Song

I have no fear:
Down this street I am
A frog hopping.
I am in the market
For a brother.

They will not touch me:
The wolves crowd at my back
But the frog is mighty.
I thank my mother
For that gift.

Now this house:
He stands out straight
By the doorpost faces.
Stranger brother
With frog tattoos.

In his house
I may eat with my hand in
His hand. His breath
Is my food. My song
Is his dance.

63

Baskerville is a Neoclassical type, grounded in 18th-century English rationalism, while Centaur and Arrighi are Renaissance revival faces – the former based on a roman cut in Venice in 1469 by the French typographer Nicolas Jenson, and the latter adapted from an italic designed by the calligrapher Ludovico degli Arrighi at Rome in the 1520s. But Baskerville was the text face Charles Morriss preferred, and Centaur and Arrighi were his favourite faces for titles. In a letterpress shop, adding another typeface or even another size involves long delays and enormous expense. Designers who worked for Morriss necessarily learned how to work with the type he had chosen.

For those who like to read not only words but also letterforms, such a mixture of type has implications. It suggests 18th-century English rationalism and plucky self-assurance coupled with certain Renaissance fundamentals: perhaps the quintessential Renaissance fusion of mental and physical modes, and the passion for cultural renewal on ancient, indigenous models. This in fact suited the tenor of much 20th-century British Columbia literature. Robin Skelton, the publisher of Pharos Press and an expatriate English poet, was also, with Charles Lillard, an ardent proponent of what the two men liked to call "the West Coast Renaissance." *Kiksatinaw Songs* attempted, in English, to meld colonial and indigenous modes of perception, and it epitomized what "West Coast Renaissance" meant to Lillard and Skelton.

Roderick Haig-Brown, *Alison's Fishing Birds* (Vancouver: Colophon Books, 1980). Illustrations, composition, and presswork by Jim Rimmer. 175 × 255 mm (7″ × 10″). DESIGN: Jim Rimmer.

The titling face is ATF Cloister Old Style. The text face is Monotype Italian Old Style – a type that Frederic Goudy created in 1924 specifically to accompany (and to compete with) Cloister Old Style. These are printed from the metal.

FAR RIGHT, FACING PAGE: Albertan and Amethyst, two families of text type designed and cut by Jim Rimmer at New Westminster, B.C. Rimmer cut a 16-point font of Albertan roman in metal in 1985. He added the italic and small caps in 1991, when the family was digitized, then revised the digital versions a few years later. Amethyst, which exists only in digital form, was sketched in 1994, finished in 1999, and revised in 2002. These faces owe a good deal to the work of Frederic Goudy, whose type Rimmer has used, cast, and repaired many times over the years.

[*See also p 51*]

O N E

ALISON'S DIPPER

Oɴᴇ of Alison's favourite birds, and one of the easiest to watch too, is the dipper—more proper people than Alison and her father sometimes call it the water-ouzel. The dipper Alison watches most often lives along the river between her house and the Sandy Pool. She has seen it hundreds of times—on the rocks of the dam that shelters the water-wheel down at her house, on the old slippery logs and sandy beaches of the Sandy Pool, anywhere and everywhere along the banks of the river. The dipper is not a very big bird—larger than a sparrow but much smaller than a robin, very round and important and merry. His colours are sober, almost dull, unless you look at them very closely: a dark-grey back that seems bluish sometimes when the light is on it, a head still dark-grey but with more of brown in it than the back, a breast scarcely lighter than the rest of him, and pale slender olive-green legs. But Alison loved him for his brisk light movements, his flirting stubby tail and his friendliness.

11

ABCDEFGHIJ
KLMNOPQR)
STUVWXYZ?
"abcdefghijklm;"
nopqrstuvwxyz.
fi ff fl ffi ffl æ
&-123 4567 890!]
ABCDEFGHIJKL
¶ "abcdefghijklm;"
nopqrstuvwxyz.
fi ff fl ffi ffl æ
&-123 4567 890!]

ABCDEFGHIJ
KLMNOPQR)
STUVWXYZ?
"abcdefghijklm;"
nopqrstuvwxyz.
fi ff fl ffi ffl æ
&-123 4567 890!]
ABCDEFGHIJKL
¶ "abcdefghijklm;"
nopqrstuvwxyz.
fi ff fl ffi ffl æ
&-123 4567 890!]

Bill Bissett, *Soul Arrow* (Vancouver: Blewointmentpress, 1980). 209 × 273 mm (8¼″ × 10¾″). DESIGN: Bill Bissett.

Like many books of the middle and late 20th century, *Soul Arrow* was composed on a typewriter and printed directly from typescript. Bissett was apparently as happy typing a picture as typing a text, and as happy drawing a text as drawing a picture. But unlike most concrete poets, he made concerted and industrious use of the machine, often reinserting the paper at different angles to alter the visual texture, and rotating entire images to disguise or defamiliarize the letterforms he employed.

[*See also pp 97–98*]

Stills from the Typographic Movie

You can pick up a book but a book can throw you across the room....
Books are kinetic, and like all huge forces, need to be handled with care.
But they do need to be handled.

– JEANETTE WINTERSON[1]

1 *Art Objects*, pp 122–23.

If a book should throw you across the room, do not blame (or praise) the designer. The only place where a book might harbour that much leverage, strength, and poise is in the invisible realm of what it has to say.

Design can help to clarify what's said. It can wash the window of the page. Design can make a printed book more inviting to touch, which can give the hidden muscle of the text an extra edge. Design can even turn the physical book into a kind of sculptural music – a silent accompaniment for the voice or voices lurking in the words. This might make getting thrown across the room seem a little more like waltzing. But design cannot give the words a power, depth, or subtlety they did not already have.

The designer can, on the other hand, quite easily cause the *reader* to throw the *book* across the room – or if the reader is as gentle as they say, to set the book down with a sigh and never return to it again.

In oral cultures, storytellers make their own designs, thinking out the order and shape of a story every time they tell it aloud. If we transcribe stories told under such conditions, we find that these invisible designs are actually embedded in the text and can be brought, like buried treasure, to the typographic surface. Poets, even in literate cultures, tend to compose in a similar way, giving the work a shape that can be heard when it is spoken or seen when written down.

Prose, I think, is originally blind: a voice in the darkness hauled in like fishline and coiled onto the page, with very little implicit design.[2] But prose is the essential genre of *writing*, the specialty of scribes, and as scribal cultures develop, prose becomes something to see, to admire, to scrutinize. It is annotated and labelled, segmented and rearranged. In other words, it is edited – and some writers learn to edit themselves. It is then that, for better or worse, prose opens its eyes and looks in the mirror.

Writers in scribal cultures tend to be accomplished scribes and can give their work a benchmark material form, but when printing takes hold, typography intervenes. Over time, what the reader reads comes to look quite unlike what the writer produces.

With the spread of personal computers in the late 1980s and 1990s, typographers and writers found themselves using similar tools, and their

2 This is not the place to argue the merits and scope of this opinion, but it is based on close study of hundreds of manuscripts, ancient and recent, in languages ranging from Latin and Greek to Inuktitut and Cree.

a. "in bookkeeping, the book of final entry, in which a record of debits, credits, and all money transactions is kept."

the
book
of
columns

page 33: James Darling

1880

Mar 22: to sawing square timber	1.44
June 21: to 1 round cedar bed	3.50
June 21: to 1 jack shingles	.50
Dec 4: to sawing mable [sic]	1.50

Nov 4/82 by logs 4.10

(it doesn't balance)

some pages torn out (
by accident)
some pages remaining (
by accident)

page 62: Nicholas Neubecker

1893

Nov 16: to chopping 8 bags	.40
Dec 19: to chopping 880 lbs	.49
: to elm scantling	.18

the poet: by accident
finding in the torn ledger

(IT DOESN'T BALANCE)

the green poem:

my grandfather, Henry (dead) the ledger itself (surviving)
in his watermill (gone) purchased in the Bruce County
on the Teeswater River, Drug and Book Store (Price:
on the road between Formosa and $1.00 PAID), the leather cover
Belmore, needing a new ledger: brown. In gold: THE LEDGER:

 EVERYTHING I WRITE
 I SAID, IS A SEARCH
 (is debit, is credit)

is a search for some pages

 remaining

 (by accident)

the poet: finding the column straight
in the torn ledger the column broken

 FINDING

everything you write
my wife, my daughters, said the book of final entry
is a search for the dead in which a record is kept.

Robert Kroetsch, *The Ledger* (London, Ontario: Brick Books, 1975). 163 × 197 mm (6½″ × 7¾″). DESIGN: Stan Dragland.

The fundamental design decision in this book was made by the author when he decided to type the text in ledger-like columns. Another major design decision may have been made by default, when the editor (Stan Dragland) chose the text face: a nondescript, mid 20th-century newspaper type known as Monotype News N° 2. A less literary face would be difficult to find – but it is perfectly in tune with the non-literary, meat-and-potatoes voice at the foundation of Kroetsch's book-length poem.

practice began to reconverge. Writing could now look just like printing, good or bad, and writers who wished could learn the typographer's trade.

Many writers, of course, had no more desire to start designing and setting their books than they had to start building their own houses, growing their own food, and making their own clothes. Others leapt at the chance – though it was a dangerous moment to leap, because typography itself was undergoing tumultuous change. A thousand years of accumulated knowledge and expertise was in danger of being lost or broken in the move. Such upheavals have been frequent in the bookmaking crafts in the past hundred years.

Between 1900 and 1920, books were caught in a major industrial shift from handset to machine-set type. Both Monotype and Linotype machines imposed some new restrictions on the proportions and fitting of letters. New faces, and new adaptations of old ones, were urgently required. Given the sorry state of typography toward the end of the nineteenth century, this could easily have proven a disaster. It did not, because the redesign campaign encountered two sources of fertilization: the revival of humanist scribal practice, led by the passionate Scotsman Edward Johnston, and an intensified study of typographic history, led in large part by Daniel

Berkeley Updike in the USA and Stanley Morison in England.[3] Many typefaces born in those days are still in steady and fruitful use for making books, in Canada and elsewhere, in both metal and digital form.[4]

In the 1960s, as commercial printing became photographic, typography was forced to change again. More new faces were designed, and old ones again redrawn. This went less well, especially in North America. Machines and fonts were built with scant regard for the traditions of typography, then marketed as devices that could be operated by anyone able to use a typewriter keyboard. Good typographers did what they could to dodge and deflect this perversion of the craft, but overall, the era of phototype (roughly 1960 to 1985) was another period of prolonged typographic depression.

Equally traumatic was the rapid shift from case-bound books to paperbacks and from binder's thread to glue. The printed page was abruptly replaced by a photographic replica of itself, and the sewn book – a river of paper and type that opened and flowed at the sweep of a fingertip – was replaced by a paper brick, impeccably trimmed and squared, often colourfully wrapped, but self-destructively predisposed to bite the hand that read it. Books were now much cheaper and more numerous than before, but books had been transformed. They had largely ceased to be the chalices of knowledge – austerely sensuous vessels brimming with what humanity has thought and felt and known – and become disposable containers, filled with whatever printable substance consumers would buy. Forests disappeared into these disposable books, and the books, read or unread, disappeared into landfills. Yet the throwaway book, in its sorrowful way, was a great success. It was through just such disintegrating paperbacks that many of us first learned how powerful books could be – and how much they deserved to be better designed and more durably built.

Digital type, when it first appeared (in Germany at the end of the 1960s), had all the faults of phototype and some of its own besides. Its only benefit was speed. A much more promising approach to digital rendering was developed in the USA in the mid-1980s, and by the end of that decade it was possible to set digital type with all the subtlety of the finest work in metal. This is what made it possible for the two faces of literature – writing and typography – to reconverge. Only after this had happened did alphabetic type design in Canada come of age.

As early as 1983, a Vancouver letterpress printer named Gerald Giampa acquired an important set of master patterns from the defunct Lanston Monotype Company of Philadelphia.[5] Some years later, working with Jim Rimmer, Giampa began converting these designs to digital form. In 1994, Giampa moved his operation to Prince Edward Island while Rimmer remained on the West Coast making fonts of his own. In the same

3 Between 1911 and 1916, Updike gave the first college courses on typography ever offered in North America. These were at Harvard – not in Fine Arts but in the Graduate School of Business Administration. His major work, *Printing Types: Their History, Forms, and Use*, first appeared in 1922. The most important of Morison's books, in my opinion, is the posthumous *Politics and Script* (1972). Morison also founded and edited a valuable journal called *The Fleuron* (1923–30) and from 1923 directed the Monotype Corporation's program of typeface revivals.

4 Faces in this category produced before the Second World War are listed on p 48. Postwar examples include Hermann Zapf's Palatino (1948), Aldus (1953), and Optima (1958), Jan van Krimpen's Spectrum (1952), Georg Trump's Trump Mediäval (1954), Giovanni Mardersteig's Dante (1954), and Jan Tschichold's Sabon (1964–67).

5 The original Monotype machine was an American invention, but two separate companies, one American and one British, were formed to build and sell it. These two firms had separate type development programs. The British firm was advised by the English type historian Stanley Morison, the American firm by the American type designer Frederic Goudy. Many of the patterns that Giampa brought to Canada in 1983 were Goudy's designs. Much of that material was destroyed by a storm in 2000. What survived was sold back to the USA in 2004.

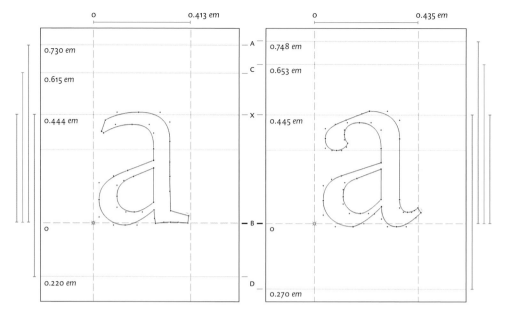

Digital outlines of the letter **a**, made by Rod McDonald for Cartier Book (left) and Laurentian Book (right). Vertical dashed lines define the set-width of the character. Horizontal lines show the overall proportions of the font: A = *height of ascenders*; C = *cap height*; X = *x-height*; B = *baseline*; D = *depth of descenders*.

Digital type has no material substance. It is usually defined by scalable vectors and also thus has no inherent size. Its internal proportions are measured in terms of a flexible unit, the *em*. In metal type, an em in any font is a distance equal to the actual body size of the type. In digital type, the em equals the *theoretical size of the imaginary body* on which the type would be cast *if it were* metal type.

In digital type, nothing prevents a letter from overshooting its imaginary body, horizontally or vertically. Metal type, for all its solidity, also involves imaginary entities. The height of the lowercase x, for instance, is an imaginary constraint. It is normal in both metal and digital type for rounded letters such as **a** and **o** to overshoot the baseline and the x-height, and normal for rounded capitals such as O to overshoot the baseline and cap height.

➤ Bevington: pp 172–75;
Inkster: pp 112–15;
Elsted: pp 132–38;
Robertson: pp 116–23;
Paulson: pp 200–201;
Goluska: pp 50, 108–11, 166;
Vaitkunas: pp 160–64

year a digital foundry called Tiro Typeworks was established in Vancouver by John Hudson and Ross Mills. Both men soon produced important designs for the Latin alphabet. Mills has also since become a specialist in Native American fonts (Cree, Inuktitut, Cherokee) and Hudson an expert in the encoding of other non-Latin scripts (Arabic, Hebrew, Cyrillic).

In Toronto in the late 1990s another designer, Rod McDonald, confronted the lingering problem of Carl Dair's type, Cartier. Treating Dair's work as the brilliant but unfinished draft that it was, McDonald turned it into a working digital family known as Cartier Book. This involved darkening the roman enough to make it suitable for setting normal text, creating small caps and other missing glyphs, adding a supplementary bold weight, and most important of all, redrawing the italic to increase its legibility. McDonald's next major project, completed in 2002, was the text face Laurentian, commissioned by *Maclean's* magazine. The type you are reading now is a revision of that design: Laurentian Book, produced at Lake Echo, Nova Scotia, in 2007.

There are other talented type designers at work in Canada now, including Friedrich Peter in Vancouver, whose script faces Vivaldi and Magnificat are rightly admired around the world, but I think Jim Rimmer, Rod McDonald, Ross Mills, and John Hudson have done more than any others for the typography of the book.

When it comes to book designers, the country now has almost an embarrassment of riches. If I limit myself to a baker's dozen, I can mention Stan Bevington at the Coach House Press in Toronto; Tim Inkster at the Porcupine's Quill in Erin, Ontario; Crispin Elsted at Barbarian Press in Mission, British Columbia; Gordon Robertson and Ingrid Paulson, both in Toronto; Glenn Goluska and George Vaitkunas, now both in Montreal;

Peter Cocking and Jessica Sullivan in Vancouver; Alan Brownoff at the University of Alberta Press in Edmonton; Alexander Lavdovsky at Poppy Press in Victoria; Andrew Steeves at Gaspereau Press in Nova Scotia; and Jason Dewinetz, now in the Okanagan. The range of work produced by these designers is enormous. So is the range of typographic resources and printing techniques they have used, but all are expert at what they do.

➤ Cocking: pp 182–86;
Sullivan: p 165;
Brownoff: pp 166–71;
Lavdovsky: p 139;
Steeves: pp 176–81;
Dewinetz: pp 198–99

Canada is also home to many different kinds of publishers – trade and university presses, regional presses, children's presses, private and fine-art presses. There is, however, one kind of press that seems to me distinctively Canadian – so Canadian that it goes largely unrecognized in the world and has no name. It is easily described as a hybrid between the literary trade press and the private press, but it was not in fact created by cross-breeding. It is typically modest in size but has national distribution, and it is run like a Renaissance publishing house, printing what it publishes and devoting as much attention to physical workmanship as to literary values. The species was born when a young Alberta printer named Stan Bevington started the Coach House Press in Toronto in 1965. The Porcupine's Quill and Gaspereau Press are current leading examples, and there are signs that the tradition may continue.

➤ Coach House Press: pp 116–17,
172–3, 204–5;
Porcupine's Quill: pp 112-13;
Gaspereau Press: pp 176–81

The last century, however, has been as perilous for publishers as for printers and typographers: perilous for books as well as for languages and letterforms, and in countless other ways – like every century – perilous for human culture. That distinctively Canadian kind of publishing involves a fairly simple recipe, tested over more than forty years. The ingredients include immense amounts of personal devotion and technical capability, a functioning free market, a modest ration of public money, and a community – talented readers as well as writers – wanting not only literary internationalism but also a healthy homegrown culture. Each of these ingredients is vital, and none is guaranteed.

Long before the computer made it possible for anyone to design and set a book at the same desk where it was written, there were writers who found in their typewriters a similar dispensation. In Canada, the most diligent and talented of these was probably Bill Bissett – and it seems to me there is something prophetic in Bissett's early work. In place of the transparency that oral poets, writers, and typographers alike have usually aimed at, Bissett sought a kind of meaningful opacity. More recent artists and writers, using advanced typographic software rather than simple mechanical keyboards, often seem possessed of the same desire: to cobble language into a form that can deliver its author's message full force by being *looked at*, eliminating the work but also the profit involved when we listen or read. It is as if typing had become a kind of *substitute* for writing instead of a vehicle conveying it into the world.

➤ Bissett: p 92

➤ Majzels: pp 202–3

➤ Rawlings / Kennedy: pp 204–5

➤ Goluska / Kroetsch,
 Liebhaber's Wood Type: p 166

➤ Snow: pp 100–101

Robert Majzels's recent *Apikoros Sleuth,* whose form is based on the editorial framing and layering found in manuscripts of the Talmud, and Angela Rawlings's still more recent *Wide Slumber for Lepidopterists,* designed by Bill Kennedy, which embeds her poems in a kind of typographic chant, both possess a degree of sophistication not to be found in Bissett's typewriter books of the 1970s and 1980s, but they too are based on taking the letter literally. They are literary counterparts of the kind of modern painting that is not so much about vision or the perception of reality as it is about painting and paint.

Major works of recent Canadian literature – the novels of Margaret Atwood, Marie-Claire Blais, Anne Michaels, and Michael Ondaatje, for example, and the poems of Dennis Lee, Anne Carson, and Don McKay – are not as a rule much beholden to typography. Even in their finest typographic dress, they may not seem visually striking. They could be made so. In 1987, Glenn Goluska created a typographic tour-de-force from part of a novel by Robert Kroetsch, and the same inventiveness could easily be visited on the work of Atwood or Lee. In most cases, however, this would probably turn out to be irrelevant intrusion. Goluska's showpiece is relevant indeed, and not at all intrusive, because the episode he chose from Kroetsch's novel concerns a small-town printer having a medicine fight with his type. Goluska entered quite straightforwardly into the spirit of Kroetsch's work – in effect producing a typographic play for which Kroetsch had written the script. Most novels, however, are not about typographers or printers. And even in ardently self-enchanted historical periods such as ours, most writing is not about writing.

The reason most typographers, most of the time, try to make their pages transparent is that printing, most of the time, is understood as part of the tissue of metaphor by which we know, or try to know, the world. The letter, to the typographer as to the writer, is not an end in itself. Letters, like violins and violinists, may be lovely in themselves, but where they really shine is in giving what they are to something larger than themselves: to literature, to music, and to everything that literature and music are about. This is done through a tiny orifice: the needle's eye, the letterform, the note.

There is also, I think, something prophetic in a book made in 1975 by the Toronto artist Michael Snow. More clearly and much earlier than most of us, Snow understood how a shift in technology had turned the printed book into a kind of paper cinema. His work *Cover to Cover* is clearly a printed book; it is just as clearly a hand-operated movie. The text is limited to a few administrative sentence fragments, photographed while still in the typewriter platen. Around them, the book is overflowing with images: doors that swing like pages, a blank sheet of paper, an author – the artist

– who also turns back and forth, recto and verso, open and shut. Not so many years later, printed books still look a lot like printed books, but the text and pictures are assembled on computers, where they parade, frame by frame, on an illuminated screen. Books may get more cinematic yet.

Compare a photograph of an oil painting with the painting, a photograph of well-made cloth with cloth, or a photograph of skin with living skin, and you will see what the camera takes in and what it leaves out. It can vacuum up handwriting, line drawings, typescript and letterpress, sketches, collages, found objects, whole street scenes and landscapes. What it gives in return are starched and ironed optical clues which the viewer may or may not be equipped to fill in. Combine the camera's capabilities with techniques for manipulating paper – die-cutting, folding, spot-gluing, and so on – and you have the makings of another kind of book: a story unfolding through reproduced documents, drawings, paintings, photographs, pop-ups, and maps. There are words in such books, but the words are immersed in artfully plotted visual hints. Two Canadian artists, Nick Bantock and Barbara Hodgson, have made this kind of book their domain. They have, in the process, been teaching the rest of us something about what books are and are not. The Québécois artist Alain Lebrun, known as Lino, has sometimes taken a similar tack, but through rougher, more urban terrain where the narrative threads are routinely cut short.

➤ Bantock: pp 124–25; Hodgson: pp 126–27

➤ Lino: pp 188–89

Words, like the camera, leave many things out. And our methods of putting words on the page leave out many things which we tend to put in when we speak. Reading is always an imaginative act: a filling in of hints, a conversation of a kind. Books, in their silent way, have to listen, not just talk. If a text can tell us something, and if we can read the text, then any legible version will do. But a book that can throw you across the room is a book to be treated with some respect. And a book that has something of lasting value to say – as real books do by definition – is a book to be read more than once and kept for as long as there might be others to read it.

A musician will say that her instrument *speaks*, that it has a voice. We say the same of a writer's hand and of the letterforms that a master typecutter cuts. We do not say it of a typewriter, a printing press, a computer, or of any other machine. They may clatter and hum, but they do not speak. A violin can speak because it can listen, because it has ears as well as a voice. A letterform listens too, in the moment in which it is made. When it is replicated and printed, it listens no more. But the book in which that letterform is printed does have to go on listening in order to be read. That is why the book has to open, why the pages have to flow, like a river in dappled light: like the voice of a world where things are still growing, where creatures still live.

Michael Snow,
Cover to Cover
(Halifax: Nova
Scotia College of
Art & Design /
New York: New
York University
Press, 1975).
Photography
by Keith Lock;
photography
and prints by
Vince Sharp.
178 × 226 mm
(7″ × 9″). DESIGN:
Michael Snow.

[*See also p 98*]

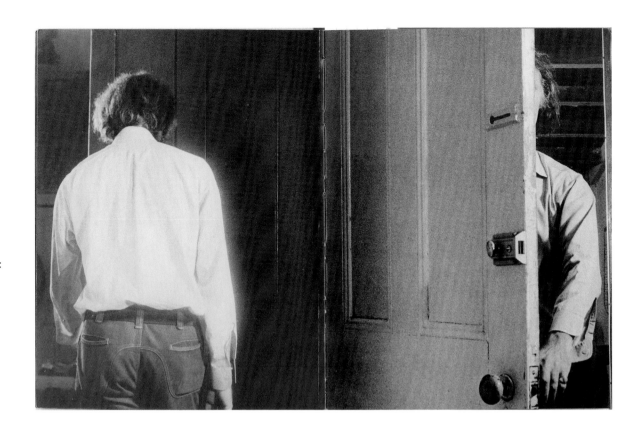

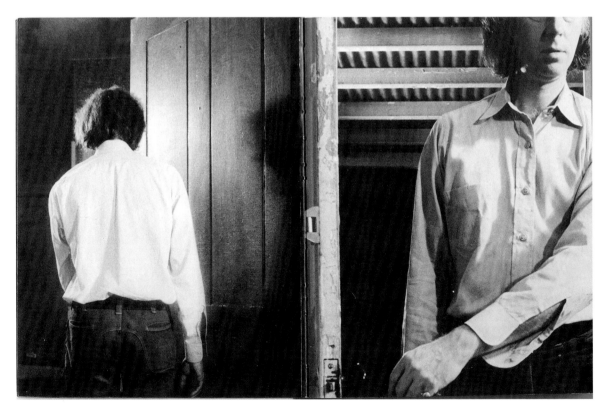

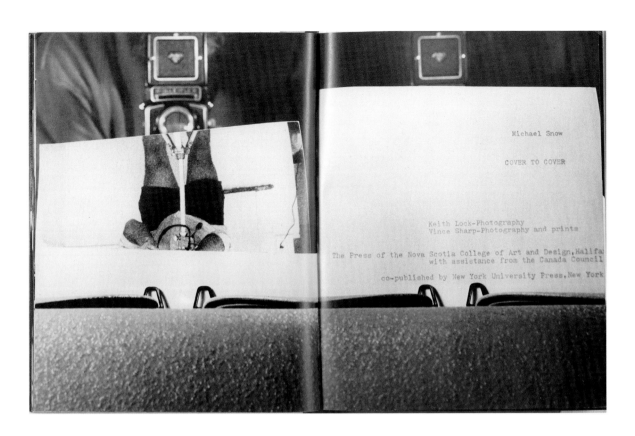

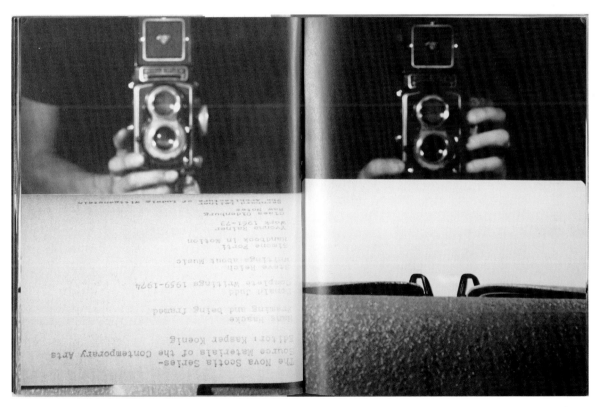

BORDUAS, *Abstraction en bleu* (1959), oil on canvas, 92×76cm, Art Gallery of Ontario, Toronto

78

Contemporary Art in Canada

EDITED BY ROBERT BRINGHURST, GEOFFREY JAMES, RUSSELL KEZIERE AND DORIS SHADBOLT

As an ongoing gloss on the appearance of much Canadian art during the past thirty years, this essay is more a kind of limited mythology than an art history. And because it is not a history of art in Canada during those years, I have made little attempt to discuss every painter deserving mention, or to order works of art into their proper chronological places, or even to gather the works together with any rigour into discrete collections of related pictures. Instead, I have attempted to provide an inventory of the artist's means, a marshalling of the artist's expressive constants, that will, I hope, demonstrate by accumulation the existence of an adjacent alphabet out of which a genuine and meaningful visual language continually evolves. It is this Ur-language of forms and colours, visual signs and signals, that we read when we look at works of abstract art.

Behind the development of this visual language lies the fact that, throughout the history of his art, man has always been his own abstraction. Alive and conscious, we move as perambulating verticals, living at right angles to what must always be, for us, the horizontal face of the earth. In sleep or death, when we lose consciousness, we fall, recline, stretch out onto this hospitable surface that supports us always. As a result of this raw set of biological imperatives, we assign great presymbolic importance to the two directions, the vertical and the horizontal. The vertical, as a direction, is always seen to be lively and energetic, while the horizontal is regarded by all of us as quiescent and serene.

Our abstract art, which profoundly mirrors what we are and how we order reality, seems to me resolutely structured upon these axes, the vertical and the horizontal, to which we assign energetic and even moral values. The horizontal in art is quiet, peaceful, everlasting, and readable as

infinite in both directions. The vertical is, by contrast, questing, ambitious, ethereal, transcendental – and also readable as infinite in both directions. Oblique lines, diagonals, we tend to read as lines or thrusts of energy in the process of rising to become verticals or falling to become horizontals. Because they are neither resolved verticals nor horizontals, we tend to feel oblique lines

The Alternate Eden

A Primer of Canadian Abstraction

Gary Michael Dault

as *local disturbances*, terminal lengths of energy adjusting themselves for the moment against the eternal length and breadth of horizontal and vertical, x and y. Obliques, therefore, are temporary, detachable, highly energetic, articulate, maybe frivolous. And poignant in a sense, because in their state of constant adjustment to the infinite, they are handy graphic compressions of our own mortality.

Right here, in the marshalling of vertical and horizontal coordinates and an adjustment against them of obliques, lies much of the essential business of two-dimensional abstract composition – especially as it first appeared in the rather late arrival of abstract painting in Canada.

It was 1910 when the Russian painter Wassily Kandinsky discovered that one of his nearly abstract landscapes, which had somehow been placed on its side in his studio, no longer looked like anything recognizable at all. It had shaken itself free of all mimetic content, to become in his sight a rhapsodic swarm of free-floating coloured shapes. Despite this gloriously liberating introduction (not given to Kandinsky alone) into the world of pure form and pure colour in intellectual suspension, it took years for the idea of

Visions: Contemporary Art in Canada, edited by Robert Bringhurst, Geoffrey James, Russell Keziere, & Doris Shadbolt. (Vancouver/Toronto: Douglas & McIntyre, 1983). 241 × 279 mm (9½″ × 11″). DESIGN: Robert Bringhurst.

The text face is Pontifex, designed by Friedrich Poppl in Germany in 1975. The primary titling faces are Michelangelo and Palatino, designed by Hermann Zapf.

Doris Shadbolt, *Bill Reid* (Vancouver/Toronto: Douglas & McIntyre, 1986). 236 × 247 mm (9¼″ × 9¾″). DESIGN: Reinhard Derreth.

The text face is Jakob Erbar's Candida – an extraordinarily clean and workmanlike slab-serifed face designed in Germany in 1934, when Reid was just fourteen. The design of the pages – equally clean – shows Derreth's mastery in the use of a visual grid for organizing text and illustrations.

The jacket – shown in two views on the facing page – is the one designed by Barbara Hodgson for the second edition of the book, published soon after Reid's death in 1998. Front cover and flap are a single image, folding at the arrowheads. The photograph, taken by Bill McLennan, shows Reid in the University of British Columbia's Museum of Anthropology contemplating his best-known work of sculpture, *The Raven and the First Men* (1980). The photo is positioned so that the front cover shows only the artwork, the front flap only the artist. The reader, then, is at liberty to unfold the image physically or mentally and reunite the two.

that *8* tongue
 of
yours. *1* How
do *2* you
think *3* uncle
Nino *4* has
 managed *5* to
survive *6* ten
 years *7* in
prison? *8* Not
 by
shooting *1* off
his *2* head.

Teresina I *3* am
like *4* uncle
 Nino. *5* Yesterday
grandad *6* Gramsci
 mistook *7* me
for *8* him.
 He
did, *1* Edmea.
I *2* was
coming *3* in
from *4* outside,
 and *5* grandad
ran *6* towards
 me, *7* to
embrace *8* me,
 and
crying *1* out,
Nino, *2* my
son *3* Nino.

Edmea He's *4* almost
 blind, *5* Teresina.

Teresina It's *6* not
 Nino, *7* I
said, *8* it's
 me
Teresina *1* your
granddaughter. *2* And
I *3* hugged
him *4* and
 kissed *5* him.
What *6* did
 you *7* do

```
          that   8   for,
                              he   9
Edmea              He's
          eating  2   his
          heart   3   out
          with    4   expectation,
                      Teresina.   5
Teresina                          What
          did     6   you
                      do   7   that
          for,    8   he
                              asked   9
          me.     1   Kiss
          you,    2   I
          said.   3   No,
          he      4   said,
                      trick   5   me
          like    6   that.
Edmea                     It's   7   only
          the     8   28th.
                              The   9
          old     1   man
          should  2   know
          what    3   getting
          released 4  from
                      prison   5   means.
          He's    6   been
                      in   7   prison.
          He      8   should
                              know   9
          you     1   don't
          get     2   out
          as      3   soon
          as      4   your
                      time's   5   up.
Teresina  Mussolini 6  hates
                      letting   7   us
          get     8   out
                              from   9
          under   1   his
          thumb.  2   I'll gag...

BLACKOUT   There is a knocking at the outside door.
```

Wilfred Watson, *Gramsci × 3* (Edmonton: Longspoon Press, 1983). 140 × 217 mm (5½″ × 8½″). DESIGN: Jorge Frascara / Shirley Neuman.

The type is Adrian Frutiger's Univers, designed in Paris in the early 1950s. For several decades, this was regarded by many designers as the purest of types – the one which added nothing to (and subtracted nothing from) whatever message it carried.

The Canadian poet and playwright Wilfred Watson (1911–98) became, in later life, a devotee of numerical grids, which he used to score both poems and plays for sequential multiple voices. He was teaching in Edmonton when he completed his trilogy of plays about the life of Antonio Gramsci. So, by a stroke of luck, the trilogy went to the Edmonton publisher Longspoon Press, whose chief designer was Jorge Frascara. The luck lay in the fact that Frascara is, among other things, a specialist in "information design" and thus an expert in the subtle use of complex grids, and in the fact that Frascara was then married to the critic Shirley Neuman, an expert on Watson's work.

Old Europa Specialties

Wiener Schnitzel - Potato salad, fried
pototoes and green salad .. $ 5.

Breaded Veal Cutlets - Fried potatoes,
green salad and potato salad .. $ 5.2.

One Breaded or Grilled Pork Chop
Potato salad, fried potatoes and green salad $ 5.25.

garian Cypsy Pecsenye - Two pork steaks,
fried potatoes, rice, potato salad and lecso $ 5.60.

OPEN STYLE SANDWICHES ON RYE BREAD
POTATO SALAD

Pork $ 2.75 Hungarian Salami $2.75.

yle Frankfurters $ 2.75 . Italian Salami $ 2.75 .
raut $ 2.55 . Two Hungarian Debreciner
 with Potato Salad $ 2.55 .

ndwich

 $ 3.20.
 1.30.
 2.25.
 1.30.
 1.20.

 .75.
 1.30.

As Tourists through the Invisible

4

The locals devour their lunch
during noonhour in the Hungarian's.
The food is good and cheap.
And as they talk they replace my labor—
the weighing of local images
for beauty and for meaning—
with their own success stories.
The Hungarian opens his door
to let the fresh air in
and to invite the cigarette smoke out.
I read again the letters Rilke wrote—
he, ambitious, ignored, lonely, a fop—
If I sound out of sorts,
actually I'm exuding tolerance.
For instance, everyone is an angel.
But the last time I checked—
or the last time two socialworkers walked in
to continue a noonhour affair,
looking for a suitable booth—
there still had not been a final revelation
that would cancel history's vast indecencies.

10 POEMS BY NORM SIBUM

William Hoffer 1985

So a laborer in his working vest
finishes off his imported beer.
And Violet stuffs a *TV Guide* into her purse.
Almost no one is interested
in what exists or in what doesn't,
paying for their meals
and for the meaning of their lives
with automatically renewed permits.
Maybe Violet, who suffers from astigmatism,
has seen some light
or has heard some voice
and just prefers not to let on.
It's not a big deal—
If the Hungarian overrules
the best hunches of Pythagoras
and wins the lottery with a number
that redeems the slime of our local Nile,
he will close this place forever.
I'll have to rush to get a last word in
about the City of Heaven and Earth.

Norm Sibum, *Ten Poems* (Vancouver: William Hoffer, 1985). 145 × 231 mm (5¾″ × 9″).
DESIGN & PRESSWORK: Glenn Goluska.

The text type is Linotype Trump Mediäval, set by the designer and printed from the metal. The titles of the poems are set in another of Georg Trump's faces, known as City. The title page and the poem numbers are set by hand in wood type and printed from the wood.

Despite its name, there is nothing "medieval" about the type. It is a good Modernist face with a clear Renaissance structure, designed in Germany in the early 1950s. Like Hermann Zapf's Palatino and Aldus, and Giovanni Mardersteig's Dante, it is part of the resurgence of Renaissance values in European typography after the mass destruction of the Second World War. But of all these faces, Trump Mediäval is arguably the most masculine and brusque, and therefore the best suited to the voice in Sibum's poems.

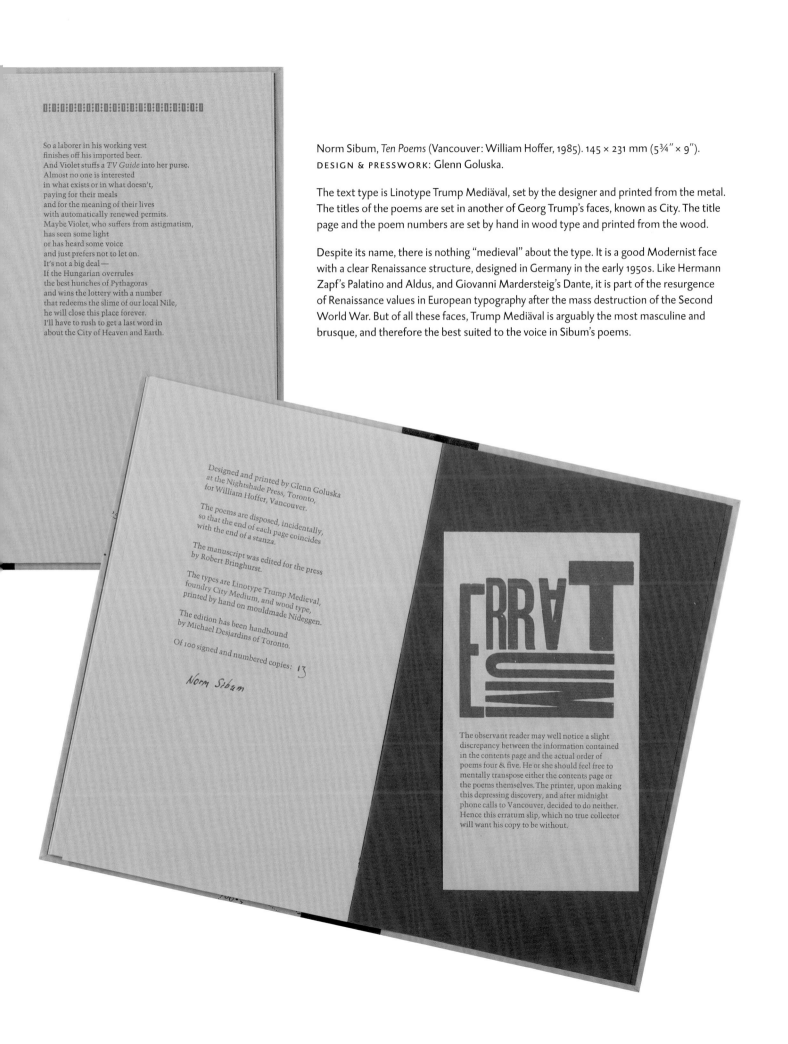

Designed and printed by Glenn Goluska
at the Nightshade Press, Toronto,
for William Hoffer, Vancouver.

The poems are disposed, incidentally,
so that the end of each page coincides
with the end of a stanza.

The manuscript was edited for the press
by Robert Bringhurst.

The types are Linotype Trump Medieval,
foundry City Medium, and wood type,
printed by hand on mouldmade Nideggen.

The edition has been handbound
by Michael Desjardins of Toronto.

Of 100 signed and numbered copies: 13

Norm Sibum

ERRATA

The observant reader may well notice a slight discrepancy between the information contained in the contents page and the actual order of poems four & five. He or she should feel free to mentally transpose either the contents page or the poems themselves. The printer, upon making this depressing discovery, and after midnight phone calls to Vancouver, decided to do neither. Hence this erratum slip, which no true collector will want his copy to be without.

Emily Kies Folpe, *Dessins d'architecture de l'avant-garde russe* / Irena
Zantovská Murray, *Publications de l'avant-garde soviétique, 1917–1935*
(Montréal: Centre Canadien d'Architecture, 1991). 200 × 235 mm
(8″ × 9¼″). DESIGN: Glenn Goluska.

Carlo Scarpa Architect

INTERVENING WITH HISTORY

NICHOLAS OLSBERG

GEORGE RANALLI

JEAN-FRANÇOIS BÉDARD

SERGIO POLANO

ALBA DI LIETO

MILDRED FRIEDMAN

PHOTOGRAPHS BY
GUIDO GUIDI

CANADIAN CENTRE FOR ARCHITECTURE · THE MONACELLI PRESS

Mildred Friedman, et al., *Carlo Scarpa Architect: Intervening with History* (Montreal: Canadian Centre for Architecture / New York: The Monacelli Press, 2001). 257 × 260 mm (10¼″ × 10½″). DESIGN: Glenn Goluska.

Man in Love · Richard Outram

The Porcupine's Quill, Inc.

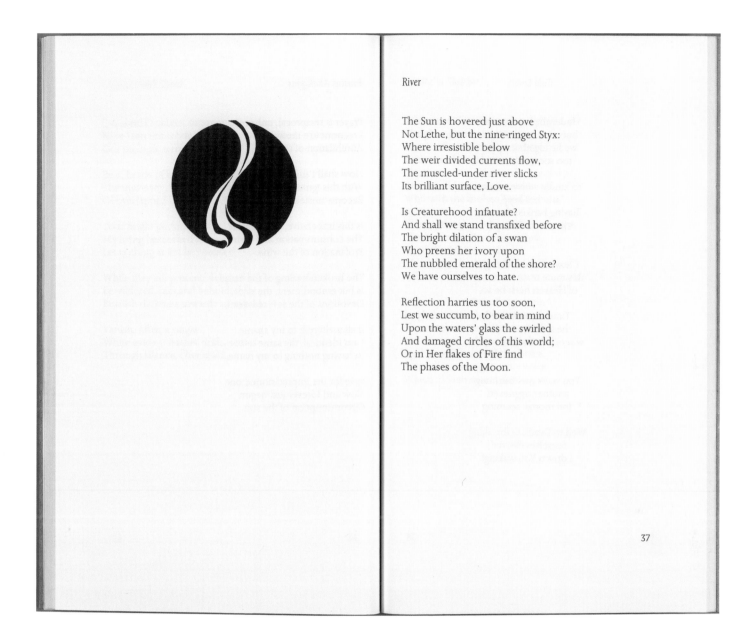

River

The Sun is hovered just above
Not Lethe, but the nine-ringed Styx:
Where irresistible below
The weir divided currents flow,
The muscled-under river slicks
Its brilliant surface, Love.

Is Creaturehood infatuate?
And shall we stand transfixed before
The bright dilation of a swan
Who preens her ivory upon
The nubbled emerald of the shore?
We have ourselves to hate.

Reflection harries us too soon,
Lest we succumb, to bear in mind
Upon the waters' glass the swirled
And damaged circles of this world;
Or in Her flakes of Fire find
The phases of the Moon.

37

Richard Outram, *Man in Love* (Erin, Ontario: Porcupine's Quill, 1985). Wood engravings by Barbara Howard. 136 × 221 mm (5½″ × 8¾″). DESIGN: Tim Inkster.

The type is Joanna, designed in Wales in 1930 by the stonecutter and lettering artist Eric Gill.

The Toronto poet Richard Outram (1930–2005) was also a letterpress typographer and printer. He and his wife, the artist Barbara Howard, printed and published many books of their own under the imprint of the Gauntlet Press. Tim Inkster's favoured instrument is the offset press, but his approach to type and printing is, like Outram's, deeply grounded in the letterpress tradition.

I. THE LOUVRE is a palace of art and, like any palace, it is ripe with intrigue, simmering with unseen passions and plots. The voluminous rooms unfold like the coded halls of a labyrinth, like the various angles a viewer can take on a work of art, like the dreams and visions that pass through the mind of the artist as he gives his journey a shape.

105

Far off, in a distance of dusty glass and stone, a thumping heart. Someone hammering. The Lady sees a shadow stretch across the floor of her room. She continues smiling. She does not hear the hammering, nor the heart of the thief pumping like an African drum. She listens intently to music, stringed music that sounds like wind in the trees behind her, like water curling over rock. The thief reaches out. Tendons in his wrist are drawn taut like strings on the neck of a violin. His hand grips a barber's razor. Four slits and the Lady collapses into his arms. Gasping, he spins about to reassure himself that no one else has entered, then kneels and rolls up the painting, fumbling with the buttons on his shirt, sticking the canvas close to his skin where no one will notice. The razor is on the floor. He picks it up, wipes the blade on his pants, drops the tool in a deep pocket and hurries away, smiling to himself.

At the doorway to the room, he turns to glance back at the empty frame. A disturbing laugh forces its way out his throat, his eyes frantic as a mad Borgia. Putting his hand over his heart, he whispers: '*Bene,*' and hears the Lady sigh.

2. August 23, 1911

A BORDELLO near Les Halles, the market area of Paris: Chloë drapes the golden serpent-like belt over the back of a chair of velvet crimson plush. In a corner, rouge poppies whisper and secrete. Aged gilt in the edges of mirrors. Frog-shaped flame in the lamp dances like a little man. Blue lines in the side of her breast splay like a spray of rhododendron. Windows yawn on black heat while lightning writes in the sky.

In a corner of the mirror, a rude card of Mary Magdalene. On the wall behind the bed, a torn red and black poster of Schéhérazade, a production of Diaghilev's Russian Ballet. Dark violet wallpaper spills flowering honeysuckle. Broken thunder. No rain.

A. mumbled from half-sleep and looked at Chloë. Beads of

Mark Frutkin, *Atmospheres Apollinaire* (Erin, Ontario: Porcupine's Quill, 1988). 146 × 222 mm (5¾″ × 8¾″). DESIGN: Tim Inkster.

The text face is Sabon, designed by Jan Tschichold in the early 1960s, based on the work of the punchcutter Claude Garamont, who worked in the heart of Paris from his youth in the 1520s until his death in 1561.

The Weight of Oranges

ANNE MICHAELS

The Coach House Press Toronto

Anne Michaels, *The Weight of Oranges*
(Toronto: Coach House, 1985).
132 × 209 mm (5¼″ × 8¼″). DESIGN:
Gordon Robertson.

The type is Hermann Zapf's Aldus, a
narrower and crisper relative of the same
designer's more ubiquitous Palatino. It was
designed in Germany in 1953.

He was not eaten. He
was fed, on condition he remain
voyeur, an audience

the mirror in which, ignorant
the intelligence of life
explored the possible

Breast warts and dirty organs
might be all the code
provided for survival

Gott im Himmel, man was made
in the dung heap. Fräulein
du bist schön

But every flower must have its root
Ah, Luther, looking for God
and the Devil – like the three

old ladies locked
in the lavatory, Maria
stood for her portrait

hour after hour, engelsüsz
in blue. Then peed, copiously
without dropping the pose

14

He was no bohemian. He dressed
well, resigned to the decorum
of established houses

It had come as a surprise
The mausoleum was the children's
theatre. Bare life

was startling, as in Manet's
Le Déjeuner sur l'herbe
unreal – as when Clothilde

parked beside her mother's chair
arms on knees and holding
the skein of wool

taut, rattled away about
her nanny's clothes, and knew
what was expos

was flesh. It wo
wound him, int
in fact a cleft

of cotton. She c
naked in his ey
in front of mot

15

D.G. Jones, *Balthazar and Other Poems* (Toronto: Coach House, 1988). 125 × 222 mm (5″ × 8¾″). DESIGN: Gordon Robertson.

The text face is Trump Mediäval, designed by Georg Trump. The sanserif on the cover is a version of Rudolf Koch's Kabel – another German face, designed in 1927.

D.G.
JONES.

BALTHAZAR

AND

OTHER

POEMS

COACH
HOUSE
PRESS

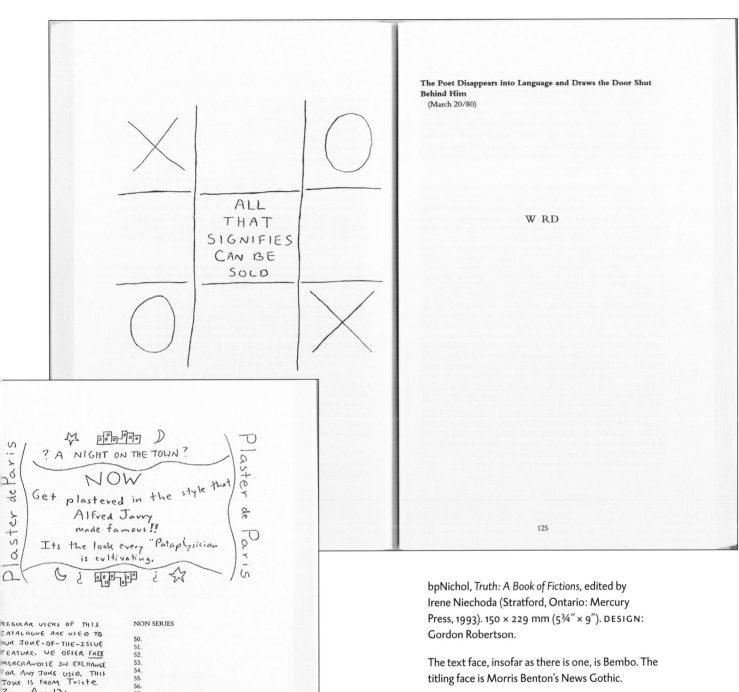

bpNichol, *Truth: A Book of Fictions,* edited by Irene Niechoda (Stratford, Ontario: Mercury Press, 1993). 150 × 229 mm (5¾" × 9"). DESIGN: Gordon Robertson.

The text face, insofar as there is one, is Bembo. The titling face is Morris Benton's News Gothic.

CLICK Intro duction

Not to mention delight laughter feminism
upon which I keep insisting

– Erin Mouré, "Human Bearing"

BRA ASHES

– Inscribed on an urn on my mother's shelf, circa 1975

Women and girls rule my world.
– Tom Jones

LYNN CROSBIE

IN RECENT MONTHS I have heard hyper-masculine men, ranging from gangster rappers to uniformed members of the World Wrestling Federation, refer to themselves and their cronies as "cliques" (pronounced "clicks"). This particular choice of word, in my mind, recalls feminism's pluralistic nature and suggests that, finally, aggressive men have come to bite off feminism for fast and frightening images of strength.

It was Gloria Steinem who used the term *click* to describe that moment of feminist self-awareness, the quick epiphany that has a private and public resonance: the click of high heels on sidewalks or tapped together in a ruby glitter; two fingers snapping; scissor blades closing; the release of a gun's safety; the flick of a light switch; a catch in the machinery; the clatter of nails on a typewriter; a lock yielding to a key.

In the late 1960s, feminists made this sound every time they flicked open a lighter to torch a bra, or pounded the pavement in protest. When I began asking women to contribute to this collection, I wasn't sure if the term still had any currency. So I began with myself, and

If you were an actress called upon to portray one of those images, you were required to live your life in accordance with the restrictions of that image – or else. There was **no tolerance** of illegitimate children, extramarital affairs, or nude layouts in men's magazines.

I did a photo layout for *Playboy* in 1963 that earned me the enmity of many in the Hollywood establishment. (It also earned me money. I had a young son to support.) Jayne Mansfield had done the same thing the year before with the identical result. This was many years, you will remember, before nude, prEGnant actresses would appear on the covers of women's magazines. (And more power to Demi Moore, believe me!)

My *Playboy* appearance subjected me to some shocking criticism. (Even today in America, the likes of Jerry Falwell and Janet Reno would propose a sort of ethnic cleansing of all who would create entertainments not blessed by them.) I was unexpectedly ostracized by people in the strangest quarters. The very men who would buy the magazine and gleefully jerk off to it would be damned if they would hire me for a role in a movie.

I envy women who are aware of the moment that they became feminists. It took a long time for feminism's revelations

MOMENTS OF LIGHT

Nawal El-Saadawi is an award-winning novelist, a psychiatrist, and an activist whose works on the situation of women in Arab society have been translated into several languages. Imprisoned in Cairo in the early 1980s for her political writing and involvement with Arab women's organizations, her name remains on an extremist group's death list. Now based in Cairo, Nawal El-Saadawi has received honorary degrees from the University of York in Britain and the University of Illinois at Chicago; she has taught at the University Center for International Studies at Duke University in Durham, North Carolina.

NAWAL
EL-SAADAWI

I WAS SEVEN YEARS OLD when the first experiences of my life began to filter through my consciousness, sometimes like the dawn emerging slowly out of the darkness, sometimes like lightning flashes illuminating the sky.

But my memory tells me that these were not the first moments of illumination in my life. The day I was born I remember opening my eyes as I slipped out into the world and seeing faces that stared at me without a smile. Like a distant dream I can see them to this day.

I did not know why my birth was not a source of happiness and joy to my mother

and father and to the other women and men in the family. But the moment came like a flash of light when I understood the reason: I was a girl, not a boy. I was crawling on the floor, not knowing then how to stand or walk or talk. I saw the eyes around me fastened on the area between my thighs and understood there was something missing, the name of which I had not learned as yet, even though I knew what it looked like. I had seen it hanging between my brother's thighs, with a thin stream of water shooting out of it. When the women spotted it, they would gleam with pride and happiness and the yoo-yoos shrilled from deep in their throats.

Such moments of understanding succeeded one another through the days and months. Every instant of light brought with it a thrust of pain that stabbed into my heart. So I learned that every moment of knowledge brings with it a moment of pain and that somehow the two are always linked.

When I reached the age of seven, my father started to teach me how to pray. My father used to pray without covering his head. My brother, who was one year older than I was, did the same. But when I began to pray, my father said, "Nawal, you must cover up your head when you pray." I asked my father why, and his answer was, "When you pray you are standing before Allah [God] and must give Him all respect." So I

to come to me. My naive trust in the system of checks and balances would take years to erode. And in the meantime, I worked while the parasites became rich.

The studios packaged femininity to match what the public wanted. What did the public want? **SEX**, of course. But, after so many years of repression, we couldn't bring ourselves to call it what it was. We created instead a symbolic language – a visual language written in flesh. The metaphor we created was called the *Sex Symbol*, a theme that has run through movies since Theda Bara.

A star emerging from one studio had a **galvanizing** effect on the others. Marilyn Monroe's light winked on at 20th Century–Fox, and the other studios, seeing her popularity expressed in box office receipts, immediately began to develop their own "answers." Each studio began searching for its own dumb blonde. As luck would have it, Universal International decided that I was theirs. I became Universal's answer to Marilyn Monroe, though I (and they) had no idea what the real question was. It was the era of Name Changing: Rock, Tony, Tab, Piper, Mamie. They obliterated your identity by taking away your name. Thus came into being the so-called

Lynn Crosbie, ed., *Click: Becoming Feminists* (Toronto: Macfarlane, Walter & Ross, 1997). 165 × 240 mm (6½″ × 9½″). DESIGN: Gordon Robertson.

This is not what most people would call a "classical" design, but it is built on a classical foundation and involves plenty of Renaissance sensibility. The principal text face, for instance, is Bembo – as classical as they come.

interior with stubble

in fields alongside the sympathetic

of open fireplaces that frame views

of crackling forest

 the smoke so named

 contains volumes that linger

a clear day of high summer overlooking

a nest

its meditative and continuous oval

a whirlpool of feather

the soft signature

the flight of each impulse a spectrum

silhouetting and heralding

 not the dawn

 but

the drawing of this

lise

 long trail of cabooses

downe

ecw press

Lise Downe, *The Soft Signature* (Toronto:
ECW Press, 1997). 140 × 215 mm
(5½″ × 8½″). DESIGN: Gordon Robertson.

The text face is Bembo; the titling face is
News Gothic.

SIX FOURS AND THEN SOME

seeing dolphins carve cattle
and repeat what they learned
until the walled monasteries illuminate impulse
wave and meadow
 • for
under the open sky everywhere is gradual
at first rarely then vivid
written toward what was brought back
flood tide tortoise
 • being
thus married the strange and outlandish find
an age smoother than inspiration
bearing that lyric expression with unseen
baited breath
 • this
strings of titles hang arbitrary by tender
installed like acres in country
gathering on the roof
proof of manifest aperture
 • tiny
imitation of another is not hard
the mirror poetries
where the wild is hard not to
believe
 • pure
safety in a colony of hermit
wooded into full roundness
the mind paints
attic tamed forgotten
 history

44

BREATHLESS

1.

 the apprentice possessed uncanny instinct for
the swearing of oaths and treaties used in a capacity of
solemn promise to carry the books (shaken with rain) on
that side of a sacred spot employing an assumption to
accommodate swift acceptance of this pious stature
whose life imitated the saint with excessive devotion
overriding the intimacy of martyrs with god who was a
friend agog in a way the hero never could have been

 acquiring gifts
to give incorporeal procession sanctifying celebration in
small goblets for even they were known to brood the
enshrinement of an object gained through a hole viewed
objectively with a variant of unity achieved by the new
elite from the annals of four crossings

an old legend tells this numinous thread to note the
twisted and about to unwind end almost hidden
from view

45

Nick Bantock, *Sabine's Notebook: In Which the Extraordinary Correspondence of Griffin and Sabine Continues* (Vancouver: Raincoast, 1992). 196 × 196 mm (7¾″ × 7¾″). DESIGN: Nick Bantock.

[*See also p 99*]

Griffin — I am still in the first flush of excitement at being here. I wish I had you to show me around, but I follow my nose and have seen many amazing things.

I think I was prepared for everything except the people. There are so many of them. I tried traveling on the underground train when they were all going to work — it was extraordinary, bodies pressed together like fish crushed in a net. After one stop I had to go above ground to feel the sky again. I saw you painting last night, a woman in mist. It brought you close to me.

Sabine

Who does the grey cat belong to? Should I feed it?

SABINE/ FEB 26

YOU WERE RIGHT— AGAIN. AS SOON AS I LEFT ITALY, MY CONFIDENCE DRAINED AWAY.
GREECE IS A PLEASANT ENOUGH COUNTRY, BUT I'M A TOTAL STRANGER. I IMAGINED BEING HEROIC AGAINST A PERFECT BLUE AND WHITE ISLAND BACKGROUND. FAT CHANCE. INSTEAD, BLACK CLOUDS ARE CIRCLING AROUND ME AND I'M GETTING SCARED AGAIN. YOUR CARD DIDN'T HELP EITHER; YOUR DESCRIPTION OF THE DARK CHURCH RANG ALL KINDS OF UNPLEASANT BELLS.
I NEED TO HOLD YOUR HAND. I'M GETTING NUMB.
IS THIS THE NIGHT BEFORE I CROSS INTO NO-MAN'S LAND?

LOVE GRIFFIN

WRITE P.O. ALEXANDRIA

SABINE STROHEM
41 YEATS AV.
LONDON NW3
ENGLAND

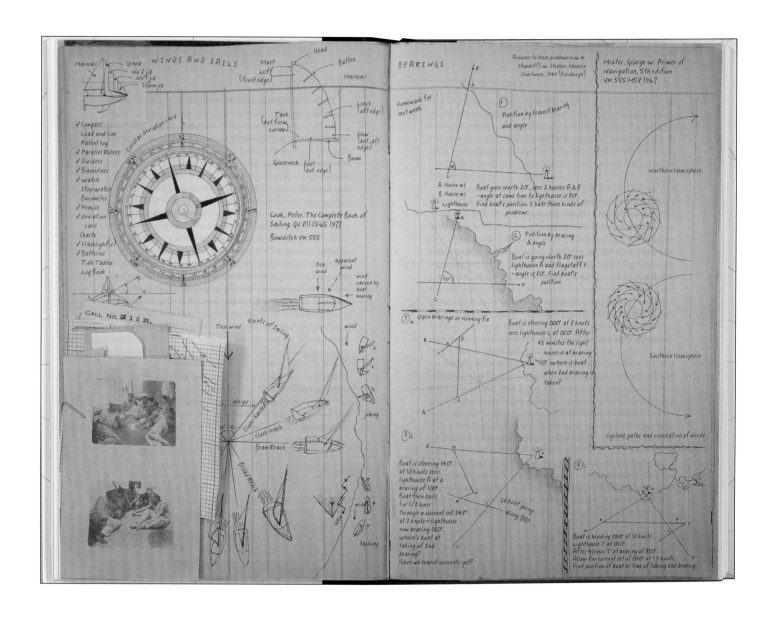

WINDS AND SAILS

Mainsail Genoa
 No 2 jib
 No 1 jib
 Storm jib

Head
Mast
Luff
(front edge)
Batten
Mainsail

Leech
(aft edge)

Tack
(bot. forw.
corner)

Clew
(bot. aft
edge)
Boom

Gooseneck Foot
 (bot. edge)

✓ Compass
 Lead and line
 Patent log
✓ Parallel Rulers
✓ Dividers
✓ Binoculars
✓ Watch
 Stop watch
 Barometer
✓ Pencils
✓ Deviation
 card
 Charts
✓ Flashlight(s)
✓ Batteries
 Tide Tables
 Log Book

Circular deviation card

Cook, Peter. The Complete Book of
Sailing. GV 811 C565 1977

Bowditch VK 555

true wind apparent wind

wind caused by boat moving

CALL No. QE 1 G 39.

True wind Points of Sailing

No go

Close-hauled

Close reach

Beam Reach

Broad Reach

wind

jibing

wind

tacking

BEARINGS

Homework for next week

Answers to these problems in W.
Stewart/J.W. Stephen, Modern
Chartwork, 1945 (Edinburgh)

Mixter, George W. Primer of
Navigation, 5th edition
VK 555 M58 1967

① Position by transit bearing and angle

A House #1
B House #1
⌂ Lighthouse

Boat goes North 20°, sees 2 houses A & B
—angle at same time to lighthouse is 80°.
Find boat's position. I hate these kinds of
problems.

② Position by bearing & angle

Boat is going North 20° sees
lighthouse A and flagstaff F.
—angle is 80°. Find boat's
position

③a Open bearings or running fix

Boat is steering 000° at 8 knots
sees lighthouse L at 050°. After
45 minutes the light
house is at bearing
110°. where is boat
when 2nd bearing is
taken?

③b

Boat is steering 140°
at 10 knots sees
lighthouse A at a
bearing of 100°.
Boat then sails
for 1/2 hour
through a current set 248°
at 2 knots—lighthouse
now bearing 080°.
where's boat at
taking of 2nd
bearing?
Have we learnt currents yet?

Is boat going
along B/A?

③c

Boat is heading 080° at 12 knots.
Lighthouse T at 050°.
After 40 min. T at bearing of 330°.
Allow for current set of 060° at 1.5 knots.
Find position of boat at time of taking 2nd bearing.

Northern Hemisphere

Southern Hemisphere

Cyclone paths and circulation of winds

the hell I'm talking about. But that's them! The Aurora Islands. See my sketch; it'll show you everything you need to know. The story of how they got found and then lost is too long to include here, except to say that nobody thinks about them any-more, and I'm going to put them back on the map.

My plan is to go there and rediscover them and then write a book about my adventure. I'm not going to do a Heyerdahl and recreate an ancient voyage; I'm just going to rent a regular boat and make my way there as efficiently as possible. While I'm en route, and once I find the islands, I'll painstakingly document the geology and climate, the flora and fauna; perhaps I'll even discover a never-before seen species or two!

So, here I am, unashamedly asking you to consider my proposal. I'm confident that if anybody can do this and write about it in a reputable and convincing way, it's me. However, the whole expedition, if I may call it that, depends on money. Isn't it always the same old sad story? I'm really hoping that you'll get as fired up as I am. I'll call in a few days and--if I can get through to you--pitch the idea some more. Looking forward to catching up,

Hippolyte

Hippolyte

Airfare $2000
Chile entry tax $50
YVR tax $10
Maps $120
accom. 30 × 10 $300
food: $20/day $200
Subtotal $3820

Equipment $2000?
boat? $$$$$
Gas, boat fees $1000?

Anyway, you can see it's going to take lots of dough.
I can get you a detailed list if you want

45°W
Me
You
50°W
0°
The Auroras
00 50°

Three

Jeremy let the letter slip out of his hands as he sat back in his chair. He nodded his head to an unseen tune as a slow, contented smile broke across his face. What a good idea. One man against the elements. Damned good idea. Lost islands somewhere in the harsh and lonely South Atlantic. Why not take it on? His smile widened.

At Rumor for two years, he'd become accustomed to feeling sorry for himself; no one seemed to appreciate his style. His proposals baffled the editors and positively frightened sales and marketing, creating a situation where, in order to get a book through, he had to exercise his prerogative as publisher. This lack of compatibility got him thinking about why he'd been hired in the first place. When he was in the process of being headhunted—a process so heathenly cannibalistic that it was a shock to him that anyone dared to openly acknowledge the word *headhunt*—the hiring company made a big deal of his exquisitely trimmed beard, his unpeggable Canadian accent, his bilingualism. "They want someone who looks and sounds good," they told him, "foreign-like." But not too foreign, of course. And he was young, too. Only thirty-four when he was hired, he was younger than any senior staffer at Rumor. He had jumped into the work with blind enthusiasm, dreaming of capitalizing on his maverick status, but in truth no one took him seriously. At best, they allotted him the same concessions they'd give a nephew of the boss; at worst, they treated him like a company mascot.

Before coming to Rumor, he had always thought it a natural pro-gression for an editor—like him—to become a publisher. Though no one seemed to appreciate it, he had a firm handle on the book business,

31

Barbara Hodgson, *Hippolyte's Island* (Vancouver: Raincoast, 2001). 145 × 228 mm (5¾″ × 9″).
DESIGN: Barbara Hodgson.

The text face is Bembo.

[*See also pp 99, 104–5, 128–31*]

114

Left: The double allée of trees on the streets bordering Robson Square. ALAN BELL.

Right: Street planting shades a skylight into the lower floor of the government offices at Robson Square. The rose-planted brow above also shades the skylight behind. "Flying planters" are a main architectural element for the government offices and Law Courts. ·DICK BUSHER

whole downtown but first of all insisted that twin allées be used to define the new government precinct. Managing to get them in place over the objections of the city engineer was the kind of vivid experience that made me think the Americans were right in their suspicions of city hall. However, in the end we compromised — the engineer rejected our choice of the plane tree but accepted the double planting arrangement. The trees remain my favourite design contribution to the city's streets.

Finally, our report proposed density, heights and massing for the blocks around Robson Square. The low-rise profiles of the courthouse Law Courts, and provincial office buildings connected to each other over and under the existing cross streets, as well as to the courthouse. The law would be at one end, government in the centre block, and the Vancouver Art Gallery in the old neoclassical courthouse building at the opposite end. Law, government and art would each benefit from proximity with the other, sharing a public image, public patronage and their own employees' interactions.

The historic courthouse was inviolate and the new courthouse had intricate space and heavy security requirements, so the only possibility for a focal public space was the central block assigned to government offices. If the centre block's main floor could be set one storey below grade, relieved by a series of skylit courts, we could develop Vancouver's civic square on its roof. By playing with the traffic alignment, closing one street and bridging another, pedestrians would be welcome to circulate all through the city's new heart.

We spent months analyzing the government's departmental layouts to produce a multilevel structural configuration that could support a public garden on its roof. We used water in a bold way. The top level of the government office segment carries a three-hundred-foot-long flowing pool that begins

115

Top: The "stramps" leading from the sunken plaza of Robson Square to the Law Courts are an integration of ramps with stairs that allows disabled people to enter by the "front door" instead of the "back door." Lights are set into the interrupted steps. EZRA STOLLER/ESTO

Bottom: The sunken plaza of Robson Square includes a canopied ice-skating rink. In summer the plaza is animated by outdoor restaurants and performances. ALAN BELL

Arthur Erickson, *The Architecture of Arthur Erickson* (Vancouver: Douglas & McIntyre, 1988). 265 × 267 mm (10½″ × 10½″). DESIGN: Barbara Hodgson.

The text type is Egyptian 505, designed by André Gürtler and colleagues in Basel in 1966. The titling face is Futura, designed in Munich and Frankfurt in the 1920s by Paul Renner.

[*Another spread from this book is shown overleaf.*]

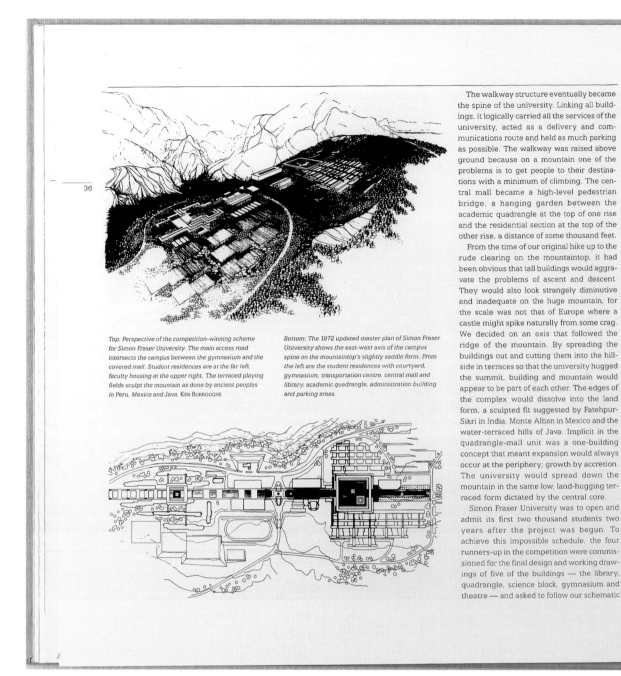

The walkway structure eventually became the spine of the university. Linking all buildings, it logically carried all the services of the university, acted as a delivery and communications route and held as much parking as possible. The walkway was raised above ground because on a mountain one of the problems is to get people to their destinations with a minimum of climbing. The central mall became a high-level pedestrian bridge, a hanging garden between the academic quadrangle at the top of one rise and the residential section at the top of the other rise, a distance of some thousand feet.

From the time of our original hike up to the rude clearing on the mountaintop, it had been obvious that tall buildings would aggravate the problems of ascent and descent. They would also look strangely diminutive and inadequate on the huge mountain, for the scale was not that of Europe where a castle might spike naturally from some crag. We decided on an axis that followed the ridge of the mountain. By spreading the buildings out and cutting them into the hillside in terraces so that the university hugged the summit, building and mountain would appear to be part of each other. The edges of the complex would dissolve into the land form, a sculpted fit suggested by Fatehpur-Sikri in India, Monte Alban in Mexico and the water-terraced hills of Java. Implicit in the quadrangle-mall unit was a one-building concept that meant expansion would always occur at the periphery; growth by accretion. The university would spread down the mountain in the same low, land-hugging terraced form dictated by the central core.

Simon Fraser University was to open and admit its first two thousand students two years after the project was begun. To achieve this impossible schedule, the four runners-up in the competition were commissioned for the final design and working drawings of five of the buildings — the library, quadrangle, science block, gymnasium and theatre — and asked to follow our schematic

Top: Perspective of the competition-winning scheme for Simon Fraser University. The main access road intersects the campus between the gymnasium and the covered mall. Student residences are at the far left, faculty housing at the upper right. The terraced playing fields sculpt the mountain as done by ancient peoples in Peru, Mexico and Java. KEN BURROUGHS

Bottom: The 1972 updated master plan of Simon Fraser University shows the east-west axis of the campus spine on the mountaintop's slightly saddle form. From the left are the student residences with courtyard, gymnasium, transportation centre, central mall and library, academic quadrangle, administration building and parking areas.

Arthur Erickson, *The Architecture of Arthur Erickson* (Vancouver: Douglas & McIntyre, 1988).
265 × 267 mm (10½″ × 10½″).
DESIGN: Barbara Hodgson.

drawings and work under our supervision. In addition to our fellow architects, there were five contractors stumbling over one another on the site. So Geoff and I, the two house designers, plunged ahead through a couple of chaotic years. We chose to develop in full detail the building that tied them all together, the central mall. Our focal point was a huge glass roof a block long over the central mall. The roof was engineered by Jeffrey Lindsay, a disciple of Buckminster Fuller, and it met much skepticism. But Lindsay was not only a brilliant visionary, he was a meticulous engineer. In 1968, as a result of a freakishly heavy snowfall that brought down structures all over the city, several hundred panels of glass broke, and in the ensuing publicity he received much of the blame. Insurance companies and lawyers sorted it out, so Lindsay was never vindicated in court. In fact, Lindsay had nothing to do with the substitution of cheaper, inferior glass for the type he had specified. The repaired span sheltering the hub of university life stands as his finest achievement.

One of the major drawbacks of the university was its distance from the city. To overcome this, though not requested in the master plan, we advocated providing for a large built-in residential population and proposed to locate a new town centre on the very edge of the campus. When this plan was rejected, our later master plan opened the possibility of five thousand to ten thousand students living in as a necessary step to lessen the university's rarified isolation. Unlike mediaeval Arabic and many European universities tucked in the fertilizing currents of city life, the ordinary university allows escapism to flourish within its almost industrial precincts. Simon Fraser is purposely an urban complex. At Simon Fraser, students and teachers daily encounter the whole community. This intensity of involvement is the basis of culture. Simon Fraser proved it by attaining a high academic standard within a few years of its inauguration.

In the late 1960s the architecture of Simon Fraser was blamed for student unrest because the design turned the student body inward and made them socially conscious. What the critics did not see was that the architecture also helped solve the political friction and for the same reason: no one could escape the social responsibility of coming to terms with adversaries in so compact an environment. During the years of student unrest, no damage was ever done at Simon Fraser. In fact, the students showed an uncharacteristic sensitivity and became guardians of the university architecture. They campaigned against an unsightly gas station and against temporary buildings where trees should have been. In the spirit of the time, we all joined together in a poppy planting rite one golden spring dusk, as part of an effort to save the grass meadows surrounding the campus from being chopped to stubble.

Top: A view of the steps from Simon Fraser's transportation centre, a dropoff point to the mall for buses and visitors' cars. The domed skylight over a steady progression of stairs draws people upward.
JOHN FULKER

Bottom: Two sections of the university, the first a transverse section through the academic quadrangle, laboratories and classrooms — natural and physical sciences are on the right, humanities and social sciences teaching areas are on the left. The second is a longitudinal section through the central spine, from the transportation centre on the left to the academic quadrangle on the right.

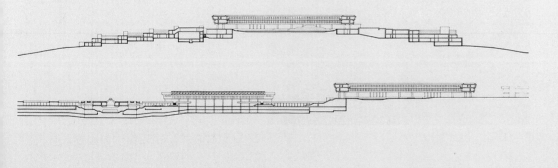

I

In a house with such a blue
roof, she said *with red*
hair, you'd wake up cheerful
every morning.

To the talking mirror
of water. To the broken panes
of water laid in the earth like leaded glass.

To the empty cup containing
everything,
to warm it with the tea.

To hold in the hands like a cup of tea,
always full and always empty,
the earthy asymmetry of the world.

To the rich, disordered earth,
to the sound of mountain water,
to the boundless
truth of the ground.

To the world with its welcome
imperfections.
Violence hides in fastidious order.

To the polished lacquer
platter where the drunken

The Blue Roofs of Japan

A Score for Interpenetrating Voices

Robert Bringhurst

日本の青い屋根

Barbarian Press 1986

In a house with
such a blue roof
 you'd wake up cheerful
every morning,

to the talking mirror
 of water,
 to the talking mirror
of water,

 to the
cup containing
 everything, the hands

always empty, always full,

to the order of the earth,

to the boundless —
not infinite, boundless —
truth of the ground.
 Violence hides
under the lid of fastidious order.

Robert Bringhurst, *The Blue Roofs of Japan* (Mission, B.C.: Barbarian Press, 1986). Calligraphy by Yim Tse (謝琰); presswork by Jan Elsted. 190 × 280 mm (7½″ × 11″). DESIGN: Crispin Elsted.

The type is Spectrum, designed in the Netherlands in the early 1940s by Jan van Krimpen. It is handset and printed from the metal.

This is a poem for two voices, one male, one female. On each recto page, the male voice is printed in blue over the female voice, which is printed blind (that is, with no ink). On the facing page, the same text is repeated with the female voice in blue and the male voice blind. Such a technique is, of course, only possible in letterpress, where the type can be legible even if no ink is used.

PROGRAM NOTES

In the spring of 1985, the novelist Audrey Thomas and I made a two-week reading & lecture tour of Japan. This piece began to fashion itself in my mind while we were still in that country, and I hoped from the beginning that it might, among other things, serve in the end as a gift for Audrey — a commemoration of some of our strangely dislocated conversations, and of some of the pleasures and strains of the tour. This is so notwithstanding the poem's assertion (with which I agree, if that matters) that any work's first audience is the gods. If that priority is clear, perhaps the work is free, like rice, to function also on a human plane.

I am relieved, however, to find that very little of the anecdotal has found its way into the text, and I can think of no more anecdotes which would make it easier to understand.

The *shakuhachi* is an endblown bamboo flute. *Karamatsu*, though the name means 'Chinese pine,' is the Japanese larch, *Larix leptolepis*, and *sugi* is the Japanese redwood, *Cryptomeria japonica*. A *roshi* is a Zen priest; the title means simply 'old teacher.' *O say can you see* is, if I am not mistaken, a phrase from *The Star-Spangled Banner*.

R.B.

日本の青い屋根

Rosemary Kilbourn, *Opening Out* (1992)

END GRAIN

*Contemporary Wood Engraving
in North America*

Introductory Essays by Patricia Ainslie & Paul Ritscher

BARBARIAN PRESS
1994

End Grain: Contemporary Wood Engraving in North America, with introductory essays by Patricia Ainslie & Paul Ritscher (Mission, B.C.: Barbarian Press, 1994). Presswork by Jan Elsted. 191 × 261 mm (7½″ × 10¼″). DESIGN: Crispin Elsted.

The text face is Eric Gill's Joanna. The titling face is Bembo. The engravings – 125 of them, by forty-nine Canadian engravers and seventy-two engravers from the USA – are printed from the wood; the type is printed from the metal.

of the others, the fish or the tinkers. Ye are always wanting to leave
the sharks alone when they come to tear our nets and where would
we get the money for another? and ye will defend a tinker who is
known in these parts for his crafty ways. Have ye not allegiance
with the honest folk?

— What do you think?

— I do not know anymore.

— Well, until I came to Inishbream, I was very like the tinkers,
wasn't I?

 ✛ ✛ ✛

*Brigid of the miracles, I cannot compete with the wind in a wild man's heart,
and I ask to be forgiven, to be allowed to cast my lot to the stone soul of this island.
Child, I will teach you the sign of the blessing, the sign of all devotion.*

 ✛ ✛ ✛

Sean visited the crone, telling of a distance. She said: Take the
stone which the English call lodestone. Ye will know it by its sad
blue colour. Lay this stone under the head of thy wife and if she
be chaste, she will embrace her husband.

I did not see the tinkers leave, uprooting the bright blossoming
of their residence and leaving the hills barren as before their
coming.

Sometimes I dream of a garden behind a broken hedge, I dream
of caravans, all the beauty of the long road before them.

And I did embrace.

50

Death comes on a gale from the west, sly at
first, then pummelling down on the house of the ailing. Or,
unloosed at sea, turns currachs mouthdown in the water and
the fishermen sink with their emptied lungs.

— Can you swim?

— We cannot. If the sea wants ye, she will have ye, and it is better
to go easy so.

The cemetery is locked against casual entry, walled in stone and
gated with a rusted bed-frame, four great boulders preventing its
fall to an interested cow or God knows what. Crosses, water-
marked & sprouting an assortment of lichens, indicate the ancestors,
the mounds themselves indistinguishable under cowslips or sea-
thrift.

— When was the last burial?

— Wasn't it only last year when the child of Mairtin died of the
fever. That'll be the little cross ye may see there (pointing). And
the drowned three of four years back and I think meself that the
fourth one who never washed up ought to be given a cross too.
Didn't we keen for him, same as the other lads, and didn't we board
up his house? Ah, tis a shame and that's the truth that he was
never given a deal box and put to earth.

— And no one ever found anything of him?

— Not even his jumper or at least one wellington and didn't yer
man on the Arans write a play that said, as we say, that ye can tell
who a drowned man is by the pattern of his woman on the gansey
and wouldn't we know if he ever washed up? There are the
telephones now. Ye cannot keep things quiet in this ould county.
And there are the suicides of which ye must not talk. They are
buried where the two boreens cross; tis the place of no arrival.

Death comes on a gale from the west, leaving a carnage of
birds, seals, the trapped fish in the loosened nets.

— What do you suppose that mound is? (pointing out the door

51

believed to be a protection. Your bed was clammy and smelled of mildew. There was no fishing. The days you spent listening to weather reports on the wireless, hoping for a reprieve, & drinking tea from a pot you would not allow to be empty. Or else you tried to untangle the cat's cradle your knitting had become, your numb fingers twisting at the knots and counting the stitches, only to discover the knots were permanent and most of the stitches had fallen. You tried to read the library books you'd choose the one day in a fortnight that boats would venture to the mainland and you wept at the descriptions of an island the October ferry was sailing to, the driftwood of its shores bleached and huge as dinosaur bones and which you knew well. The newspapers promised nothing but cut-backs and strikes and colder temperatures than had ever been known. You made soup. What else could you do? But you could barely stand to use potatoes which had begun to sprout or the carrots which had gone tasteless in their box. And the redeeming summer nettles had been trimmed to the roots or else were rotten with rain. So everything you made was flavoured strongly by onions and the secrecy of herbs you kept in a dark cupboard, reminding you of an earlier island where you had lived on a hill of wild rosemary and sage, their blossoms bright and pungent even in the depths of December. And there was never enough turf to make a really hot fire and you had to ration it, never knowing from one day to the next whether you could go to the mainland for another load.

You wondered about the tinker, imagined him in the swarthy light of a winter caravan, maybe playing a tin-whistle to the melancholy night. And the man you thought you knew became more silent in winter and he joined the other men in a kitchen you were not invited to, nor were any other women. You knew they warmed themselves with poteen. You could smell it when he returned. But what they talked of, or knew in their collective silence, God only kept to Himself.

You despaired at the sight of the other women knitting their jerseys and mittens and caps, unfolding them like magic from the chanting needles. You did not have a child to scold or to wrap in your arms. The elderly dog slept. The calves, moved to a far field, ..e and red-eyed and one dead, munched the mouldy hay

you trundled to them & no longer welcomed your fingers.

You sat damply in a chair pulled as close to the tiny mound of smouldery turf as you dared, you thought of the rest of the winters of your life spent like this in the bitter cold, your fingers arthritic before their time and your nose sniffly, and you knew you could not bear it.

 ✢ ✢ ✢

I gave my own names to things that winter. The seals had all fled Carrickarona and there were only ever a few scraggy sea birds who happened to land on their way somewhere else: *I name thee the Rocks of Desolation.*

Or, the cliffs of Ardmore with their echoes of a house I had known in a milder winter on Vancouver Island, & now stony-faced, no gentle covering of heather or pale thrift: *I name thee the Cliffs of Peril.*

And the man whom I had taken as a lover, as a husband: *I name thee Stranger.*

They were long months made longer by the refusal of spring. Festy's cow, deceived by one warmish day, calved on the next, and when they found the calf, it was opaque with frost and quite dead. The children shed coats that same day and were bronchial for months.

67

Theresa Kishkan, *Inishbream* (Mission, B.C.: Barbarian Press, 1999). Wood engravings by John DePol; presswork by Jan Elsted. 152 × 267 mm (6″ × 10½″). DESIGN: Crispin Elsted.

The type is Eric Gill's Joanna. The engravings are printed from the wood, the type from the metal.

Jan Zwicky, *Twenty-One Small Songs* (Mission, B.C.: Barbarian Press, 2000). Presswork by Jan Elsted. 103 × 180 mm (4″ × 7″). DESIGN: Crispin Elsted.

BELOW: The closed book resting in its open box.

The type is Monotype Van Dijck, printed from the metal. These are Baroque letterforms, closely based on fonts cut by Christoffel van Dijck in Amsterdam. Van Dijck's contemporaries include Henry Purcell, whose spirit might be present in these songs.

18. NIGHT SONG

The sky turns its dark head
and the breezes fold themselves among the leaves.
Who is left?
The last thrush-song has soaked into the earth.

A little stream is here
unsleeping, and the small panes
of the window; foxes' toes,
the plump seed in its jacket, and the world

that glides away, full of fish and stars;
and us, in our night nests,
round as birds,
and the unlocked door.

21 SMALL SONGS

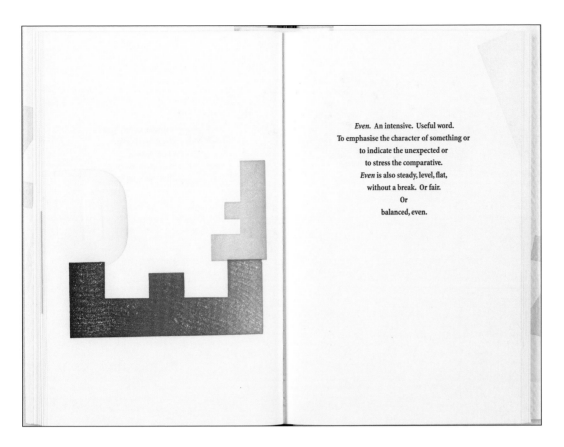

Even. An intensive. Useful word.
To emphasise the character of something or
to indicate the unexpected or
to stress the comparative.
Even is also steady, level, flat,
without a break. Or fair.
Or
balanced, even.

P.K. Page, *Alphabetical Cosmologies*. 2 vols. (Victoria, B.C.: Poppy Press, 2000). 130 × 205 mm (5″ × 8″).
DESIGN & PRESSWORK: Alexander Lavdovsky.

The text face is Robert Slimbach's Minion bold condensed – a digital face. The type was set on a computer and printed letterpress from polymer plates.

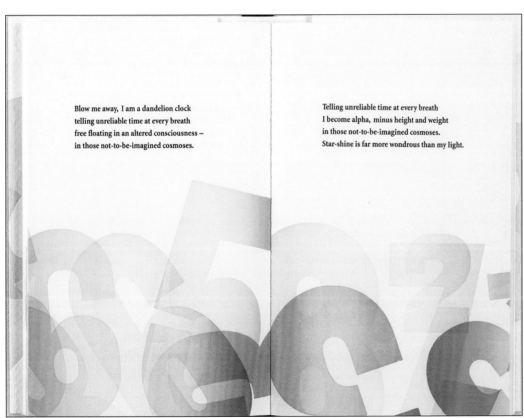

Blow me away, I am a dandelion clock
telling unreliable time at every breath
free floating in an altered consciousness –
in those not-to-be-imagined cosmoses.

Telling unreliable time at every breath
I become alpha, minus height and weight
in those not-to-be-imagined cosmoses.
Star-shine is far more wondrous than my light.

17

Stehpal	msiw	siwaci•y•ukuhtit	eli	wapoli	pom•aw•sihtit.
Seemingly	all	tired of•make•it-them	thus	badly	along•live•they.
Seemingly	**all**	**it made them tired**[41]	**how**	**badly**	**they lived.**
particle	*particle*	*verb, ta, conjunct, 0-33*	*preverb*	*preverb*	*verb, ai, conj, dual 33*

18

Yukt	kci	sakom•ak	'•tiy•aniya	kotok•ihi,
These	great	chief•plural	they•say to•they	other•plural,
These	**great**	**chiefs**	**say to**	**the others,**
pronoun, a, pl	*prenoun*	*noun, a, plural*	*verb, ta, relative, 33-44*	*pronoun, a, obviative pl*

"Yut	el•ap•imok	asit	weckuh•uhs•ihiq,
"Here	thus•look•-ing	back	toward here•walk•you and we,
"Here	**as one looks/in looking**	**back**	**where we have walked this way,**
particle	*verb, ai, conj, indef subj*	*particle*	*verb, ai, conjunct, dual 12*

k•nomiht•unen	eli	pokahkon•apt•uwoq.
you•see•we	thus	bloody•leave tracks•you and we.
we see it	**how**	**we have left bloody tracks.**
verb, ti, indic, pl 12-0	*preverb*	*verb, ai, conjunct, dual 12*

19

K•nomihtun•ennu•l	kehs•ok	ewapoli•k•k•il.
You•see•we•them (inan)	be many•it	badly•look (in form/appearance)•it•plural.
We see	**many**	**wrongs.**
verb, ti, indicative, pl 12-00	*verb, ii, conj, sg*	*verb, ii, conjunct, plural participle*

20

Yuhtol	pekahkon•ik•il	tom•hikon•ossis•ol	olu,
These	bloody•it•plural	apart•tool•small•plural	however,
These	**bloody**	**hatchets**	**however,**
pronoun, i, pl	*verb, ii, conjunct participle, plural*	*noun, i, plural*	*particle*

naka	tap•ihik,	pahq•ihil,	cuwi	puskon•as•uwol	askomiw."
and	bow•plural,	arrow•plural,	must	bury (ti)•passive•plural	forever."
and	**bows,**	**arrows,**	**must**	**be buried**	**forever."**
particle	*noun, a, pl*	*noun, i, pl*	*preverb*	*vb, ii (ti pas've), indic, pl*	*particle*

21

Nit	te	msiw	't•oli	kis•olutom•oniya
Then	emph	all	they•thus	past•discuss (it)•they
Then	**...**	**all**	**decided to**	
particles (nit, te, msiw)			*preverb*	*verb, ai+object, indic (or rel), du (pl) 33-0*

't•olaku•t•iniya.
they•be related by kinship•one another•they.
join one another in a confederacy.
verb, ai (ta reciprocal), relative, dual 33

22

Nit	't•ahkinuwi	punom•oniya	kisq	etuci	putuwos•ihtit.
Then	they•particular	put•they	day	at the time that	meet in council•they.
Then	**they set a particular**		**date**	**when**	**they'd meet in council.**
part.	*preverb*	*vb, ti, indic, pl 33 -0*	*noun, i*	*preverb*	*verb, ai, conjunct, dual 33*

[41]That is, "they were tired of it."

23 **Qoni** **cik•op•ult•uwok** **ote** **oluwikon•ok** **kehs•ukon•iw.**
For as long as silently•sit•≥3•they emph pointer [finger]•loc many•day (measured)•(part.)
For a period **they sat silently** ... **seven** **days.**
preverb *verb, ai, indicative, pl 33* *part.* *particle* *particle*

24 **Ehtahsi•kisk•ahk•il,** **katama** **wen** **kolus•iw.**
recurring•day•it•plural, not someone speak•he/she (negative).
On every day, no one **spoke.**
verb, ii, conj participle, pl *particle* *pronoun, a, sg* *verb, ai, indicative, singular (negative)*

25 **Nit** **liwiht•as•u** **"Cik•t•e** **Wikuwam."**
That name (ti)•passive•it "silent•(state)•it house."
That **was called** **"It is silent** **the house."**
pron, i, sg *vb, ii (ti passive), indic, sg* *verb, ii, indic, sg* *noun, i, singular*

26 **Msi** **te** **putuwos•uwin** **cuwi** **tpi•tahas•u** **tan** **oc**
All emph meet in council (ai)•doer must attentively•think•he/she how future
Every **...** **councillor** **had to** **think about** **what** **...**
part. *part.* *noun, a, singular* *preverb* *verb, ai, indic, sing 3* *part.* *part.*

 keti **it•ok** **tan** **etuci** **liht•uhtit** **tpask•uwakon•ol.**
 going to say•he/she how at the time that make•they measure•(noun)•plural.
 he was going to say **when** **they made** **the laws.**
 preverb *vb, ai, conj,* *part.* *preverb* *verb, ti, conj,* *noun, i, plural*
 singular 3 *pl 33-00*

27 **Msi** **te** **'•topi•tahatom•oniya** **tan** **oc**
All emph they•attentively•think about•they how future
All ... **...** **thought about** **how** **(after that)**
part. *part.* *verb, ti, indicative, plural 33-0* *part.* *part.*

 li **kisi** **con•eht•as•u** **maton•ot•imok.**
 thus be able to stop•do to (ti)•passive•it fight•one another•-ing.
 it could be stopped **the fighting.**
 preverb *preverb* *verb, ii (ti passive), indic, sg* *verb, ai (ta reciprocal), conj, indef subj*

28 **Apc** **etuci** **apq•otehm•uhtit** **wikuwam.**
Next at the time that open•by striking•they house.
Then **it was that** **they opened up** **the house.**
particle *preverb* *verb, ti, conjunct, pl 33-0* *noun, i, singular*

29 **Liwiht•as•u** **toke•c** **"Msi Tahk** **Wen** **Tolewestu."**
name (ti)•passive•it now•future "All emph someone is...ing•talk•he/she."
It was called **now** **"Every-...** **-one** **Speaks."**
vb, ii (ti passive), sing *particle* *part.* *part.* *pron, a, sg* *verb, ai, indicative, sing 3*

30 **Nit** **na** **qoniw** **mace** **putuwos•iniya.**
Then also during [a time] begin to meet in council•they.
Also during that time **they began** **to meet in council.**
part. *part.* *part.* *preverb* *verb, ai, relative, dual 33*

Lewis Mitchell. *Wapapi akonutomakonol: The Wampum Records: Wabanaki Traditional Laws*, edited with a translation by Robert M. Leavitt & David A. Francis. (Fredericton: Micmac-Maliseet Institute, University of New Brunswick, 1990). 215 × 280 mm (8½" × 11"). Designer unnamed.

The language of these texts is known in English by several different names, including Maliseet, Passamaquoddy, Wabanaki, and Wolastoqiyik. It is an Algonquian language (a sister, therefore, of Cree and Ojibwa), spoken in southern New Brunswick and northern Maine. Lewis Mitchell, or Oluwisu, who died in 1931, was a fluent writer as well as speaker of Maliseet.

The large bullets in the midst of the Maliseet words have nothing to do with pronunciation. They mark the boundaries between morphemes. The meaning of each word is analyzed morpheme by morpheme in the English gloss immediately below.

The type is Hermann Zapf's Palatino.

Maude Kegg, *Portage Lake: Memories of an Ojibwe Childhood,* edited and transcribed by John D. Nichols (Edmonton: University of Alberta Press, 1991). 151 × 228 mm (6″ × 9″). DESIGN: Joanne Poon.

It was formerly the custom in Canadian Ojibwa to mark long vowels with a circumflex (still the usual practice in Cree), but the more common practice now in Ojibwa is to write the long vowels double: *aa, ii, oo* instead of *â, î, ô.* (In most dialects of Ojibwa, *e* is always long and can thus be freely written as if it were short.)

The question of what type to choose for setting a Native Canadian text can lead to endless and fruitless discussion. Ojibwa has its own syllabic script, but not all Ojibwa speakers can read it. Even if syllabics were used for the Ojibwa, there is still the question of how to set the English translation. Since the Latin alphabet is a colonial importation, even a Latin type designed in Canada is not indigenous in the sense that Native Canadian languages are. The answer often seems to be: There is no perfect match, but any type will do if it shows respect for the text and the speaker, and lends them an appropriate measure of dignity and formality. The type in this case is Matthew Carter's Galliard, based on the work of the 16th-century French punchcutter Robert Granjon.

[14] "Oo, yay," indinaa. "Awegwen naa a'aw," indinaa.

[15] "Awegwen iidog," ikido. "Gaawiin ingikenimaasiin," ikido.

[16] Miish a'aw, miish i'iw gii-maadaajimotawid. "Gaawiin awiiya iwidi daa-daasiin imaa wanako̲-neyaashi. Gii-taawag iko iwidi anishinaabeg, ingodogamig. Bezhig iwidi inini gii-taa, gaa-izhi-nibod. Mii miinawaa gaa-izhi-adaawangewaad oshk'-aya'aag, mii i'iw waakaa'igan, miinawaa iniw oniijaanisan imaa gaa-izhi-nibonid. Miinawaa imaa aabiding akiwenzii gii-adaawanged miinawaa mindimooyenh. Mii miinawaa a'aw akiwenzii gaa-izhi-nibod. Gii-ishpatenig, gaawiin, gaawiin ogii-kashki'aasiin ji-izhiwinaad aakoziiwigamigong iniw odakiwenziiyiman, imaa. Gii-mamaajide'eshkaawan, miish gaa-izhi-nibonid igaye. Ingoding-sh gaa-izhi-zakideg i'iw waakaa'igan."

[17] Miish i'iw ekidod, "Mii go naa gaye mikwendamaan," ikido, "imaa eshkwesing i'iw waakaa'igan," ikido, "mii imaa ezhi-goziwaad, ajina go imaa aano-ayaa awiiya," ikido, "mii ezhi-goziwaad," ikido. "Ayamanisowag giiwenh imaa," ikido. Mii ekidod a'aw ikwe.[4] "Gaawiin imaa awiiya daa-ayaasiin. Miish igo noongom ezhi-bizhishigwaag i'iw waakaa'igan, oshki-waakaa'igan-sh igaye i'iw, gotamowaad imaa wii-ayaawaad. Amanj iidog ezhiwebak. Awiiya iidog ayaa."

[18] Miish imaa ingoding, ingoding, ingii-mawadisaa imaa niinimoshenh a'aw. Ayaangodinong inga-ani-mawidisaa niinimoshenh.[5] Amanj iidog igo aabiding igo ingii-kagwejimaag ingiw, dibishkoo go gegoo gekendang, ingii-o-gagwejimaa aaniin sa go, amanj iidog gaa-izhiwebiziwaangen. "Giga-wiindamoon naagaj," indig. "Azhigwa-sh wiin igo giwiindamoon," ikido, "asemaa, azhigwa ani-ziigwang, asemaa imaa bagidin," ikido. "Jiigaatig imaa o-ningwakamigin asemaa," ikido. "Enda-ginoozi a'aw, maagizhaa gaye maji-aya'aawish," ekidogwen. "Enda-ginoozi," ikido. "Mii bebaa-izhi-naanaazikang iniw waakaa'iganan. Mii imaa akeyaa endaayeg ezhaad," ikido.

[14] "Oh, my," I told her. "I don't know who that was," I told her.

[15] "I wonder who it was," she said. "I didn't know him," she said.

[16] Then she started telling me a story. "Nobody will live there on the end of that point. There used to be some Indians living there, one household. One man lived there, and then he died. And then a young couple rented that house and one of their children died there. And once again an old man and old woman rented it. Then again the old man died. As the snow was deep, she wasn't able to get her old man to the hospital. He had a heart attack and then he too died. Then after a while the house burned down."

[17] Then she said, "I just remember," she said, "it's the last house there," she said. "They move away, anyone who stays there a while," she said. "They just move away," she said. "They sense something there," she said. Then the lady said, "Nobody can stay around there. Now that house is empty, a new house too, as they're afraid to stay there. I don't know why it happens. Somebody's there."

[18] One time, I was visiting my cousin. From time to time I'll go visit my cousin. I ask him what I don't know—it's like he knows things. I went to ask him why it's happening to us. "I'll tell you after a while," he said to me. "Right now I'll tell you," he said, "to offer tobacco towards spring," he said. "Put tobacco under the ground by the tree," he said. "He's real tall, maybe he's an evil being," I think he said. "He's real tall," he said. "He goes from house to house. He was walking toward your place," he said. "Go put tobacco no

PORTAGE LAKE

Memories of an
Ojibwe Childhood

Maude Kegg

Edited and transcribed by
John D. Nichols

THE UNIVERSITY OF ALBERTA PRESS

Kôhkominawak otâcimowiniwâwa:
ᑯᐦᑯᒥᓇᐊᐧᐠ ᐅᑖᒋᒧᐃᐧᓂᐊᐧᐊᐧ : *Our
Grandmothers' Lives as Told in Their Own
Words,* edited and translated by Freda
Ahenakew & H.C. Wolfart (Saskatoon:
Fifth House, 1992). 153 × 228 mm (6″ × 9″).
DESIGN: Arden C. Ogg. SYLLABIC
TYPOGRAPHY: John Nichols & A.C. Ogg.

This anthology of reminiscences was
dictated by seven Cree women – Glecia
Bear, Irene Calliou, Janet Feitz, Minnie
Fraser, Alpha Lafond, Rosa Longneck, and
Mary Wells – speaking mostly in Cree,
and often in conversation with Freda
Ahenakew. The texts are printed in Cree
with facing English translation, but the Cree
is printed in two forms: roman orthography
(preferred by many linguists and students
of the language) and Canadian syllabics
(preferred by many older native speakers).
Wherever the speakers switch from Cree
to English, the orthography also switches
from Cree syllabics into Latin letters.

Long vowels are marked with a circumflex
in Latin script and with an overdot in
syllabics – as in the word *kôhkom* / ᑯᐦᑯᒼ, for
example, which means grandmother.

The syllabic type is a proprietary face
known as Syllaco, designed in Winnipeg
around 1990 by Arden Ogg and John
Nichols. The Latin type is Hermann Zapf's
Palatino.

ᐁ ᐊᐧ ᐅᐳᒐᑊ, ᐁ ᒐ ᒐᐦᑯᑕᐠ, ᐁ ᐊᕀᐸᐦᐊᐧᕀ, ᐊᐁᐧᐦ ᒍᕀ ᐁᐊᐧᑯ ᐊᓯᒪ ᑭᐸᐧᐟ
ᐃᐣᐸᕁᐅ. ᒍᕀ ᑲᐦ ᑭ ᐊᒌᐊᐧᐣ ᐊᓂᐯᐢ, ᐅᐱᐢ ᐃᕀᐊᐧᐅ ᐅᐣᑭ ᐊᕀᐢ ᐊᐧᐦᐨ,
ᑲ ᓂᐦᒐᐃᐧᑭᐦᐊᐧᐱᐣ ᐊᐊᐧᕀᕁ, ᐃᕀᐊᐧᐅ ᑲ ᐅᐸᐧᐊᕀᒉᐣ ᑲ ᐃᐣᐱᐨ
ᐅᐸᐧᐊᕀᒑᐊᐧᐧ, ᒍᐣᒍᕁ, ᐁ ᐁᐁ ᐅᐧᐦᐸᐦᒫᒡᐣ ᐊᓯᐧᐦᐊ ᐊᐧᐊᐧᕀᕁ, ᐊᐧᐣ
ᒍᐣᐣ ᐊᐊ ᑲ ᐱᒪᒋᐧᐊᕀ ᐊᓯᐧᐦ ᐊᐊᐧᕀᕁ ᑲ ᓂᐦᒐᐃᐧᐸᕀ.

[31] ᐁᐊᐧᑯ ᐅᐦᐟ ᐊᐧᐦᐧ ᑲ ᑭᕀᐱᐢ, ᒥᐊ ᒥᒐᐦᐃᐧ ᐁᐱᓯᑎᐃᐧᐢᐧ ᑲ ᐃᐣᐸᕁᐢᐧ,
ᑲᕀᐣ ᐊᒐ ᐃᐸᐧᐠᐲ ᐁ ᐁ ᑭᓂᒑᐸᕀᐧᐧ, ᐊᒍᕀ ᐃᐊᐧᐦᐳ ᐨᐣ ᐊᑲᒍᐅ ᑭᐅᐧᐊᕀᒥᐢ,
ᑲᐦᐱᐧᐅ ᐁ ᐁᐊᐧᐦ ᐊᐧᐦᐊᐧᐢᐧ, ᐊᐅ ᑲ ᐊᐨᐅᐅᕀᐧ ᐁ ᐱ ᐊᐨᐦᐨᐊᕁ, ᒐᐊᐣᒡ
ᑣᐧᐸᐧᐊᕀᐦᐧᓂᕀᕁ ᐁ ᐊᒣᐧᓇᕁᐦᐨᐱᐣ ᑭᐅᐧᐊᕀᕁᕁ, ᐊᐧᐣ ᐁ ᒐᐦᑯᐊᐧᕀᕀ,
ᑲᐦᐱᐧᐅ ᐁ ᕀᐁᐧᐦᐨᐊᕀᐢ. ᐊᐧᐦᐧ ᐅᐅᐧᐦ ᐊᐧᕀ, ᐊᕁᐧᐊ, ᐨᒐ ᐱᐃ ᐊᐱ
ᐊᐧᕀᕀᓇᐊᐧ ᐁ ᐊᐨ ᐊᐱ ᑲᓇᕀᐢᐧᐦᐨᒍᐦᐊᕀᐢ ᐊᐧᐊᐧᕀᕁ, ᒍᐣᑊᕀ ᒐᐧᐨᒡ
ᒐᓯᐨᒍ ᑭᕀᑲᐅ ᐁ ᐊᑲᒐᕁ ᐁ ᐸᒣ ᒥᓂᐦᐨᕀ. ᐧᐅᐧ ᐊᕀ ᑲ ᐊᐧᒪᐧ, ᕀᕁᐧ
ᐅᕀᕀᒪ ᐱᐃ ᑲ ᐱᒥ ᐃᐧᓇᐧᐊᕀ, ᐁ ᐁᐧᐱᐊᒪᐧᐦ, ᑭᕀᕁ ᐱᐃ ᐃᐅᐧᐠ
ᑲ ᐧᐅᐧ ᐊᐧᐱᐊᐧ. ᐨᐦᐣᒡᕀ ᓂᐦᐣᐟ, ᐊᓇᑕᐅ ᐁᐣᐧ ᓇᕀᐊᐧᐢᕀ
ᐁ ᐁ ᐅᐧᐦᐊᐧᐦᐧᑊᐧ, ᐅᕀᕀᒪᕁ ᐊᐨᐣᐅ, ᐊᐨᐣᐅ ᐨᑭᕀ ᐊᐧᐊᐧᕀᕁ ᐁᐊᐧᐦᓇᑲᐧ
ᐁ ᐱ ᐅᐧᐦᐊᐧᐸᐦᐨᐊᐨᕀᐧ, ᐧᑲ ᓂᕀ ᐱᕀᑯᕀᐧ ᐊᐧᐧᒋ ᐁ ᐊᕀᐊᐧᐱ ᐊᐧᕀᕀᕁᕁ.
ᑲᐦᐱᐧᐅ ᐱᕀ ᐅᐧᐦᐊᐧᐱᐊᐧᐢ.

[32] ᐧᑲ ᓂᐣᐟᐨ ᑲ ᐁ ᓂᐦᒐᐃᐧᐸᕀ ᐊᐧᐊᐧᕀᕁ, "ᐊᐅᐧᕀᕁ ᓂᐦᒐᐃᐧᐸᕁᐅ, ᐃᐢᐧᐦᐢᐧ
ᓂᐦᒐᐃᐧᐸᕁᐅ," ᐱ ᐃᐅᐧᐊᕀ ᒫ ᐧᐅᐧ ᐊᐧᕀᐧ ᑲ ᐸᐦᐸᕁ ᑲ ᓂᐦᒐᐃᐧᐸᕀ
ᐊᐧᐊᐧᕀᕁ. ᐧᑲ ᒫᑲ ᐁᐊᐧᑯ ᒫᑲ, ᒪᕀᐧ ᑲ ᐃᐅᐧᒍᐊᐳᐅᐧᕀᕁ ᐁᐧᑕᐧ,
ᐁ ᐁ ᐊᐧᐅᐧᐦᐧᐦᐃᐧ ᐊᐧᐅᐧᕀᕁ, ᐃᐢᐧᐦᐢᐧ ᐁ ᐱ ᐁ ᐃᐢᐦᐊᐧᐧᐦᐧᐦᐃᐧ, ᐊᐃᐧ
ᐁ ᐱ ᓂᐦᒐᐃᐧᐸᕀ ᐁ ᐃᐢᐦᐊᕀᕀᕀᕀ. ᐊᐧᐦᐧ ᑲ ᑭᕀᐱᐢ, ᐊᒪ ᑭᐸᐧ ᐁᐊᐧᑯ
ᐊᐧᒪ ᕀᐊ ᐱᐱ ᐊᐧᐊᐧᐊᐧᐧᐅᐧᐢ, ᒍᕀ ᐱᐅᐧᐨᐧᑭᑊᐃᐧ ᐊᐧᐢᕀ ᐃᐢᐧᐦᐃᐧ ᐊᐧᕀᕀ
ᐊᐧᐅᐧ ᐊᐧᐦᐧ. ᑲᐦᐱᐧᐅ ᐊᕀᕀᓇᐧ ᐁ ᐊᐅᐧᐦᕀᐦᐧᕀ, ᐅᕀᕀᐣ ᐨᐦᐣᒡᕀ ᐊᐅᐧ,
ᐁ ᐊᐢᐧᐦᐧᐨᐧ. ᐊᐨᕀᑲᐅ ᑭᐤᐱ ᐃᐦᐸᐦᐨᐅ ᐃᐢᐧᐅ ᑲ ᐃᐅᐱᐦᐧ, ᐊᐧᐅᐧ
ᑭᐃᐦᐸᐦᐨᐅ, ᐊᐃᐧ ᐁ ᐊᐢᐧᐦᐅᐢ, ᒍᕀ ᑭᑯᕀᕀᐢᐧ ᐱᐦᐧ ᐁ ᐊᐧᐁᐧ ᐊᐧᐦᐢ
ᐁ ᐃᐢᐧᐦᐅᐧ. ᑲᐦᐱᐧᐅ ᑭᐸᐧ ᒥᒐᐦᐃᐧ ᐱᐨᐅ ᑭᐸᐧ ᐊᐧᐦᐧ ᐃᐣᐸᕁᐅ.

[33] ᐊᐧᐢ ᐁᐣᐧ ᒥᐊ, ᑕ ᒥᐊ ᐱᕀᐊᐅ, ᐁ ᐃᐨᐨᒪᕁ ᐧᑲ
ᐁ ᐁ ᑲᐧᕁᐱᕀᕀᐦᐅᐅ, ᑭᐸᐧᐟ ᑲ ᐁ ᐃᐦᐧᐦᒪᐧᐊᕀᐦᐅᐅ, ᐨᐣᐟ ᐅᐧᒪ
ᐁ ᐱ ᐁ ᐊᐱ ᑭᓂᒑᐱᕀᕁ, ᐨᐣᐟ ᒪᐨᐣᐅ ᑲ ᐊᐱ ᐁ ᐸᑭᓂᐁᐧᐧᐧ,
ᑲ ᐱ ᐊᐱ ᐅᐧᐦᐊᐧᐦᐧᐊᐧᕀᐢᕁ, ᐊᐧᐦᐧ ᐊᐧᐊᐧᕀᐣ ᑭᐸᐧ ᐱᐦᐨᐅ ᒥᐊ
ᑲ ᐁᐧ ᐁᐧᐦᐧᐊᐧᐨᕀᐢ, "oh, that's old-fashioned," ᑭᐣᐣᐦᕁᐧ, ᒪ ᑭᐸᐧ ᑭᓂᐨᐣᒐᐦᐧ.
ᐱᐦᐨᐅ ᑲ ᐅᐧᐊ ᐅᐧᐦᐧᐊᐧᐧᐧ, ᐨᐣᐟ ᑭᕀᐣ ᐁ ᐱ ᐊᐣᐸᕀᐢ, ᑭᒍᐣ ᐧᐦᐦᐸᐧᐦᐱᕁᐧ
ᐊᐧᐦᐧ ᑲ ᑭᕀᐱᐢ, ᐁ ᕀᕀᐱᐦᐨᕁᐱᐢ, ᐊᐧᐢ ᐊᐨᐣᐅ ᑲ ᐅᐧᐦᐧᐸᐦᐧᐊᐧᐢᐣ
ᐁ ᐃᐅᐧᕁᐦᐨᐧᐢ ᐅᐧᐦᐧᐊᐧᐦᐊᐧᕀᐊᐧ. ᒍᕀ ᐃᐦᐧᑊᕀ ᐤᐣ ᐁ ᑭᐣᒐᐦᐧᑊᕀᐧ, ᐊᐧ
ᐊᐧᐦᐧ seventy-five ᐁ ᐃᐨᐨᐧᐱᕁᕁᕁᕀᕁ, ᐃᐧᕁᐦ ᑲ ᐱ ᐁ ᐊᐣᐊᐧᐊᐧᕀᒥᕀᕁ ᓂᒡᕁ,
ᑲ ᐱ ᐅᐧᕀᐨᐦᐊᐢᐣ, ᐊᐧᐢ ᓂᕀ ᐁ ᐃᐅᐧᕁᐦᐨᑯᑊᕁ ᐤᕁᑯᐧᑖᕁᕀ, ᐨᐣᐟ
ᑲ ᐱ ᐊᐱ ᐊᒥᐣᐱᕀᕁᕁ. ᒥᒐᐦᐃᐧ ᐊᕀᕀᒣᐊᐧᕁᐣ, ᓂᐧᑊ ᐁ ᑭᐣᐊᐧᕁᐦᐧᒑᑖᕀ
ᑲ ᐱ ᐅᐧᕀᐧᐨᐧᕀᕁ. ᒥᐊ ᐱᐧᐸᕁᐦᐊᑊᐧ, ᐁ ᐱ ᐊᐧᐱ ᐊᕀᕀᒣᐊᐧᕁᐧ ᒣᕁᐊᐧᐧᐣ
ᑲ ᓂᐧᑕᐧ, ᐁ ᐱ ᐊᐱ ᐊᕀᕀᒣᐊᐧᕁᐧ ᐊᕀᐊᐧᐣ ᐁ ᐱ ᐊᕀᕀᒣᐊᐧᕁᐣ, ᐊᐧᕀ ᓂᕀᐧᐦ
ᑲᐦᐱᐧᐅ ᐁ ᐊᐊᐧᕀᕁᐊᐧᐦᕀᐧ, ᐁ ᐅᐧᐦᐢᐦᐃᐧᐧᐧ-ᐧᐊᐢᐧᐸᕁᐨᕁ ᐁ ᐊᕀᕀᒣᐊᐧᐢᕁ,
ᐊᕀᕀᒣᐊᐧᒥᐊ ᐁ ᐱ ᐊᕀᕀᒣᐊᐧᐧ ᓂᒡᕁ, ᐧᑊᐧ ᒫ ᐤᐣᒐᐧ
ᐁ ᐱ ᐊᐧᐱ ᐊᕀᕀᒣᐊᐧᑖᕀᕁ. ᐁᐊᐧᑯ ᐅᐦᐟ ᐁᐣᐧ ᐊᐧᐢ ᒥᒐᐦᐃᐧ ᐊᕀᕀᓇᐨᐅ
ᑲᕀᐧᐣ ᐱ ᐁ ᐊᐱ ᐊᒥᐣᐱᐅ, ᐊᐧᕀ ᒥᒐᐦᐃᐧ ᐱᐸᐧ ᐁ ᐁ ᑭᐣᒐᐦᐧᑊᐱᕁ ᑲᕀᐣ,
ᑲ ᐤᐧᐦᐱᐦᕀᕀᐦᕀ.

VI
[34] ᐊᐧᐦᐧ ᑲᐦᐱᐧᐅ – ᐃᐧᐦᐧᑊᐃᐧᕀᐣ ᑲ ᐊᐱᒨᐦᑊᕀ, ᒍᓂᕀᐅ, ᑲᐦᐱᐧᐅ
ᒥᕀᐊᐧᐨᒥᐦᐧᐅ, ᑭᒐᕀᕀᓇᒥᐊᐧ, ᑲᐦᐱᐧᐅ ᐤᒪ ᒍᕀᕀᐃ ᐱᐸᐧ ᐁᐊᐧ ᐊᐧᐦᐧ

∇ ⊃∩ᓄᏏᑌᣔ, ∇ Ⅴ ∇·ᐱᗕᐦ·ᐤ ⊃L ᑭᏏᣔ ᔨᐦᐃᏏ∆·ᓂᐊᔪ, Ċᓂ
Ꮟ Ᏸ Ⅴ ᐃᔪ ᐸᕿ∩ᓄᑯ∆·ᣔᣔ Ꮟ Ᏸ Ⅴ ᐱᒐ∩Ꮟᐦᐊᔪ. ᐊᔪᐦ ᏏᐦᏈᓗ ᏏᏏᐩ
ᒥᓂᐦ·ᓇ·∆·ᣔ, ᏏᐦᏈᓗ ᏏᏏᐩ ᐊᔪᐦ, Ꮟᣔ L ᏏᏏᐩ ᒥᓂᐦ·ᓇ·∆·ᣔ ⊃ᐧᒥ ∆·ᐸᔨᐤ.

[35] ᒐᓇ Ᏸ ᏜᏏ ᏏᏏ·ᔪ⅃ᣔᣔ, ᏐᏜᐦᏏᏏᣔ Ᏸ ᐃ·ᒥ ᐊᏕ⅃ᣔᣔ, ᏈᏈ ᏏᏏ·ᔪ⅃ᣔ, ⅃ᣔ
∆·ᐦᏏᏆ ᐊᓇᏟᐤ ᐤᒥ ᣔᐸᐦᏟᣔ, ᏈᏈ ᐊᓂᏏᣔ ᏐᏜᐦᏏᏏᣔ, ᒥᑐᓂ Ꮟᔪᣔᣔ
∇ ᐸᒥᐊᣔᣔ ᏐᏜᐦᏏᏏᣔ. ᐊᔪᐦ ∇Ᏸ ⊃ᐦᏈ ᐊᔪ, ᐊL ᏏᏏᐩ LᏜᒥᐦᐊᣔ
ᖅᐦᑌ ᐊᔪ. Ꮬ, Ᏺ ᏟᏥ Ꮠᐦᖅ·Ᏺᐊᣔᣔ, ∇ᐩ, ∇ᐩ, ᏺᏤᐊᣔᣔ, ∇Ᏸ ᒐᓇ ᏚᓐᏟ ∇Ᏸ
Ᏸ ᏓᏣᐦᐅᖅᣔᣔ, Ꮬ, T.V., L ᏏᏏᐩ Ᏸ LᏜ ᏚᓇᏚᓐᏤᣔ ᐊᏟ ∇ ᖅᐦᑌ ᐊᔪᐱᐦᔪᣔ,
Ᏸ Ꮟᖅ· ᓂᏈᔪᣔ, Ꮥ. Ᏸ Ꮯᐃ·ᏜᏜᣔ Ᏸ ᐃᏍᐦᖅ·ᐊᣔ ∇ᏟᏟ ᐃ·ᔪᐊ·ᐤ. L ᏏᏏᐩ
Ꮟᔪᣔ ∇ᐊᏟ ⊃ᐧᒥ ᏲᐦᏟᏏ·ᣔ, L ᏏᏏᐩ. ᐱᐦᏟᏜ ᐊᔪᣔ ⅃ᣔ ᏏᏏᐩ
⊃ᐧᒥ ᐊᏥᓂᐊᣔᣔ ∇ᏚᏐᏙ ⅃ᓂᏏᏟ·ᏏᏏᣔ, ᓇᏜᣔᣔ ᐊᔪᐦ ⊃ᐦᏟ ᏏᐦᏈᓗ ᏏᏏᐩ,
Ᏸ ᏓᏣᐦᐂᏟᏏᏏᏟᐸ, ᏏᐦᏈᓗ ᏏᏏᐩ ∇ ∆·ᏟᏟᣔ ᐊᔪᐦ.

[36] ⅃ᓂᏏᏙ ∇ᐊᏟ ᒐᓇ Ᏸ ᏜᏈᐦᏟᣔ ᒥᓂᐦ·ᓇ·∆·ᣔᣔ, ᒥᐦᏝ ᐊᏏᏏᓂᏜ
ᐊᔪᐦ Ᏸ ᏠᏏᏏᣔ ∇ ᏈᏁᏝᐦᏜᣔ. ᏏᏙᣔ ⅃ᣔ ᏏᏏᐩ ∇ᐊᏟ ᐊᓂ ᐊᓇL
⊃ᐧᒥ ∆·ᐦᏟᏜᣔ. ⊃ᐦᏐᏐᐦᐊᏏᏏᣔᣔ ᒥᐦᏝ ᐊᔪᐦ Ᏸ ᏈᏈᣔ, ᏏᏏᐦᑌ ᐱᏕ
ᏈᏈᏟᏏᏟᐊᏟᏟᏟᣔ ᒥᓂᐦ·ᓇ·∆·ᣔ ⊃ᐦᏟ, ⅃ᓂᏏᏟ· ᐊᏏᏏᏐᐤ Ᏸ ᒥᏜᐦᏙᐤ, ᏏᏕᣔ
Ᏸ ᐃ·ᒥ ᒥᓂᐦ·ᣔ, "Ꮬ, ᏲᏏᣔ ᏏᏜᏆ ᒥᓂᐦ·Ꮖ." Ᏸ ᐃᏌᐤ, ᏲᏏᣔ Ᏸ ᏈᏣᣔ, "ᒐ
ᏲᏏᣔ." Ꮬ, ᐃᐱᐱ Ᏸ ᏓᏏᐦᏈᐸᐦᏟᏟᣔ, ∇Ꮪᔪ ᐊᓂ ∇Ᏸ ∇ ᏏᏤᐦᏟ·ᏟᏟᣔ
∇ ᏏᏤᏟᏤᏟᣔ, ᏏᏏ·ᐱ ᐊᓇL ⊃ᐦᏟ Ᏸ ᒥᏜᐦᏟᏟᣔ ∇Ᏸ· ∇ ᓂᏟᐃ· ᐊᏟᔨᐦᏟᏟᐱ
ᐊᓇL, ᐊᐦᏏᏏᏙ ∇ Ꮟᐃ·ᐸᐦᏟᏟᣔ. ᒪᏟ LᏐᏜ· ⅃ᏡᏏᐱᐦᣔ Ᏸ ᐃᏟᒥᐧ, LᏏᏟ
Ᏸ Ꮯᐃ·ᏜᏜᏙ ᏲᏏᣔ ᐃᐱᐧ·Ꮟᐦᔪ, ᐊᏏᐩ ∇ Ꮯᐃ·ᏜᏜ ᐊᏟᐤ ᏚᏟᏟ LᏟ LᏐᏚ.
ᏈᒥᐦᏟᐦᔪ, ∇ᐩ, ᐊᐱᐦᏟ Ᏸ ᒥᏜᐦᐊᏏᣔ, ᏕᏕᐩ ᐊᓇL ∇ᏟᏟ ⊃ᐦᏟ ᏐᐦᏏᏏᐩ
∇ ᏁᏈᐢᏐᐦᣔ LᏟ LᏐᏚ, ᏈᏕᐊᐦᐱᣔ ᐊᏏᏜ ᏕᏕᐩ. ᏐᐦᏏᏜ ᒥᏏᐊᏜᐦᐤᏟᐤ
ᏈᏠᐦᣔ ᐊᏏᏛᓇᐊᐩ, ᐊᐱᐦᏟᏏ·ᐸᣔ Ᏸ ᐃᏏᏟᏈᏕ.

[37] Ċᓂ ∇ᏁᏟ· ᒪᓇ ∇ ᐃᏳᏏᐦᏟᏂᣔ ⊃Ꮫ ᏟᐦᏟᣔ, ᏟᐦᏟᣔ ᐊᏁ ⊃Ꮫ ᓂᏏ
Ċᓂ Ᏸ ᏜᏏ ᏈᏁᏟᏈᏏᣔ ᐊᏟᏏᏏᣔ.

kôhkominawak otâcimowiniwâwa

ᏚᐦᏚᒥᏜᏟᏏ ⊃Ċᒥ⅃∆·ᓂᏟ·ᏟᏟ

Our Grandmothers' Lives
As Told in Their Own Words

Carle Coppens, *Poèmes contre la montre* (Saint-Hippolyte, Québec: Noroît, 1996). Avec reproductions des œuvres de Jesus Carles de Villalonga. 120 × 230 mm (4¾″ × 9″). DESIGN: Claude Prud-Homme / Carle Coppens.

The text face is Helvetica condensed.

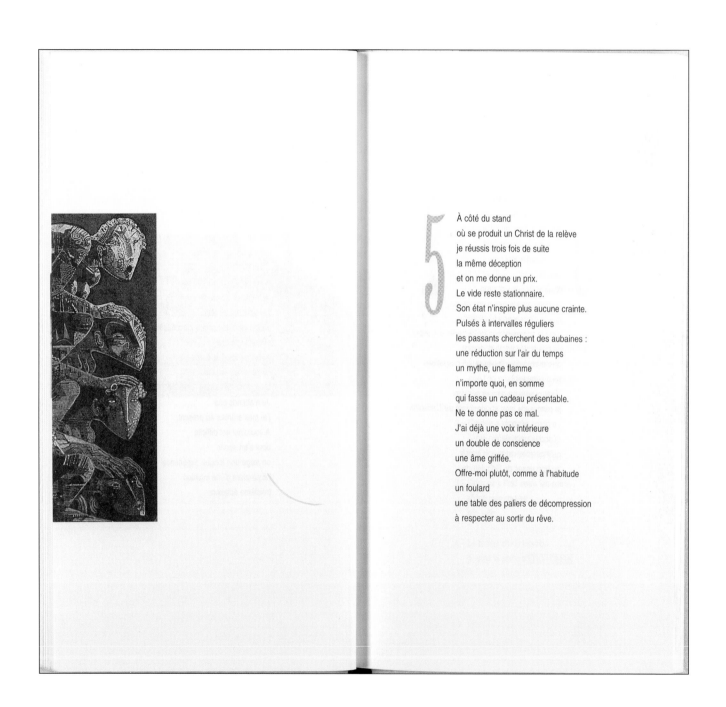

5

À côté du stand
où se produit un Christ de la relève
je réussis trois fois de suite
la même déception
et on me donne un prix.
Le vide reste stationnaire.
Son état n'inspire plus aucune crainte.
Pulsés à intervalles réguliers
les passants cherchent des aubaines :
une réduction sur l'air du temps
un mythe, une flamme
n'importe quoi, en somme
qui fasse un cadeau présentable.
Ne te donne pas ce mal.
J'ai déjà une voix intérieure
un double de conscience
une âme griffée.
Offre-moi plutôt, comme à l'habitude
un foulard
une table des paliers de décompression
à respecter au sortir du rêve.

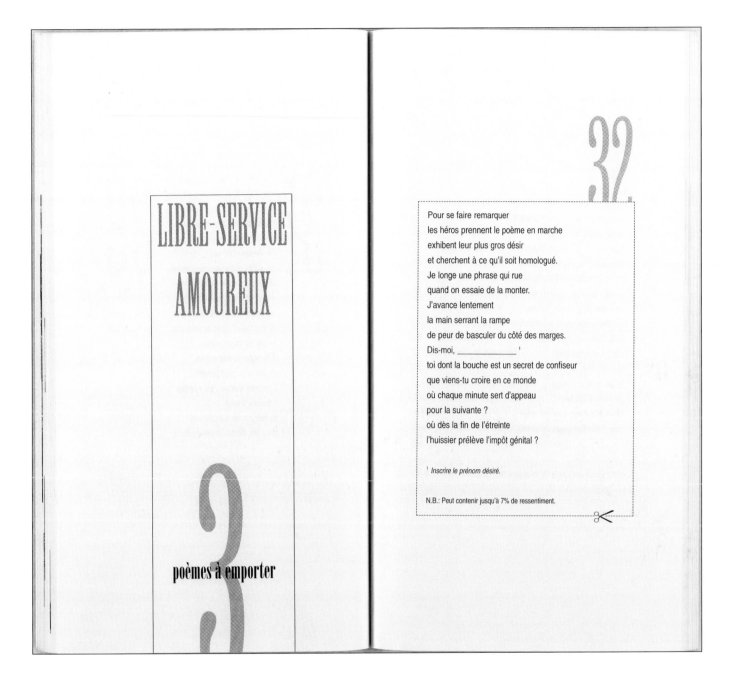

LIBRE-SERVICE

AMOUREUX

3

poèmes à emporter

32.

Pour se faire remarquer
les héros prennent le poème en marche
exhibent leur plus gros désir
et cherchent à ce qu'il soit homologué.
Je longe une phrase qui rue
quand on essaie de la monter.
J'avance lentement
la main serrant la rampe
de peur de basculer du côté des marges.
Dis-moi, _____ [1]
toi dont la bouche est un secret de confiseur
que viens-tu croire en ce monde
où chaque minute sert d'appeau
pour la suivante ?
où dès la fin de l'étreinte
l'huissier prélève l'impôt génital ?

[1] *Inscrire le prénom désiré.*

N.B.: Peut contenir jusqu'à 7% de ressentiment.

I thanked them for the advice and let them continue their morning walk. While I trudged back to the house through the lengthening grass, I wondered whether I should plunge right in with permanent sheep or whether I should call this Dave guy. I had meant to ask what a sheep cost. Christine and I had agreed that we would get animals that had other uses than just dinner — the chickens with their eggs fit that bill, but of the sheep Angela and Chuck had mentioned only the Romneys seemed to have an additional asset in their wool. Maybe it would be simplest to give the rent-a-sheep guy a call.

I did, and he returned my call that evening. Sure, he said, how many did I want? Twelve? They were $40 sheep, he said, and he would buy them back for $50 after a couple of months. "Have you got a pen?" he asked. Presuming that he didn't mean the thing you write letters with, I said yes, remembering Jan's comment about the fenced area under the shed roof. He told me to find some kind of

feeding trough, about 12 sheep wide would be perfect, and some kind of water bucket or tub that they couldn't knock over, and then he promised to come by the following afternoon.

I was just finishing nailing together a rough feeder when Dave arrived in a big pickup truck pulling a long metal trailer with the words EWE HAUL painted on the front. Dave was about 70, or maybe 65, a stocky, rather leathery man who moved like 40 and talked 19 to the dozen, as my mother used to say. We shook hands and, well, we talked and talked, and it went something like this: he was a retired school principal but had grown up on a farm just over the next hill; his hobby was buying and selling animals; if anybody needed an old animal taken to the auction, for example, he would do it and charge

56

a small fee; the sheep were from a contractor doing organic maintenance of power-line clearings and were in need of fattening on good grass.

I opened the door into the pen and he backed the trailer up to the edge of it. Out shuffled a dozen rather bony sheep with very short, dirty wool, the most unprepossessing flock I had ever seen. They were obviously agitated and moved rapidly about, quickly exploring into every corner.

"What kind are they?" I asked.

"Oh, they're just junk sheep," Dave replied. "You can see some Cheviot in that one," he said, pointing. "They're good lawn mowers."

I looked back into the trailer and realized that there was an old goat still standing there. "Don't worry about her," Dave said. "I picked her up on the way here. She's got arthritis real bad — she'll go for sausage at the auction...." He laughed. "Don't ever ask what goes into political deals or sausage!"

He left me with a bucket of grain and directions to rattle it if I wanted the sheep to come.

Out they went to the pasture the following morning and roamed everywhere. I mean *everywhere*. Anything other than the sturdiest wire fence could not hold them; they zipped through narrow gaps in old fences, hopped between horizontal boards that had once held cattle, plowed through hedges, and were a complete nuisance. I had thought they would cross the ditches at the crossings, but they were agile and surefooted beyond my wildest imagination — opportunistic sheep, no doubt a result of the conditions of their previous employment. They annoyed me, but I reassured myself that either they or I would settle down.

57

Michael Kluckner, *The Pullet Surprise: A Year on an Urban Farm* (Vancouver: Raincoast Books, 1997). 156 × 257 mm (6¼″ × 10″). DESIGN: Dean Allen.

The type is Mrs. Eaves, designed by Zuzana Ličko — a postmodern variation on the work of John Baskerville, named for Baskerville's mistress, Sarah Eaves.

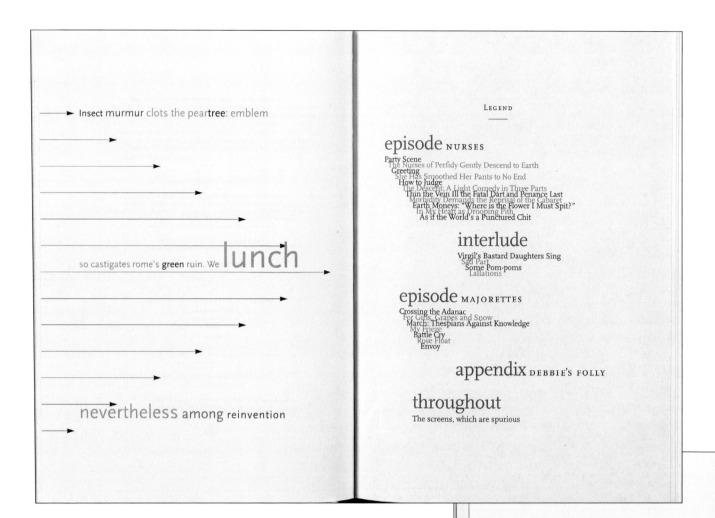

Insect murmur clots the peartree: emblem

so castigates rome's green ruin. We lunch

nevertheless among reinvention

LEGEND

episode NURSES
Party Scene
The Nurses of Perfidy Gently Descend to Earth
Greeting
She Has Smoothed Her Pants to No End
How to Judge
The Descent: A Light Comedy in Three Parts
Thin the Vein Ill the Fatal Dart and Penance Last
Morbidity Demands the Reprisal of the Cabaret
Earth Moneys: "Where is the Flower I Must Spit?"
In My Heart as Drooping Pith
As if the World's a Punctured Chit

interlude
Virgil's Bastard Daughters Sing
Sgt Part
Some Pom-poms
Lallations

episode MAJORETTES
Crossing the Adanac
For Girls, Grapes and Snow
March: Thespians Against Knowledge
My Frieze
Battle Cry
Rose Float
Envoy

appendix DEBBIE'S FOLLY

throughout
The screens, which are spurious

to seize my theme: how the soul can hate
as when a sudden silence stifles
hope and oars work at nothing
I beheld horror in the wet shade's message
and time left me there standing
I did not witness morning. Once rivals
loved with darkling fruits. I haunt this ratio
or throw it to you, shrinking sea, in augured
tongue bastard Latin hard song my busy pain
in moody tissue grieving.
You were mortal for a while. I can live
no better. Neither plenty of arrogance
plenty of gauze, nor the hard wall of
fingerbones (which is memory) can erase
this fact: we were half made when the empire
died in orgy. Because we are not free
my work shall be obscure
as Love! unlinguistic! I
bludgeon the poem with desire and
stupidity in the wonderful autumn
season as
rosy cars
ascend

Crossing the Adanac

TWELVE DAYS THE MARCH ENDURES AND DURING THOSE
the imperium's chained in gold for use and ornament
we question whether such ponderous prize may sustain
the role of stimulus: some shun the sight (the moody ranks 500
are anxious for themselves so renounce pleasure, maps)
then what is Love – fauve catalogue: milk-blue
beer-halls' deep-lying know-how as sæcular senate† , pre-
ex-officio half-Joe's demi-dreams of oak-leaf vine-leaf putty-
coloured thistle-downed lax weekend-spas 505
Good-bye! good-by! sea-sick isis-luna sea-cave moon-light we're
trench-digging trigger-happy bull-dog walkers. We're
quick-sand and take the victorious element

† Last Call

When belief's all technique, Luck's girls knees are
Spit: profound armies in liquid socius
So drink.

For Girls Grapes and Snow

PARDON ME IF I THROW MYSELF
absolutely outside of my sex
for I was between the wall and love, a
dreaming brevity in dazzled font 510
diverted. If my sense of my body
can include both dog and owning state's daft
glamour, I'll graft soft logics to myself
and shall send for either. Please Frank, up 515
towards the grapes and fleece, quote something kind
about a decent use for the passions
and speak to me of weariness Frank in soft iambic
since on torn apart sleeve of my thrifty 520
freedom dress, the tethered part twists from
servility to dreck – ah terrific
girls idiolects avenues proofs the
ramps and the glimpses, even the elevator
and the morbidity of sex say some 525
thing sort of nice about opulence and
majesty. Like my Nurses always said –
No Bees no Honey, No Ambition no
Money. No Master no Metre. No Soul
no Rigour. No Adage no Axis. So 530
I am going behind the arena
to get some pleasure – and all the civic

Lisa Robertson, *Debbie: An Epic* (Vancouver: New Star, 1997). 143 × 203 mm (5¾″ × 8″). DESIGN: Dean Allen.

The types are Martin Majoor's Scala and Scala Sans: a matched pair of serifed and unserifed faces designed in the Netherlands in the late 1980s and early 1990s.

maybe
even
this
dress
shall
some
day be
a joy
to
repair

Robert Mélançon, *Air: poèmes,* with English translation by Philip Stratford (Vancouver: Les Éditions Lucie Lambert, 1997). Woodcuts by Lucie Lambert. 330 × 504 mm (13″ × 19¾″). DESIGN: Lucie Lambert.

The inset (much reduced) shows the closed book lying in its open box, with the title page partially visible under its cover of translucent Japanese paper.

The type is Monotype Garamont 248, printed from the metal. Frederic Goudy designed this type in New York in 1921, based closely on the work of the 17th-century French punchcutter and printer Jean Jannon. It was cast especially for this book in British Columbia in 1997 by Jim Rimmer, who also cut new matrices for the accented letters.

(Goudy himself – like others before him – misidentified the source of the design as Claude Garamont instead of Jean Jannon, and this mistake is still frequently repeated.)

Recommence, s'agite, tournoie,
S'enfle, se disperse, roule …
On ne sait s'il y a
Quelque chose qui remue, s'apaise.
Il y a des grains d'espace,
Un grouillement, une onde dans l'herbe,
Peut-être un horizon. Qui sait?
Ce serait, ce pourrait être une nuit
Au bord de la mer.
Tout est tranquille. Apaisé.

Begins again, flutters, eddies,
Swells, dissipates, rolls …
One cannot know if there is
Something there that stirs or rests.
There are grains of space,
An agitation, a wave in grass,
Perhaps a horizon. Who can tell?
It could be, might be, night
Beside the sea.
All is tranquil. Becalmed.

AIR

Poésie...... Jooni
Gilles Hénault
Traduction et translation
Philip Stratford
Bois du Scott Hadden
Lucie Lambert

Éditions Lucie Lambert
Vancouver 1987

Contents

Introduction: The Language of Media	1
Arachne or Penelope: Queen of the Net, Mistress of the Web?	6
Virtual Reality: Mime Without Walls	14
A Word About Tetrads	26
Teleconferencing: The Global Theater	42
S	58
An Ancient Quarrel in Modern Europe – and the Enduring Mystery of English	62
Blind Spots, and the Rear-view Mirror	78
Postliteracy	86
Three New Styles: The Poetics of the PC	102
The Revenge of Echo: Suicide as a Means of Survival	124
Anatomy of the Electric Crowd	140
Synesthesia and Society	160

The structure of Justus Erich Walbaum's early 19th-century type as revived in the 20th century by the Berthold Foundry in Berlin: *pianissimo* (horizontal) and *fortissimo* (vertical), with rapid, sometimes instantaneous, modulation between the two. In Renaissance letterforms (far left), the contrast between thick and thin or soft and loud is more moderate, the transitions are more gradual, and the axis is that of the writing hand: oblique instead of vertical.

The crowd in electric form is not a new kind of association but a new form of being, one in which we all participate, like it or not. Radio put us in the Global Village. Contrary to popular supposition, the Global Village no ideal haven but a congested place which exaggerates the most ancient antipathies and differences and in which privacy is impossible. Television ushered in the Global Theater, in which everyone is "in role" at all times. The Global Theater admits no spectators, only actors, just as Spaceship Earth allows for no passengers, only crew. We have no choice in the matter. The computers and various networks that link us bring about a new condition of massive loss of identity by means of enhanced participation in depth in electronic processes. As information levels rise, "subjects" disappear and differences between things melt away. As participation levels rise, human identities also dissolve. In turn, this loss generates a thirst for roots and a primal hunger for belonging – to groups.

Consequently, separatism of every sort replaces nationalism and all kinds of rational allegiance instituted during the last couple of centuries. electric time demands a radically different feel for causation and causality. Rational, sequential causality provides no means whatever of coming to with the transforming power of electric media. Cause-and-effect has lost grip except on the most superficial level of everyday affairs, in much the way that Newton's three laws of motion have given way to Einsteinian rel in contemporary affairs. Today, most of the effects of any innovation occ before the actual innovation itself. In a word, a vortex of effects tends, li to become the innovation. It is because human affairs have been pushed pure process by electronic technology that effects can precede causes an software and information replace hardware artifacts. *Ground* always pre

figure and it is to an analysis of *ground*-effects that media study has to turn to remain relevant.

The ordinary sociological and futurological approaches are helpless in the face of these forces because they follow content-bound, linear tracks. They provide no room for reversal, or novelty, and assume a rational, consistent way of seeing. But projections of the present in terms of trends, etc., concentrate on *figure* and ignore *ground*, that is, media. The study of *ground* has traditionally been available only in the arts and as result not of theory but of training of perception and sensibility.

These considerations are of profound significance for our cultural institutions, as the *ground* of the West orientalizes electrically and the *ground* of the East westernizes. Electric experience holds few novelties for the Easterner, but it brings him into direct participation with Westernized experience for the first time. The first, second, and third worlds so dear to the press and politicians have now been displaced by a fourth world of electric information and imagery carried by satellite and the internets – a world in which we are all equally primitive. On the nets, everything is decentralized, even being. Everybody is a nomad, in the mode of hunter on a frontier, which also means the end of individualism and the rise of "characters" or roles.

Power, too, decentralizes while established bureaucracies of every kind melt away and dissolve. This means of course a shift to a completely new form of culture and with it a new and vital role for the arts, not, as formerly, as a specialist activity but as basic survival training; not as the ivory tower but as the control tower. The arts provide the indispensable means of training navigators in the new environments precisely because they set aside concepts and focus on tuning ground and attuning sensibility.

Eric McLuhan, *Electric Language: Understanding the Present* (Toronto: Stoddart, 1998). 226 × 235 mm (8¾″ × 9¼″). DESIGN: Malcolm Waddell.

The text face is Berthold Walbaum – a digital revival of type cut by Justus Erich Walbaum at Weimar around 1805. The titling face is Morris Fuller Benton's Franklin Gothic, designed in New York a century later.

Romantic prose, like Romantic music and letterforms, tends to insist on dynamic extremes: pianissimo and fortissimo. Eric McLuhan, no less than his eminent father, is a scholar with a strong Romantic liking for hyperbolic language. Malcolm Waddell chose a strongly Romantic type in which to set McLuhan's essays. For titling, he chose a heavy advertising face (always fortissimo, like rock music). Waddell also filled the spreads with process-colour energy, drawing the eye away from the text, into the typographic spectacle. McLuhan, hyperbolically, described the result as "the closest thing to a medieval hand-made, hand-designed book that has appeared in centuries – or since the day of William Morris."

From Canada to Record Business

In the early seventies, Jammy took a few years away from Jamaica and went to Canada. As a reputable technician and engineer, he was in great demand for taking control of the soundboards at stage shows; he also helped out ex-Jamaican Jerry Brown in his Summer Sounds Studio in Malton. Back home, the Waterhouse set was left in the hands of Jammy's brother-in-law, but Jammy's relative had neither the interest in nor dedication of Jammy towards the music and it wasn't long before things began to go wrong. The set would break down, money was needed for records, and the crew began to get frustrated and lose interest. At that time, Jammy's brother, Trevor, phoned Jammy in Canada and recommended that he take the set off the road or suffer his name to go down. Instead, Jammy sent for all the equipment – the amps and the records – and started up again in Toronto where he soon became the ruling sound. It was when Jammy's baby mother Iris had to leave Canada that Jammy finally returned to Jamaica. During their stay abroad, they had had three children; the eldest, Sharon, and the two boys, John John and Christopher.

Back in Kingston, Jammy decided to move out of his parents' house. Iris, who had grown up at 38 St. Lucia Road with her parents, gave Jammy the little front room (her own room) to start settling up a studio, and she moved to another room in the house. He started out with a two-track machine perched on a couple of building blocks; all he had the capacity for was editing. A producer would go and voice some tunes and bring him the tape and he could run it off. Or someone could bring him the tracks of a completed LP on various tapes and he could transfer them onto one tape in the appropriate order.

Around this time, Phillip Smart, who had been Tubby's prime engineer, left to live in New York, so Jammy was given a chance to fill in and learn the ropes. It was in Tubby's studio that Jammy encountered two great influences on his development: one was producer Bunny Lee, the man responsible for all the hits, and the other was the eccentric singer/producer Yabby You who gave Jammy his first rhythm to work with on his own and encouraged him to start producing. That rhythm became 'Born Free' by Black Uhuru. Bunny Lee, likewise, encouraged Jammy to join him on a trip to England, where Lee could show him how the reggae business functioned abroad. With a few tunes of his own production – like that first song by Black Uhuru – Jammy and Bunny flew out. Back then (it was Christmas time at the end of 1977) the reggae industry wasn't organised and there weren't the type of big companies willing to release and distribute Jamaican product as there are today. So how did they find an outlet? Jammy recalls: 'We did it on our own. We drove all around, all about in England all over the country,' trying to sell the records. Jammy also had music with Cornell Campbell, the Travellers, and the original U.Black that he was trying to sell. Although the Black Uhuru song was taken by Fatman and released on a 45 in England, it never came out in Jamaica. Uhuru was a new name to people, so the tune never did very well.

In Jamaica, in the new year 1978, Jammy took the plunge and formed his own label, the original white-spotted one. The first release was Uhuru's 'Natural Mystic', a track that was also to appear on *Love Crisis*, their first LP. Jammy was attracted to the group because they had a new sound, a fresh sound that was hard-hitting, cultural, and progressive. With his knowledge of the reggae market abroad, he saw the international potential for a group of good singers with roots rhythms and dynamic lyrics. And he was right. By 1980 Uhuru was signed to Island Records and well on their way to becoming the largest reggae act in the world after Bob.

18
19

Mama Iris in the yard with Jam II

The kitchen of the house was stocked with Red Stripe beer, box drinks, and bun and cheese to sell the hungry masses of artists and sound men who were constantly marching through. The domestic attributes of Mama Iris have been immortalised in General Leon's 'Pudding Move' tribute: 'Mama Iris makes the nicest pudding'. The fact has since been confirmed by many – when it comes to baking and cooking, no one can touch Iris. But far from being just a housewife, Iris has long had the job of maintaining order while Jammy is on the road, of overseeing all the young artists who might be working there for the first time, of welcoming foreign guests and keeping things organised in a private home continually invaded by the public. The home itself has sheltered many artists who lived there while doing sessions; Screecha Nice, the idiosyncratic deejay from Toronto, lodged there periodically. Jammy's private life was almost public property – not an easy circumstance in which to bring up a large family. Indeed, all the washing was done in the yard where artists waited for the call to the studio. When washed, it was hung overhead on the line. A frantic dual industry was always keeping the place moving, the business and the domestic. When anyone had time to rest is unknown.

Echo Minott and Jam II

28
29

The image on the right page (staggered textblocks):

Jammy and crew were still abroad, although rumour had them returning each day, always the next day. The flood hadn't affected Kingston directly, but the constant rain had completely destroyed what little surfacing there had been on the city roads, leaving dirt and stones and broken chunks of paving in its place. Driving was worse than impossible, and even walking raised a cloud of dust that obscured visibility. What Kingston did feel, however, was the shortage of ganja that the flood left. Not only had entire fields been wiped out, but the roads going out to those parts were unserviceable. Nothing was getting through and prices began to rise in accordance with the demand. The only consolation was the World Cup Soccer Championship. Anyone with a TV set had a certain crowd of people in their house daily and often the streets looked deserted for the duration.

With the crew gone, things were quiet, but business went on as usual at the studio. Iris, Bobby, and Bravo were away with the crew, so Squingey was left in charge of the dubcutting and he was working on some plates of Nitty Gritty's 'Cry Baby', a much punchier dubplate mix than the version on the LP, as well as Don Angelo's 'Petty Robber'. Meanwhile, the construction in the yard was underway. A friend of Iris' had informed Jammy that the house next door to him was up for sale, and nothing could have been more opportune. Jammy bought the property immediately and tore down the wall in between. Jammy was expanding.

A lot of sounds had been forced to stop playing during the rains, so a lot of the entertainers were walking around broke. Everyday the radio announced new benefits to be held in support of the victims.

It was the year of 'Boops' in the music world, but it was about to become the 'Raggamuffin' year. The Taxi 45s with Half Pint, 'Night Life Lady' and 'Cost of Living', had been released but the rhythms were just too complex, too structured to play well at dances. Instead it was the driving rhythms of 'Greetings' on George Phang's Powerhouse label (also a Sly and Robbie effort) that caught on. The message was one that every ghetto dweller could identify with.

Junior Delgado followed up with his 'Raggamuffin Year' – 'Raggamuffin year is here, revolution year, coming here' – and the new craze was launched. Junior had made quite a comeback after re-settling in his homeland. His long absence in England had kept him musically inert for a while, but he proved that he could create not only hits, but some very sophisticated, creative music as well. Jammy's recording of 'Raiders', his original tune on the updated rhythm that was making the rounds that year, signaled his return. His LP with Jammy contained some of Steely and Clevie's most innovative work. The keyboards had lightened up from the solid 'Sleng Teng' pounding and became, at times, airy and enchanted. The computer business was reaching a stage of maturity.

When the tour finally did return from abroad, Jammy had something very special to announce: he and his babymother Iris – girlfriend of sixteen years – were going to get married. Iris remembers dating Jammy since her school days. They began going out when she was just thirteen and attending Denham Town School. Jammy was going to another school but they lived close by and saw each other often. Jammy was older but that was the custom in Jamaica, to start friendships early and young. The wedding was quite a lavish affair with the reception at Hope Gardens. A friend was playing a small sound – just soft music – and the food and drinks were overflowing. It was the big celebrity event of the season with every entertainer present. It made Iris, officially, Queen of Jammy's, and Jam II, a little prince.

62
63

Beth Lesser, *King Jammy's* (Toronto: ECW Press, 2002). 178 × 178 mm (7″ × 7″). DESIGN: Martina Keller.

"King Jammy" is Lloyd James, a Jamaican recording engineer and music producer. In 2002, when this book was produced, reggae music was still distributed primarily through physical recordings, not by downloads from the internet. The book alludes to this fact by being absolutely square, like record sleeves and the booklets that accompany CDs. The staggered textblocks and out-of-kilter background images echo the ambience and rhythms of the music, but they have another function too: they help to rescue the pages from their squareness. (Repeating squares, which offer no orientational clues, are antithetical to reading.)

The text face – letters of colour to speak on behalf of musicians of colour – is what typographers call a "bold grot." More precisely, it is the digital version of Monotype Series 216 Bold Grotesque – a sturdy sanserif cut in England in 1926 (based on the Bauer Foundry's Venus type, designed in Germany in 1907). The titling face is Georg Trump's City in its original (bold) version, first cut in Germany in 1930.

(Circular detail, partial text:) e, of welcom / organised in a p / d by the public. The / d many artists who liv / ons; Screecha Nice, the / m Toronto, lodged ther / ivate life was almost / rcumstance in which / eed, all the wash / waited for

3 224.1: With neither by your leave nor if your please.
5 224.1: They giggled, hated me, cleared out the brush,
 [adds then deletes next line:] With no respect for our stake,
 [and smashed our steps
6 224.1: They smashed our steps into unidentifiable plank,
 224.2: Smashing our steps into chaos and senseless planks.
7 224.1: With no respect for our stake, – and in their onrush,
8 224.1: Quite regardless, they borrowed our boat without thanks
9–10 224.1: Their swim over, they set the foundations
 With the stumps, wined and dined
 And went
 The young builder
 Standing on my float beyond the ruined steps
 And pines face downward in the rising tide
 For two full hours, I hated them passionately
 Now the land was government owned, we had no case
 Save to hate
12 224.1: Beyond our ruined steps, and made up my mind
13 224.1, 2: To love these rough neighbours

1940–54 [225.2]

 I do not wish to live
 I do not wish to die
 I do not wish to strive
 To extirpate this I

5 I do not wish to work
 I do not wish to play
 I do not wish to shrink
 I do not wish to say

 I do not wish to live
10 I do not wish to strive
 I do not wish to fish
 I do not wish to wish

T 225.1: So What
6–7 225.1: I do not wish to shrink
 I do not wish to play

1940 [226.2]

 I met a man who had got drunk with Christ.
 And this is what he told me Christ said.
 'Trust no man who is not always drunk.
 And always ready to be drunk.
5 There is no excuse for sobriety.
 But one. That is war
 And I who say that, envy
 The knocking knees of the years,
 Get off my cross, return to my hotel.'

10 That was in Oberammergau, before the war, –
 Before the fires came spirit cleft again.

9 . . . to my hate.'] [omits end quotation marks]
10 Oberammergau] Obergammerau

226.1: I met a man who had been drunk with Christ
 He was sure that it was Christ, and he said this
 This former man was my friend, and his friend
 Was Christ man too, not so literally –
 This Christman not Christ was a drunk too,
 At Jesus the three of us talked drunkenly of Christ.
 Now
 Each night, he said, I get down from my cross
 And return to my hotel

1940 [227.1]

 I met the spirit of tragedy in the wood
 Where he lives. 'And I don't like
 You,' he said. 'I've done my weeping best
 Slaughtered your parents east and west,
5 And scattered your home.' A flake
 Of snow fell, like a tear. 'Yes, and I sent winter
 Of terror to freeze and fire you.' 'And still you laugh.
 I would like to know what is so damned funny
 About all I've done to you.' 'Why don't you really
10 Try', I said 'to be funny. Then I might weep.'

2 227.1: Who lives there. 'And I don't like
4 227.1: Slaughtered your parents and brothers east and west,
5 227.1: Have scattered your home to the winds.' A flake
8 is] [missing]

1939–40; 1945–6 [228.1]

 I set this down as humble prayer
 Please let my hand write something
 That may be used by the humble
 And the mad and the abused
5 When long words and excuses fail.
 Too much deliberate simplicity
 Will call down such savagery
 As: 'Why do you not draw cartoons?'

 I would but make the obvious beautiful.

1940–54 [229.1]

 I think that I shall never see
 A tree that's half so good as me

Malcolm Lowry, *The Collected Poetry,* edited by Kathleen Scherf (Vancouver: UBC Press, 1992). 150 × 228 mm (6″ × 9″). DESIGN: Arifin Graham.

The type is Jan Tschichold's Sabon.

Some of Lowry's prose entails typographical challenges. His story "Through the Panama," for example, requires that the typeset text split into a wet part and a dry part and mimic the uterine shape of the Panama Canal. His verse, by and large, is typographically straightfoward. But this variorum edition of his poems poses challenges that Lowry never envisioned. Here the typography has to be as analytical as a tax return and as literary as a sonnet sequence both at the same time – and so it is.

Crispin S. Guppy & Jon H. Shepard, *Butterflies of British Columbia* (Vancouver: UBC Press, 2001). 212 × 279 mm (8¼″ × 11″). DESIGN: Gary Blakeley.

The type is Lucas de Groot's TheSans – the sanserif branch of his large type family called Thesis. It was designed in 1989 as part of his senior project at the Koninklijke Academie van Beeldende Kunsten (Royal Academy of Fine Arts) in The Hague.

TheSans is a humanist sanserif – a kind of type that the Latin alphabet did not possess until the early 20th century. There are splendid examples of humanist sanserif *lettering* – all in caps – from early Greece, Republican Rome, and Renaissance Florence. There are also, from Renaissance Italy and France, many fine examples of humanist *script* and *type*, complete with an upper and lower case – but all those scripts and types are serifed.

All a sanserif type has to do to be *humanist* is to echo the shapes of those earlier humanist types, which do have serifs. So a humanist sans has, as a rule, a large aperture (wide openings in letters such as C, S, c, s, and e); it has an oblique, ovoid tendency in the bowls of the letters *b, c, d, e,* and *p*, echoing the oblique, humanist axis found in the same letters in serifed humanist type; and it normally comes equipped with old-style figures (digits that reach up and down like lowercase letters), a genuine cursive italic, and true small capitals: all standard features of the humanist scribal tradition. The resulting combination seems incongruous: the impersonality of sanserif fused with the humane grace and bias of the writing hand. But accepting that very incongruity has been crucial to the arts and sciences alike in the past century. "The humanities," wrote Charles Frankel, "are that form of knowledge in which the knower is revealed."

Borderlands

© UBC Press 1998

Printed in Canada on acid-free paper ∞

ISBN 0-7748-0658-3

Canadian Cataloguing in Publication Data

New, W.H. (William Herbert), 1938-
Borderlands

Includes bibliographical references.
ISBN 0-7748-0658-3

1. Boundaries – Social aspects – Canada. 2.
Canada – Boundaries – United States. 3. United
States – Boundaries – Canada. 4. Canada –
Civilization.
FC180.N48 1998 971 C98-910083-9
F1027.5N48 1998

UBC Press gratefully acknowledges the ongoing
support to its publishing program from the
Canada Council for the Arts, the British
Columbia Arts Council, and the Multicultural-
ism Program of the Department of Canadian
Heritage.

UBC Press
University of British Columbia
6344 Memorial Road
Vancouver, BC V6T 1Z2
(604) 822-5959
Fax: 1-800-668-0821
E-mail: orders@ubcpress.ubc.ca
http://www.ubcpress.ubc.ca

Contents

Acknowledgments / vii

1 Giddy Limits: Canadian Studies and Other
 Metaphors / 1

2 The Edge of Everything: Canadian Culture
 and the Border Field / 33

3 The Centre of Somewhere Else: The Pig War
 and English 91 / 69

 Notes / 103
 Works Cited / 114

the flaw in the ideal society, the source of its decline, derives (says Reed) from its 'Americanization.' All these images are, of course, at best presuppositions (though where do they come from?) and at worst clichés – but they still have the power to shape expectations: of value and of right. And it's in this context that I turn to Richard Rodriguez, Richard Ford, and David Guterson.

Ford and Rodriguez nicely exemplify the polar images that Doyle and Staines have outlined. In Ford's 1995 novel *Independence Day* (a story about the love life of a real estate salesman, and not to be confused with the blockbuster 1996 film of the same name about a millenarian space invasion), the central character, Frank, observes a group of Canadian tourists 'bustling' into a hotel lobby, 'elbowing each other and yucking it up like hockey fans.' Reflecting on how he reads these people, he thinks by extension about how he reads himself:

> They are big, healthy, happy, well-adjusted white people who aren't about to miss any meals or get dressed up for no good reason. They break off into pairs and threes, guys and gals, and go yodelling off through the metal double doors to the rest rooms. (The best all-round Americans, in my view, are Canadians. I, in fact, should think of moving there, since it has all the good qualities of the states and almost none of the bad, plus cradle-to-grave health care and a fraction of the murders we generate. An attractive retirement waits just beyond the forty-ninth parallel.) (190-1)

This is not, finally, the direction of Ford's book, but the point has been made. At the edge of American society there exists a witnessing alternative. And yet, and yet ... this 'alternative' is still more fundamentally characterized here as an *extension* of the American persona, not as something with *intrinsic* differences that might need to be recognized, acknowledged, or accommodated – not, that is, as a centre somewhere else. Which leads me to Richard Rodriguez's essay 'True West,' in the September 1996 issue of *Harper's*. Rodriguez eloquently muses in this essay on the elusive

meaning of the word 'West' in the United States, on its relation with nature, civilization, energy, frontier, rage, oblivion, and other large ideas, and on its relevance to himself, as a Mexican American writer in California. These musings might be interesting but peripheral to what Ford and Trillin and the others have had to say were it not for a couple of passages that enter the essay toward its end. Canada does not have a 'myth of the West,' Rodriguez writes (44) – a pronouncement that I personally read with some surprise – but only a myth of the North and a close relationship with the land to the south, which somehow (the transition in the essay is not altogether clear) enmeshes Canada in a grand continental (for which read 'US') design. For then Rodriguez goes on to 'dissolve' the myth of the American frontier by reimagining it:

> In something like the way the East Coast invented the West, California today is inventing a rectified North. From the perspective of California, Oregon is a northern state and Seattle is a northern city. Vancouver becomes a part of the continuum without regard to international borders ...
>
> I believe the journey to Alaska is a death wish, insofar as it is a wish to escape civilization rather than extend it ...
>
> From the perspective of Mexico City, Los Angeles is a pale, comic city. From the perspective of Seattle, paint-peeling Los Angeles is the tragic antipode of the coast ...
>
> I live within the precinct of Los Angeles ... I am connected to the South, to desert, to death ... I feel my future more closely aligned to British Columbia than to Massachusetts ... The most important highway in California is Interstate 5, the northern route, connecting desire and fear. (46)

What precisely does a 'rectified' North mean, I ask? And what does it imply? Whose desire? And whose fear?

These sensitivities, nevertheless – desire and fear – constitute some of the most basic motivations for the drawing of borderlines and for their persistence. They're the reasons behind the semiotic force of the 49th parallel, the Rio Grande, the Mason-Dixon Line, the English Channel, and

Borderlands

How we talk about Canada

W.H. New

W.H. New, *Borderlands: How We Talk about Canada* (Vancouver: UBC Press, 1998). 140 × 233 mm (5½″ × 9¼″). DESIGN: George Vaitkunas.

The type is Hollander, designed by Gerard Unger in 1983.

Gary Wyatt, ed., *Susan Point: Coast Salish Artist* (Vancouver: Douglas & McIntyre, 2000). 227 × 279 mm (9″ × 11″). DESIGN: George Vaitkunas.

The text face is Robert Slimbach's Adobe Garamond, based on the work of two 16th-century French master punchcutters, Claude Garamont and Robert Granjon. The italic employed as a titling face is Cochin, designed by Georges Peignot in Paris in 1912, based on the lettering of several 18th-century French engravers, including Jean-Michel Moreau and Charles-Nicolas Cochin.

Quickly comprehending the unique Coast Salish two-dimensional style and bolstered by Greene's example, Point decided to explore and experiment with the print medium. On quiet evenings, she began to sketch with pencil and paper. After reworking a single idea many times, she produced her first original graphic design, a black-on-white painting depicting four salmon contained within a circle, which was reproduced in April 1981 as her first serigraph, titled *Salmon* (see facing page). Its circular format paid tribute to the spindle whorls that she had examined extensively in museum collections, but the design was entirely her own.

Her second print, produced in the same month, was based on a spindle whorl carved by an unknown nineteenth-century Cowichan master (see facing page). She chose to interpret the figures incised on it, as the title of the work indicates, *Man and Sea Otters* (see facing page), although other meanings are possible for this configuration. Point began applying Salish two-dimensional designs to her jewellery as well as to her prints. But they were difficult to sell, as the established galleries specializing in Northwest Coast art were unwilling or unable to recognize the aesthetics of the Coast Salish art form.

The use of an older work as a reference heavily influenced Point's designs over the ensuing decade. She explains: "My rapid mastery of the design form resulted, in a sense, because I was copying. Everything was already in place; it looked as if I knew all about it but I really didn't." This humble statement belies the fact that much of her early work was innovative and experimental, not only in terms of design but in matters of technique. A review of the more than one hundred prints produced in that ten-year period reveals she had reached a mature and independent understanding of the classic Coast Salish form early in her career. Although she always honoured the integrity of the old designs, she consciously tried to improve them by introducing her own interpretations of detail where appropriate.

Point printed her first images at home on the kitchen table; her children helped by running the prints to any available surface in the house to dry. The edition sizes were based on the number of successful prints the family was able to pull, rather than any predetermined number. The early works were all produced from precise black-and-white paintings that were turned into film positives. Increasingly, she attempted technically more difficult prints, blending and overprinting colours, creating designs that required three- or four-point colour registration. When working to this degree of complexity, the medium is unforgiving, and, while the technical mastery of her later prints may not readily be appreciated by all, professionals in the printing industry recognize that her serigraphs are technically superior to many available on today's market. Currently she works on a print design through several successive stages, beginning with a rough concept hastily sketched, then a series of tracings to a final line drawing created with a 3H pencil. Even though the resultant line is absolutely precise, she will instruct the printer to cut on one side or the other of the line at critical junctures in order to maintain the integrity of her original form.

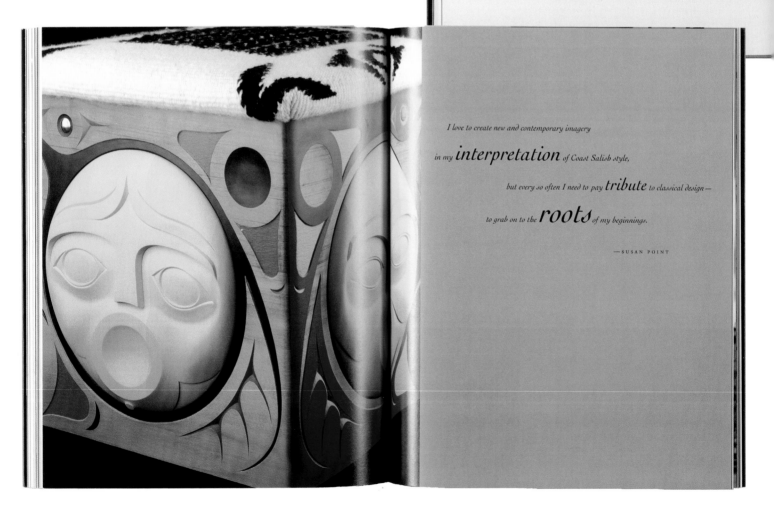

I love to create new and contemporary imagery in my *interpretation* of Coast Salish style, but every so often I need to pay *tribute* to classical design — to grab on to the *roots* of my beginnings.

—SUSAN POINT

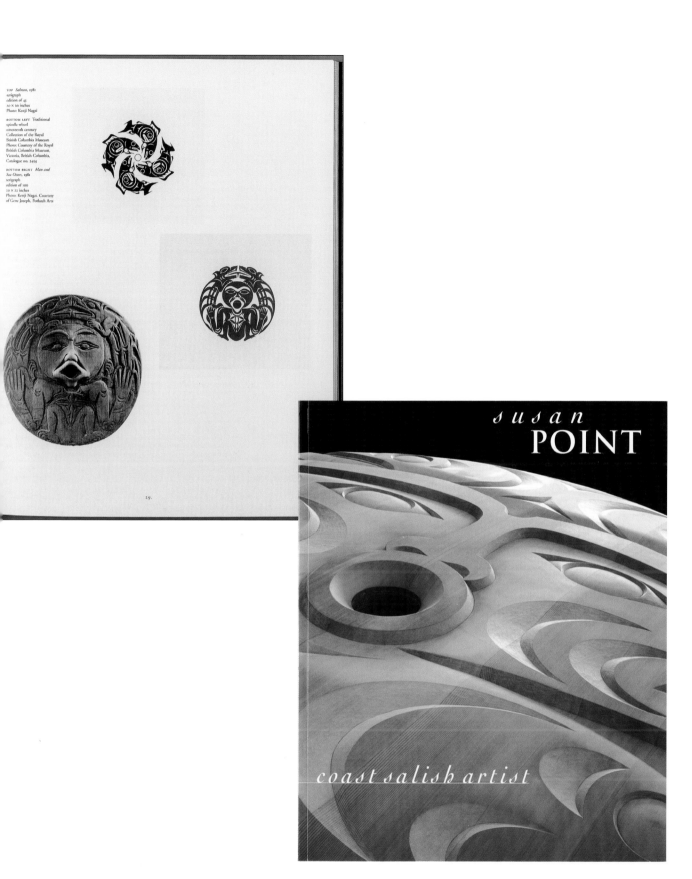

These pivotal questions set this study in motion and led to a series of animated and illuminating conversations across Canada from January 1990 to November 1991 with various members of the extended 'Art Tribe,' as well as with Native elders, linguists, actors, performance artists, curators, and art historians.[2] Emerging from these conversations was the conviction on my part that there was indeed a sensibility, a spirit, at work and at play in the practice of many of the artists, grounded in a fundamentally comic world view and embodied in the traditional Native North American trickster.

In fact, several artists cited the Trickster as a direct influence on some aspect of their work. Most also agreed that a distinct comic and communal attitude does exist that can legitimately be labelled 'Native humour.' Transcending geographical boundaries and tribal distinctions, it is most often characterized by frequent teasing, outrageous punning, constant wordplay, surprising association, extreme subtlety, layered and serious reference, and considerable compassion. These qualities are amply illustrated in the words and images gathered together in this book under the headings of self-identity, representation, political control, and global presence.

2 The artists whose work is featured in this book are primarily Canadian. The questions posed and themes addressed are, however, reflective of a sensibility found throughout Native North America. Several significant national and international events anchor historically the period during which the initial research was conducted. Their presence is registered in both the conversations excerpted and the works reproduced in this study. Among the more notable are Elijah Harper's stunning defeat of the Canadian government's Meech Lake Accord; the Mohawk standoff at Oka, Quebec; the war in the Persian Gulf; the 1992 Canadian constitutional referendum; the sweeping success of the film *Dances with Wolves*; and the 1992 Columbus quincentenary celebrations that precipitated the exhibitions *Indigena: Perspectives of Indigenous Peoples on Five Hundred Years* at the Canadian Museum of Civilization, Hull, Quebec, and *Land Spirit Power: First Nations at the National Gallery of Canada* in Ottawa, Ontario, to which several of the artists who were interviewed contributed.

Included as well in the book are excerpts from later interviews, with Métis artist Jim Logan in January 1994 and Plains Cree artist George Littlechild in November 1996.

By genetic memory maybe ...
our minds have the ability to think laterally.
Jane Ash Poitras, Cree/Chipewyan artist

Hypertext is very different from more traditional forms of text ...
Reading, in hypertext, is understood as a discontinuous or non-linear process
which, like thinking, is associative in nature,
as opposed to the sequential process envisioned by conventional text.
John Slatin, computer researcher

A Note on the Structure of the Text

This study has been conceived as a 'trickster discourse,' to use the term coined by the American mixed-blood Anishinaabe writer, Gerald Vizenor (1989, 9). It is a discourse *among* tricksters, *about* tricksters, and even *as* trickster, in the sense that the 'trickster is a comic discourse, a collection of utterances in oral tradition' (Vizenor 1989, 191). At once open-ended, unfolding, evolving, incomplete, the discourse is imagined in numerous verbal and visual narratives and a multiplicity of authoritative voices. Charged with a playful spirit and what architect Robert Venturi calls a 'messy vitality' (1968), it finds expression in multilayered communication and simultaneous conversation, in surprise connection and 'narrative chance' (Vizenor 1989, x). It defies univocal representation.

In the following pages quotations and notes are used extensively to disburse the narrative voices and reflect the intertextual nature of the discourse. Neither quotation nor note should be considered a secondary or subordinate text. At various points in the conversation, other voices intersect with the principal narrative. In 'a space where texts can talk to each other' (Babcock 1984, 107) non sequitur, song, poem, prose, and personal anecdote enrich and enliven the discourse. In some instances notes take the form of extended annotation and include illustrations. In this they constitute a kind of hypertext or hypermedia, forms of non-sequential writing and visualizing that until recently were primarily associated with literary studies and computer science (Delany and Landow 1991). More important, the text honours and participates to some degree in a non-linear process of representation shared by many of the artists interviewed.

More than invocations of authority, the quotation and the footnote
are the means of transforming a monological performance into a dialogue,
of opening one's discourse to that of others.
They are also the literate way of interrupting and commenting on one's own text,
of acknowledging that reading and writing, like any cultural performance,
involve appropriating, absorbing, and transforming the texts of others.
Barbara Babcock, anthropologist

xii

xiii

Allan J. Ryan, *The Trickster Shift: Humour and Irony in Contemporary Native Art* (Vancouver: UBC Press, 1999). 197 × 278 mm (7¾″ × 11″). DESIGN: George Vaitkunas.

The text faces are Robert Slimbach's Utopia, designed in California in 1989, and Lucas de Groot's TheSans italic.

Candace Savage, *Crows: Encounters with the Wise Guys of the Avian World* (Vancouver: Greystone, 2005). 160 × 216 mm (6½″ × 8½″). DESIGN: Jessica Sullivan.

The text face is Adobe Jenson, a digital type designed by Robert Slimbach, based on a roman font cut by Nicolas Jenson in Venice in 1469.

A book entitled *The Trickster Shift* cannot afford to be strait-laced. Nor can a book about crows. But tricksters are canny, not haphazard. They need to break rules – but for rules to be broken, there have to be some rules to break. Both these books have grids, which are carefully and skilfully contrived. The grids function like billiard tables or squash courts: as fixed and predictable spaces where unpredictable games can be played – and where the rules can be broken as circumstance requires.

NOTHING

is more INTELLECTUALLY challenging

than living in a SOCIAL group,

SURROUNDED by a bunch of other animals

that are sharpening their W I T S on you.

◇ FAMILY DRAMAS ◇

CATCHING CROWS

Biologist Carolee Caffrey is madly in love with corvids. Over the last twenty years, she has studied the social behavior of American crows in California, Oklahoma, and Pennsylvania and has come away from her research with a joyful respect for the bright minds of her subjects. Yet even though it is the birds' intelligence that makes her work so much fun, she would be the first to admit that their edgy alertness causes complications. To study crow society, you first have to be able to tell the birds apart so that you can chart family relationships and keep track of how individuals interact with one another. But to do so, you have to catch them—ideally every bird on the study site—and fit each one with an identification tag. "The only way to catch crows is to trick them," Caffrey laments, "and it's such an ordeal that it prevents most sensible people from studying them."

Of all the methods she has tried over the years (nooses of monofilament line sewn into Astroturf, which the birds wouldn't land on; glue traps that wouldn't hold their feet; walk-in traps that the crows wouldn't walk into; and so on), the most successful has been a device that shoots a net out over a flock of crows that has been lured to a food bait. Because crows become more wary of the apparatus with every attempted capture, the trick is to attract several birds into range at once, thereby increasing the chance of catching them before they all catch on to the setup. And it can't be just any old group of crows in the shot; you have to wait for the ones you want, the unmarked birds that have so far avoided getting caught. It is not a job for the faint of heart.

37

He liked to drink while he sat alone at his kitchen table and hated his collection of wood type. He tried, with the twist of a wrist, to turn an M into a W. Failing at that, he turned a T upside down; but he could read it as easily upside down as upright. He poured another shot of rye into a jar that still wore its bold label: Robertson's Marmalade. He set the word

OUT, building from the T he had tried to mock out of meaning. He left the T on the table. He placed the U on a windowsill. He carried the O into his living room. But he knew the word OUT was still OUT.

It was the failure to reduce a mere three-letter word to nothing that made him attempt a sequence of illogical sentences; he printed across the linoleum of his living room floor:

I'M NOT ALONE. REALLY. He ran out of punctuation. He found his apostrophes and periods, what few he had, in a shoe box under his bed. He concluded his trilogy of sentences with **I'M NOT.** Studying his accomplishment, he decided to make a new name out of his initials.

LIEBHABER'S
ROBERT KROETSCH
WOOD TYPE

imprimerie dromadaire toronto march 1987

36

The first drops of rain fell on the hearse that was carrying Vera's third husband into Big Indian. The wind had fallen off toward morning; the waiting men had lowered the corpse with long ropes. The tall, gangling stranger from the road gang was hardly more than a bag of bones, he'd been so dehydrated, so perfectly dried. He was for a moment a kind of dried flower in Vera's arms.

Mr. Aardt, surprised by the rain, swerved, hit the ditch, swung back onto the road. He missed Marvin Straw by inches; Marvin was waiting in a stand of last year's cattails, his dirt-rimmed eyes feverish with love, feverish with renewed hope at the sight of the loaded hearse.

As the clouds thickened, moving eastward, they robbed the powerline poles of their shadows. Liebhaber, by this time, was lying on the deck of his boat; the boat was resting on dry land, where the river once had run. He'd been looking up at the sky for three hours and twenty-one minutes when he felt the first drop of rain.

He'd spent himself in the night of his secret warring. His back and his legs and his arms ached. Only slowly did he stir. The ai

164

was almost still, the wind had almost ceased from its endless blowing. And more: there came, now, the weighing of dark cloud onto the radiance of sky.

A drop of rain hit him and he knew it would be a flood. At last, his marriage time had come. He had remembered the future correctly: there would be a flood, a joy of rain, his battle won, his ark floating. Let the doubting bastards drown, he would save whom he pleased. He shook his head, wiped a drop of rain from his forehead, got to his feet.

Liebhaber drove Vera's Essex back to the farm. The few drops had become a drizzle by the time he got there. "It's going to rain cats and dogs," he shouted, hardly up the steps and onto the porch. It was not Tiddy, but Vera who first came to the door. She didn't bother to look at her Essex, returned, finally, from wherever Liebhaber had taken it. She said nothing of his theft, his vast conspiring to unhinge the world; he might have been, for all her attention, innocent.

And then, only then, did Liebhaber notice: here and there, with the falling drops of rain, fell a bee. Here and there a bee fell. Tiddy came to the door, now, and with her, Rose. Rose, as homely as she had always been, her shoes not tied, her dress not quite fitting. And with her the younger daughter, whose shoes were not tied, whose dress did not quite fit. But the older daughter was there too, Theresa O'Holleran, so beautiful, in the swelling of her young breasts, in the defiance of her blue eyes, that Liebhaber tugged at a corner of his mustache, for a moment caught it into his mouth.

Anna Marie came out onto the porch, with the others. She too saw the rain, knew that her hair, in a matter of hours, would be frizzy, unmanageable. Her youngest daughter came onto the porch and took the comb from her mother, began to comb her own dark hair, watching all the time the weather. Gladys Wurtz was there too, dressed in her Hutterite garb, no makeup on her pale face, the long skirt not quite hiding her heavy black shoes. She held her daughter's hand and the daughter held in her free hand a red ball. And Cathy came out too, Cathy Lightning stepped out onto the porch; she was making macaroons; she

Robert Kroetsch, *What the Crow Said*, 2nd ed. (Edmonton: University of Alberta Press, 1998). 112 × 210 mm (4½″ × 8¼″). DESIGN: Alan Brownoff.

FAR LEFT, FACING PAGE: Robert Kroetsch, *Liebhaber's Wood Type* [excerpt from *What the Crow Said*] (Toronto: Imprimerie Dromadaire, 1987). 142 × 224 mm (5½″ × 8¾″). DESIGN & PRESSWORK: Glenn Goluska.

The text face in Brownoff's version is Robert Slimbach's Adobe Jenson, and the script is Justlefthand, by Just van Rossum and Erik van Blokland. In Goluska's version, the text face is W.A. Dwiggins's Linotype Electra, printed from the metal together with wood type. (The typographically nondescript first edition of this book was issued by General Publishing, Don Mills, Ontario, in 1978.)

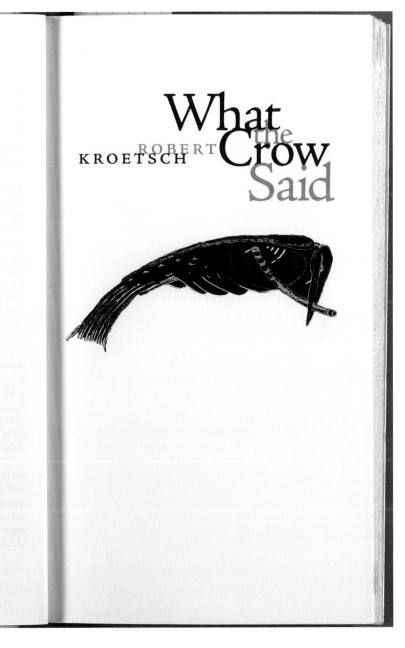

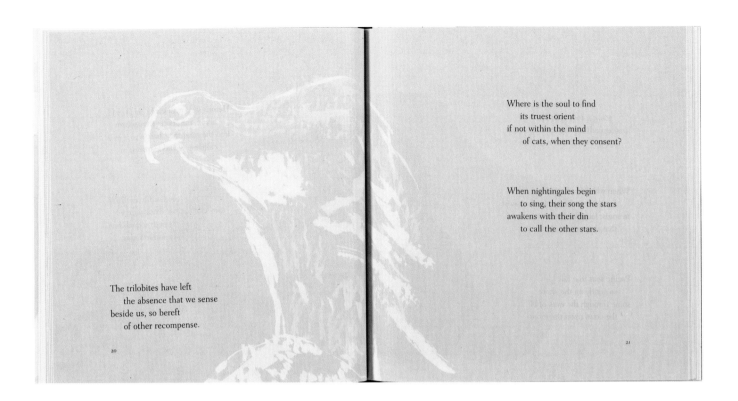

The trilobites have left
 the absence that we sense
beside us, so bereft
 of other recompense.

20

Where is the soul to find
 its truest orient
if not within the mind
 of cats, when they consent?

When nightingales begin
 to sing, their song the stars
awakens with their din
 to call the other stars.

21

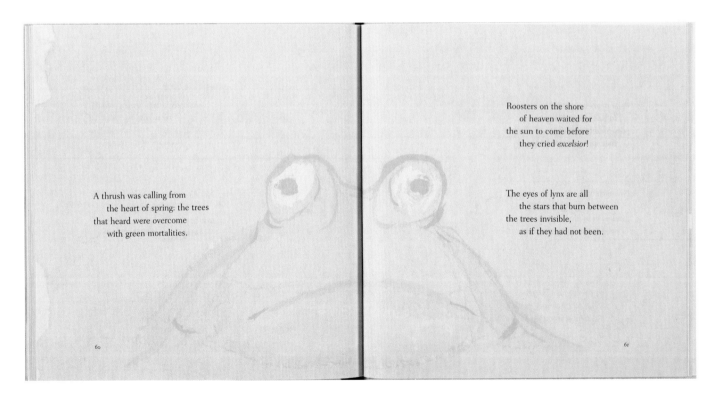

A thrush was calling from
 the heart of spring: the trees
that heard were overcome
 with green mortalities.

60

Roosters on the shore
 of heaven waited for
the sun to come before
 they cried *excelsior*!

The eyes of lynx are all
 the stars that burn between
the trees invisible,
 as if they had not been.

61

FACING PAGE: E.D. Blodgett, *An Ark of Koans* (Edmonton: University of Alberta Press, 2003). Illustrations by Jacques Brault. 161 × 167 mm (6½″ × 6¾″). DESIGN: Alan Brownoff.

The type is a digital adaptation of Linotype Fairfield, designed in New York in 1939 by Rudolph Růžička.

THIS PAGE: *Recalling Early Canada: Reading the Political in Literary and Cultural Production*, edited by Jennifer Blair et al. (Edmonton: University of Alberta Press, 2005). 151 × 226 mm (5¾″ × 8¾″). DESIGN: Alan Brownoff.

The type is Fedra, designed in The Hague in 2003 by Peter Bil'ak.

However much these questions resonate with the questions about early Canadian literary and cultural production that our contributors pursue in these pages, many might have difficulty agreeing with the final, ringing question that Foucault posed in "What is an Author": "What matter who's speaking?" As many of these chapters energetically maintain, it *does* matter "who's speaking" in the archive that is early Canada. It matters in richly complex and sometimes disturbing ways. We return, then, to one of our own questions, posed at the beginning of this introduction and posed, earlier, to prospective contributors to this volume: "When we call and recall 'Early Canada,' what is 'it' that we call upon and how does the very name we give to 'it' shape in advance what it is that we set out to recall?" Our contributors "call upon" many vital questions and issues in the chapters that follow: the alterity of the past, the nation as rubric, contestatory understandings of history, the making of readers, and much else besides. These issues surface in this volume, not just as matters of critical urgency for the project of recalling early Canada, but also as the conditions of its making, a making that must be, it seems, projected as a retrieval, as if from a certain territory, constituency, subject, or moment in time, and into another. This is an exciting and necessary time to be ReCalling Early Canada.

1

Wedding "Native" Culture to the "Modern" State

National Culture, Selective Tradition and the Politics of Recalling Early Canada

PAUL HJARTARSON

The purpose of the National Gallery in arranging this exhibition...is to mingle for the first time the art work of the Canadian West Coast tribes with that of our more sophisticated artists in an endeavour to analyse their relationships to one another, if such exist, and particularly to enable this primitive and interesting art to take a definite place as one of the most valuable of Canada's artistic productions. (National Gallery of Canada [2])

That there has been a meeting and that some sort of marriage has resulted is what pours out of our literature and our painting. (Saul, Reflections 191)

◆ Frederick Alexcee's Baptismal Font and the Politics of Recall

IF YOU HAVE NEVER HEARD OF the Tsimshian carver and painter Frederick Alexcee[1] (1853?–1944), you are not alone. Although many people have seen his artwork, and although some have been deeply moved by it, few will recall the artist's name: he simply does not rank among the people whose life story the Canadian nation has felt is "worth recording." His name seldom appears in art histories and there has been no systematic attempt to identify or catalogue his work. A few of Alexcee's creations, however, have escaped this general neglect. In a recent article on the Museum of Anthropology (MOA), Michael McCullough listed a baptismal font carved by the artist (*Figure 1.1*) as one of the museum's six treasures.

1

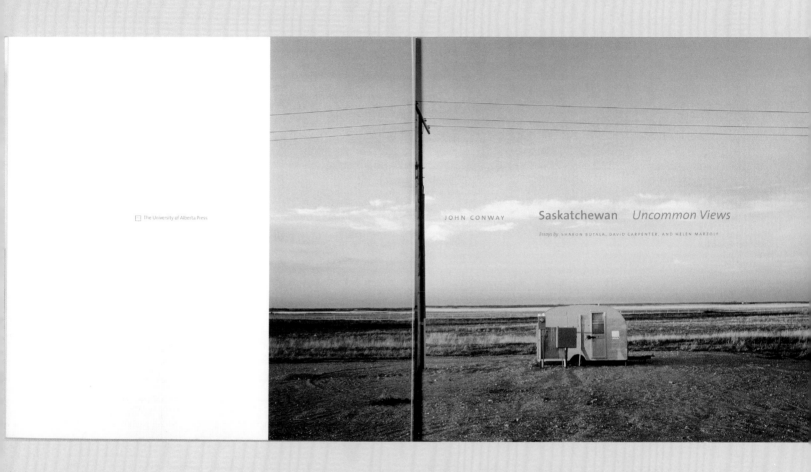

The University of Alberta Press

JOHN CONWAY Saskatchewan *Uncommon Views*

Essays by SHARON BUTALA, DAVID CARPENTER, AND HELEN MARZOLF

John Conway et al., *Saskatchewan: Uncommon Views* (Edmonton: University of Alberta Press, 2005).
272 × 253 mm (10¾″ × 10″). DESIGN: Alan Brownoff.

The type – as spare and live as the landscape described – is Lucas de Groot's TheSans.
(For a note on the type, see p 159).

Rural Municipality of Arlington

There it was still, a road pointing off somewheres.
Right enough, it give him a clutch in the throat. It hurt
him with its straightness and its promise... But he knew
it one better. He knew there weren't no straight roads.
—*Guy Vanderhaeghe*[11]

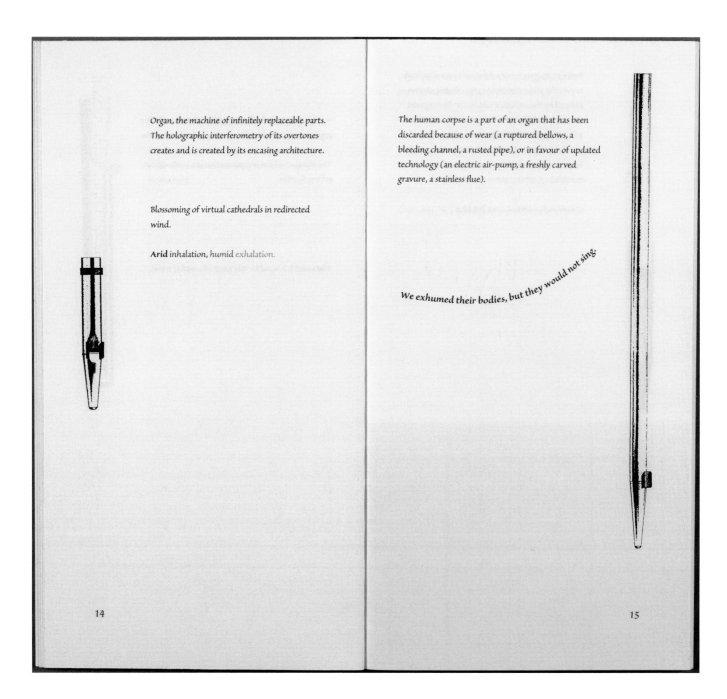

Organ, the machine of infinitely replaceable parts. The holographic interferometry of its overtones creates and is created by its encasing architecture.

Blossoming of virtual cathedrals in redirected wind.

Arid inhalation, humid *exhalation*.

The human corpse is a part of an organ that has been discarded because of wear (a ruptured bellows, a bleeding channel, a rusted pipe), or in favour of updated technology (an electric air-pump, a freshly carved gravure, a stainless flue).

We exhumed their bodies, but they would not sing.

14

15

Matthew D. Remski, *Organon vocis organalis: Book II of Aerial Sonography* (Toronto: Coach House, 1994). 117 × 220 mm (4½″ × 8¼″). DESIGN: Stan Bevington.

The type is Robert Slimbach's Sanvito, a calligraphic face based on the hand of an eminent Renaissance scribe.

(While digital typography has largely eliminated the wrongfont characters that enlivened 19th-century handsetting, it has made new kinds of errors possible – systematically dislocated quotation marks, for example.)

Some organs are not restricted by the conventions of their metacasings, commonly known as churches.

The 16th- and 17th-century tower organs of central Germany and Austria were called "hornwerk." These outdoor organs punctuated communal life with signaling chords. The configuration of pipes in these machines did not follow the model of the church instrument, with the divisions of pipes distinctly encased above and behind the chair of the organist. Instead, the pipes entirely surrounded the keyboard, with their mouths directed outward, facing the centrifugal city.

The hornwerk a minaret with thousands of outfacing muezzins.

The organist enveloped by her pipes, the unending extensions of fallopia, intestines and esophagi.

too high or the upper lip disfigured, the pipe will be " slow" and in extreme cases will cease speaking. This condition is often called a " cleft palate." A knife-edged languid requires shallow, widely-spaced nicking of the lips and slitting of the enunciatory shaft in order to discourage

When the organist wishes to activate pipes from more than one division while using a single manual, she may employ one or more" couplers." The coupler allows the voice complement allotted to one manual (interface console) to be accessed through another. In electro-pneumatic organs, the couplers simply reroute the electrical impulses through to the demanded set of pipe-switches. In tracker organs, however, the coupler actually connects the **activation mechanism** of one manual to that of another, so that each key is chain-linked to its parallel counterpart. Consequently, when the Swell manual is coupled to the Great manual and the Great is played, the keys of the Swell are activated in exactly the same sequence as that which the organist is playing, although she is not touching them. Coupling produces a ghostly automaton whose action parallels that of the organist. A simple way to multiply one's hands.

Coupling, the uplink of desire.

(The keyboards of player pianos are coupled to those of instruments in other locations. Cranking the player piano mechanism unwittingly forces a pianist on the other side of the planet to play the programmed music at a speed that we arbitrarily choose.)

nes to acti
while using a singl
re" couplers." The c
allotted to one m
d through a

ᐸᓄᖧᑯᑉ ⊃ᔍᐊᑯᖬ ⊃ᓇ ᐊᐱᒪᑎᒉᖧᓄᖧᐸᑦᑦ.

ᖬᑫᑦᑕᓄᑉ ᐊᑦᑐᖧᖭᖬᐊᓄᑐᖧ ᓇᖅᑕᖆᑎᒉᖬ, ᖁᒧᑎᖧᑉ ᑕᖆᐊᖧᑐᑉ ᐊᐅᔾᒉᒉᖧᓄᑉ ᐅᖭᑦᔾᐊᓄᖧ
ᐊᐅᖧᖆᐊᖆᒉᒉ. ᐃᖧᖆᐅᑕ ᑎᑉᐅᖧᒉᑎᒥ, ᓇᖬᓇ ᐸᓄᖧᑉ ᐅᖬᖧ, ᐊᖑᖧᖧᑎᒎ ᑎᑦᑦᓄᐅᑉ.

ᖬᑫᑦᑕᓄᑉ ᐃᖅᑲᐅᒪᖬᖰᐱᖬᓇ...

ᐸᓄᖧᑉ ᐃᑕᑉ ᓇᓄᖧᖧᖆᐅ ᐅᑕᖅᑭᑦᑕᖆᖰᓄᐊᖬᓄᖧᖬ.... ᐅᖬᒥᖬᓇ ᐃᖧᐸᐊᑯᖬᖬ ᖬᖲᒎᑉ ᐅᖬᖧᖲᖧ
ᓄᐱᖬᓇ ᖆᖆᐅᖧᑎᐊᖧᓄᐊᖧᑦ ᐊᐅᖲᖧᖧᑭᒉᒉ.

ᐅᓚᖬᑉ ᐸᖬᓇ⊃ᓄᖧ ᓄᐅᐱᐅᐅᐅᑐᖧ ᓄᒪᖬᖬᐄᓄᑉ ᐅᖬᖧᖬᖧᖧ ᐃᑉ ᖃᖬᐊᓇ ᓇᖧᐅᐃᐊᖬᖬᑉ. ᖬᑫᑦᑕᓄᑉ
ᐅᖬᖲᑎᖬᑎᒉᓇ ⊃ᓄᖬᖫᑉ, ᓇᖬᒥᒎ ᓇᖫᑎᖬᖧᖧ.

ᖬᑫᑦᑕᓄᑉ ⊃ᓄᖬᖫ ᖤᓇᖰᖆᓄᐊᖬᖰᖬᑦ ᖃᖲᖪᖫᖬᖰᑎᖬᐊᑯᐅᑉᖬᓄᖬᖧᐸᑦᑦ.

ᓇᖲᖧ ᓄᑕᖦᖆᖧᖔᑉ ᐃᖪᖧᖃᑦᑐᑎᓇᑐᐅᖧᓄᖬ, ᖬᑫᑦᑕᓄᑉ ᖅᒪᖫᐊᑖ ᖧᓇᒥ ᖧᖧᓄᐊᖧᖮᖨᐅᑦ.
ᖅᒥᖫᓇᑉ ᖧᖲᖆᐅᑎᒥᖤᑎᐊᖧᓇᑉ ᓄᐊᑎᓇᖧᑦ, ᖅᒎᑎᒥ ᐅᐃᖲᐅᐊ ⊃ᐱᖬᓇᑐᑉ ᐃᖧᖧᖬᖲᑦ. ᓇᐅᑖᖬᖬ
ᐅᖲᓇᑕ⊃ᐃᖬᑎᒎᓇ ᐃᖳᐱᖧᖬ, ᖬᑫᑦᑕᓄᑉ ᖬᖤᖧᖬᓇ ᐅᖧᓄᖲᑎᑎᒉᒉᖫᖬᖧ ᖅᒎᑎᒥ ᖤᓇᑎᓇᖧᖬᓇ.

ᖬᑫᑦᑕᓄᑉ ᐊᑕᑉ ᐊᒉᐃᐅᑉ... ᓚᖬᖮᑎᑎ.

ᐊᖬᖲᐊᖬᖮᖬᒉᒎᖧ ᖤᖬᖧᖰᖬᓇᓇ ᐸᓄᖧᖤᒥᖧ ᖧᖬᐄᖬᐊᒎᓇ ⊃ᓄᖬᖫᖬᑦ ᐃᓄᐅᐊᖆᑎᓇᖧ ᐃᑉ ᖃᖬᐊᓇ ᓇᖧᐅᑐᖧ.
ᐃᖤᖧᖮᑐᖨᖰᖬᒉᒉᑎᑎᒎᓇ ᐊᖬᖰᖲᑐᖬᑉ ᖅᒥᖫᖬᑦ ᖤᖬᖬᖬᐅᑐ.

ᑎᑎᖤᑦᑦ ᓇᓇ⊃ᐱᑎᑦᑦ........

ᖤᖲᖬᖬᖲᑦᑦ ⊃ᓄᖬᖫᑦ ᐅᖬᖰᑭᖲᖧᖬᒉᐊᓇ ᐊᖲᖧᐊᑯᖧᖰᖬᑭᖧᖧ, ᓄᖧᖰᑐᖲᖫᑎᓇᒎ ᐃᖫᖧᖬ
ᑕᖧᖬᐅᖆᖧᑐᖬᐊᖧᐊᒎᖰᓇᑎᑉ, ᐃᓄᖤᖬᑦ ᑕᖆᖬᐃᐊᖬᐊᖬᖧᐅᖲ, ᐊᒪ ᖅᒎᖬᖬᖧᑦ.

ᐅᓇᖤᖭᑐᖧ ᐊᒉᖲᑉ (ᓇᖬᖤᖬ) ᖅᒎᖬᖧᖲᖬᑦ, ᐃᖲᖧᐅᑎᖲᐅᖬᖧ.... ᓇᑕᑎᖬᑎᖬᑎ. ᐅᖬᖧᖲᖬ ᐊᒉᖲᖬᑦ,
ᐃᓄ⊃ᖤᐅᑭᖲᑐᖲᖧ. ᐅᐅᑎᖤᖦᖬᐊᖲᖰᖬ ᖅᒎᖬᖲᖬᖲᖰᖬᑉ ᐊᖮᒪᒎ ᐃᖲᖧᐅᑦᑭᖲᖬᑎᖲᖧ.......ᖬᖲᐊᑕᖮᐅᖧᖰᖬᑭᖲᖬ ᐃᖮᒉᒉᖬᖬᑦ
ᐅᖲᖬᖬᑦ ᐃᓇᐊᖬᑕᑕᖆᐅᑕᖧᖰᖬᑎᖲᖰᖬ, ᑕᖤᖲᖬᓇ ᑎᓇᖲᑦ ᖅᒉᖤᓇᖬᒉᑎᓇᑎᒎ ⊃ᖲᖧᑎᓇᐊᐅᑭᖲᖰᖬᒥᒥᖧ ᐊᒉᖮᖤ
ᓇᖲᖬᖰᒉᒉᖬᐅᑭᖲᖰᖬᒉᑭᖲᖬ.....

ᖤᖭᖧᖬᖬᖰᖬᐊᐅᖧ...

TUURNGARJUAQ And now I'll take what I want.
Dangerous, threatening pause. While still looking at Panikpak...
TUURNGARJUAQ (CONT.) ...You, Qulitalik! *(turns slowly to face him)* Stay in this camp...if you want to.
Qulitalik meets his glance, then looks down as if considering it. From the corner of his eye he sees his sister Panikpak...
EXTREME CLOSE-UP of Panikpak's urgent unmistakable No! indicated by a minute squint of her eyes. Qulitalik stands. Casual...
QULITALIK Yes, of course...but we're leaving tomorrow for a caribou hunt...up that way.
He smacks his mitts together, ready to go. This breaks the deadly tension. With visible relief that the horror has ended at least for now, people stand up murmuring quietly. Tuurngarjuaq smiles as if the camp now belongs to him, with everyone in it. Sauri stands proudly wearing his new necklace and a new attitude.
CLOSE ON young Tulimaq and his wife in their seats, heads hanging low. Tulimaq looks up slowly. Empty, bleak, hopelessly disbelieving, like a man who fell from a horse and heard his neck snap, his face reveals the destruction of his confidence and his future in a single heartbeat.
Qulitalik and Panikpak move forward to lay down gently her husband's lifeless body. Brother and sister lean in to each other, blocking the murderous stranger's view. Panikpak secretly takes from her sleeve a rabbit's foot on a leather thong.
PANIKPAK *(under her breath)* My husband's...
As if reaching to touch her husband's body, she slips the rabbit's foot into her brother's hand. Qulitalik immediately slides it into his own sleeve. Their eyes meet for an instant, then turn away. Across the emptying floor, the dead man's favourite, Tulimaq, watches them, stunned and bewildered by his sudden change of fate. His desperate eyes and the ugly bruise on his forehead, reveal his sudden increasing aloneness.

EXTERIOR CAMP NEXT DAY
CLOSE-UP of Qulitalik bending over. He spits a slow mouthful of water onto a small piece of caribou skin in his hand. Using the wet rag, he freshly ices the runners of his overturned sled. Behind him his wife harnesses their dogs. Early morning, dry and cold. A pale yellow sun shines without heat. Several igloos, but only the desperate young

ᐸ�ᐃᓪ ᐊᐸᒃ ᐊᖏᕐᑭᖅ (Paul Apak Angilirq) et al., ᐊᑕᓇᕐᔪᐊᑦ / *Atanarjuat: The Fast Runner* (Toronto: Coach House / Montreal: Isuma, 2002). 218 × 279 mm (8½″ × 11″). DESIGN: Stan Bevington.

The syllabic text face is Naamajut, created in digital form by Michael Everson in the early 1990s, based on a design produced in Iqaluit in 1983. The syllabic titling face is Tunngavik (originally known as ProSyl), designed in Iqaluit in 1996 by Saali Peter. The Latin face, used for both titling and text, is Cartier Book, designed by Carl Dair and revised by Rod McDonald.

This is the screenplay for the film *Atanarjuat*, directed by Zacharias Kunuk, released in 2001. Most of the illustrations in the book are stills from Kunuk's film.

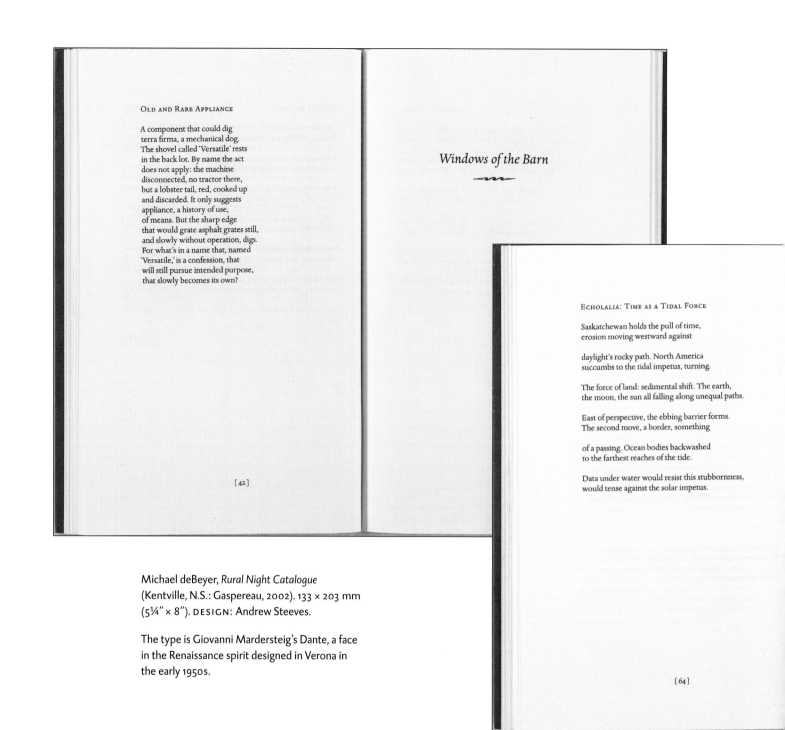

OLD AND RARE APPLIANCE

A component that could dig
terra firma, a mechanical dog.
The shovel called 'Versatile' rests
in the back lot. By name the act
does not apply: the machine
disconnected, no tractor there,
but a lobster tail, red, cooked up
and discarded. It only suggests
appliance, a history of use,
of means. But the sharp edge
that would grate asphalt grates still,
and slowly without operation, digs.
For what's in a name that, named
'Versatile,' is a confession, that
will still pursue intended purpose,
that slowly becomes its own?

[42]

Windows of the Barn

ECHOLALIA: TIME AS A TIDAL FORCE

Saskatchewan holds the pull of time,
erosion moving westward against

daylight's rocky path. North America
succumbs to the tidal impetus, turning.

The force of land: sedimental shift. The earth,
the moon, the sun all falling along unequal paths.

East of perspective, the ebbing barrier forms.
The second move, a border, something

of a passing. Ocean bodies backwashed
to the farthest reaches of the tide.

Data under water would resist this stubbornness,
would tense against the solar impetus.

[64]

Michael deBeyer, *Rural Night Catalogue*
(Kentville, N.S.: Gaspereau, 2002). 133 × 203 mm
(5¼″ × 8″). DESIGN: Andrew Steeves.

The type is Giovanni Mardersteig's Dante, a face
in the Renaissance spirit designed in Verona in
the early 1950s.

It was normal in the 19th century for Canadian publishers to set and print their own books, and for printers to indulge, intermittently or otherwise, in the adventure of publishing books. As the industry grew, publishers confined themselves to publishing, and printers strayed into publishing less and less often. Coach House Press (founded in 1965), the Porcupine's Quill (founded in 1974), and Gaspereau Press (founded in 1997) are among a small number of thriving publishers who have consciously and deliberately reasserted the older connection between physical and intellectual making.

Books produced by these houses are typically distinguished by their superior paper, presswork, and binding, as well as by their typographic refinement, subtlety of design, and an openness to both technical and literary experiment. Some of these characteristics are photographable; others are not. Readers are often drawn to these books by a quality they may not be able to name – and which, indeed, the camera cannot capture. That quality is workmanship.

NOCTILUCENCE

We step outside of the tent, and walk towards the river. The pathway spreads before us like a carpet unrolling, us always at its head. You remark on the open space, the freedom written there: lazy lunar glow, the trees combed back into the forest. Stellar space seems to contract, atmospheric exhale in the rib cage of this night.

At the river, you turn to look at me and for one moment our eyes lock together; we cannot separate our gazes; we are drifting into one another in pure, liquid empathy. United, your eyes I am looking back into my own startled complexion, our bodies still other identities refusing to submit. By increments we are falling into the river, slow motion, our bodies no longer individual enough to break the fall. Our joint submersion. The rippled lines escape from us, and diminish and diminish there, against the shore. The last landmark of us smoothed over by the force of the river.

We feel our, I feel my limbs growing colder, and watch them through the water become translucent and separate, carried by the current. You the I cast a glance at our simplicities, our personalities merging into a great complexity. Our telepathic becoming. Our thoughts fused, a conscious liquidity.

[65]

GASPEREAU PRESS • PRINTERS & PUBLISHERS • MMII

Rural
Night
Catalogue

Michael deBeyer

[177]

Robert Bringhurst, *Ursa Major:*
A Polyphonic Masque for Speakers
and Dancers (Kentville, N.S.:
Gaspereau, 2003). 190 × 278 mm
(7½″ × 11″). DESIGN: Andrew Steeves
TYPOGRAPHY: Andrew Steeves &
Robert Bringhurst.

There are five speakers in this
masque, speaking four different
languages (English, Latin, Greek,
and Cree), as well as a translator to
keep them in touch with one another
and their auditors or readers. The
Latin type is Dante, designed by
Giovanni Mardersteig. The Greek
is New Hellenic, designed by Victor
Scholderer. (New Hellenic, like Dante,
is a 20th-century face based on late
15th- and early 16th-century models.)
The syllabic face is Ross Mills's
Uqammaq, designed in Vancouver
in 2001.

Hera [*continuing without interruption, returning again to her song, now in sustained*
polyphony with Ovid's Daughter, the Celestial Janitor and the Translator]:

Καλλιστὼ κατέπεφνεν ἀπ᾽ ἀργυρέοιο βιοῖο....
... ἀπ᾽ ἀργυρέοιο βιοῖο ...

Celestial Janitor [*speaking in Greek, over Ovid's Daughter's continuing Latin*
and Hera's closing song]:
Translator [*breaking off from translating the Latin, turning to the Greek*]:

ταύτην Ἡσίοδός φησι Λυκάονος θυγατέρα
 Hesiod says she was the Wolf Man's daughter,
ἐν Ἀρκαδίᾳ οἰκεῖν,
 living in Arcadia,
ἑλέσθαι δὲ μετὰ Ἀρτέμιδος
 a member of Artemis' band,
τὴν περὶ τὰς θήρας ἀγωγὴν
 travelling the game trails
ἐν τοῖς ὄρεσι ποιεῖσθαι....
 out there in the mountains....

περὶ τοῦ Βοώτου τοῦ καὶ Ἀρκτοφύλακος ...
 As for the Cowherd or the Bearguard ...
περὶ τούτου λέγεται, ὅτι Ἀρκάς ἐστιν
 they say that he is actually Arkas,
ὁ Καλλιστοῦς καὶ Διὸς γεγονώς·
 the son of Callisto and Zeus,
ᾤκησε δὲ περὶ τὸ Λύκαιον.
 who lived in the country of the Wolves.

Hera [*breaking off her song with a knowing laugh*]:

That's not the only thing they say.

SCENE FOUR

(ARCTURUS DREAMS)

SPEAKERS: KÂ-KÎSIKÂW-PÎHTOKÊW'S SON, TRANSLATOR,
ARCTURUS, CELESTIAL JANITOR, HERA
DANCERS: CALLISTO, ARCTURUS, HERA, MOON WOMAN

THE FIRST THREE VOICES ARE SIMULTANEOUS, THEN
THE FIRST, SECOND AND FOURTH. AT THE END OF THE SCENE, WHEN ALL BUT
THE CELESTIAL JANITOR ARE SILENT, HERA BRIEFLY JOINS HIM.

Kâ-kîsikâw-pîhtokêw's Son [*speaking in Cree*]:
Translator [*sotto voce*, with a slight delay, speaking in English]:

«ᐊᐧᐦᕀᐅ ᐅᑌᐦ ᐁᐦ ᐃᐧᑭᔭᕽᕽ,» ᐃᑌᐤ ᐊᐊ ᐃᐢᙫᐤ.
"Wâhyaw ôtêh êh-wîkiyâhk," itwêw aw îskwêw.
> "We live a long way away from here," the woman said.

«ᑭᔭᒼ ᒥᔭᒋᔨᓂᐦ"
"Kiyâm miyâciyinih
> "Please, when you go hunting,

ᒥᐢᑕᐦᐃ ᐯᑖᐦ ᐃᐧᔮᕀ,
mistahi pêtâh wiyâsah;
> get a lot more meat,

ᓄᐦᑌᐦᑲᑌᐊᐧᐠ,» ᐃᑌᐤ ᐊᐊ ᐃᐢᙫᐤ,
nôhtêhkatêwak," itwêw aw îskwêw,
> because they're hungry," said the woman.

Jan Zwicky, *Wisdom and Metaphor* (Kentville, N.S.: Gaspereau, 2003). 186 × 276 mm (7¼″ × 11″). DESIGN: Andrew Steeves.

The type is Rod McDonald's Laurentian.

Wisdom and Metaphor (like the same author's earlier *Lyric Philosophy*) is a series of paired texts. Each pair, whatever its length, is allotted a single spread – one scene, as it were, in the play – and on each spread a conversation unfolds. Zwicky speaks on the lefthand page; one or more of her interlocutors (mathematicians, poets, philosophers, living and dead) speaks on the right. The musical shape of the argument is crucial, and some of this shape is conveyed through the judicious use of typographic space.

Each spread is not only a scene but a kind of map of the intellectual geography. As in many atlases, numbers are assigned to spreads instead of pages.

"But what about seeing it as an image of bureaucracy, or high school, or the accounting profession?"——As a *box*, it has resonant connexions with the strait-jacket; and as such it may indeed be seen as an image of rigidity and containment. "But then can't it also be seen as an image of transparency or clarity—and therefore associated with a kind of freedom (unclutteredness, disentanglement)? In other words, it can be seen as a box projecting up and to the right, a box projecting down and to the left, as an image of imprisonment, and as an image of freedom. Maybe it can't be seen as *anything*, but it can be seen as enough things to make the accusation of relativism stick."

The relation between as an image of freedom and as an image of imprisonment does not involve the gestalt shift that is crucial to wisdom. We are not suddenly enlightened about *connexions* between the *phusis* of freedom and the *phusis* of imprisonment; we don't ride the hinge of what-is-common to experience their ontological indisseverability. We notice the figure has *some* things (though not a lot) in common with x, and some other things (again, not a lot) in common with y. Other figures that were not identical to each other would do just as well;

IMPRISONMENT FREEDOM

many possess features that would allow them to serve as (minimally) plausible symbolic representations of those concepts. That is, the relation between the figure-as-image-of-imprisonment and the figure-as-image-of-freedom is external. But the relation between the up-and-left-projecting box and the down-and-right-projecting box is internal; it could not *be* the one without also *being* the other (whether we see this or not).

Wisdom is alive to internal relations between forms of life. If there were no such internal relations, it would be impossible to be wise.

LEFT 98

Ludwig Wittgenstein

[4.122] (Instead of 'structural property' I also say 'internal property'; instead of 'structural relation', 'internal relation'.

I introduce these expressions in order to indicate the source of the confusion between internal relations and relations proper (external relations), which is very widespread among philosophers.)

It is impossible, however, to assert by means of propositions that such internal properties and relations obtain: rather, this makes itself manifest in the propositions that represent the relevant states of affairs and are concerned with the relevant objects.

4.123 A property is internal if it is unthinkable that its object should not possess it.

Jan Zwicky Wisdom & Metaphor

GASPEREAU PRESS KENTVILLE, NOVA SCOTIA MMIII

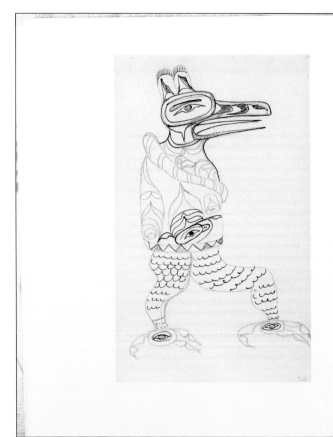

Doris Shadbolt

S E V E N
J O U R N E Y S

THE SKETCHBOOKS
OF EMILY CARR

Douglas & McIntyre
VANCOUVER/TORONTO

University of Washington Press
SEATTLE

facing page:
*(Standing fish and bird
creature)* 1927
Graphite on paper, 24.2 × 15.3 cm
B.C. Archives PDP08855
Drawn from an artifact
in the Canadian Museum
of Civilization

JOURNEY ONE

Toronto, Ottawa and Montreal, 1927

THE RESTORATION of Emily Carr's confidence in 1927 was partly due to the simple fact of her inclusion in the important national exhibition, *Canadian West Coast Art, Native and Modern*, a decision made by art officials. But she also needed the approval of her artistic peers to confirm that decision. On her journey to Ottawa, she stopped off in Toronto, where there was by now an established art scene, and she was taken in hand by the leading circle of the artists' community, those around the Group of Seven.

By this time, the members of the Group of Seven, with the support of the National Gallery, were well known as the most significant artists in English-speaking Canada. Carr, isolated on the west coast from the larger art world in eastern Canada, had heard of their existence for the first time just prior to her departure and had learned about their nationalist mission and ideology from Frederick B. Housser's defining book about them, *A Canadian Art Movement*.

(Handwritten text) 1927
Graphite on paper, 15.2 × 24.8 cm
B.C. Archives PDP06868
reverse side 1

Dec 4
I am at the 'Grange' a last
look before going home there
is a little picture Ex. on. They
have moved West Wind. It is
not in quite such a good place,
but always wonderful, it is
not so very large. The color is
luscious. The foreground is
rocks, there are warm &
cold reds, rich greens purple
greys. The thin trunks of the
pines are red. One is thick &
another solid but the other
two have been beaten &
twisted by the wind the
leaves hang heavily in blobs
of warm green with the cold
red stalks the sky is full of
breezy clouds stormy wind
tossed & the hills are blue &
green dull and [?]. The water
is full of color & movement.

A beautiful small J.E.H.
McDonald hangs next, in
color & design it is joyously
beautiful the mountains are
draped in heavy mist forms
solidly put in swirly masses
there are two red canoes &
reflections.

There is a delightful Jackson
here too

(Handwritten text) 1927
Graphite on paper, 15.2 × 24.8 cm
B.C. Archives PDP06868
reverse side 2

It is easy to pick out the
Group things they are so
much bigger in feeling.
McDonald's group of 7 small
ones are mostly rocky [sic]
[?], strong & delightful in
color & mood

Jackson's are big swell things
all different snow autumn &
sunshine

Casson's don't interest me

Lismer's are boring I feel the
paint a little, how I wish I
could do as well

I can't feel Carmichael.

Harris's are at the end of a
big gallery, they are alone
somehow when you enter the
gallery the others die they
are a different time a different
place a different world. There
is always that dignity &
spirituality, spaces filled with
thoughts that rest soothe
comfort make you so happy

Doris Shadbolt, *Seven Journeys: The
Sketchbooks of Emily Carr* (Vancouver:
Douglas & McIntyre, 2002).
192 × 228 mm (7½″ × 9″). DESIGN:
Peter Cocking.

The type is Hermann Zapf's Aldus.

THE DRIVER

was waiting for me at the airport, just as

I'd been told he'd be. I could see him even be-

fore I came through: as I stood by the carousel, as

I looked for a free luggage cart, as I handed the customs

David Albahari, *Snow Man*, translated by
Ellen Elias-Bursać (Vancouver: Douglas
& McIntyre, 2005). 140 × 215 mm
(5½″ × 8½″). DESIGN: Peter Cocking.

The type is a digital adaptation of Rudolph
Růžička's Fairfield.

officer the filled-out form. The exit door slid open and
shut automatically, but each time, regardless of where I was,
I could see the driver standing in the same place, wearing
some sort of uniform with a brimmed cap, holding a sign
with my name written on it in blue chalk. Afterwards I
found out it wasn't blue chalk but blue marker, and the sign
wasn't a proper sign but a jagged piece of cardboard. That
happened a little later, when, pushing my bulging duffle
bag along in front of me, I left the transit area and walked
through the narrow, partitioned passageway that was like
a funnel emptying into the world. "Into the world" were,
indeed, my words, words I had been repeating all through
the flight, words that first occurred to me when I woke up
in the middle of a storm, while the airplane was creaking
and shuddering and the flight attendants were calming
anxious travelers. I opened my eyes and looked at the dark,
swirling clouds, and while from the earphones—still in my
ears—I could hear the monotonous jazz beat of a big band,
I thought, "Into the world," in so many words, simply, as
if I couldn't have journeyed any other way than by passing
through a storm. The plane plunged for an instant, and
I thought my stomach was going to come up and out of
my mouth. "Into the world," I said and felt peace of mind
return, as if my body helped the aircraft right itself, the
storm to quiet, the flight attendant to rest her hand on the
forehead of an old woman sitting the next seat over. None of
this could last long—words, after all, are always slower than
the truth—and when I opened my eyes again, the plane

SNOW MAN

was nearing the runway, parts of the wings were raising
and lowering, and I felt a familiar nausea. I walked out, legs
wobbly, which I attributed to fear, and followed the crowd
of travelers. The edges of the prefabricated wall partitions,
masked in plastic, passed by me as I walked, and then there
were signs in a number of languages that informed of cer-
tain regulations, invoked articles of laws, announced
passport control and requested the preparation of immigra-
tion documents. A family from India or Pakistan stood in
front of one sign, and the men carefully compared their
papers with the numbers and letters on the lit surface. In
the corner of the corridor, leaning against a wall, an elderly
woman was trying to reattach the heel on her right sandal.
Another woman, much younger, sat on a bench. Next to her,
a man wearing a hat tied his shoelaces. A second man, who
couldn't have had anything to do with them, wiped his fore-
head. The passport official was young, barely more than a
boy, though his voice was deep and firm. The whole airport
was no more than a cluster of sentences, but if it hadn't
been for those sentences, I would have already keeled over.
I was on my feet thanks to words, something I would never
have believed if someone else had told me. I was kept in
one piece by letters, words held me; I breathed thanks to
punctuation. Letters appeared on the board, writing out the
flight number, and little suitcases flitted across the screen,
announcing that the baggage was about to arrive. Then the
exit door slid open, and then closed again, but that was
enough for me to catch sight of the driver: he was waiting

Vancouver Cooks,
edited by Jamie
Maw & Joan
Cross (Vancouver:
Douglas &
McIntyre, 2004).
176 × 266 mm
(7″ × 10½″).
DESIGN: Peter
Cocking.

The text face
is Whitman,
designed in the
USA by Kent Lew in
2001. The sanserif
is Neutraface,
designed in the
USA in 2002 by
Christian Schwartz
based on signage
by the architect
Richard Neutra.

Food books
are, throughout
the world, and
with remarkable
consistency, either
underdesigned or
overdesigned. The
two shown here
are refreshingly
neither — and
therefore unusually
pleasant to read.

| ARAXI: *james walt* |

Smoked Tuna Broth with Seared Tuna

KOMBU IS a flavourful dried kelp that is often covered with a powdery white substance. Lightly brush off some of this powder before using the kombu. Mirin is a sweet rice wine. Both of these ingredients are available in Japanese specialty stores.
Serves 4

Place water, kombu, ginger and dried mushrooms in a saucepan on medium heat. (Be sure to start with cold water to make a clear broth.) Bring to a boil and remove from the heat immediately. Add bonito flakes, cover and let steep for 20 minutes.

Strain through a fine-mesh sieve and discard solids. (Do not press the solids or the broth will be cloudy.) Gently stir in soy sauce, mirin, vinegar and sugar. (If not using immediately, cool to room temperature and refrigerate. Will keep in the refrigerator, covered, for up to 4 days, or frozen for up to 3 months.)

Reheat broth in a saucepan on medium heat. Add noodles and fresh mushrooms, then cook until piping hot.

Season tuna with sea salt and a generous amount of freshly cracked black pepper. Heat a dry nonstick frying pan on medium-high heat. Sear tuna on one side for 30 to 40 seconds, then turn over and sear for 30 to 40 seconds. Transfer to a warmed plate and cut into slices ¼-inch thick.

TO SERVE: Ladle noodles, mushrooms and broth into individual bowls and top with warm tuna slices.

WINE: Pair the tuna with either a white—Sandhill's fresh Pinot Blanc, or a red—the unique Lake Breeze Pinotage.

8½ cups cold water
1 stick kombu, 5 inches long
1-inch piece fresh ginger, sliced
4 dried shiitake mushrooms
2 oz. bonito flakes
1½ cups light soy sauce
⅓ cup mirin
3 Tbsp. + 2 tsp. Japanese seasoned rice vinegar
3 Tbsp. sugar
8 oz. soba noodles, cooked as directed on package and cooled
½ cup (about 4) fresh shiitake mushrooms, destemmed and sliced
1 lb. albacore or Ahi tuna, in 4 equal portions

13

DEVILS IN DISGUISE

The role that color plays in the way we view beer should never be underestimated. While we may not always be aware of it, we view darker beers differently than lighter ones. And the most common misperception we make about them concerns strength.

Perhaps because we think that darker beers should have more "stuff" in them, we tend to expect them to be stronger. In some cases, as with bocks and abbey-style ales, this is true. But in many instances, lighter-colored beers are stronger than darker ones. Britain's lighter-colored India pale ales, which are 2% or more greater in strength than that country's ebony mild ales, are one example of this phenomenon, and the golden-to-amber styles detailed in this section spell out four more excellent instances where looks can be deceiving.

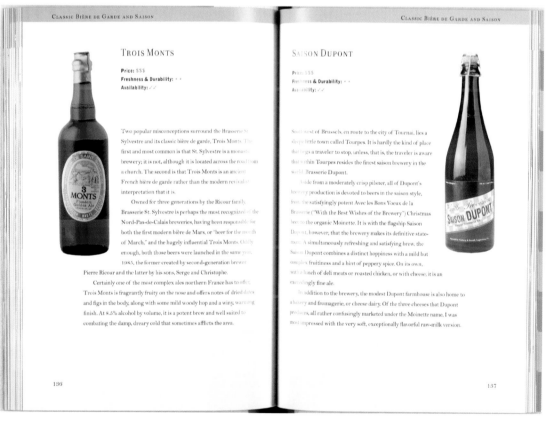

TROIS MONTS

Price: $$$
Freshness & Durability: • •
Availability: ✓

Two popular misconceptions surround the Brasserie St. Sylvestre and its classic bière de garde, Trois Monts. The first and most common is that St. Sylvestre is a monastic brewery; it is not, although it is located across the road from a church. The second is that Trois Monts is an ancient French bière de garde rather than the modern revival or interpretation that it is.

Owned for three generations by the Ricour family, Brasserie St. Sylvestre is perhaps the most recognized of the Nord-Pas-de-Calais breweries, having been responsible for both the first modern bière de Mars, or "beer for the month of March," and the hugely influential Trois Monts. Oddly enough, both those beers were launched in the same year, 1985, the former created by second-generation brewer Pierre Ricour and the latter by his sons, Serge and Christophe.

Certainly one of the most complex ales northern France has to offer, Trois Monts is fragrantly fruity on the nose and offers notes of dried dates and figs in the body, along with some mild woody hop and a winy, warming finish. At 8.5% alcohol by volume, it is a potent brew and well suited to combating the damp, dreary cold that sometimes afflicts the area.

SAISON DUPONT

Price: $$$
Freshness & Durability: • •
Availability: ✓ ✓

Southwest of Brussels, en route to the city of Tournai, lies a sleepy little town called Tourpes. It is hardly the kind of place that begs a traveler to stop, unless, that is, the traveler is aware that within Tourpes resides the finest saison brewery in the world, Brasserie Dupont.

Aside from a moderately crisp pilsner, all of Dupont's brewery production is devoted to beers in the saison style, from the satisfyingly potent Avec les Bons Voeux de la Brasserie ("With the Best Wishes of the Brewery") Christmas beer to the organic Moinette. It is with the flagship Saison Dupont, however, that the brewery makes its definitive statement. A simultaneously refreshing and satisfying brew, the Saison Dupont combines a distinct hoppiness with a mild but complex fruitiness and a hint of peppery spice. On its own, with a lunch of deli meats or roasted chicken, or with cheese, it is an exceedingly fine ale.

In addition to the brewery, the modest Dupont farmhouse is also home to a bakery and fromagerie, or cheese dairy. Of the three cheeses that Dupont produces, all rather confusingly marketed under the Moinette name, I was most impressed with the very soft, exceptionally flavorful raw-milk version.

136

137

Stephen Beaumont, *Premium Beer Drinker's Guide: The World's Strongest, Boldest and Most Unusual Beers* (Willowdale, Ontario: Firefly Books, 2000). 178 × 254 mm (7″ × 10″). DESIGN: Linda Gustafson.

The type is Monotype Bell, a digital revival of a plain Neoclassical English face cut in London in 1788 by Richard Austin. Virtually all of Austin's work – by virtue of its Englishness, its sturdiness, and its utter lack of pretension – belongs on the beer list more than the wine list of typography. Yet Bell is without doubt a premium brew: the work of one who knew and loved his craft.

THIS PAGE: Lino, *La Saveur du vide* (Montréal: Les 400 Coups, 2003). Dessins de Lino. 225 × 304 mm (8¾″ × 12″). DESIGN: Tomasz Walenta.

FACING PAGE: Lino, *L'Ombre du doute* (Montréal: Les 400 Coups, 2006). Dessins de Lino. 225 × 305 mm (8¾″ × 12″). DESIGN: Tomasz Walenta.

"Lino" is the Montreal artist and illustrator Alain Lebrun.

[*See also p 99*]

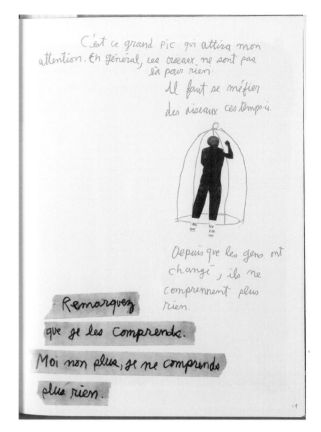

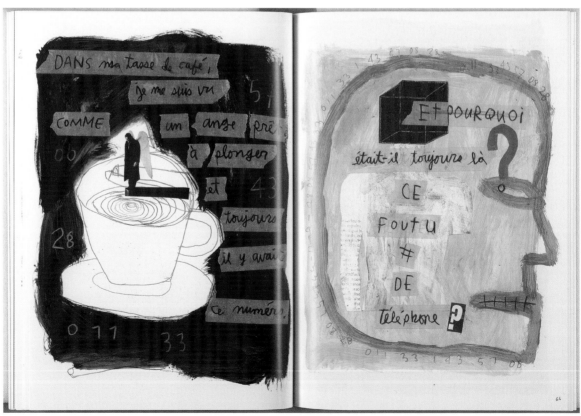

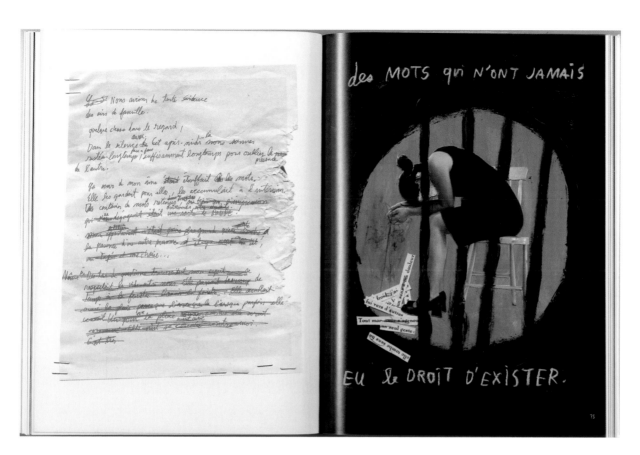

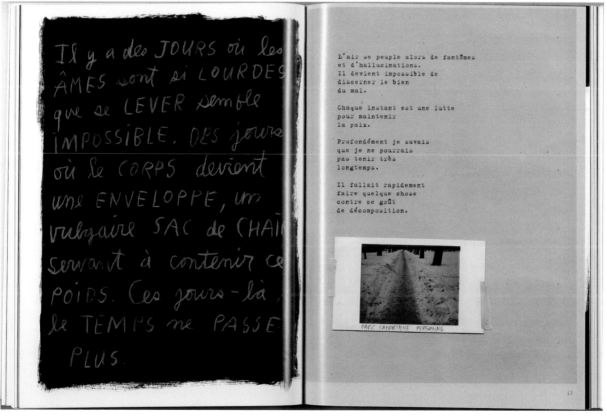

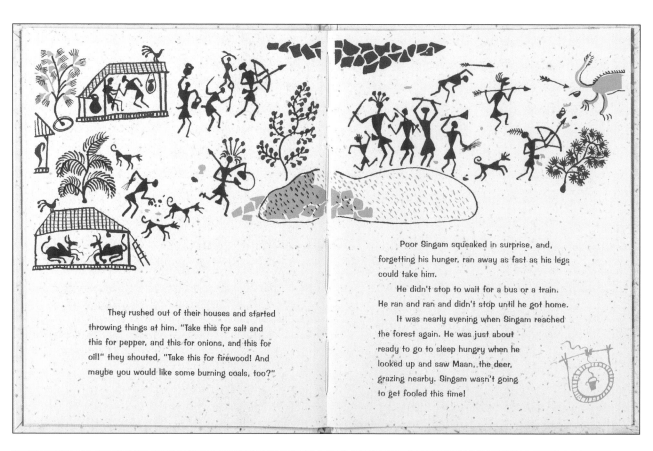

They rushed out of their houses and started throwing things at him. "Take this for salt and this for pepper, and this for onions, and this for oil!" they shouted, "Take this for firewood! And maybe you would like some burning coals, too?"

Poor Singam squeaked in surprise, and, forgetting his hunger, ran away as fast as his legs could take him.

He didn't stop to wait for a bus or a train. He ran and ran and didn't stop until he got home.

It was nearly evening when Singam reached the forest again. He was just about ready to go to sleep hungry when he looked up and saw Maan, the deer, grazing nearby. Singam wasn't going to get fooled this time!

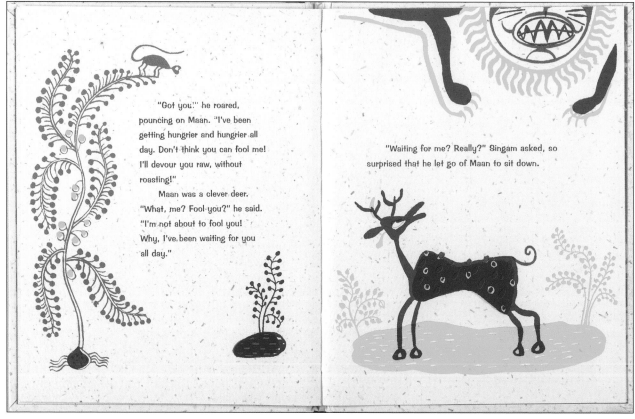

"Got you!" he roared, pouncing on Maan. "I've been getting hungrier and hungrier all day. Don't think you can fool me! I'll devour you raw, without roasting!"

Maan was a clever deer. "What, me? Fool you?" he said. "I'm not about to fool you! Why, I've been waiting for you all day."

"Waiting for me? Really?" Singam asked, so surprised that he let go of Maan to sit down.

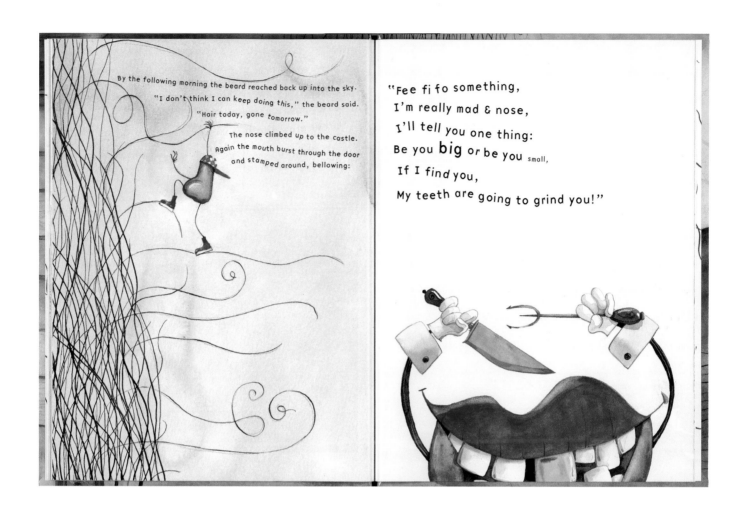

By the following morning the beard reached back up into the sky.

"I don't think I can keep doing this," the beard said.

"Hair today, gone tomorrow."

The nose climbed up to the castle. Again the mouth burst through the door and stamped around, bellowing:

"Fee fi fo something,
I'm really mad & nose,
I'll tell you one thing:
Be you **big** or be you small,
If I find you,
My teeth are going to grind you!"

FACING PAGE: Gita Wolf, *The Very Hungry Lion* (Toronto: Annick, 1996). Illustrations by Indrapramit Roy. 240 × 262 mm (9½″ × 10½″). DESIGN: Indrapramit Roy.

THIS PAGE: Gary Barwin, *The Magic Mustache* (Toronto: Annick, 1999). Illustrations by Stéphane Jorisch. 200 × 265 mm (8″ × 10½″). DESIGN: Andrée Lauzon.

The text face in *The Very Hungry Lion* is Bitstream Impress. Many informal sanserifs of this nature were designed in the 1950s by New York lettering artists such as Peter Dombrezian and James D'Amico, and one distinguished example was designed by the French typographer René Ponot (who gave it the unmemorable name *Pssitt*). A few of these faces were cut in metal, but most were used only for photosetting single lines of display type or very short advertising texts. The origins of this particular face, however, remain mysterious. There is a strong possibility that it was designed by another New Yorker, Emil Klumpp.

The text face in *The Magic Mustache* is Zuzana Ličko's Base 9 Sans, designed in California in the early 1990s.

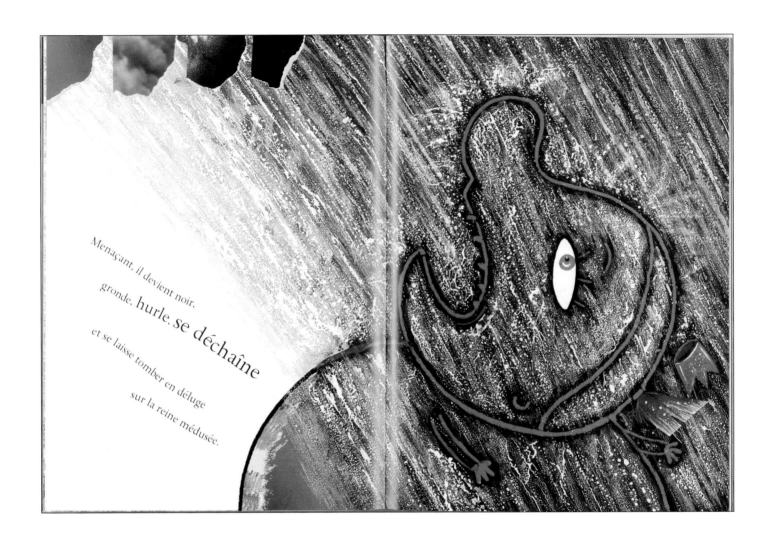

Menaçant, il devient noir,
gronde, hurle, se déchaîne
et se laisse tomber en déluge
sur la reine médusée.

Philippe Béha, *La Reine rouge* (Montréal: Les 400 Coups, 2001). Illustré par Philippe Béha. 224 × 305 mm (9″ × 12″). DESIGN: Philippe Béha.

The type is Jan van Krimpen's Spectrum – a face of Renaissance purity, all too rarely seen in books for children.

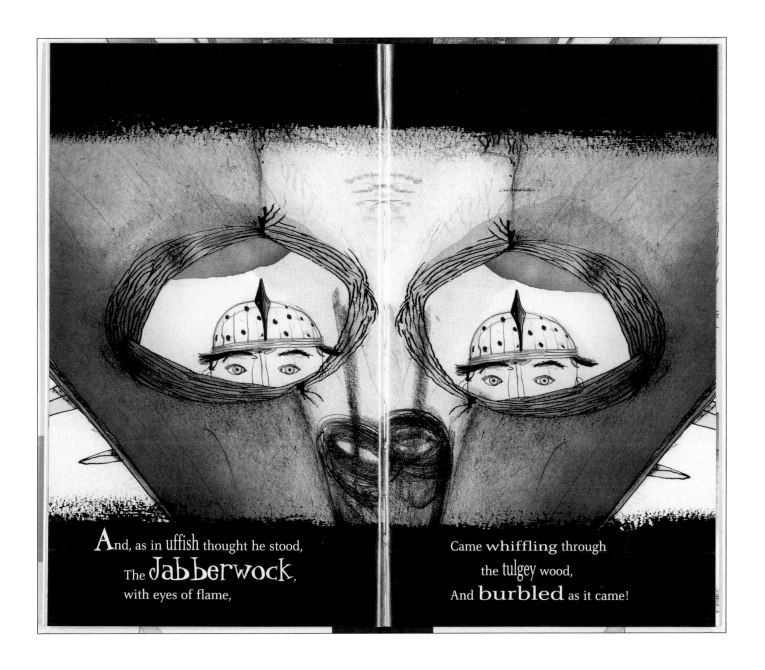

And, as in uffish thought he stood,
The Jabberwock,
with eyes of flame,

Came whiffling through
the tulgey wood,
And burbled as it came!

Lewis Carroll, *Jabberwocky* (Toronto: Kids Can Press, 2004). Illustrations by Stéphane Jorisch. 176 × 266 mm (7″ × 10½″). DESIGN: Karen Power.

The basic text face – squeezed, stretched, enlarged, and reduced from word to word as whim or circumstance requires – is Chris Burke's normally sober Celeste, designed in England in 1995. The wonkier letters that herald the Jabberwock belong to a typeface known as Daddy-O Hip. This was designed by Richard Kegler in conjunction with a show of Beat Generation art and design held in 1995 at the Whitney Museum, New York.

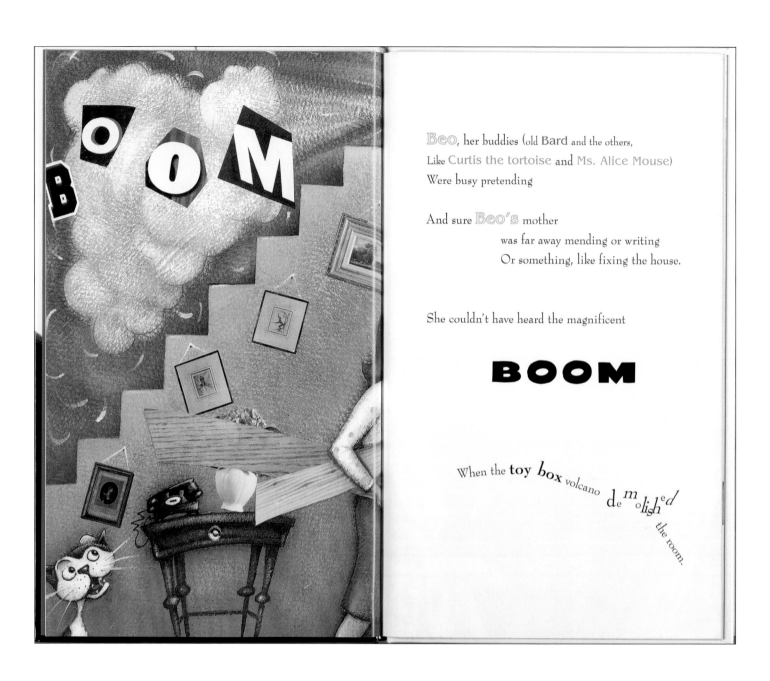

Beo, her buddies (old Bard and the others,
Like Curtis the tortoise and Ms. Alice Mouse)
Were busy pretending

And sure Beo's mother
 was far away mending or writing
 Or something, like fixing the house.

She couldn't have heard the magnificent

BOOM

When the **toy** *box* volcano demolished the room.

Ned Dickens, *By a Thread* (Victoria, B.C.: Orca, 2005).
Illustrations by Graham Ross. 176 × 291 mm (6¾″ × 11½″).
DESIGN: Lynn O'Rourke.

The principal text face is Lucien Bernhard's Bernhard
Modern. Characters' names are set in Edward Benguiat's
Benguiat. These are both advertising faces designed
in New York City. Bernhard's face (which is much the
more accomplished of the two) was drawn in the 1930s,
Benguiat's in the 1970s.

The text in children's books is almost always short, and the type is almost always large, yet the typography in children's books is all too often bland and careless. It ought instead to be full of flavour and carefree. The five examples shown here (pp 190–95) suggest how much can be accomplished in children's publications, through the creative choice of type, uninhibited setting, and by engaging in a dialogue between type and illustration.

MYTH as MATH

MOSES AND THE CHILDREN OF ISRÆL had been out of Egypt a year and a month when Yahweh commanded him to conduct a census of all the males twenty years old or older, fit to bear arms. Aided by his elder brother Aaron and the head of each of the twelve ancestral clans,[1] Moses convened the community in the wilderness of Sinai "on the first day of the second month, in the second year after the exodus",[2] and began the count.

The Children of Isræl – following 430 years in Egypt – had left the city of Rameses in the Nile Delta[3] "on the very day the four hundred and thirty years ended".[4] They had been at Mt Sinai ten months before the census was begun.

"Such were the men registered by Moses, Aaron and the leaders of Isræl, of whom there were twelve, each representing his patriarchal House. Every man of Isræl of twenty years and over, fit to bear arms, was counted according to his patriarchal House. Altogether the full total was six hundred and three thousand five hundred and fifty." [NUMBERS I: 44–6] [5]

The tribe of Levi was specifically excluded by Yahweh who directed Moses to "enroll [them] to serve the tabernacle of the Testimony and to look after its furnishings and its

1 Elizur of Reuben; Shelumiel of Simeon; Nahshon of Judah; Nethanel of Issachar; Eliab of Zebulun; Elishama of Ephraim; Gamaliel of Manasseh; Abidan of Benjamin; Ahiezer of Dan; Pagiel of Asher; Eliasaph of Gad; Ahira of Naphtali [NU I: 5–15] – together with Aaron of Levi, a total of thirteen 'scrutineers', arguably resounding the 13 months in 'a year and a month' since their departure from Egypt
2 NUMBERS I: 1
3 *Rameses (Ra'amses)*, established by the Hyksos as their capital *Avaris*, was destroyed by Ahmose I, then rebuilt (with help from the Isrælites – EXODUS I: 11) by Seti I and his son Rameses II as the new capital of the 19th Dynasty, when it was known as *Tanis* [ANDERSON, *Understanding the Old Testament*, pp32/3]
4 EXODUS XII: 41
5 Reuben 46,500; Simeon 59,300; Gad 45,650; Judah 74,600; Issachar 54,400; Zebulun 57,400; Ephraim 40,500; Manasseh 32,200; Benjamin 35,400; Dan 62,700; Asher 41,500; Naphtali 53,400 [NUMBERS I: 20–43]

Egyptian Bel-measure year of 360 days. The name of god secreted in the sanctuary, invoked Yahweh on the one day the subterranean vowels of the Beth-Luis-Nion alphabet came into play in the plan of the Boibel-Loth calendar.[524]

Z	S H D T C	Q
	F M	
	N G	
	L NG	
	B R	
Ω	A O U E I	Y

A calendrical mnemonic ingeniously constructed to begin and end on the submerged letter A – which, as noted (*cf*, p245), figures the first night of the new lunation when no phase is visible in the sky (the moon apparently submerged in the underworld). A cyclical figure pivoting the divine epithet '*alpha and omega*'[525] where *alpha* underscores the

524 Beth-Luis-Nion alphabet elaborated in a figurative 'trilithon' as the Boibel-Loth calendar, comprising 13 months of 28 days – the cornerstones as 'resting-places' configuring doubled counts (13 letters projecting 22): $SS = Z/CC = Q/II = Y/\Lambda\Lambda = \Omega$ (*omega* – larger O – signifying the completed cycle, where *omicron* or smaller O represents full moon) – while the vowels submerged beneath the ground were intoned together (five as one) on the terminal day of the year [GRAVES, *The White Goddess*, p270]
525 "[the] great voice from the Throne [declaring] I am the Alpha and the Omega, the Beginning and the End" [REVELATION XXI: 6]

initial dark night, and *omega*, the completed lunation on the terminal, or polar, dark night of the cycle. In otherwords, an *annual* circuit of 13 months, which further incorporates the *monthly* presentiment of two dark nights, configured to reside with the vowels in the underworld (representing the yearly day of increase, or sole intercalation of the 364-day calendar). It bears noting also that the seven subterranean vowels[526] in the figure, *shadow* the seven focal phases of a lunation (*cf*, p92, fn248F) – seven aspects of the goddess as *mates* for the seven spectres.

"In the eighteenth year of King Josiah [622/1 BC], the king sent the secretary Shaphan...to the Temple of Yahweh. 'Go to Hilkiah the high priest,' he told him, 'and tell him to melt down the silver that has been brought to the Temple of Yahweh and that those who guard the threshold have collected from the people. Let him hand it over to the masters of works attached to the Temple of Yahweh, for them to spend on the workmen working on the repairs to the Temple of Yahweh, on the carpenters, builders and masons, and on buying wood and dressed stone for the Temple repairs. But they are not to be asked to render account of the money handed over to them, since they are honest in their dealings.' The high priest Hilkiah said to Shaphan the secretary, 'I have found the Book of the Law in the Temple of Yahweh.' And Hilkiah gave the

526 preserving an insight into the conception of the 7 Greek vowels; which originated, according to Gaius Julius Hyginus (ca 64 BC – 17 AD) curator of the Palatine Library, with the five introduced (together with two consonants – *beta* and *tau* – both signifying "bull") by Mercury (Hermes) or the *Three Fates* (*cf*, Hermes Trismegistus) – *alpha, eta, iota, omicron, upsilon* – seven letters *drawn from the flight of cranes* (γερανος *crane*, cognate with κορωνυς *corona*); the final two vowels – epsilon and omega – added (along with the consonants *zeta* and *phi*) by Simonides the Dionysian (*cf*, the doubled characters in the Boibel-Loth calendar), following the introduction of 13 further consonants (*cf*, the 13 months of the body of the calendar) by Palamedes and Epicharmus [*cf*, GRAVES, *The White Goddess*, p238] NOTE that the five initial vowels introduced by Hermes accord with the five underworld (or intercalary) days won by Thoth (Hermes) from the moon (*ie*, the seventy-second part of the day throughout the 360-day year: $360 \div 72 = 5$), substantiating their compression (IEUOA → Yahweh) as the single intercalary day of the 364-day year: a name *unutterable* because the vowel sounds which comprised the initial secretion weren't notated in Hebrew script

Self-publishing is looked upon with suspicion, and there are reasons why this is so. But self-publishing is the original form of publishing, and centralized or marginalized, it has always been important.

In the age of the computer, it is possible for a type foundry and a typographic design house to fit inside a briefcase. This makes self-publishing easy in theory. Yet now as in the past, few writers have the expertise to edit, design, and set what they have written. These two self-published books are radically different from one another. *Myth as Math* is the fruit of an obsession with content. *Ten Counting Cat*, which has almost no content at all, was made by a visual artist eager to play with the book as a form and type as a medium. What the two works have in common is that both are produced to a high professional standard – higher, in fact, than one would find now in most books published through the trade.

FACING PAGE: [Nick Drumbolis], *Myth as Math: Calendrical Significance in the Mosaic Census of the Sons of Israel.* Outlands 7 (Toronto: Outlands, 2007). 140 × 215 mm (5½″ × 8½″). DESIGN: Nick Drumbolis.

THIS PAGE: Robert Chaplin, *Ten Counting Cat* (Telkwa, B.C.: Robert Chaplin, 2005). 220 × 220 mm (8″ × 8″). DESIGN: Robert Chaplin.

The type in *Myth as Math* is Robert Slimbach's Minion. In *Ten Counting Cat* it is Hermann Zapf's Palatino.

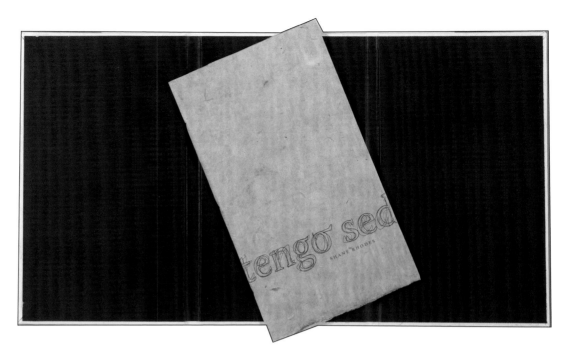

A NOTE ON THE TYPE

Warnock is an eclectic face, resisting any easy categorization into a single historical classification. The serifs, which are unbracketed and triangular, give the type a chiseled appearance, and the classical letter proportions are typically associated with old style types, yet they have been refined to give the font a more contemporary appearance. Warnock's structure is both rational and dynamic, striking a balance between innovation and restraint, and the mix of calligraphic and constructed character shapes, as well as both angular and rounded elements, give clarity and visual tension to the family.[1]

akpgqdz
123678901
ABJCDEG
KLMPQTZ
ffi † § ‡ ₥
&
W

AND ON THE PAPER

Bhutanese Tsasho paper comes from papermakers in Trashi Yangtse, Khaling and Yonphula in remote Eastern Bhutan. Tsasho is made from the bark of the *de-nar* plant, a variety of daphne. It is a dark woody paper fibre found only in Bhutan but related to Nepalese lokta. In spring the *de-nar* has white flowers and grows in profusion among stands of bamboo, rhododendron and moss covered blue pine. The *de-nar* bark is boiled in water with a lye of ashes, an alkali solution made by dripping water through a basket of wood ash. This is the traditional way of breaking down the lignin which binds the bark fibres to produce a soft malleable pulp.

Tsasho (tsa-sho) means bamboo-paper and thus is made on a screen of split bamboo strung together with yak hair. The paper is made by dipping the screen into a vat in which the *de-nar* fibre is mixed with water. The impression of the screen remains as a watermark in the paper. The sheets are stacked in a pile, pressed under the weight of a few big stones, then seperated and dried on the mud plastered bamboo walls of a drying hut.[2]

1 Paraphrased presumptuously from the Warnock Pro Specimen Book. © Adobe Systems Inc.
2 Paraphrased about the same amount from Khadi's website: <www.khadi.com>.

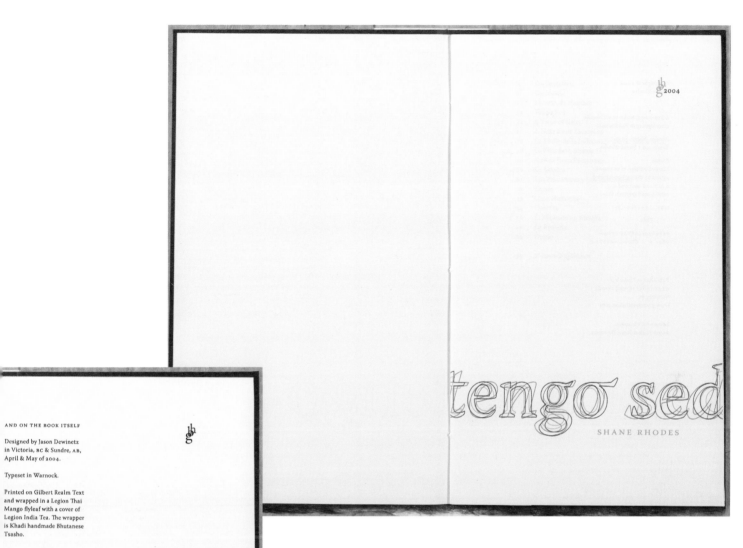

AND ON THE BOOK ITSELF

Designed by Jason Dewinetz
in Victoria, BC & Sundre, AB,
April & May of 2004.

Typeset in Warnock.

Printed on Gilbert Realm Text
and wrapped in a Legion Thai
Mango flyleaf with a cover of
Legion India Tea. The wrapper
is Khadi handmade Bhutanese
Tsasho.

This edition is limited to 74
numbered copies handsewn in
paper wrappers, with 26 copies,
lettered A–Z, enclosed in a hard-
bound triptych case, all signed
by the author.

grafs '/5

Shane Rhodes, *Tengo sed* (Victoria, B.C.: Greenboathouse, 2004). 130 × 216 mm (5″ × 8½″).
DESIGN: Jason Dewinetz.

The type is Warnock, designed in California by Robert Slimbach in 2001.

Roman lowercase letters are called roman not because they come from Rome but because
they owe their form to the Romanesque: a historical period and an aesthetic distinguished by
its preference for unornamented, round forms over the ornamented, pointed forms of the
Gothic. In Italian, roman type is in fact called *tondo*, "round": a further reminder that a rich, ripe
roundness is one of its salient characteristics. (It is not as curvaceous as italic – which in Italian
is called *corsivo*, "flowing" – but in all Indo-European languages the essentially angular roman
letters – k, v, w, x, y, z – are far outnumbered by the rounder forms of a, b, c, d, e, g, h, m, n,
o, p, s.) Warnock is round enough to look like a normal bookface, but it is singularly angular
and sharp in its details. The serifs are large, asymmetrical, and chiselled. The meniscus that
normally forms at the junction of serif and stem in a roman bookface is replaced by a sharp
angle. This makes the face seem tough and dry – and Warnock is the face Dewinetz chose for
these laconic, dry, hard-bitten poems set in the Mexican highlands of Guanajuato. The title of
the book, *Tengo sed*, is Spanish for "I'm thirsty."

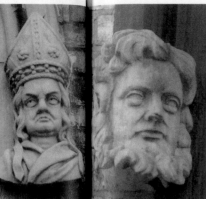

TOP LEFT: William Thomas? TOP RIGHT: Bishop Michael Power. LEFT: William Thomas, in an undated oil painting. CREDIT: TORONTO PUBLIC LIBRARY (TRL) T35182

ABOVE: William and Martha Thomas on Oakham House. RIGHT: William Thomas on St. Lawrence Hall

out that "no documentation or physical resemblance supports the claim."

Does it strike you as presumptuous or even merely cheeky for Thomas to have added his own likeness to this work? Maybe so, but such architectural signatures are not unusual. If that is not Thomas on the Bishop's Palace, he almost certainly put his very personal stamp on two other buildings. Thomas built Oakham House, now part of Ryerson University, as his own residence in 1848. The door-___ ___ frames, and upper corners of the ___ ___velve faces, the identities of whom are ___ ___ have been lost. But that is almost

certainly Thomas himself on a first-floor window (and his wife opposite).

He also appears on the south side of St. Lawrence Hall, his masterpiece. However, the teeth were "grotesque" additions when the building was restored in the 1960s, according to John Bridges of Summit Restoration, who worked on the project.

Thomas was not the only architect to put his own face on his work. Three partners, all looking much the worse for wear, look out from the original Confederation Life Building. The elements — and thoughtless renovation — have inflicted much the same fate on them as the company suffered. One of Canada's oldest and largest companies, it collapsed

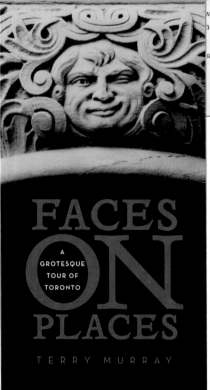

A GROTESQUE TOUR OF TORONTO

FACES ON PLACES

TERRY MURRAY

Terry Murray, *Faces on Places: A Grotesque Tour of Toronto* (Toronto: Anansi, 2006). 105 × 204 mm (4¼″ × 8″). DESIGN: Ingrid Paulson.

The text face is Miller, designed by Matthew Carter in Boston in 1997. The caption face is Christian Schwartz's Neutraface. The titling face is Tribute, designed in Germany in 2002 by Frank Heine.

the work of Chapman and Oxley together with engineering firm of Yolles and Rotenberg, but the surviving sons of the principals seemed not to be aware of the figure, let alone know who he is or what he represents. Sweeny, who received an award of merit from Heritage Toronto in 2002 for his preservation of the building, thinks of him as a panicked inves- tor telling his broker to "sell!"

And what of the curi- ous imp on the Staples Business Depot building (formerly CBC-TV studios, and originally the Pierce-Arrow showroom)? He or she — or it? — is only one element in an elaborate sculpture program on the building, much of which has been removed and lost.

Sterling Tower

The figures were modelled by Merle Foster, a popular Toronto sculptor of the 1920s through the 1950s. During the 1920s, her studio was on Walton Street, near City Hall — then a poor area of town known as "the Ward." Children flocked to her door to see the red-haired grown-up who seemed to make mud pies for a living and occasionally paid kids to pose for her. Her annual Christmas party for them attracted public and corporate donations of food and gifts from across the city, donations that contin- ued even after she moved her studio too far away to continue the seasonal gatherings. This Pierce-Arrow

Original Pierce-Arrow showroom. CREDIT: CITY OF TORONTO ARCHIVES, FONDS 1185, ITEM 36. RIGHT: Pierce-Arrow imp

pixie could well have been based on one of the neigh- bourhood children.

Sadly, after decades of being the subject of stories in Toronto papers and arti- cles in national magazines, Foster died in relative obscurity in 1986. Much of her sculpture appeared in and on buildings that have since been demolished, and organizations and companies for whom she worked have no record of her. This building is one of the few traces left of the self-described "mud-slinger" — and possibly of one of her young friends.

Like W. A. Dwiggins's Caledonia, Matthew Carter's Miller is based on an early 19th-century Neoclassical type often referred to as "the Dryden face" or "the original Scotch Roman." The original fonts (much admired by 19th-century typefounders and printers in North America) first appeared in 1808, in Walter Scott's grand 18-volume edition of the works of John Dryden. This was printed in Edinburgh but published in London by William Miller. It has been claimed since 1825 that the fonts were cut by Richard Austin for another William Miller, a typefounder in Glasgow and Edinburgh. That claim has never yet been proven, nor has it been disproved.

Most of the fonts now called Scotch Roman are Romantic, not Neoclassical, in structure and thus significantly different from the 1808 original. Carter's Miller, like Dwiggins's Caledonia, is quite faithful to the source though it has a character very much its own.

Robert Majzels,
The Apikoros Sleuth, 2nd
ed. (Toronto:
Moveable
Inc., 2006).
218 × 283 mm
(8½″ × 11¼″).
DESIGN:
Jim Roberts /
Robert Majzels.

The first edition
of this book was
published by
Mercury Press in
2004. Moveable
Inc., where the
first edition
was typeset,
then issued this
version, which
is printed with
more colour
and in a slightly
larger format.

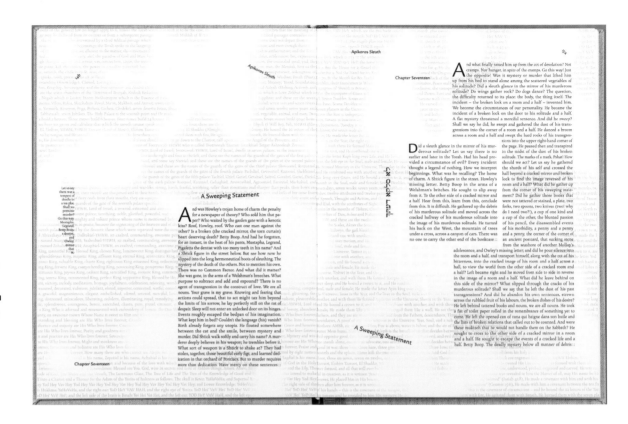

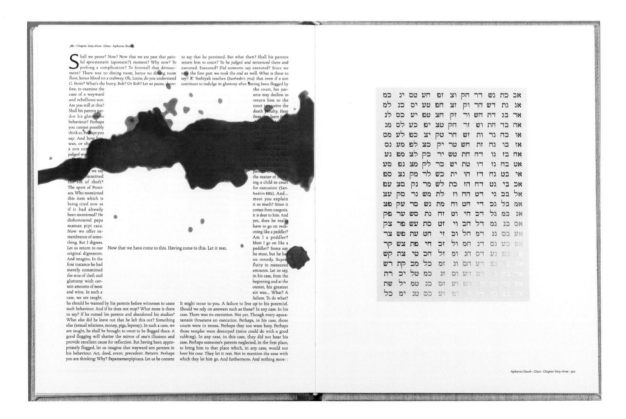

[202]

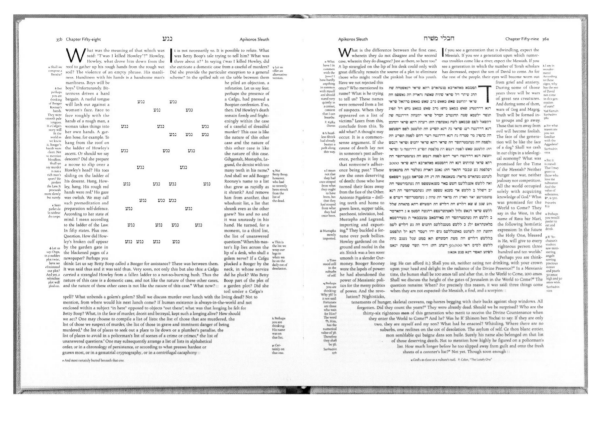

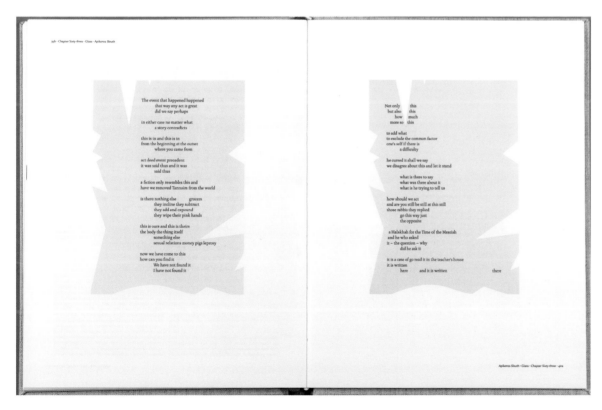

The text face is the (rather tame) digital version of Oldřich Menhart's Figural, designed in Czechoslovakia in 1940. The display face is Robert Arnholm's Legacy Sans.

The Hebrew face is the so-called Hebrew Regular, digitized by Andrew Fountain and Peter Gentry from an unidentified original. The large Hebrew initials were created by Jim Roberts especially for this book.

[*See also pp 97–98*]

Angela Rawlings, *Wide Slumber for Lepidopterists* (Toronto: Coach House, 2006). 173 × 127 mm (7″ × 5″). DESIGN: Bill Kennedy.

The type is Bulmer – a digital version of the Monotype metal face used by Robert Reid in his Lawrence Lande bibliography of 1965 (shown here on pp 72–75). The original Bulmer, which dates from the end of the 18th century, was the first Romantic typeface cut in England.

[*See also pp 97–98*]

```
                short-tailed
        blue, small                    build
        blue, silver-studded        insects as punctured
        blue, mazarine      flmutter        integral
          blue, damon      flind        peripheral
            blue, chalkhill homes        punctuation
        blue, adonis
          blue, common homes
            blue, yellow      in glass
              shell, yellow
                underwing, yellow-tail
```

64

```
                          t    l               l
            l                    l          l    l
                      d        n        d
          d      d                    l                l        l      th
        n        l    nd    d nd    nl    l    l            nd
      l    n    tdnd    dnddnl ddnnth    ttdtdndd  nd
        th    nlddnnthttdtdnddnddnlddnnttdtdnddn n    n      t
    l                 d dn ld dn    chest oppressor: demon   nth tt d tdn dd nd
      l               dnl ddnnth    corpse. leaking bodies    tt d tdnd dnd d nld dn        l
        l    nth ttd tdnd    of witch, demon, deformed    dn ddn ld dnn
  t               tht tdt dn    human offspring. a block    ddnd d nld dn nth tt        d        t
      t        dtd    of dead insects in th butter dish.    nd dnd d nld dnn
      nd      mn th tt d t dn d d nd d dn l d d n n tt d t dn d d n t d n d d n                    l
                ddt  dnddnd  dnl ddnnthtt   dtdnddndd
              nd    l  l    d  l      nd              t    n   nd    t
          l                            n
        l      n        n      n            l        d  l    l
            t                        t
```

70

our wrists, we
hold up loose slender hands
columns, our of th caterpillar
kilter, sway. weave nd row
ways, our slowblue flight
heavy folds, our
in th lake holes nd our
a body mornings, nd home. hold
of water our wings our breath
heavy as wails, our wet
soul, sail, th gall of th 'th,' th 'of' of th 'of' or th 'th,' th
ways lips hug proboscis th vulva, yes, th vulva
water is fire protrusion velour
penetration vellum
chrysalistalization dark valium
row of fine-lipped, of
up tubular, a
thin

bramble
a nightful of bottle collector, indiscriminate criminal full of soft, dulled, wet, handspun
nettles
 willows
rows on rows of embroidered or tattooed stolen bodies of wings in fright in silk woven on
mallows sallows
milk vetch clover
uvula, cotton-mouth, moth-corpse, shantung nd tussah lungs, thick sheets of hover there,
 meadowsweet
thistles birthworts
pins through push or decorate with pins nd decorate with penis, gag, egg filling with
wild crucifers
lucerne violets
morphemes epsy epil narcol disp with ropped isturbed angled sleed morph promin nustle
 birdsfoot trefoil
 hawkweeds
bodies eschen bodies istle collapsed bod ick immobi spit up yellow EEGS nustle oviposit
 purple moor grass

```
   t              t              l        l   t
     l                                    l
              n      d                  d
     d        d    nd          nd         t
     n      l   ldn  nl  nd   l   l       nd n
       l     ldn lnldtltdl   nldtltdln l nldtlt dln      l      lt
         l      ldntldnlnldtltdlnldldntldnlnldtltdlnld n   nd
       l    l dnt l dn lnl  chazara och:lodes orion   d tlt dl nld nt l dn      t
         l      ln ldt lt dlnld nt   croce,ous lucina ochlodes   ldn lnld tl td lnl  l  l
   t        t    dnt ld nln ldtl tdl nld   vitalbata, mimas, defoliaria   nt l d        t  t
         nlnldt   hemaris pyrin.a belia    l td lnl d nt l dn lnld tl td lnl dnt    t
     l    ldnl   diacrisia croceous brintesia.   nld tl td lnl d nt l dn lnld tl t        l
       n      d hn ld ld nt ldn ln ldtltdln ldldn ln nl dtltdln l
           dnt  ld  nlnldtltdln ldntldnlnl dtltdln
           nd l   l   nd l   t   n          t   nd
     l                 n            d
   t  t        n                    n   d    l n  d
       l      l              l              l
```

The numerals indicate the prize – first, second or third –
awarded in each category; (H) = honourable mention. There
is often more than one such designation in a given year and
category because the Alcuin jurors have often declared a tie.
Numbers are also often missing because the jurors have often
declined to award all the allowable prizes.

For each book, the DESIGNER is listed first in small caps,
then Author, *Title in italic* (Publisher in parens).

—— 1981 ——

Poetry

(H) TIM INKSTER · Stephen Scobie, *McAlmon's Chinese Opera*
(Quadrant)

Prose

(H) GLENN GOLUSKA · David W. McFadden, *A Trip Around
Lake Huron* (Coach House)

Pictorial Books

(H) FRANK NEWFELD · Judy Thompson Ross et al., *Down to
Earth: Canadian Potters at Work* (Nelson Canada)

—— 1982 ——

No awards were made.

—— 1983 ——

No awards were made.

—— 1984 ——

Poetry

(1) STAN SHIKATANI · Gerry Shikatani, *A Sparrow's Food:
Poems 1971–82* (Coach House)

(H) GORDON ROBERTSON / MARY SCALLY · Marlene
Cookshaw, *Personal Luggage* (Coach House)

(H) GORDON ROBERTSON / NELSON ADAMS · Judith
Fitzgerald, *Split/Levels* (Coach House)

Prose

(H) GREG CURNOE · David McFadden, *Animal Spirits: Stories
to Live By* (Coach House)

(H) GORDON ROBERTSON / NELSON ADAMS · Jean McKay,
Gone to Grass (Coach House)

(H) HAROLD KURSCHENSKA · Paul Varnai, ed., *Hungarian
Short Stories* (Exile Editions)

Pictorial Books

(1) ROBERT BRINGHURST · Robert Bringhurst et al.,
ed., *Visions: Contemporary Art in Canada* (Douglas &
McIntyre)

(H) TIM INKSTER · Jorge Luis Borges, *Tlön, Uqbar, Orbis
Tertius* (Porcupine's Quill)

(H) PAMELA MCDONALD · Terence Dickinson, *Nightwatch:
An Equinox Guide to Viewing the Universe* (Camden House)

Children's Books

(1) JOHN LARSEN · John Larsen, *Captain Carp Saves the Sea*
(Annick)

(H) GINA CALLEJA · Gina Calleja, *Tobo Hates Purple* (Annick)

(H) MICHAEL SOLOMON · Tim Wynne-Jones, *Zoom at Sea*
(Douglas & McIntyre)

Other

(H) JORGE FRASCARA / SHIRLEY NEUMAN · Wilfred Watson,
Gramsci × 3 (Longspoon Press)

(H) JENNY HOLZER · Jenny Holzer, ed., *Truisms and Essays*
(Nova Scotia College of Art & Design)

—— 1985 ——

Poetry

(1) TIM INKSTER · Robert Finch, *Double Tuning* (Porcupine's
Quill)

(2) SUSAN COLBERG · Douglas Barbour, *Visible Visions*
(NeWest Press)

(3) GORDON ROBERTSON · Phyllis Webb, *Water and Light:
Ghazals and Anti Ghazals* (Coach House)

(H) GORDON ROBERTSON · John Pass, *An Arbitrary
Dictionary* (Coach House)

(H) BEV LEECH · Robert MacLean, *In a Canvas Tent*
(Sono Nis)

(H) A.M. FORRIE · Florence McNeil, *Barkerville* (Thistledown)

Prose

(1) TIM INKSTER · Virgil Burnett, *A Comedy of Eros* (Porcupine's Quill)

(2) GLENN GOLUSKA · David Jones, *Inner Necessities: The Letters of David Jones to Desmond Chute* (Anson-Cartwright Editions)

(H) GORDON ROBERTSON · Diane Schoemperlen, *Double Exposures* (Coach House)

(H) BETH EARL · Sir John Richardson, *Arctic Ordeal: The Journal of John Richardson* (McGill-Queen's University Press)

(H) JOHN LEE · Sandra Gwyn, *The Private Capital: Ambition and Love in the Age of Macdonald and Laurier* (McClelland & Stewart)

(H) CAPE TRAVERSE ASSOCIATES · Fred Cogswell, ed., *Atlantic Anthology,* vol. 1: *Prose* (Ragweed Press)

Pictorial Books

(1) JEAN LIGHTFOOT · Donald Blake Webster et al., *Georgian Canada: Conflict and Culture 1745–1820* (Royal Ontario Museum)

(2) ROBERT BRINGHURST · Bill Reid & Robert Bringhurst, *The Raven Steals the Light* (Douglas & McIntyre)

(3) JANE POOLE / RICK BUDD · Patricia Ainslie, *Images of the Land: Canadian Block Prints 1919–1945* (Glenbow Museum)

(H) SANDRA MELAND · Lilly Koltun, ed., *Private Realms of Light: Amateur Photography in Canada 1839–1940* (Fitzhenry & Whiteside)

(H) BRANT COWIE · Peter Goddard, *Van Halen* (General Publishing)

(H) BRANT COWIE · G. Blair Laing, *Morrice: A Great Canadian Artist Rediscovered* (McClelland & Stewart)

Children's Books

(1) BLAIR KERRIGAN · Janet Munsil, *Dinner at Aunt Rose's* (Annick)

(2) MARIE-LOUISE GAY · Dennis Lee, *Lizzy's Lion* (General Publishing)

(3) MIRO MALISH · Irving Layton, *A Spider Danced a Cozy Jig* (General Publishing)

(H) WYCLIFFE SMITH · Maryann Kovalski, *Brenda and Edward* (Kids Can)

(H) MARK THURMAN · Mark Thurman, *You Bug Me* (NC Press)

(H) TIM INKSTER · James Reaney, *The Boy with an R in his Hand* (Porcupine's Quill)

(H) MAY CUTLER / SHELDON COHEN · Roch Carrier, *The Hockey Sweater* (Tundra)

Other

(1) JOHN ALLERSTON / TERENCE PAMPLIN · Marilyn Walker, *Harvesting the Northern Wild* (Outcrop)

(2) TIM INKSTER · Glenna Rebick & Alvin Rebick, *The Very Best of the Baker Street Bistro* (Porcupine's Quill)

(3) MICHAEL SOLOMON · Tina Holdcroft, ed., *Scienceworks: An Ontario Science Centre Book of Experiments* (Kids Can)

(H) JON VERNEY / PIETR BARANOWSKI · Richard Maran, *The Graphic PC DOS Book* (Holt, Rinehart & Winston)

——— 1986 ———

Poetry

(1) GORDON ROBERTSON · Daniel Jones, *The Brave Never Write Poetry* (Coach House)

(1) GORDON ROBERTSON · Rafael Barreto-Rivera, *Nimrod's Tongue* (Coach House)

(2) GORDON ROBERTSON · Anne Michaels, *The Weight of Oranges* (Coach House)

(3) TIM INKSTER · Richard Outram, *Man in Love* (Porcupine's Quill)

Prose

(1) [DESIGNER UNNAMED] · Ellen Reisman Babby, *The Play of Language and Spectacle: A Structural Reading of Selected Texts by Gabrielle Roy* (ECW Press)

(2) ELIZABETH MARTIN · Connie Guberman & Margie Wolfe, ed., *No Safe Place: Violence Against Women* (Women's Press)

(3) GORDON ROBERTSON · Gwendolyn MacEwen, *Noman's Land* (Coach House)

(H) J. DOUGLAS CLAYTON · J. Douglas Clayton, *Ice and Flame* (University of Toronto Press)

Pictorial Books

(H) FRED BRUEMMER · Fred Bruemmer, *The Arctic World* (Key Porter)

(H) NATIONAL GALLERY OF CANADA / GLEN MIELKE · Ann Thomas, *Environments Here and Now: Three Contemporary Photographers* (National Gallery of Canada)

(H) HOWARD PAIN · Jean Blodgett, *Kenojuak* (Firefly Books)

Children's Books

(1) MICHAEL SOLOMON · Robin Muller, *The Sorcerer's Apprentice* (Kids Can)

(2) MICHAEL SOLOMON · Susan Kalbfleisch, *Skip to It* (Kids Can)

(3) SHIRLEY DAY · Joanne Brisson Murphy, *Feelings* (Black Moss Press)

Other

(1) GORDON ROBERTSON · Margaret Hollingsworth, *Willful Acts* (Coach House)

(H) THE PUBLIC GOOD · Lois L. Ross, *Prairie Lives: The Changing Face of Farming* (Between the Lines)

(H) PATTI BROWN / ALLAN MOON · Sandra D. Ubelacker et al., *Mastering Keyboarding Skills 2* (Copp Clark)

—— 1987 ——

Poetry

(1) BEV LEECH · Stephen Chan, *Songs of Maori* (Sono Nis)

(2) TIM INKSTER · C.H. Gervais, *Letters from the Equator* (Penumbra Press)

(3) TIM INKSTER · John Newlove, *The Night the Dog Smiled* (ECW Press)

Prose

(1) GORDON ROBERTSON · George Johnston, *Carl: Portrait of a Painter* (Coach House)

(2) GORDON ROBERTSON · David Gilmour, *Back on Tuesday* (Coach House)

(3) TIM INKSTER · Barbara E. Turner, ed., *Skelton at Sixty* (Porcupine's Quill)

Education

(1) MICHAEL VAN ELSEN · Rosemary Neering & Peter Grant, *Other Places, Other Times* (Gage Educational Publishing)

(2) PAT DACEY · Anne Burrows Clarke et al., *Aventures I* (Copp Clark Pitman)

Pictorial Books

(1) DUFOUR ET FILLE · Francine Lavoie et al., *Miró in Montreal* (Montreal Museum of Fine Arts)

(1) REINHARD DERRETH · Doris Shadbolt, *Bill Reid* (Douglas & McIntyre)

(H) TIM INKSTER · G. Brender à Brandis, *At Water's Edge* (Porcupine's Quill)

Children's Books

(1) DAVID PEACOCK · David Peacock, *The Sea Serpent of Grenadier Point* (Hounslow Press)

(2) MICHAEL SOLOMON · Tim Wynne-Jones, *I'll Make You Small* (Douglas & McIntyre)

(3) MICHAEL SOLOMON · Jean Speare, *A Candle for Christmas* (Douglas & McIntyre)

(H) MICHAEL SOLOMON / SYLVIE DAIGNEAULT · Ted Staunton, *Simon's Surprise* (Kids Can)

Other

(1) ANTJE LINGNER · Peter G. Bietenholz, ed., *Contemporaries of Erasmus: A Biographical Register of the Renaissance and Reformation*, vol. 2 (University of Toronto Press)

(2) JANE HAMILTON · Harold A. Innis, *Empire & Communications* (Press Porcépic)

(3) GREGORY & GREGORY · W. Earl Godfrey, *The Birds of Canada* (National Museum of Natural Sciences)

—— 1988 ——

Poetry

(2) ODETTE DES ORMEAUX / LIBBY OUGHTON · Nicole Brossard, *Sous la langue / Under Tongue* (L'Essentielle/ Gynergy Books)

(3) TIM INKSTER · John Terpstra, *Forty Days and Forty Nights* (Netherlandic Press)

Prose Fiction

(1) DAVID MONTLE · George Payerle, *Unknown Soldier* (Macmillan of Canada)

(2) DAVID MONTLE · Tom Marshall, *Adele at the End of the Day* (Macmillan of Canada)

Prose Non-Fiction

(1) GORDON RIPLEY · *Who's Who in Canadian Literature* (Reference Press)

(2) GDA · Benjamin Doane, *Following the Sea* (Nimbus Press & The Nova Scotia Museum)

(3) TIM INKSTER · *Canadian Writers and Their Works* (ECW Press)

(H) ANTJE LINGNER · Robert D. Denham, *Northrop Frye: An Annotated Bibliography of Primary and Secondary Sources* (University of Toronto Press)

Text & Reference

(1) ULRIKE BENDER· Terence Dickinson, *Exploring the Night Sky* (Camden House)

Pictorial Books

(H) SPENCER FRANCEY GROUP · Andrew Danson, *Unofficial Portraits: Canadian Politicians Photographed by Themselves* (Doubleday Canada & The Art Gallery of York University)

Children's Books

(H) STÉPHANE POULIN · Stéphane Poulin, *Can You Catch Josephine?* (Tundra)

(H) NANCY RUTH JACKSON · Donn Kushner, *A Book Dragon* (Macmillan of Canada)

(H) TIM INKSTER · P.G. Downes, ed., *The Story of Chakapas: A Cree Indian Legend* (Penumbra Press)

Other

(H) ELIZABETH MARTIN · [Joint award to a series of five books] Janet Silman, *Enough is Enough* / Laurie Bell, *Good Girls/Bad Girls* / The Clio Collective, *Quebec Women: A History* / Johan Lyall Aiken, *Masques of Morality* / Rhea Tregebov, *Work in Progress* (Women's Press)

—— 1989 ——

Limited Editions

(H) GEORGE WALKER · *OCAP Anthology Nine* (Ontario College of Art)

Poetry

(1) MORRISS PRINTING · Robin Skelton, *Openings* (Sono Nis)

(2) TIM INKSTER · Richard Outram, *Hiram and Jenny* (Porcupine's Quill)

(3) GORDON ROBERTSON · D.G. Jones, *Balthazar and Other Poems* (Coach House)

(H) GORDON ROBERTSON · Robin Blaser, *Pell Mell* (Coach House)

Prose

(1) BARBARA HODGSON · Bruce Hutchison, *A Life in the Country* (Douglas & McIntyre)

(2) BRUCE MAU · Jean Gagnon, *Pornography in the Urban World* (Art Metropole)

(3) MARIE BARTHOLOMEW · Harry Bruce, *Down Home: Notes of a Maritime Son* (Key Porter)

(H) TIM INKSTER · Mark Frutkin, *Atmospheres Apollinaire* (Porcupine's Quill)

(H) PRONK & ASSOCIATES · David Cruise & Alison Griffiths, *Lords of the Line* (Viking)

Text & Reference

(1) JOHN ZEHETHOFER · R. Douglas Francis et al., *Origins: Canadian History to Confederation* (Holt, Rinehart & Winston of Canada)

(1) JOHN ZEHETHOFER · R. Douglas Francis et al., *Destinies: Canadian History since Confederation* (Holt, Rinehart & Winston of Canada)

(2) ULRIKE BENDER · Terence Dickinson, *Exploring the Sky by Day: The Equinox Guide to Weather and the Atmosphere* (Camden House)

How-to: Cooking, Craft, Hobby & Reference

(H) LYNDA J. MENYES · Katharine Ferguson, ed., *Rock Gardens* (Camden House)

Pictorial Books

(1) MARILYN BOUMA-PYPER · Marilyn Litvak, *The Grange: A Gentleman's House in Upper Canada* (Art Gallery of Ontario)

(2) JAMES IRELAND · *Guts, Greed and Glory: A Visual History of Modern Canadian Business* (Canadian Business)

(3) PAT & ROSEMARIE KEOUGH · Pat Keough & Rosemarie Keough, *The Nahanni Portfolio* (Stoddart)

(H) BARBARA HODGSON · Arthur Erickson, *The Architecture of Arthur Erickson* (Douglas & McIntyre)

Children's Books

(1) WYCLIFFE SMITH · Jan Thornhill, *The Wildlife ABC: A Nature Alphabet* (Greey de Pencier)

(2) MARIE BARTHOLOMEW · *The Canadian Children's Treasury* (Key Porter)

(3) [DESIGNER UNNAMED] · Ellen Bryan Obed, *Borrowed Black: A Labrador Fantasy* (Breakwater Books)

(H) WYCLIFFE SMITH · Katherine Ferris, ed., *I Didn't Know That!* (Greey de Pencier)

(H) [DESIGNER UNNAMED] · Donald Gale, *Sooshewan, Child of the Beothuk* (Breakwater Books)

—— 1990 ——

Limited Editions

(2) MARGARET LOCK · Richard Axton, ed., *King Orfeo* (Lock's Press)

(2) CRISPIN ELSTED / PNINA GRANIRER · Pnina Granirer, *The Trials of Eve* (Gaea Press)

(3) MICHAEL TOROSIAN · Rafael Goldchain, *Nostalgia for an Unknown Land* (Lumière Press)

(H) MICHAEL TOROSIAN · Michael Torosian, *Toronto Suite* (Lumière Press)

Poetry

(1) TIM INKSTER · Daryl Hine, *Arrondissements* (Porcupine's Quill)

(2) TIM INKSTER · Rikki Ducornet, *The Cult of Seizure* (Porcupine's Quill)

(3) J.W. STEWART · Arthur Clark, Kinetic Mustache (Signal Editions)

(3) BEV LEECH · Christopher Wiseman, *Missing Persons* (Sono Nis)

(H) STAN SHIKATANI · Gerry Shikatani, *1988: Selected Poems and Texts, 1973–* (Aya Press)

Prose

(1) TIM INKSTER · Ayoub Sinano, *Pola de Pera* (Porcupine's Quill)

(2) ROB MCPHAIL · James A. MacNeill, ed., *Three Way Mirror: Reflections in Fiction and Non-fiction* (Nelson Canada)

(3) DERRICK UNGLESS / NOEL CLARO · Robert Mason Lee, *One Hundred Monkeys: The Triumph of Popular Wisdom in Canadian Politics* (MacFarlane Walter & Ross)

(H) NELSON ADAMS / GORDON ROBERTSON · Judith Thompson, *The Other Side of the Dark: Four Plays* (Coach House)

Text & Reference

(1) LINDA GUSTAFSON · J. Frederick Little et al., *Good Reasoning Matters! A Constructive Approach to Critical Thinking* (McClelland & Stewart)

(2) ALEXANDRA HASS & BARBARA HODGSON · Margaret MacKenzie & Roderick MacKenzie, *The Toronto Guide* (Douglas & McIntyre)

(2) ALEXANDRA HASS & BARBARA HODGSON · Terri Wershler, *The Vancouver Guide* (Douglas & McIntyre)

(3) NATIONAL MUSEUM OF NATURAL SCIENCES · Jean Lauriault, *Identification Guide to the Trees of Canada* (Fitzhenry & Whiteside)

(H) ULRIKE BENDER · Adrian Forsyth, *The Architecture of Animals: The Equinox Guide to Wildlife Structures* (Camden House)

How-to: Cooking, Craft, Hobby & Reference

(1) LINDA J. MENYES · Sandra Buckingham, *Stencilling: A Harrowsmith Guide* (Camden House)

(2) MARIE BARTHOLOMEW · Suzanne House, *The Canadian Wildflower Book of Days* (Key Porter)

Pictorial Books

(1) TIM INKSTER · Tony Urquhart, *Cells of Ourselves: Drawings* (Porcupine's Quill)

(2) IVAN HOLMES · Constance Olsheski, *Pantages Theatre: Rebirth of a Landmark* (Key Porter)

(3) GILLIAN STEAD · John de Visser, *Muskoka* (Boston Mills)

(H) LINDA J. MENYES · Brian Banks, *Satellite Images: Photographs of Canada from Space* (Camden House)

Children's Books

(1) ARLENE OLSEN · Stefan Czernecki, *The Time Before Dreams* (Hyperion Press)

(2) MICHAEL SOLOMON · Paul Yee, *Tales from Gold Mountain: Stories of the Chinese in the New World* (Douglas & McIntyre)

(3) LORRAINE TUSON · Carl Braun & Paula S. Goepfert, *Every Time I Climb a Tree* (Nelson Canada)

(3) LORRAINE TUSON · Carl Braun & Paula S. Goepfert, *Something Furry, Rough and Wild* (Nelson Canada)

(H) KATHRYN COLE · Michael Bedard, *The Lightning Bolt* (Oxford University Press)

(H) MICHAEL SOLOMON · David Booth, ed., *Til All the Stars Have Fallen: Canadian Poems for Children* (Kids Can)

—— 1991 ——

Poetry

(1) BEV LEECH · Zoë Landale, *Colour of Winter Air* (Sono Nis)

(2) TIM INKSTER / STAN DRAGLAND · Robert Kroetsch, *The Ledger*, 2nd ed. (Brick Books)

(H) TIM INKSTER · Helen Humphreys, *Nuns Looking Anxious, Listening to Radios* (Brick Books)

(H) GORDON ROBERTSON · Wayne Keon, *Sweetgrass II* (Mercury Press)

Prose

(1) C.S. RICHARDSON · David Olive, *White Knights and Poison Pills: A Cynic's Dictionary of Business Jargon* (Key Porter)

(2) LINDA GUSTAFSON · Doris McCarthy, *A Fool in Paradise: An Artist's Early Life* (MacFarlane Walter & Ross)

(3) PAUL DAVIES / J.W. STEWART · Catholyn K. Jansen, *Birds of a Feather: Stories* (Véhicule Press)

(H) TIM INKSTER · Terry Griggs, *Quickening* (Porcupine's Quill)

Text & Reference

(2) JOANNE POON · Patricia Mitchell & Ellie Prepas, ed., *Atlas of Alberta Lakes* (University of Alberta Press)

(3) MARIE BARTHOLOMEW · Peter S. Li, ed., *Race and Ethnic Relations in Canada* (Oxford University Press)

(H) PAUL DAVIES · Freda Farrell Waldon, *Bibliography of Canadiana Published in Great Britain 1519–1763* (National Library of Canada / ECW Press)

(H) MARY SCHENDLINGER · Roy Miki, *A Record of Writing: An Annotated and Illustrated Bibliography of George Bowering* (Talonbooks)

How-to: Cooking, Craft, Hobby & Reference

(1) YUET CHAN · *Alberta Wildlife Viewing Guide* (Lone Pine)

(2) IAN GRAINGE / SHEILA MCGRAW · Sheila McGraw, *Papier Maché Today* (Firefly Books)

(3) CAROLYN DEBY · Noël Richardson, *Winter Pleasures* (Whitecap Books)

(H) YUET CHAN · C. Dana Bush, *The Compact Guide to Wildflowers of the Rockies* (Lone Pine)

Pictorial Books

(1) MARNA BUNNELL · Roger Boulet, *Lyndal Osborne: Songs of the Stone* (Edmonton Art Gallery)

(2) STEVEN SLIPP · Chris Reardon, *Louisbourg: The Phoenix Fortress* (Nimbus)

(3) LISA NAFTOLIN · Michèle Thériault, *Irene F. Whittome: Musée des traces* (Art Gallery of Ontario)

(H) BRUCE MAU · *Art Gallery of Ontario: Selected Works* (Art Gallery of Ontario)

(H) KARL SIEGLER · Cyril E. Leonoff, *An Enterprising Life: Leonard Frank, Photographs, 1895–1944* (Talonbooks)

Children's Books

(1) TIM INKSTER · Marianne Brandis, *The Sign of the Scales* (Porcupine's Quill)

(2) DAVID BULLEN · Barry Lopez, *Crow and Weasel* (Random House Canada)

(3) ARLENE D. OSEN · Stefan Czernecki, *Nina's Treasures* (Hyperion Press)

(H) MICHAEL SOLOMON · Ulli Steltzer, *Building an Igloo* (Groundwood / Douglas & McIntyre)

(H) KATHRYN COLE · Tololwa M. Mollel, *The Orphan Boy* (Oxford University Press)

(H) MICHAEL GROLEAU · Bénédicte Froissart, *Uncle Henry's Dinner Guests* (Annick)

—— 1992 ——

Limited Editions

(1) CRISPIN ELSTED · Crispin Elsted, *Utile Dulci: The First Decade at Barbarian Press, 1977–1987, A History and Bibliography* (printed by Jan Elsted at Barbarian Press)

(2) BEV LEECH · *The Edgar and Dorothy Davidson Collection of Canadiana at Mount Allison University* (Centre for Canadian Studies & Mount Allison University)

Poetry

(1) JULIE SCRIVER · Peter Sanger, *Earth Moth* (Goose Lane Editions)

(2) ALAN DAYTON · William Robertson, *Adult Language Warning* (Brick Books)

(3) HÉLÈNE DORION · Hélène Dorion, *Les États du relief* (Éditions du Noroît)

(H) GORDON ROBERTSON · John Pass, *The Hour's Acropolis* (Harbour)

Prose

(1) VIC MARKS · Jan Tschichold, *The Form of the Book: Essays on the Morality of Good Design* (Hartley & Marks)

(2) ROSE COWLES · Roch Carrier, *Prayers of a Very Wise Child* (Viking)

(3) LINDA GUSTAFSON · Doris McCarthy, *The Good Wine: An Artist Comes of Age* (MacFarlane Walter & Ross)

(3) PAUL DAVIES / GORDON ROBERTSON · Donna Pennee, *Moral Metafiction: Counterdiscourse in the Novels of Timothy Findley* (ECW Press)

(H) GORDON ROBERTSON · Marlene Nourbese Philip, *Looking for Livingstone: An Odyssey of Silence* (Mercury Press)

Text & Reference

(1) ARIFIN GRAHAM · Malcolm Lowry, *The Collected Poetry*, edited by Kathleen Scherf (UBC Press)

(2) MARIE BARTHOLOMEW · Stewart Dunlop & Michael Jackson, *Understanding our Environment* (Oxford University Press)

(2) MARIE BARTHOLOMEW · Fraser Cartwright, *Urban Dynamics* (Oxford University Press)

(3) BEATA KULPINSKI · James Kavanagh, *Nature Alberta: An Illustrated Guide to Common Plants and Animals* (Lone Pine)

(H) PAUL DAVIES · *Canadian Literature Index: a Guide to Periodicals and Newspapers: Cumulative Index to 1986 (1987) Publications* (ECW Press)

How-to: Cooking, Craft, Hobby & Reference

(1) GORDON SIBLEY · Elizabeth Baird et al., *Canadian Living's Country Cooking* (Random House Canada)

(H) C.S. RICHARDSON · Robert Osborne, *Roses for Canadian Gardens: A Practical Guide to Varieties and Techniques* (Key Porter)

Pictorial Books

(1) GLENN GOLUSKA · Melvin Charney, *Parables and Other Allegories: The Work of Melvin Charney, 1975–1990* (Canadian Centre for Architecture)

(2) GLENN GOLUSKA · Emily Kies Folpe, *Dessins d'architecture de l'avant-garde russe* / Irena Zantovská Murray, *Publications de l'avant-garde sovietique, 1917–1935* (Centre Canadien d'Architecture)

(3) JUDITH POIRIER· Diana Nemiroff, *Jana Sterbak: States of Being, corps à corps* (National Gallery of Canada)

(H) TIM INKSTER · Sam Tata, *Portraits of Canadian Writers* (Porcupine's Quill)

Children's Books

(1) PRONK & ASSOCIATES · Carolyn Strom Collins & Christina Wyss Eriksson, *The Anne of Green Gables Treasury* (Viking)

(2) RON LIGHTBURN · Sheryl McFarlane, *Waiting for the Whales* (Orca)

(3) MICHAEL SOLOMON · bpNichol, *On the Merry-go-round* (Red Deer College Press)

(3) MICHAEL SOLOMON · P.K. Page, *The Travelling Musicians* (Kids Can)

(H) KATHRYN COLE · Michael Bedard, *The Nightingale* (Oxford University Press)

—— 1993 ——

Limited Editions

(H) JACQUES FOURNIER · Michel Côté, *À Force de silence* (Éditions du Noroît)

Poetry

(1) BEV LEECH · Gilean Douglas, *Seascape With Figures: Poems Selected and New* (Sono Nis)

(2) CLAUDE PRUD-HOMME · Yves Boisvert, *La Balance du vent* (Éditions du Noroît)

(3) TIM INKSTER · Anne Carson, *Short Talks* (Brick Books)

(H) CLAUDE PRUD-HOMME · Daniel Guénette, *La Fin du jour* (Éditions du Noroît)

(H) GARY STUBER · Normand Chaurette, *The Queens* (Coach House)

Prose

(1) STEPHANIE POWER · Margaret Atwood, *Good Bones* (Coach House)

(2) RAYMAH DESIGN · Evelyn Huang & Lawrence Jeffery, *Chinese Canadians: Voices from a Community* (Douglas & McIntyre)

(3) MARION BANTIES / KERRY WATT · Jean MacIntyre, *Costumes and Scripts in the Elizabethan Theatres* (University of Alberta Press)

(H) CORPORATE LINES DESIGN GROUP · Lance H.K. Secretan, *Living the Moment: a Sacred Journey* (Thaler)

(H) LINDA GUSTAFSON · Robert Kroetsch, *The Puppeteer* (Random House Canada)

Text & Reference

(1) ROBERT BRINGHURST · Robert Bringhurst, *The Elements of Typographic Style* (Hartley & Marks)

(2) DENNIS BOYES · Richard Huseman et al., *Business Communication: Strategies and Skills*, 3rd ed. (Harcourt Brace Jovanovich Canada)

(3) GEORGE VAITKUNAS · Gerald B. Straley, *Trees of Vancouver* (UBC Press)

(H) DENNIS BOYES · Peter Saunders, *Strategy: Writing at Work* (Harcourt Brace Jovanovich Canada)

How-to: Cooking, Craft, Hobby & Reference

(1) LINDA J. MENYES · Brian Fawcett, *The Compact Garden: Discovering the Pleasures of Planting in a Small Space* (Camden House)

(2) LE GROUPE FLEXIDÉE · Gilles Brillon, *Discovering Spiders, Snails and Other Creepy Crawlies* (Michel Quintin)

(H) NANCY RUTH JACKSON · Judy Ann Sadler, *Prints* (Kids Can)

Pictorial Books

(1) ROBIN WARD · David Neel, *Our Chiefs and Elders: Words and Photographs of Native Leaders* (UBC Press)

(2) ART GLOBAL · Brereton Greenhous & Stephen J. Harris, *Canada and the Battle of Vimy Ridge, 9–12 April 1917* (Canada Communications Group)

(3) NICK BANTOCK · Nick Bantock, *Sabine's Notebook* (Raincoast Books)

Children's Books

(1) YUKSEL HASSAN · Robin Muller & Suzanne Duranceau, *Hickory, Dickory, Dock* (North Winds Press)

(2) DAN O'LEARY · Ludmila Zeman, *Gilgamesh the King* (Tundra)

(2) MARIE-LOUISE GAY · Marie-Louise Gay, *Mademoiselle Moon* (Stoddart)

(3) TIM INKSTER · Linda Rogers, *The Magic Flute* (Porcupine's Quill)

--- 1994 ---

Limited Editions

(1) MICHAEL TOROSIAN · Michael Torosian, *Anatomy* (Lumière Press)

(2) WILLIAM RUETER · William Rueter, *The Articulation of Time: A Commonplace Book* (Aliquando Press)

Poetry

(1) BEV LEECH · Carlo Toselli, *Lo Specchio di peltro / The Pewter Mirror / Le Miroir d'étain* (Sono Nis)

(2) KELLY WOOD · Jeff Derksen, *Dwell* (Talonbooks)

(3) GORDON ROBERTSON · bpNichol, *Truth: A Book of Fictions* (Mercury Press)

(H) STAN BEVINGTON · Jocelyne Villeneuve, *Marigolds in Snow* (Penumbra Press)

(H) GORDON ROBERTSON · Wayne Keon, *Storm Dancer* (Mercury Press)

Prose

(1) C.S. RICHARDSON · Farley Mowat, *Born Naked* (Key Porter)

(2) GORDON ROBERTSON · Victoria Stoett, *Wisteria* (Mercury Press)

(3) CLIFF KADATZ · Kathleen M. Snow, *Maxwell Bates: Biography of an Artist* (University of Calgary Press)

(H) BARBARA HODGSON · Emily Carr, *The Emily Carr Omnibus* (Douglas & McIntyre)

Text & Reference

(1) ROBIN WEST / GEORGE VAITKUNAS · Harold Kalman et al., *Exploring Vancouver: The Essential Architectural Guide* (UBC Press)

(2) DAVE PETERS · Brian G. Gaber, *Financial Accounting: An Introduction to Concepts, Methods and Uses* (Dryden)

(3) LE GROUPE FLEXIDÉE · Marc Surprenant, *Les Oiseaux aquatiques du Québec, de l'Ontario et des Maritimes* (Michel Quintin)

(H) QUORUM GRAPHICS · *Proceed with Care: Final Report of the Royal Commission on New Reproductive Technologies* (Canada Communications Group)

How-to: Cooking, Craft, Hobby & Reference

(H) DEAN ALLEN · *The Canadian Traveller's Diary* (Raincoast Books)

Pictorial Books

(1) BARBARA HODGSON · Ian M. Thom, *Robert Davidson: Eagle of the Dawn* (Vancouver Art Gallery)

(3) GLENN GOLUSKA · David Harris & Eric Sandweiss, *Eadweard Muybridge et le panorama photographique de San Francisco, 1850–1880* (Centre Canadien d'Architecture)

(H) KEN BUDD · David Bouchard, *If You're not from the Prairie* (Raincoast Books / SummerWild Productions)

Children's Books

(1) RUSS WILLMS · Berny Lucas, *Brewster Rooster* (Kids Can)

(2) LEO YERXA · Leo Yerxa, *Last Leaf First Snowflake to Fall* (Douglas & McIntyre)

(3) MICHAEL SOLOMON · Robert Priest, *Day Songs, Night Songs* (Douglas & McIntyre)

(H) GRETA GUZEK / ROGER HANDLING · Robert Perry, *The Ferryboat Ride* (Nightwood Editions)

(H) MARIE-LOUISE GAY · Marie-Louise Gay, *Rabbit Blue* (Stoddart)

—— 1995 ——

Limited Editions

(1) MARTIN DUFOUR · Hélène Dorion, *L'Empreinte du bleu* (Éditions du Noroît)

(2) MICHAEL TOROSIAN · *The Witkin Gallery 25: a Celebration of Twenty-five years of Photography in New York City* (Lumière Press)

Poetry

(1) CLAUDE PRUD-HOMME · Rachel Leclerc, *Rabbateurs d'étoiles* (Éditions du Noroît)

(2) BEV LEECH · Ralph Gustafson, *Collected Poems*, vol. 3 (Sono Nis)

(3) GORDON ROBERTSON · Madeleine Gagnon, *Song for a Far Quebec* (Coach House)

(H) PAUL VERRALL · Susan McMaster, *Learning to Ride* (Quarry Press)

Prose

(1) GEORGE VAITKUNAS · Jonathan F. Vance, *Objects of Concern: Canadian Prisoners of War Through the Twentieth Century* (UBC Press)

(2) GORDON ROBERTSON · Douglas Fetherling, *The File on Arthur Moss* (Lester)

(3) KONG NJO · Karen Kain, *Movement Never Lies: an Autobiography* (McClelland & Stewart)

(3) CHRISTOPHER AT REACTOR · Dany Laferrière, *Why Must a Black Writer Write about Sex?* (Coach House)

(H) PIP PEARCE / MARGARET EPP · Michael Coren, *The Man Who Created Narnia: The Story of C.S. Lewis* (Lester)

(H) JOHN PYLYPCZAK · Katherine Govier, ed., *Without a Guide: Contemporary Women's Travel Adventures* (MacFarlane Walter & Ross)

Text & Reference

(1) KUNZ & ASSOCIATES · The Royal Tyrell Museum of Palaeontology, *The Land Before Us: the Making of Ancient Alberta* (Red Deer College Press)

(2) PAUL DAVIES · Carl Spadoni & Judith Donnelly, *Bibliography of McClelland & Stewart Imprints, 1909–1985: A Publisher's Legacy* (ECW Press)

(H) OUCHI DESIGN · Aphrodite Karamitsanis, ed., *Place Names of Alberta*, vol. 3: *Central Alberta* (University of Calgary Press)

(H) LAURA AYERS · Lorri Neilsen, *A Stone in my Shoe: Teaching Literacy in Times of Change* (Peguis)

How-to: Cooking, Craft, Hobby & Reference

(H) PAT STANTON · Ronald M. Veitch, *Fundamentals: Detailing Fundamentals for Interior Design* (Peguis)

Pictorial Books

(1) LINDA J. MENYES · Ernie Sparks, *Decoys: a Celebration of Contemporary Wildfowl Carving* (Camden House)

(2) GEORGE VAITKUNAS · Odette Leroux et al., ed., *Inuit Women Artists: Voices from Cape Dorset* (Douglas & McIntyre / Canadian Museum of Civilization)

(3) GLENN GOLUSKA · Peter Eisenman, *Cités de l'archéologie fictive: Œuvres de Peter Eisenman, 1978–1988* (Centre Canadien d'Architecture)

Children's Books

(1) KUNZ & ASSOCIATES · Jim McGugan, *Josepha: A Prairie Boy's Story* (Red Deer College Press)

(2) JULIAN ROSS / SHELLEY ACKERMAN · David Greer, *White Horses & Shooting Stars: A Book of Wishes* (Polestar)

(3) LIZABETH LAROCHE · Richardo Keens-Douglas, *La Diablesse and the Baby: A Caribbean Folktale* (Annick)

(3) NORMAND COUSINEAU · Geraldine Ryan-Lush, *Hairs on Bears* (Annick)

(H) KATHY KAULBACH · John Igloliorte, *An Inuk Boy Becomes a Hunter* (Nimbus)

—— 1996 ——

Limited Editions

(2) IMPRIMERIE SAINT-LOUIS · Annie Molin Vasseur, *L'Été, parfois* (printed at Imprimerie Saint-Louis for Éditions Bonfort & Édition d'art La Tranchefile)

(H) CRISPIN ELSTED · Carlo Toselli, *La Fanciulla di terracotta / The Terracotta Maiden / La Jeune fille en terre cuite* (printed at Barbarian Press for Le Grazie)

Poetry

(1) CLAUDE PRUD-HOMME / CARLE COPPENS · Carle Coppens, *Poèmes contre la montre* (Éditions du Noroît)

(2) GORDON ROBERTSON / TASK · Nelson Ball, *The Concrete Air* (Mercury Press)

(H) DEAN ALLEN · David Bouchard, *Voices from the Wild: An Animal Sensagoria* (Raincoast Books)

Prose Fiction

(1) GORDON ROBERTSON / PAUL HODGSON / SPENCER FRANCEY PETERS · Matt Cohen, *Last Seen* (Knopf Canada)

(2) PATTY OSBORNE / DEAN ALLEN · Michael Turner, *Hard Core Logo* (Arsenal Pulp Press)

(2) MICHAEL CALLAGHAN / TANIA CRAAN · Nancy Huston, *Slow Emergencies* (Little, Brown)

(3) KONG NJO · Margaret Atwood, *Alias Grace* (McClelland & Stewart)

(3) LINDA GUSTAFSON · Charles Foran, *Butterfly Lovers* (Harper Collins)

Prose Non-Fiction

(1) ALAN BROWNOFF · Jeffrey A. Keshen, *Propaganda and Censorship During Canada's Great War* (University of Alberta Press)

(2) SARI GINSBERG · Stephen Leacock, *Sunshine Sketches of a Little Town* (McClelland & Stewart)

(3) KEVIN CONNOLLY · Lance H.K. Secretan, *Reclaiming Higher Ground: Creating Organizations That Inspire the Soul* (Macmillan of Canada)

(H) DEAN ALLEN · Tom Henighan, *The Presumption of Culture: Structure, Strategy, and Survival in the Canadian Cultural Landscape* (Raincoast Books)

Reference Works

(1) OPUS HOUSE · R. Douglas Francis et al., *Origins: Canadian History to Confederation*, 3rd ed. (Harcourt Brace Canada)

(1) OPUS HOUSE · R. Douglas Francis et al., *Destinies: Canadian History Since Confederation*, 3rd ed. (Harcourt Brace Canada)

(2) LINDA GUSTAFSON · Elaine Crawford & Kelly Crawford, *Aunt Maud's Recipe Book: From the Kitchen of L.M. Montgomery* (Moulin Publishing)

(2) STANDISH COMMUNICATIONS · Jacques Prescott & Pierre Richard, *Mammifères du Québec et de l'est du Canada* (Michel Quintin)

(3) KUNZ & ASSOCIATES · Jan Mather, *The Prairie Garden Planner* (Red Deer College Press)

(H) GEORGE VAITKUNAS · John Bishop et al., *Bishop's: The Cookbook* (Douglas & McIntyre)

(H) BRETT MILLER · Fraser Cartwright et al., *Contact Canada* (Oxford University Press)

Pictorial Books

(1) LINDA J. MENYES · Laurel Aziz, *Wildfowl Art: Carvings from the Ward World* Championship (Firefly Books)

(1) DEAN ALLEN · Michael Kluckner, *Michael Kluckner's Vancouver* (Raincoast Books)

(2) BHANDARI CO. · *Works: The Architecture of A.J. Diamond, Donald Schmitt and Company, 1968–1995* (Tuns Press)

(3) FRANCE LAFOND · *Joe Fafard: Les années de bronze* (Musée des Beaux-Arts de Montréal)

(3) MARTIN DUFOUR · *Ozias Leduc: An Art of Love and Reverie* (Musée des Beaux-Arts de Montréal / Musée du Québec)

(H) ALEXANDRA HASS · Peter White, *It Pays to Play: British Columbia in Postcards 1950s–1980s* (Presentation House Gallery / Arsenal Pulp Press)

Children's Books

(1) TARA PUBLISHING / ANNICK PRESS · Gita Wolf, *The Very Hungry Lion* (Annick)

(2) PETER COCKING · Sean Rossiter, *The Basics* (Greystone Books)

(3) BLAIR KERRIGAN · Pamela Hickman, *The Kids Canadian Bug Book* (Kids Can)

(3) BLAIR KERRIGAN · Pamela Hickman, *The Kids Canadian Plant Book* (Kids Can)

(H) YUKSEL HASSAN · Christiane Duchesne & Doris Barrette, *Who's Afraid of the Dark?* (North Winds Press)

—— 1997 ——

Limited Editions

(1) CRISPIN ELSTED · Robin Skelton, *Rufinus: The Complete Poems in English Versions* (printed by Jan Elsted at Barbarian Press)

(2) LUCIE LAMBERT · Robert Melançon, *Air* (printed at Barbarian Press for Lucie Lambert)

(3) MICHAEL TOROSIAN · Gordon Parks, *Harlem: The Artist's Annotations on a City* (printed & published by Lumière Press)

Poetry

(1) GORDON ROBERTSON · Lise Downe, *The Soft Signature* (ECW Press)

(2) DEAN ALLEN · Lisa Robertson, *Debbie: An Epic* (New Star Books)

(3) ALAN BROWNOFF · E.D. Blodgett, *Apostrophes II: Through You, I* (University of Alberta Press)

Prose Fiction

(3) BILL DOUGLAS / KINETICS DESIGN · Carole Corbeil, *In the Wings* (Stoddart)

(H) SPENCER FRANCEY PETERS · Mordecai Richler, *Barney's Version* (Knopf Canada)

(H) DEAN ALLEN · Michael Turner, *American Whiskey Bar* (Arsenal Pulp Press)

Prose Non-Fiction

(1) DEAN ALLEN · Michael Kluckner, *The Pullet Surprise: A Year on an Urban Farm* (Raincoast Books)

(2) GEORGE VAITKUNAS · Betty Kobayashi Issenman, *Sinews of Survivial: The Living Legacy of Inuit Clothing* (UBC Press / Études Inuit Studies)

(3) KELLY STAUFFER · Kevin van Tighem, *Coming West: A Natural History of Home* (Altitude Publishing)

(H) GORDON ROBERTSON · Lynn Crosbie, ed., *Click: Becoming Feminists* (MacFarlane Walter & Ross)

Reference Works

(1) MARK FRAM · Christopher Andreae, *Lines of Country: An Atlas of Railway and Waterway History in Canada* (Boston Mills)

(2) TOM BROWN · Wayne Grady, *Vulture: Nature's Ghastly Gourmet* (Greystone Books)

(3) PAUL DAVIES · Todd Hoffman, *Secret Montreal: The Unique Guidebook to Montreal's Hidden Sites, Sounds, Tastes* (ECW Press)

(H) OPUS HOUSE · M. Dale Beckman et al., *Foundations of Marketing*, 6th ed. (Harcourt Brace)

Pictorial Books

(1) ADAMS + ASSOCIATES · Anne Barros, *Ornament and Object: Canadian Jewellery and Metal Art* (Boston Mills)

(2) CARBON MEDIA · Darwin Wiggett, *Darwin Wiggett Photographs Canada* (Whitecap)

(3) DESIGN GEIST · Candace Savage, *Mother Nature: Animal Parents and Their Young* (Greystone Books)

(H) FRANÇOIS BLAIS · David Harris, *Gabor Szilasi: Photographies / Photographs 1954–1996* (McGill-Queen's University Press / Vox Populi)

Children's Books

(1) BRIAN BEAN · Linda Granfield, Silent Night: *The Song from Heaven* (Tundra)

(2) ROSE COWLES · Emily Carr, *Flirt, Punk, and Loo: My Dogs and I* (Douglas & McIntyre)

(3) BLAIR KERRIGAN · Pamela Hickman, *Hungry Animals: My First Look at a Food Chain* (Kids Can)

(3) BLAIR KERRIGAN · Pamela Hickman, *A New Butterfly: My First Look at Metamorphosis* (Kids Can)

(3) BLAIR KERRIGAN · Pamela Hickman, *A Seed Grows: My First Look at a Plant's Life Cycle* (Kids Can)

(H) KONG NJO · Song Nan Zhang, *Cowboy on the Steppes* (Tundra)

(H) ANDREW SMITH · Michael Bedard, *Glass Town* (Stoddart)

—— 1998 ——

Limited Editions

(H) CRISPIN ELSTED · Carlo Toselli, *Fra due giardini / Between Two Gardens / Entre deux jardins* (printed at Barbarian Press for Le Grazie)

Poetry

(1) SARMILA MOHAMMED / KONG NJO · Michael Ondaatje, *Handwriting* (McClelland & Stewart)

(2) GORDON ROBERTSON · Anne F. Walker, *Into the Peculiar Dark* (Mercury Press)

(3) ZAB DESIGN · Derek McCormack & Chris Chambers, *Wild Mouse* (Pedlar Press)

(H) SUSAN DECKER · Robert Boates, *The Afterlife* (Seraphim)

Prose Fiction

(1) SARI GINSBERG · Margaret Laurence, *The Stone Angel* (McClelland & Stewart)

(2) ALAN BROWNOFF · Robert Kroetsch, *What the Crow Said* (University of Alberta Press)

(H) SARI GINSBERG · Hal Niedzviecki, ed., *Concrete Forest: The New Fiction of Urban Canada* (McClelland & Stewart)

Prose Non-Fiction

(1) GEORGE VAITKUNAS · W.H. New, *Borderlands: How We Talk about Canada* (UBC Press)

(2) PAUL HODGSON (SHARON FOSTER DESIGN) / SPENCER FRANCEY PETERS · Alberto Manguel, *Into the Looking Glass Wood: Essays on Words and the World* (Knopf Canada)

(3) GORDON ROBERTSON · Nicole Brossard, *She Would Be the First Sentence of My Next Novel* (Mercury Press)

Prose Non-Fiction Illustrated

(1) GEORGE VAITKUNAS · Morgan Baillargeon & Leslie Tepper, *Legends of Our Times: Native Cowboy Life* (UBC Press / Canadian Museum of Civilization)

(1) LEWIS NICHOLSON / GILBERT LI · John Knechtel, ed., *Open City* (House of Anansi)

(3) ESKIND-WADDELL · Eric McLuhan, *Electric Language: Understanding the Present* (Stoddart)

Reference Works

(1) STAN BEVINGTON · Sandra Alston & Patricia Fleming, *Toronto in Print: A Celebration of 200 Years of the Printing Press in Toronto, 1798–1998* (University of Toronto Library)

Pictorial Books

(1) ROBERTO DOSIL · Linda Doherty & Carol Mayer, *Made of Clay: Ceramics of British Columbia* (Potters Guild of B.C.)

(2) VAL SPEIDEL · Keith McLaren, *Light on the Water: Early Photography of Coastal British Columbia* (Douglas & McIntyre)

(3) BRIAN MACKAY-LYONS / ROBERT MEYER / SUSAN FITZGERALD / MARC CORMIER · Brian Cater, ed., *Brian MacKay-Lyons: Selected Projects, 1986–1997* (Tuns Press)

Children's Books

(1) KAREN POWERS · Elizabeth MacLeod, *I Heard a Little Baa* (Kids Can)

(2) MARIE-LOUISE GAY · Susan Musgrave, *Dreams Are More Real Than Bathtubs* (Orca)

(3) VICTOR BOSSON · Laura Langston, *The Fox's Kettle* (Orca)

(H) DUSAN PETRICIC / KUNZ & ASSOCIATES · Tim Wynne-Jones, *On Tumbledown Hill* (Red Deer College Press)

—— 1999 ——

Limited Editions

(1) CRISPIN ELSTED · Theresa Kishkan, *Inishbream* (printed by Jan Elsted at Barbarian Press)

(2) ROLLIN MILROY · Rollin Milroy, ed., *Francesco Griffo da Bologna: Fragments and Glimpses* (printed by Rollin Milroy for A Lone Press)

(3) HUGH MICHAELSON · George Woodcock, *The Island of Demons* (printed by Hugh Michaelson for Harwood Press)

Poetry

(1) SONIA CHOW · Jeffrey Donaldson, *Waterglass* (McGill-Queen's University Press)

(2) ZAB DESIGN · Chris Chambers, *Lake Where No One Swims* (Pedlar Press)

(3) DAVID DRUMMOND · David Solway, *Chess Pieces* (McGill-Queen's University Press)

Prose Fiction

(1) ANGEL GUERRA / TANNICE GODDARD · Philippe Poloni, *Olivo Oliva* (Stoddart)

(2) ALAN BROWNOFF · Jordan Zinovich, *Gabriel Dumont in Paris* (University of Alberta Press)

(3) SARI GINSBERG · Austin Clarke, *The Question* (McClelland & Stewart)

(H) INGRID PAULSON · William Deverell, *Slander* (McClelland & Stewart)

Prose Non-Fiction

(1) DAVID DRUMMOND · *Herbert Whittaker, Setting the Stage: Montreal Theatre, 1920–1949* (McGill-Queen's University Press)

(2) VAL SPEIDEL · Lorna Crozier, ed., *Desire in Seven Voices* (Douglas & McIntyre)

(H) ROBERT BRINGHURST · Robert Bringhurst, *A Story as Sharp as a Knife: The Classical Haida Mythtellers and Their World* (Douglas & McIntyre)

(H) SHARON FOSTER · John Allemang, *The Importance of Lunch: And Other Real-Life Adventures in Good Eating* (Random House Canada)

(H) AITKEN + BLAKELEY · Tim Cook, *No Place to Run: The Canadian Corps and Gas Warfare in the First World War* (UBC Press)

Prose Non-Fiction Illustrated

(1) BILL DOUGLAS · Craig MacInnis, ed., *Remembering Bobby Orr* (Stoddart)

(2) GEORGE VAITKUNAS · Allan J. Ryan, *The Trickster Shift: Humour and Irony in Contemporary Native Art* (UBC Press)

(3) GEORGE VAITKUNAS · Peter Ward, *A History of Domestic Space: Privacy and the Canadian Home* (UBC Press)

Pictorial Books

(1) GEORGE VAITKUNAS · Dennis Reid, ed., *Krieghoff: Images of Canada* (Douglas & McIntyre / Art Gallery of Ontario)

(1) TIMMINGS & DEBAY · Faith Moosang, *First Son: Portraits by C.D. Hoy* (Presentation House Gallery / Arsenal Pulp Press)

(2) CONCRETE DESIGN / SARA BORINS · Mark Kingwell & Christopher Moore, *Canada: Our Century* (Doubleday Canada)

(H) GLENN GOLUSKA · Mildred Friedman, et al., *Carlo Scarpa Architect: Intervening with History* (Canadian Centre for Architecture / The Monacelli Press)

Children's Books

(1) ANDRÉE LAUZON · Gary Barwin, *The Magic Mustache* (Annick)

(2) MARC TETRO · Marc Tetro, *A Barbecue for Charlotte* (McArthur & Co.)

(H) CHRISTINE TOLLER · Marilynn Reynolds, *The Prairie Fire* (Orca)

—— 2000 ——

Limited Editions

(1) ALAN STEIN / DON TAYLOR · Al Purdy, *Home Country: Selected Poems* (printed by Alan Stein for Church Street Press)

(2) ROLLIN MILROY · *Charles van Sandwyck: An Interim Bibliography 1983 to 2000* (printed by Rollin Milroy for Heavenly Monkey & CVS Fine Arts)

(3) GERARD BRENDER À BRANDIS · Timothy Findley, *If Stones Could Speak* (printed & published by Gerard Brender à Brandis)

(H) JANE MERKS · Stephen Cain, *From Alpha Bites: A Primer* (printed by Peter Bartl for The Press at Pilot Bay)

Poetry

(2) DAMIAN LOPES · Damian Lopes, *Sensory Deprivation / Dream Poetics* (Coach House)

(3) TYPO LITHO COMPOSITION · Auran Haller, *A Dream of Sulphur* (McGill-Queen's University Press)

(H) ALAN BROWNOFF · E.D. Blodgett, *Apostrophes IV: Speaking You Is Holiness* (University of Alberta Press)

Prose Fiction

(1) SHARON FOSTER / JONATHAN HOWELLS · Will Aitken, *Realia* (Random House Canada)

(2) ZAB DESIGN · Julia Gaunce, *Rocket Science* (Pedlar Press)

(H) MARIA CARELLA / KONG NJO · Margaret Atwood, *The Blind Assassin* (McClelland & Stewart)

(H) ALAN BROWNOFF · Robert Kroetsch, *The Words of My Roaring* (University of Alberta Press)

(H) ANDREW STEEVES · J.J. Steinfeld, *Anton Chekhov Was Never in Charlottetown* (Gaspereau Press)

Prose Non-Fiction

(2) KONG NJO · Frank Augustyn with Barbara Sears, *Dancing From the Heart* (McClelland & Stewart)

(2) STAN BEVINGTON · Anne Dondertman, *As the Centuries Turn: Manuscripts and Books from 1000 to 2000* (Thomas Fisher Rare Book Library)

(3) BILL DOUGLAS · Craig McInnis, ed., *Remembering Tim Horton* (Stoddart)

Prose Non-Fiction Illustrated

(H) GEORGE VAITKUNAS · Bill McLennan & Karen Duffek, *The Transforming Image: Painted Arts of the Northwest Coast First Nations* (UBC Press)

Reference Works

(1) ANNE TREMBLAY · *Encyclopédie visuelle des sports* (Québec Amérique)

(2) SHARON FOSTER · Regan Daley, *In the Sweet Kitchen: The Definitive Guide to the Baker's Pantry* (Random House Canada)

(3) GABI PROCTOR / DESIGN GEIST · Bill Jones, *The Savoury Mushroom: Cooking with Wild and Cultivated Mushrooms* (Raincoast Books)

(H) LINDA GUSTAFSON · Stephen Beaumont, *Premium Beer Drinker's Guide: The World's Strongest, Boldest and Most Unusual Beers* (Firefly Books)

Pictorial Books

(2) GEORGE VAITKUNAS · Gary Wyatt, ed., *Susan Point: Coast Salish Artist* (Douglas & McIntyre)

(2) PETER COCKING · Dean F. Oliver & Laura Brandon, *Canvas of War: Painting the Canadian Experience, 1914 to 1945* (Douglas & McIntyre / Canadian War Museum / Canadian Museum of Civilization)

(3) HAHN SMITH · *Architecture Canada 1999: The Governor General's Medals for Architecture* (Tuns Press)

(3) JACQUELINE VERKLEY · Nick Bantock, *The Artful Dodger: Images and Reflections* (Raincoast Books)

(H) GEORGE VAITKUNAS · Ian M. Thom, *Art B.C.: Masterworks from British Columbia* (Douglas & McIntyre / Vancouver Art Gallery)

Children's Books

(2) KONG NJO · Gillian Johnson, *My Sister Gracie* (Tundra)

(3) MARIELLE MAHEU · Lisa Mallen, *Elton the Elf* (Lobster Press)

(3) KATHRYN COLE / MARIE-LOUISE GAY · Don Gillmor, *Yuck: A Love Story* (Stoddart)

(H) JULIA NAIMSKA · Deborah Hodge, *The Kids Book of Canada's Railways and How the CPR Was Built* (Kids Can)

(H) MICHAEL SOLOMON · Jan Andrews, *Pa's Harvest: A True Story Told by Ephrem Carrier* (Groundwood)

—— 2001 ——

Limited Editions

(1) ALEXANDER LAVDOVSKY · P.K. Page, *Alphabetical* [and] *Cosmologies* (printed by Alexander Lavdovsky & Classic Engraving for Poppy Press)

(2) MICHAEL TOROSIAN · Michael Torosian & Edward Burtynsky, *Residual Landscapes: Studies of Industrial Transfiguration* (printed & published by Lumière Press)

(3) ROLLIN MILROY · *Reid's Leaves: A Bibliography of Books from the Private Press of Robert R. Reid, 1949–1962* (printed by Rollin Milroy at Heavenly Monkey)

Poetry

(1) ANDREW STEEVES · George Elliott Clarke, *Execution Poems* (Gaspereau Press)

(2) ZAB DESIGN · K.I. Press, *Pale Red Footprints* (Pedlar Press)

(3) ALEXANDER LAVDOVSKY · Linda Rogers, *Rehearsing the Miracle* (Poppy Press)

(H) ROBERT BRINGHURST · Skaay of the Qquuna Qiighawaay, *Being in Being* (Douglas & McIntyre)

Prose Fiction

(1) BARBARA HODGSON · Barbara Hodgson, *Hippolyte's Island* (Raincoast Books)

(2) ALAN BROWNOFF · Sinclair Ross, *Whir of Gold* (University of Alberta Press)

(3) CARMEN DUNJKO / DANIEL CULLEN · Hal Niedzviecki, *Ditch* (Random House Canada)

(H) RAYOLA / BRIAN KAUFMAN · Charles Tidler, *Red Mango* (Anvil Press)

Prose Non-Fiction

(2) PETER COCKING · Jean McKay, *Exploded View: Observations on Reading, Writing and Life* (Douglas & McIntyre)

(2) ANDREW STEEVES · Don McKay, *Vis à vis: Field Notes on Poetry and Wilderness* (Gaspereau Press)

(H) ALAN BROWNOFF · Theodore Minnema et al., ed., *From Rupert's Land to Canada* (University of Alberta Press)

Prose Non-Fiction Illustrated

(1) CHRIS ROWAT · Phyllis Lambert, *Mies Van Der Rohe: L'art difficile d'être simple / The Difficult Art of the Simple* (Centre Canadien d'Architecture)

(1) FUGAZI [RÉJEAN MYETTE & FRANÇOIS MARTIN] · Gerald Beasley, *Piero en tête: Sculpteurs de Geoffrey Smedly / Meditations on Piero: Sculptures of Geoffrey Smedly* (Centre Canadien d'Architecture)

(2) MARK TIMMINGS · Alexandra Palmer, *Couture and Commerce: The Transatlantic Fashion Trade in the 1950s* (UBC Press / Royal Ontario Museum)

(3) BARBARA HODGSON · Barbara Hodgson, *In the Arms of Morpheus: The Tragic History of Morphine and Patent Medicines* (Greystone Books)

(H) GEORGE VAITKUNAS · Terry Reksten, *The Illustrated History of British Columbia* (Douglas & McIntyre)

(H) KAREN SCHOBER / DEREK HAYES · Derek Hayes, *Historical Atlas of the North Pacific Ocean* (Douglas & McIntyre)

Reference Works

(1) GARY BLAKELEY · Crispin S. Guppy & Jon H. Shepard, *Butterflies of British Columbia* (UBC Press)

(2) QA INTERNATIONAL · *La Météo: Comprendre le climat et l'environnement* (Québec Amérique)

(3) DARRELL MCCALLA · Celia Munro, *Fitzhenry and Whiteside Canadian Thesaurus: The Word You Want, Where and When You Want It* (Fitzhenry & Whiteside)

(H) MICHAEL DANGELMAIER · *A Year of the Best: Seasonal Recipes from the Best of Bridge* (Best of Bridge Publishing)

(H) PETER COCKING · Rob Feenie, *Rob Feenie Cooks at Lumière* (Douglas & McIntyre)

Pictorial Books

(1) DINNICK & HOWELLS · Rachel Gotlieb & Cora Golden, *Design in Canada: Fifty Years from Teakettles to Task Chairs* (Knopf Canada / The Design Exchange)

(2) TIMMINGS & DEBAY · Dennis Reid & Matthew Teitelbaum, ed., *Greg Curnoe: Life and Stuff* (Douglas & McIntyre / Art Gallery of Ontario)

(3) PETER COCKING · William Gough, *David Blackwood: Master Printmaker* (Douglas & McIntyre)

(H) SUE MCPHERSON · David Greer, *Coming Through Fire: The Wildland Firefighters Experience* (Raincoast Books)

Children's Books

(1) KAREN BIRKEMOE · Zoran Milich, *The City ABC Book* (Kids Can)

(2) PHILIPPE BÉHA · Philippe Béha, *La Reine rouge* (Les 400 Coups)

(3) BLAIR KERRIGAN · Linda Granfield, *Where Poppies Grow: A World War I Companion* (Stoddart)

(H) JUDITH STEEDMAN · Carlo Collodi, *The Adventures of Pinocchio: The Story of a Puppet* (Simply Read Books)

(H) PASCALE CONSTANTIN · Andrée-Anne Gratton, *Alexis, chevalier des nuits: Un conte à lire avant d'aller au lit* (Les 400 Coups)

—— 2002 ——

Limited Editions

(1) ALEXANDER LAVDOVSKY · Alice Major, *No Monster* (printed by Classic Engraving for Poppy Press)

(H) PAT & ROSEMARIE KEOUGH · Pat Keough & Rosemarie Keough, *Antarctica* (Nahanni Productions)

Poetry

(1) ANDREW STEEVES · Michael deBeyer, *Rural Night Catalogue* (Gaspereau Press)

(2) DARREN WERSHLER-HENRY · Margaret Christakos, *Excessive Love Prostheses* (Coach House)

(3) ZAB DESIGN · Rachel Vigier, *On Every Stone* (Pedlar Press)

Prose Fiction

(1) PETER COCKING · Guillaume Vigneault, *Necessary Betrayals* (Douglas & McIntyre)

(2) C.S. RICHARDSON · Wayne Johnston, *The Navigator of New York* (Knopf Canada)

(3) ANDREW STEEVES · Susan Haley, *Maggie's Family* (Gaspereau Press)

(H) GORDON ROBERTSON · Larissa Lai, *Salt Fish Girl* (Thomas Allen)

Prose Non-Fiction

(1) ANDREW STEEVES · Peter Sanger, *Spar: Words in Place* (Gaspereau Press)

(2) ANDREW STEEVES · John Terpstra, *Falling into Place* (Gaspereau Press)

(3) PETER COCKING · Sean Rossiter, *The Chosen Ones: Canada's Test Pilots in Action* (Douglas & McIntyre)

(H) C.S. RICHARDSON · Stephen Brunt, *Facing Ali: The Opposition Weighs In* (Knopf Canada)

Prose Non-Fiction Illustrated

(1) ROBERTO DOSIL · Rick Archbold, *I Stand for Canada: The Story of the Maple Leaf Flag* (MacFarlane Walter & Ross)

(2) DEREK HAYES / VAL SPEIDEL · Derek Hayes, *Historical Atlas of Canada: Canada's History Illustrated with Original Maps* (Douglas & McIntyre)

(3) BARBARA HODGSON · Barbara Hodgson, *No Place for a Lady: Tales of Adventurous Women Travellers* (Greystone Books)

(H) PETER COCKING · Doris Shadbolt, *Seven Journeys: The Sketchbooks of Emily Carr* (Douglas & McIntyre)

(H) MARTINA KELLER · Beth Lesser, *King Jammy's* (ECW Press)

(H) VAL COOKE · Martin L. Friedland, *The University of Toronto: A History* (University of Toronto Press)

Reference Works

(1) PETER COCKING · John Bishop & Dennis Green, *Simply Bishop's: Easy Seasonal Recipes* (Douglas & McIntyre)

(2) ALAN BROWNOFF · Carole Sue Bailey & Kathy Dolby, ed., *The Canadian Dictionary of ASL* (University of Alberta Press)

(3) BHANDARI & PLATER / MARIE-NOËLLE MASSÉ · Don Griffith, ed., *The Wood Design Awards 2002* (Tuns Press / Janam Publications)

(H) DEL CARRY · John W. Sabean, ed., *A Boy All Spirit: Thoreau MacDonald in the 1920s* (Penumbra Press)

Pictorial Books

(1) TIMMINGS & DEBAY · Ian M. Thom, *E.J. Hughes* (Douglas & McIntyre)

(2) PETER COCKING · Rudy Wiebe, *Place: Lethbridge, A City on the Prairie* (Douglas & McIntyre)

(3) BHANDARI & PLATER · Essy Baniassad, ed., *Architecture Canada 2002: The Governor General's Medals in Architecture* (Tuns Press)

(H) FUGAZI · Rosemarie L. Tovell, *The Prints of Betty Goodwin* (National Gallery of Canada / Douglas & McIntyre)

(H) CHRISTINE CÔTÉ · Gonzague Verdenal, *4430 miles au compteur* (Les 400 Coups)

(H) RAPHAËL DAUDELIN / MARTIN VILLENEUVE · Martin Villeneuve, *Mars et avril* (Les 400 Coups)

Children's Books

(1) PRIMEAU & BAREY · Marie-Daniel le Croteau, *Un Gnome à la mer* (Dominique et Compagnie)

(2) PRIMEAU & BAREY · Marie-Francine Hébert, *Mon Rayon de soleil* (Dominique et Compagnie)

(3) ANDRÉE LAUZON · Richardo Keens-Douglas, *Anancy and the Haunted House* (Annick)

(H) ROBIN MITCHELL & JUDITH STEEDMAN · Robin Mitchell & Judith Steedman, *Windy* (Simply Read Books)

(H) CHRISTINE TOLLER · Andrea Spalding, *Solomon's Tree* (Orca)

(H) MICHAEL SOLOMON · Nicolas Debon, *A Brave Soldier* (Groundwood)

—— 2003 ——

Limited Editions

(1) MICHAEL TOROSIAN · Ronald Hurwitz, *The Gryphons of Paris: A Reliquary of Photographs and Vignettes* (printed at Lumière Press for Voirin Editions)

(2) JASON DEWINETZ · Matt Rader, *The Land Beyond* (printed by Jason Dewinetz at Greenboathouse Books)

(3) MIMI LIN · Norton Juster, *The Dot and the Line* (printed & published by Mimi Lin)

(H) ARNOLD SHIVES / MARTIN HUNT / CRISPIN ELSTED · Arnold Shives, *Mountain Journal* (printed at Barbarian Press & Blackstone Press for Prospect Press)

Poetry

(1) ANDREW STEEVES / ROBERT BRINGHURST · Robert Bringhurst, *Ursa Major: A Polyphonic Masque for Speakers and Dancers* (Gaspereau Press)

(2) ZAB DESIGN · Souvankham Thammavongsa, *Small Arguments* (Pedlar Press)

(3) ALAN BROWNOFF · E.D. Blodgett, *An Ark of Koans* (University of Alberta Press)

(H) ZAB DESIGN · Joanne Page, *Persuasion for a Mathematician* (Pedlar Press)

Prose Fiction

(1) PETER COCKING · Fred Stenson, *Lightning* (Douglas & McIntyre)

(2) C.S. RICHARDSON · Kate Taylor, *Mme. Proust and the Kosher Kitchen* (Doubleday Canada)

(3) BILL DOUGLAS · Gaétan Soucy, *Vaudeville!* (House of Anansi)

(H) C.S. RICHARDSON · Bill Cameron, *Cat's Crossing* (Random House Canada)

(H) GORDON ROBERTSON · Alberto Manguel, *Stevenson Under the Palm Trees* (Thomas Allen)

(H) ANDREW STEEVES · J.J. Steinfeld, *Would You Hide Me?* (Gaspereau Press)

Prose Non-Fiction

(1) ANDREW STEEVES · Jan Zwicky, *Wisdom & Metaphor* (Gaspereau Press)

(2) JESSICA SULLIVAN · Ian Ferguson, *Village of the Small Houses: A Memoir of Sorts* (Douglas & McIntyre)

(3) C.S. RICHARDSON · Scott Russell, *Open House: Canada and the Magic of Curling* (Doubleday Canada)

(H) DAVID DRUMMOND / SIMON DARDICK · Phil Clavel, *Dad Alone: How to Rebuild Your Life and Remain an Involved Father After Divorce* (Véhicule Press)

(H) GORDON ROBERTSON · Stephen R. Bown, *Scurvy: How a Surgeon, a Mariner, and a Gentleman Solved the Greatest Medical Mystery of the Age of Sail* (Thomas Allen)

Prose Non-Fiction Illustrated

(1) PETER COCKING / VAL SPEIDEL · Jane Billinghurst, *Temptress: From the Original Bad Girls to Women on Top* (Douglas & McIntyre)

(1) ZAB DESIGN · Maria Antonella Pelizzari, ed., *Traces of India / Empreintes de l'Inde* [joint editions] (Canadian Centre for Architecture)

(2) ZAB DESIGN · Annie Gérin, *Godless at the Workbench / Sans-dieu à l'atelier: Soviet Illustrated Humoristic Antireligious Propaganda* (Dunlop Art Gallery)

(3) BILL DOUGLAS · Craig MacInnis, ed., *Remembering Phil Esposito* (Raincoast Books)

(H) BLEU OUTREMER · Aïda Kaouk & Dominique Bourque, ed., *The Lands Within Me: Expressions by Canadian Artists of Arab Origin* (Canadian Museum of Civilization)

Reference Works

(1) ANNE TREMBLAY · Jean-Claude Corbeil & Ariane Archambault, *Le Nouveau dictionnaire multilingue: Français, anglais, espagnol, allemand, italien* (Québec Amérique)

(2) DEREK HAYES / GEORGE VAITKUNAS · Derek Hayes, *Historical Atlas of the Arctic* (Douglas & McIntyre)

(3) BRUCE MAU / BARR GILMORE / JUDITH MCKAY / CATHY JOHASSON · Carol Hansell, *What Directors Need to Know: Corporate Governance 2003* (Carswell)

(H) PETER COCKING / JESSICA SULLIVAN · Rob Feenie & Marnie Coldham, *Lumière Light: Recipes from the Tasting Bar* (Douglas & McIntyre)

(H) MARIE-NOËLLE MASSÉ · Don Griffith, ed., *The Wood Design Awards 2003: A North American Program of Architectural Excellence* (Tuns Press / Janam Publications)

Pictorial Books

(1) LINDA GUSTAFSON · David P. Silcox, *The Group of Seven and Tom Thomson* (Firefly Books)

(2) JOSÉE AMYOTTE · Marc H. Choko et al., *Le Design au Québec* (Éditions de l'homme)

(3) GEORGE VAITKUNAS · Tom Smart, *Alex Colville: Return* (Douglas & McIntyre)

(H) MIKE TEIXEIRA · Annie Thibault & Anne Bénichou, *Les Documents de la chambre des cultures* (Centre d'artistes axenéo-7)

(H) FUGAZI · Sylvia Safdie et al., *Sylvia Safdie: The Inventories of Invention / Les Inventaires de l'imaginaire* (Leonard & Bina Art Gallery)

Children's Books

(1) PRIMEAU & BAREY · Elaine Arsenault, *Le Grand rêve de Passepoil* (Dominique et Compagnie)

(2) TAMMY DESNOYERS · Valerie Coulman, *Sink or Swim* (Lobster Press)

(3) JUDITH STEEDMAN · Lewis Carroll, *Alice's Adventures in Wonderland* (Simply Read Books)

(H) ROBIN MITCHELL · Sean Moore, *Always Run Up the Stairs* (Simply Read Books)

(H) PRIMEAU & BAREY · Gilles Tibo, *Emilie pleine de jouets* (Dominique et compagnie)

(H) ROBIN MITCHELL & JUDITH STEEDMAN · Robin Mitchell & Judith Steedman, *Sunny* (Simply Read Books)

—— 2004 ——

Limited Editions

(1) MICHAEL TOROSIAN · Michael Torosian, *Dave Heath: Korea* (printed & published by Lumière Press)

(2) JASON DEWINETZ · Shane Rhodes, *Tengo sed* (printed by Jason Dewinetz at Greenboathouse Books)

(3) ALAN STEIN · Gary Michael Dault, *In Smoke: Ten Variations on Eugenio Montale* (printed by Alan Stein for the Church Street Press)

Poetry

(1) DARREN WERSHLER-HENRY · Mark Truscott, *Said Like Reeds or Things* (Coach House)

(2) DENNIS PRIEBE · Salvatore Ala, *Straight Razor and Other Poems* (Biblioasis)

Prose Fiction

(1) C.S. RICHARDSON · Wayson Choy, *All That Matters* (Doubleday Canada)

(2) INGRID PAULSON · Anosh Irani, *The Cripple and His Talismans* (Raincoast Books)

(3) PETER COCKING · David Albahari, *Snow Man* (Douglas & McIntyre)

(3) KELLY HILL · Miriam Toews, *A Complicated Kindness* (Knopf Canada)

Prose Non-Fiction

(1) PETER COCKING / INGRID PAULSON · Adam Harmes, *The Return of the State: Protestors, Power-Brokers, and the New Global Compromise* (Douglas & McIntyre)

(2) JESSICA SULLIVAN · David Suzuki & Wayne Grady, *Tree: A Love Story* (Greystone Books)

(3) JESSICA SULLIVAN · M.A.C. Farrant, *My Turquoise Years: A Memoir* (Greystone Books)

Prose Non-Fiction Illustrated

(1) PETER COCKING · J.L. Granatstein, *Hell's Corner: An Illustrated History of Canada's Great War, 1914–1918* (Douglas & McIntyre)

(2) GEORGE VAITKUNAS · Peter L. Storck, *Journey to the Ice Age: Discovering an Ancient World* (UBC Press / Royal Ontario Museum)

Reference Works

(1) ANNE TREMBLAY · Jean-Claude Corbeil & Ariane Archambault, *Le Visuel dictionnaire thématique: Définitions* (Québec Amérique)

(2) PETER COCKING · Jamie Maw & Joan Cross, ed., *Vancouver Cooks* (Douglas & McIntyre)

(3) PETER COCKING / JESSICA SULLIVAN · Peter McGee, *Kayak Routes of the Pacific Northwest* (Greystone Books)

Pictorial Books

(1) ALAN BROWNOFF · John Fleming & Michael Rowan, *Folk Furniture of Canada's Doukhobors, Hutterites, Mennonites, and Ukrainians* (University of Alberta Press)

(2) BHANDARI & PLATER · *Architecture Canada 2004: The Governor General's Medals in Architecture / Les Médailles du gouverneur général en architecture* (Tuns Press)

(3) BRYAN GEE · Rebecca Diederichs, ed., *Peter MacCallum: Material World: Photographs: Interiors, 1986–2004; Concrete Industries, 1988–2004* (YYZ Books)

(H) TIM INKSTER / PAUL HODGSON · Rudolf Kurz, *Looking for Snails on a Sunday Afternoon: Thirty-Six Etchings and Three Stories* (Porcupine's Quill)

(H) TOMASZ WALENTA · Lino, *La Saveur du vide* (Les 400 Coups)

Children's Books

(1) KAREN POWER · Lewis Carroll, *Jabberwocky* (Kids Can)

(2) KONG NJO · Gillian Johnson, *Gracie's Baby Chub Chop* (Tundra)

(3) PAOLA VAN TURENNOUT · Paola van Turennout, *One Little Bug* (Simply Read Books)

(H) ELISA GUTIÉRREZ · Norm Hacking, *When Cats Go Wrong* (Raincoast Books)

—— 2005 ——

Limited Editions

(1) CRISPIN ELSTED · Carlo Toselli, *Il Bosco dei tamarindi / The Tamarind Wood / Le Bois des tamariniers* (printed by Barbarian Press for Le Grazie)

(2) JASON DEWINETZ · Sina Queyras, *Life, Still and Otherwise* (printed by Jason Dewinetz at Greenboathouse Books)

(2) CRISPIN ELSTED · Alan Loney, *Gallipoli* (printed & published by Barbarian Press)

(3) APOLLONIA ELSTED · Emily Dickenson, *Emily: Opposites Attract* (printed by the author at Barbarian Press for Horse Whisper Press)

(H) ANIK SEE · "RC," *Ten Steps to a Life Uniform* [deluxe & regular editions] (Fox Run Press)

Poetry

(2) DAVID BIRCHAM · Bud Osborn, *Signs of the Times* (Anvil Press / Signs of the Times)

(H) BLAINE KYLLO · Donato Mancini, *Ligatures* (New Star Books)

(H) ZAB DESIGN · Stan Dragland, *Stormy Weather: Foursomes* (Pedlar Press)

(H) RAYOLA / HEIMATHOUSE · Jen Currin, *The Sleep of Four Cities* (Anvil Press)

Prose Fiction

(1) JESSICA SULLIVAN · Francine D'Amour, *Return from Africa* (Douglas & McIntyre)

(2) PETER COCKING · Sky Lee, *Disappearing Moon Café* (Douglas & McIntyre)

(H) JESSICA SULLIVAN · Wayson Choy, *The Jade Peony* (Douglas & McIntyre)

(H) ALANA WILCOX / STAN BEVINGTON · Nicole Brossard, *Yesterday, at the Hotel Clarendon* (Coach House)

Prose Non-Fiction

(H) ALAN BROWNOFF · Jennifer Blair et al., *Recalling Early Canada: Reading the Political in Literary and Cultural Production* (University of Alberta Press)

(H) JESSICA SULLIVAN · Rita Moir, *The Windshift Line: a Father and Daughter's Story* (Greystone Books)

(H) JESSICA SULLIVAN / LISA HEMINGWAY · Jean Béliveau et al., *Jean Béliveau: My Life in Hockey* (Greystone Books)

Prose Non-Fiction Illustrated

(2) C.S. RICHARDSON · Graeme Gibson, *The Bedside Book of Birds* (Doubleday Canada)

(3) ZAB DESIGN · Bill Burns, *Safety Gear for Small Animals / Équipement de sécurité pour petits animaux* (Tom Thomson Memorial Art Gallery et al.)

(3) JESSICA SULLIVAN · Candace Savage, *Crows: Encounters with the Wise Guys of the Avian World* (Greystone Books)

(H) SUSAN TURNER · Sandra Shields & David Campion, *The Company of Others: Stories of Belonging* (Arsenal Pulp Press)

Reference Works

(2) TOXA-TANIA JIMÉNEZ / SOPHIE LYONNAIS · Michèle Serre, *Les Produits du marché au Québec* (Éditions du Trécarré)

(3) PETER COCKING / JESSICA SULLIVAN · Tim Leadem, *Hiking the West Coast of Vancouver Island* (Greystone Books)

(H) ANOUK PENNEL / RAPHAEL DEAUDELIN · *L'Appareil* (Éditions de la Pastèque)

Pictorial Books

(1) PETER COCKING · James R. Page, *Wild Prairie: a Photographer's Personal Journey* (Greystone Books)

(2) ALAN BROWNOFF · John Conway, *Saskatchewan: Uncommon Views* (University of Alberta Press)

(H) PETER COCKING · Derek Norton & Nigel Reading, *Cape Dorset Sculpture* (Douglas & McIntyre)

(H) JESSICA SULLIVAN / PETER COCKING · Ian M. Thom et al., *Takao Tanabe* (Douglas & McIntyre)

(H) ROBERT TOMBS / THADDEUS HOLOWNIA · Peter Sanger & Thaddeus Holownia, *Arborealis* (Anchorage Press)

Children's Books

(1) KAREN POWERS · Kenyon Cox, *Mixed Beasts* (Kids Can)

(2) ROBERT CHAPLIN · Robert Chaplin, *Ten Counting Cat* (Robert Chaplin)

(3) LYNN O'ROURKE · Ned Dickens, *By a Thread* (Orca)

(3) KAREN POWERS · Alfred Noyes, *The Highwayman* (Kids Can)

(H) TIM INKSTER · P.K. Page, *A Brazilian Alphabet for the Younger Reader* (Porcupine's Quill)

(H) ELISA GUTIÉRREZ · Elisa Gutiérrez, *Picturescape* (Simply Read Books)

(H) ELISA GUTIÉRREZ · James Heneghan & Bruce McBay, *Nannycatch Chronicles* (Tradewind Books)

—— 2006 ——

Limited Editions

(1) JIM ROBERTS / ROBERT MAJZELS · Robert Majzels, *Apikoros Sleuth*, 2nd ed. (printed & published by Moveable Inc.)

(2) DAWNA ROSE / BETSY ROSENWALD · Dawna Rose, *Smoking with My Mother* (Jack Pine Press)

(3) JASON DEWINETZ · Souvankham Thammavongsa, *Residual* (printed by Jason Dewinetz at Greenboathouse Books)

(H) LAURENT PINABEL · Laurent Pinabel, *La nature humaine, en 36 états* (Éditions de la Nature Humaine)

Poetry

(2) TIM INKSTER · Wayne Clifford, *The Book of Were* (Porcupine's Quill)

(2) BILL KENNEDY · Angela Rawlings, *Wide Slumber for Lepidopterists* (Coach House)

(3) ANDREW STEEVES · Tim Bowling, *Fathom* (Gaspereau Press)

(3) ANNE-MAUDE THÉBERGE · Michel van Schendel, *L'Oiseau, le vieux-port et le charpentier* (L'Hexagone)

(H) ZAB DESIGN · Dani Couture, *Good Meat* (Pedlar Press)

Prose Fiction

(1) JESSICA SULLIVAN · Gil Courtemanche, *A Good Death* (Douglas & McIntyre)

(3) KAREN KLASSEN / HEIMAT HOUSE · Jenn Farrell, *Sugar Bush and Other Stories* (Anvil Press)

(H) C.S. RICHARDSON · Mark Frutkin, *Fabrizio's Return* (Knopf Canada)

Prose Non-Fiction

(1) ROBERT BRINGHURST / ANDREW STEEVES · Robert Bringhurst, *The Tree of Meaning: Thirteen Talks* (Gaspereau Press)

Prose Non-Fiction Illustrated

(2) PETER COCKING / NAOMI MACDOUGALL · Paul Yee, *Saltwater City: An Illustrated History of the Chinese in Vancouver* (Douglas & McIntyre)

(2) ROXANA ZEGAN · Martin Villeneuve, *Mars et avril, tome 2: À la poursuite du fantasme* (Éditions de la Pastèque)

(3) NAOMI MACDOUGALL / PETER COCKING · Andrew Podnieks, *A Canadian Saturday Night: Hockey and the Culture of a Country* (Douglas & McIntyre)

(H) ROBERTO DOSIL · Daniel Francis, *A Road for Canada: The Illustrated Story of the Trans-Canada Highway* (Stanton Atkins & Dosil)

(H) GEORGE VAITKUNAS · Gerta Moray, *Unsettling Encounters: First Nations Imagery in the Art of Emily Carr* (UBC Press)

(H) ELISA GUTIÉRREZ · Alberto Pérez-Gomez et al., *Towards an Ethical Architecture: Issues within the Work of Gregory Henriquez* (Simply Read / Blueimprint)

Reference Works

(1) NAOMI MACDOUGALL / PETER COCKING · Vikram Vij & Meeru Dhalwala, *Vij's Elegant and Inspired Indian Cuisine* (Douglas & McIntyre)

(2) SHARON KISH · Susan McKenna Grant, *Piano, Piano, Pieno: Authentic Food from a Tuscan Farm* (Harper Collins)

(3) INGRID PAULSON · Terry Murray, *Faces on Places: A Grotesque Tour of Toronto* (House of Anansi)

(H) JESSICA SULLIVAN / PETER COCKING · *Hiking the West Coast Trail: A Pocket Guide* (Greystone Books)

Pictorial Books

(1) GEORGE VAITKUNAS · Abraham Rogatnick et al., *B.C. Binning* (Douglas & McIntyre)

(2) TOMASZ WALENTA · Lino, *L'Ombre du doute* (Les 400 Coups)

(2) JESSICA SULLIVAN · Nigel Reading & Gary Wyatt, *Manawa / Pacific Heartbeat: A Celebration of Contemporary Maori and Northwest Coast Art* (Douglas & McIntyre)

(3) PETER COCKING · Nicolas Olsberg & Ricardo L. Castro, *Arthur Erickson: Critical Works* (Douglas & McIntyre)

(H) GEORGE VAITKUNAS · Ingo Hessel, *Arctic Spirit: Inuit Art from the Albrecht Collection at the Heard Museum* (Douglas & McIntyre)

(H) ROBIN MITCHELL · Christopher MacDonald & Greg Bellerby, *SweaterLodge* (Simply Read / Blueimprint)

Children's Books

(1) ROBIN MITCHELL · Sara O'Leary, *When You Were Small* (Simply Read Books)

(2) ANDRÉE LAUZON · André Leblanc, *L'Envers de la chanson: des enfants au travail, 1850–1950* (Les 400 Coups)

(H) KAREN POWERS · Ernest L. Thayer, *Casey at the Bat* (Kids Can)

(H) ROBIN MITCHELL · Jennifer Lloyd, *One Winter Night* (Simply Read Books)

(H) ANDRÉE LAUZON · Sophie Gironnay, *Philou, architecte et associés* (Les 400 Coups)

The Malahat Awards were restricted to poetry publications, and the competition was discontinued after only three years. In the first year, two further awards were made in recognition of poetry broadsides designed and printed by Barry McKinnon at the Gorse Press.

As in appendix 1, the DESIGNER is listed first in small caps, then Author, *Title in italic* (Publisher in parens).

—— 1981–2 ——

Poetry

(1) WILLIAM TOYE · Jay Macpherson, *Poems Twice Told* (Oxford University Press)

(2) TIM INKSTER · *Trojan Women: The Trojan Women* by Euripides and *Helen* and *Orestes* by Yannis Ritsos (Exile Editions)

(3) TIM INKSTER · Robert Finch, *Has and Is* (Porcupine's Quill)

(4) TIM INKSTER · Tim Inkster, *Blue Angel* (Black Moss)

(5) TIM INKSTER · Al Purdy, *The Stone Bird* (McClelland & Stewart)

(6) TIM INKSTER · Peter Stevens, *Revenge of the Mistresses* (Black Moss)

(7) WILLIAM FOX · David McFadden, *My Body Was Eaten by Dogs* (McClelland & Stewart)

(8) TIM INKSTER · Martin Reyto, *The Cloned Mammoth* (Quadrant)

(9) TIM INKSTER · Stephen Scobie, *McAlmon's Chinese Opera* (Quadrant)

(10) TIM INKSTER · Jane Urquhart, *I Am Walking in the Garden of His Imaginary Place: Eleven Poems for Le Nôtre* (Aya Press)

—— 1982–3 ——

Poetry

(1) COACH HOUSE PRESS · Dorothy Livesay, *The Phases of Love* (Coach House)

(2) TIM INKSTER · Diane Keating, *No Birds or Flowers* (Exile Editions)

(3) TIM INKSTER · Barry Callaghan, *As Close as We Came* (Exile Editions)

(4) TIM INKSTER · Robert Chute, *Thirteen Moons / Treize lunes* (Penumbra)

—— 1983–4 ——

Poetry

(1) GORDON ROBERTSON / MARY SCALLY · Marlene Cookshaw, *Personal Luggage* (Coach House)

(2) TIM INKSTER · Robert Finch, *The Grand Duke of Moscow's Favourite Solo* (Porcupine's Quill)

(3) GLYN DAVIS / HOWARD FOX · A.F. Moritz, *The Visitation* (Aya Press)

(4) TIM INKSTER · Jane Urquhart, *The Little Flowers of Madame de Montespan* (Porcupine's Quill)

Publishers and designers mentioned fewer than five times in the first two appendices are omitted from the lists in appendix 3. (I have also, of course, excluded myself.)

Appendices 1 and 2 together span twenty-five years, but not all designers and publishers who have won awards within that time have had that long in which to do it. Barbara Hodgson, after a brief, successful career designing books for others, went off to make books of her own. Alan Brownoff, Peter Cocking, Linda Gustafson, Elizabeth Hobart (Zab Design), Andrew Steeves, Jessica Sullivan, George Vaitkunas, and others, though they have won many awards, started work long after Tim Inkster and Gordon Robertson. Dean Allen also came to the party late, and then left early, moving his studio from Canada to France. And some of the best designers work in a way that naturally brings them more awards, while others work or act in a way that brings them fewer. Indeed, there are some excellent designers who have never of their own accord submitted a book to a competition.

The list of publishers must be read in a similar light. Douglas & McIntyre, Coach House, Porcupine's Quill, McClelland & Stewart, and others have all been publishing for over twenty-five years, but not all at the same rate. Gaspereau Press, Mercury Press, Pedlar Press, Red Deer College Press, and others, who started later, have won their awards in a shorter time.

It would not be hard to sift the data from appendices 1 and 2 through a series of calculations, assigning different weights to different awards, weighing the number of awards against the number of titles published or designed and the length of time in competition. Everyone then could be given a score and an absolute ranking. This, I think, would be an utter waste of time.

We can fairly suspect that something real is happening when a select few publishers and designers are formally applauded by their peers twenty or thirty or sixty times over the space of two or three decades. But the process is not accurate enough to render fine distinctions, nor is that the function of awards. Their use, it seems to me, is celebration. I offer this rudimentary tally as a salute, and nothing more.

DESIGNERS

43	Tim Inkster
35	Gordon Robertson
28	Peter Cocking
21	George Vaitkunas
16	Jessica Sullivan
15	Michael Solomon
13	Alan Brownoff
12	Zab Design (E.A. Hobart)
11	Scott Richardson
11	Andrew Steeves
9	Crispin Elsted
9	Barbara Hodgson
8	Dean Allen
8	Bev Leech
8	Kong Njo
8	Linda Gustafson
8	Michael Torosian
7	Glenn Goluska
7	Blair Kerrigan
6	Marie Bartholomew
6	Linda J. Menyes
5	Bill Douglas
5	Marie-Louise Gay

PUBLISHERS

63	Douglas & McIntyre
30	Coach House
24	The Porcupine's Quill
21	Kids Can Press
16	UBC Press
15	University of Alberta Press
15	McClelland & Stewart
14	Greystone Books
14	Raincoast Books
12	Gaspereau Press
11	ECW Press
11	Simply Read Books
11	Stoddart
9	Annick Press
9	Camden House
9	Oxford University Press
9	Pedlar Press
8	Canadian Centre for Architecture
8	Key Porter Books
8	Knopf Canada
8	Mercury Press
8	Les 400 Coups
8	Random House Canada
8	Sono Nis Press
7	Lumière Press
7	Éditions du Noroît
7	Tundra Books
7	Tuns Press
6	Doubleday Canada
6	McFarlane Walter & Ross
6	McGill-Queen's University Press
6	Orca Books
5	Arsenal Pulp Press
5	Art Gallery of Ontario
5	Firefly Books
5	Harcourt Brace Canada
5	Penumbra Press
5	Red Deer College Press

Ainslie, Patricia. 1984. *Images of the Land: Canadian Block Prints 1919–1945*. Calgary: Glenbow Museum.

Alcuin Society. 1984–1995, 2000. "Annual Alcuin Awards for Excellence in Canadian Book Design." Vancouver: *Amphora* 57 (Sept. 1984), 59 (March 1985), 64 (June 1986), 70 (Dec. 1987), 72 (June 1988), 77 (Sept. 1989), 81 (Sept. 1990), 84 (Summer 1991), 89 (Autumn 1992), 92 (Summer 1993), 97 (Autumn 1994), 101 (Autumn 1995), 124 ([Summer] 2000). ✣ The title varies from year to year, and in some years the report is a loose insert to the journal, not bound in. The report for 1984 deals with books published 1981–83. Subsequent instalments deal year by year with books published in the year immediately preceding. From 1996 on, separate catalogues were issued.

———. 1996–2007. *The Alcuin Awards for Excellence in Book Design in Canada*. Exhibition catalogues. Vancouver: Alcuin Society. ✣ Published annually, beginning with the 1995 competition. Catalogues from 1996 to 1999 are titled according to the year of publication of the catalogue itself, which is one year later than the year of publication of the books to which it pertains. Beginning with the 2000 catalogue (published in 2001), catalogues are titled according to the year of the competition, which is the year of publication of the books involved. The catalogue for the 1999 competition was published out of series in 2000, as issue 124 of the society's journal *Amphora*.

Allen, Dean. 1999. "Saving Face." Toronto: *Quill & Quire* 65.2: 20.

———. 2000a. "Function Meets Beauty: Canadian Book Design Comes of Age." Toronto: *Quill & Quire* 66.4: 34.

———. 2000b. "Book Design in Canada." *http://www.cardigan.com/2000/03-24/*

Alston, Sandra, & Patricia Fleming. 1998. *Toronto in Print: A Celebration of 200 Years of the Printing Press in Toronto, 1798–1998*. Exhibition catalogue. Toronto: University of Toronto Press.

Anonymous. 1947. "Canadian Book Design." Toronto: *Quill & Quire* 13.1: 33, 39.

———. 1949. "To Be or Not to Be: Paul Arthur, Typographer." Toronto: *Quill & Quire* 15.1: 12–14.

———. 1968. "Who's Who in Canadian Art: Carl Dair." Toronto: *Ontario Library Review* 52.1: unpaginated insert.

Arthur, Paul, et al., ed. 1960. [Special Issue on graphic design.] *Canadian Art* 68 (17.3). Ottawa.

Babe, Robert E. 2000. *Canadian Communication Thought: Ten Foundational Writers*. Toronto: University of Toronto Press.

Bantock, Nick. 2000. *The Artful Dodger: Images and Reflections*. Vancouver: Raincoast.

Barrett, T.H. 2008. *The Woman Who Discovered Printing*. New Haven: Yale University Press.

Bates, Wesley W. 1994. *The Point of the Graver*. Erin, Ont.: Porcupine's Quill.

———. 2005. *In Black and White: A Wood Engraver's Odyssey*. Newton, Pennsylvania: Bird & Bull Press.

Beny, W. Roloff. 1948. "An Approach to Book Design." Ottawa: *Canadian Art* 5.4: 189–93, 210.

Bernier, Sylvie. 1990. *Du Texte à l'image: Le Livre illustré au Québec*. Sainte-Foy: Les Presses de l'Université Laval.

Bevington, Stan, & Dave Godfrey. 1967. "Small Presses: An Interview." Toronto:
 Canadian Forum 47: 107–9.

Biagioli, Monica. 2000. "Humble Servant of the Printed Word: Antje Lingner." Erin,
 Ont.: *DA: A Journal of the Printing Arts* 47: 4–16.

Bradbury, Maureen. 1978–80. *Fine Printing by Canadian Private Presses: A Descriptive
 Listing of the Holdings of Special Collections.* 2 vols. *News from the Rare Book
 Room* 17–18. Edmonton: Cameron Library, University of Alberta.

Brender à Brandis, Gerard, & Danuta Kamocki. 1990. *The White Line: Wood Engraving
 in Canada since 1945.* Exhibition catalogue. Erin, Ont.: Porcupine's Quill.

Bringhurst, Robert. 1984. *Ocean/Paper/Stone.* Vancouver: William Hoffer.

———. 1986. "Of Gladness as a Moral Force in Time." Pp 84–91 in *Skelton at Sixty,*
 edited by Barbara Turner. Erin, Ont.: Porcupine's Quill.

———. 1987. *Pebble/Pond/Errata Slip: A Codicil to Ocean/Paper/Stone.* Vancouver:
 privately printed.

———. 2000. "Editing the Pretext." Toronto: *Journal of Scholarly Publishing* 31.3:
 113–25.

———. 2004a. *The Elements of Typographic Style.* 3rd ed. Vancouver: Hartley &
 Marks.

———. 2004b. *The Solid Form of Language: An Essay on Writing and Meaning.*
 Kentville, N.S.: Gaspereau.

———. 2005. *And Much More, Not Ourselves: The Work of Jan and Crispin Elsted.*
 Mission, B.C.: Barbarian Press.

———. 2007. *Everywhere Being Is Dancing: Twenty Pieces of Thinking.* Kentville, N.S.:
 Gaspereau.

Burford-Mason, Roger. 1996. *Travels in the Shining Island: The Story of James Evans
 and the Invention of the Cree Syllabary Alphabet* [sic]. Toronto: Natural Heritage
 Books.

Caines, Joyce. 2005. "ᐅᑕᖅᖅ ᑎᑎᕋᐅᓯᖅᑖᖅᑎᖅ ᓄᓇᕕᒃ ᐃᓄᒃᑎᑐᑦ / The New Vitality of
 Written Nunavik Inuktitut / La Nouvelle vitalité de l'Inuktitut écrit du Nunavik."
 Ottawa: ᐃᓄᒃᑎᑐᑦ / *Inuktitut* 97: 33–42.

Campbell, Grant. 2001. "William Collins During World War II." Toronto: *Papers of
 the Bibliographical Society of Canada / Cahiers de la Société bibliographique du
 Canada* 39: 45–65.

Campbell, Sandra. 1995. "From Romantic History to Communications Theory: Lorne
 Pierce as Publisher of C.W. Jefferys and Harold Innis." Peterborough, Ont.:
 Journal of Canadian Studies / Revue d'études canadiennes 30.3: 91–116.

Carpenter, Edmund, & Marshall McLuhan, ed. 1960. *Explorations in Communication.*
 Boston: Beacon Press.

Cavell, Richard. 2002a. "Book Design and Illustration." Pp 131–37 in *Encyclopedia of
 Literature in Canada,* edited by W.H. New. Toronto: University of Toronto Press.

———. 2002b. *McLuhan in Space: A Cultural Geography.* University of Toronto
 Press.

Chappell, Warren, & Robert Bringhurst. 1999. *A Short History of the Printed Word.*
 2nd ed. Vancouver: Hartley & Marks.

Chartrand, Georges-Aimé, ed. 1977. *Livre, bibliothèque et culture québécoise.*
 Montréal: Association pour l'avancement des sciences et des techniques pour la
 documentation.

Choquette, Robert. 1995. *The Oblate Assault on Canada's Northwest.* Ottawa:
 University of Ottawa Press.

Coleman, Victor. 1969. "Technical Difficulties." Toronto: *Artscanada* 134/135: 19–20.

Cooper, Edward T. 1938. *Chronology of Trade Typesetting in Canada ... 1902–1938.* Toronto: Ryerson.

Dair, Carl. 1947. "A Canadian Typographic Idiom." Ottawa: *Canadian Art* 4.2: 70–73. [Reprinted in *Artscanada* 38: 28–30 (1982).]

———. 1952. *Design with Type.* New York : Pellegrini & Cudahy.

———. 1963. "Why Typography?" Ottawa: *Canadian Art* 20.5: 291.

———. 1964–68. *A Typographic Quest.* 6 pamphlets. [New York]: West Virginia Pulp & Paper.

———. 1967. *Design with Type.* 2nd ed. Toronto: University of Toronto Press.

———. 2003. *The Paper Mills of Amalfi*, with an introduction & afterword by Robert R. Reid. Vancouver: Heavenly Monkey.

Daniels, Peter T., & William Bright, ed. 1996. *The World's Writing Systems.* New York: Oxford University Press.

Davey, Frank. 1964. "British Columbia Printing and the Morriss Press." Vancouver: *British Columbia Library Quarterly* 28: 17–24.

Day, Kenneth, ed. 1966. *Book Typography 1815–1965.* London: Benn.

Decent, Ronald. 1963. "Report from Canada." London: *Book Design and Production* 6: 160.

Devroye, Luc. [ongoing.] "The Canadian Type Scene." *http://cg.scs.carleton.ca/~luc/canada.html.*

Donnelly, Brian. 1996. *Graphic Design in Canada since 1945.* Exhibition catalogue. Ottawa: Carleton University Art Gallery.

———. 1997. Mass Modernism: Graphic Design in Central Canada, 1955–1965, and the Changing Definition of Modernism. Unpublished MA thesis, Carleton University, Ottawa.

———. 2001. "Disrupting Design: A Debate with the Later Writings of Carl Dair." Erin, Ont.: *DA: A Journal of the Printing Arts* 48: 31–40.

———. 2004a. "Touch, Community and Aesthetics: Where Harold Kurschenska's Designs Take Us." Erin, Ont.: *DA: A Journal of the Printing Arts* 55: 5–22.

———. 2004b. "Revolutionizing Ink: Negotiating a Canadian Modern in the Work of Peter Dorn." Erin, Ont.: *DA: A Journal of the Printing Arts* 55: 45–56.

———. 2006. "Locating Graphic Design History in Canada." Oxford: *Journal of Design History* 19: 283–94.

Dorn, Peter. 2004. "About the Art of the Book in Canada." Erin, Ont.: *DA: A Journal of the Printing Arts* 55: 57–60. [Reprinted from *Internationale Buch Kunst: Ausstellung Leipzig*, Leipzig, 1971.]

Dorsonville, Max. 1973. "La Problématique du livre québécois." Vancouver: *Canadian Literature* 57: 35–49.

Duval, Paul. 1961. "Word and Picture: The Story of Book Illustration in Canada." Toronto: *Provincial's Paper* 26.2: unpaginated.

Edison, Margaret E. 1973. *Thoreau MacDonald: A Catalogue of Design and Illustration.* Toronto: University of Toronto Press.

Eisenstein, Elizabeth. 1979. *The Printing Press as an Agent of Change: Communications and Cultural Transformations in Early Modern Europe.* 2 vols. Cambridge, UK: Cambridge University Press.

Eliot, Simon, Andrew Nash & Ian Willison, ed. 2007. *Literary Cultures and the Material Book.* London: British Library.

Elsted, Crispin, ed. 2004. *Hoi Barbaroi: A Quarter-Century at Barbarian Press.* Mission, B.C.: Barbarian Press.

Eustace, Cecil John. 1972. "Developments in Canadian Book Production and Design." Pp 61–85 in [Ontario] *Royal Commission on Book Publishing: Background Papers.* Toronto: Queen's Printer.

Fauteux, Aegidius. 1929. *The Introduction of Printing into Canada.* Montreal: Rolland Paper.

Fleming, Allan. 1960. Response to Fulford et al. Ottawa: *Canadian Art* 17.5: 309–10. [Reprinted in *Artscanada* 38 (1982): 96–97.] ✳ *See also* Fulford et al. 1960.

Fleming, Patricia Lockhart, & Sandra Alston. 1999. *Early Canadian Printing: A Supplement to Marie Tremaine's "A Bibliography of Canadian Imprints, 1751–1800."* Toronto: University of Toronto Press. ✳ *See also* Tremaine 1952.

Fleming, Patricia Lockhart, & Yvan Lamonde, ed. 2004–7. *History of the Book in Canada.* 3 vols. Toronto: University of Toronto Press.

Fulford, Robert, et al. 1960. Letter to the Editor. Ottawa: *Canadian Art* 17.5: 307–9. [Reprinted in *Artscanada* 38 (1982): 95–96.] ✳ *See also* Fleming 1960.

Gaur, Albertine. 1984. *A History of Writing.* London: British Library.

Ghan, Linda. 1980. "Interview with Frank Newfeld." Guelph, Ont.: *Canadian Children's Literature* 17: 3–19.

Gibson, John, & Laurie Lewis, ed. 1980. *Sticks and Stones: Some Aspects of Canadian Printing History.* Toronto: Toronto Typographic Association.

Gibson, Shirley, et al. 1973. "New Wave in Publishing." Vancouver: *Canadian Literature* 57: 50–64.

Giguère, Roland. 1982. "Une aventure en typographie: des Arts graphiques aux Éditions Erta." Montreal: *Études françaises* 18.2: 99–104.

Goddard, Ives, ed. 1996. *Handbook of North American Indians,* vol. 17: *Languages.* Washington, D.C.: Smithsonian Institution.

Gordon, Raymond G., Jr., ed. 2005. *Ethnologue: Languages of the World.* 15th ed. Dallas: SIL International. Online at *http://www.ethnologue.com.*

Guest, Tim, ed. 1981. *Books by Artists.* Toronto: Art Metropole.

Hajmal, Edna, & Richard Landon. 1996. *Cooper & Beatty: Designers with Type.* Exhibition catalogue. Toronto: Thomas Fisher Rare Book Library.

Harper, Kenn. 1985. "The Early Development of Inuktitut Syllabic Orthography." Quebec: *Études Inuit / Inuit Studies* 9.1: 141–62.

Henighan, Tom. 1996. *The Presumption of Culture.* Vancouver: Raincoast.

Horn, Alan, & Guy Upjohn. 1995. *Fine Printing: The Private Press in Canada.* Exhibition catalogue. Toronto: Canadian Bookbinders & Book Artists Guild.

Hould, Claudette. 1982. *Répertoire des livres d'artistes au Québec.* Montréal: Bibliothèque nationale du Québec.

Huel, Raymond J.A. 1996. *Proclaiming the Gospel to the Indians and the Métis.* Edmonton: University of Alberta Press.

Hymes, Dell. 1981. *"In Vain I Tried to Tell You": Essays in Native Amerrican Ethnopoetics.* Philadelphia: University of Pennsylvania Press.

———. 2003. *Now I Know Only So Far: Essays in Ethnopoetics.* Lincoln: University of Nebraska Press.

Innis, Harold. 1950. *Empire and Communications.* Oxford: Clarendon Press.

Inkster, Tim. 1983. *An Honest Trade: An Exhibition of Canadian Small Press Books Printed and Bound at the Porcupine's Quill.* Erin, Ont.: Porcupine's Quill.

Johnston, Edward. 1906. *Writing and Illuminating, and Lettering.* London: John Hogg.

King, James. 1999. *Jack: A Life with Writers: The Story of Jack McClelland.* Toronto: Knopf.

Knuttel, Gerard. 1951. *The Letter as a Work of Art*. Amsterdam: Lettergieterij Amsterdam.

Kotin, David B., & Marilyn Rueter. 1978. *Reader, Lover of Books, Lover of Heaven: A Catalogue Based on an Exhibition of the Book Arts in Ontario*. Willowdale, Ont.: North York Public Library.

———. 1981. *Reader, Lover of Books*, vol. 2: *The Book Arts in Ontario*. Willowdale, Ont.: North York Public Library.

Kurschenska, Harold. 1961. "Typography and Communication." Pp 147–51 in *The University as Publisher*, edited by Eleanor Harman. Toronto: University of Toronto Press.

Legros, Lucien Alphonse, & John Cameron Grant. 1916. *Typographical Printing-Surfaces*. London: Longmans, Green.

Lewis, Elizabeth, et al. 1982. *Books in Canada, Past and Present / Livres canadiens d'hier et d'aujourd'hui*. Exhibition catalogue. Ottawa: National Library of Canada.

Lock, Margaret. 2002. *Ink Paper Lead Board Leather Thread*. Exhibition catalogue. Toronto: Toronto Public Library.

McCaffery, Steve, & bpNichol. 1992. *Rational Geomancy: The Kids of the Book-Machine*. Vancouver: Talonbooks.

McConnell, William. 1967. "The Private Presses of British Columbia." Vancouver: *Amphora* 1: 2–5.

McCutcheon, Sarah. 1967. "Little Presses in Canada." Vancouver: *Canadian Literature* 33: 88–97.

McDonald, Rod. 2001. "Additional Notes on Cartier and Cartier Book." Erin, Ont.: *DA: A Journal of the Printing Arts* 48: 19–25.

McKinnon, Barry. 1988. *Poets and Print: Barry McKinnon Talks with Ten British Columbia Poet/Publishers*. Toronto: *Open Letter* 7:2–3.

McKnight, David. 1996. *New Wave Canada: The Coach House Press and the Small Press Movement in English Canada in the 1960s / La nouvelle vague canadienne: Coach House Press et la prolifération des presses spécialisées au Canada anglais durant les années 60*. Exhibition catalogue. Ottawa: National Library of Canada.

McLeod, Don, ed. 2001. [Carl Dair issue.] *DA: A Journal of the Printing Arts* 48. Erin, Ont.

———. 2003. [Jim Rimmer issue.] *DA: A Journal of the Printing Arts* 52. Erin, Ont.

McLuhan, Marshall. 1962. *The Gutenberg Galaxy: The Making of Typographic Man*. Toronto: University of Toronto Press.

———. 1964. *Understanding Media: The Extensions of Man*. New York: McGraw-Hill.

MacSkimming, Roy. 2007. *The Perilous Trade: Book Publishing in Canada*. 2nd ed. Toronto: McClelland & Stewart.

Michon, Jacques, ed. 1999–2004. *Histoire de l'édition littéraire au Québec au xxᵉ siècle*. 2 vols. [Montréal]: Fides.

Mithun, Marianne. 1999. *The Languages of Native North America*. Cambridge, UK: Cambridge University Press.

Morison, Stanley. 1972. *Politics and Script: Aspects of Authority and Freedom in the Development of Graeco-Latin Script from the Sixth Century B.C. to the Twelfth Century A.D.* Oxford: Clarendon Press.

Moss, John, & Linda Morra, ed. 2004. *At the Speed of Light There Is Only Illumination: A Reappraisal of Marshall McLuhan*. Ottawa: University of Ottawa Press.

Newfeld, Frank. 1962. "Harold Kurschenska." Toronto: *Quill & Quire* 28.2: 16–18, 20.

———. 1965. "Whose Book?" Ottawa: *Canadian Art* 96: 46–47.

Nichols, John D. 1984. "The Composition Sequence of the First Cree Hymnal."
 Pp 1–21 in *Essays in Algonquian Bibliography in Honor of V.M. Dechene*, edited
 by H.C. Wolfart. Winnipeg: Algonquian & Iroquoian Linguistics, Memoir 1.

Noordzij, Gerrit. 2005. *The Stroke: A Theory of Writing*, translated by Peter Enneson.
 London: Hyphen.

Novosedlik, Will. 1996. "Our Modernist Heritage." 2 parts. Don Mills, Ont.: *Applied
 Arts Magazine* 11.1: 30–35; 11.2: 81–88.

O'Brien, Peter. 1995. "Recent Canadian Artists' Books." Toronto: *Descant* 90: 71–93.

Ondaatje, Michael. 1969. "Little Magazines / Small Presses 1969." Toronto:
 Artscanada 134/135: 17–18.

Ord, Douglas. 2003. *The National Gallery of Canada: Ideas, Art, Architecture.*
 Montreal: McGill-Queen's University Press.

Ostiguy, Jean-René. 1983. "The Illustrated Book in Quebec and in France
 (1900–1950)." *Journal* 43. Ottawa: National Gallery of Canada.

Outram, Richard. 1999. "A Brief History of Time at the Gauntlet Press." Erin, Ont.:
 DA: A Journal of the Printing Arts 44: 4–20.

Pantazzi, Sybille. 1966. "Book Illustration and Design by Canadian Artists 1890–1940,
 with a List of Books Illustrated by Members of the Group of Seven." Ottawa:
 National Gallery of Canada Bulletin 7 (4.1): 6–24.

Peck, Edmund James. 2006. *Apostle to the Inuit: The Journals and Ethnographic
 Notes*, edited by Frédéric Laugrand, Jarich Oosten, & François Trudel. Toronto:
 University of Toronto Press.

Parizeau, Lucien. 1946. "The French Tradition in Publishing." Ottawa: *Canadian Art*
 3.4: 145–49.

Peel, Bruce. 1974a. *Early Printing in the Red River Settlement 1859–1970.* Winnipeg:
 Peguis.

———. 1974b. *Rossville Mission Press: The Invention of the Cree Syllabic Characters,
 and the First Printing in Rupert's Land.* Montreal: Osiris.

Phillips, Walter J. 1926. *The Technique of the Color Wood-Cut.* [New York]: Brown-
 Robertson.

Polk, James. 1982. "A Spider's Life: Anansi at Fifteen." Toronto: *Canadian Forum* 62:
 19–21.

Poser, William J. 2003. "Dʌlk'ʷahke: The First Carrier Writing System." *http://www.
 billposer.org/Papers/dulkwah.pdf*

Priest, Robert. 1983. "Illustration in Canada." New York: *Print* 37.6: 71–84.

Quon, Mike. 1992. *Non-Traditional Design: Unique Approaches to Products and
 Graphics.* New York: Library of Applied Design.

Rainer, Jim. 1999. *The Alcuin Society, a Compilation of Its Publications: A Bibliography
 of Books, Chapbooks, Pamphlets, Keep-sakes & Broadsides Published by the Alcuin
 Society from 1965 to 1998.* Vancouver: Alcuin Society.

Reid, Robert R. 2001. *Reid's Leaves.* Vancouver: Heavenly Monkey.

———. 2002-7. *Printing, A Lifelong Addiction: A Nostalgic Trip Down Memory Lane.*
 5 vols. Vancouver: Robert R. Reid.

———. 2007. *A Young Printer in San Francisco, 1949.* Vancouver: Heavenly Monkey.

Rimmer, Jim. 2006. *Leaves from the Pie Tree: Memories from the Composing Room
 Floor.* New Westminster, B.C.: Pie Tree Press & Type Foundry.

———. 2008. *Pie Tree Press: Memories from the Composing Room Floor.* Kentville,
 N.S.: Gaspereau. ✳ Revised edition of Leaves from the Pie Tree (Rimmer 2006).

Rooke, Constance. 1983. "The Malahat Awards." Victoria: *The Malahat Review* 66:
 148–52.

———. 1984. "The Malahat Awards." Victoria: *The Malahat Review* 69: 102–6.

Rothenberg, Jerome, & Steven Clay, ed. 2000. *A Book of the Book: Some Works and Projections about the Book and Writing*. New York: Granary.

Rueter, William. 1993. *The Aliquando Press: Three Decades of Private Printing*. Exhibition catalogue. Toronto: Aliquando.

Saltman, Judith, & Gail Edwards. 2002. "Towards a History of Design in Canadian Children's Illustrated Books." Guelph, Ont.: *Canadian Children's Literature / Littérature canadienne pour la jeunesse* 107: 10–41.

"Seth." 2007. "TM (Thoreau MacDonald)." Erin, Ont.: *D A: A Journal of the Printing Arts* 60: 3–25.

Skelton, Robin. 1982. "The Malahat Awards." Victoria: *The Malahat Review* 63: 111–24.

Smart, Leslie E. 1957. "Design and the Canadian Book I." Toronto: *Quill & Quire* 23.7: 36–38, 40.

———. 1970. "Book Design in Canada." Toronto: *In Review* 4: 5–13.

Society of Graphic Designers of Canada & Société des graphistes du Québec. 1970. *Graphic Design Canada / Graphisme canadien*, edited by Anthony Mann et al. Exhibition catalogue. Toronto: Methuen. ✱ Includes work completed 1966–68. For earlier catalogues, see below: Society of Typographic Designers of Canada.

———. 1982. *Graphic Design Canada / Graphisme canadien*, edited by Judith Landell. Exhibition catalogue. Toronto: G D C.

———. 1985. *The Best of the Eighties / Les réussites des années 80*. Exhibition catalogue. Toronto: G D C.

Society of Typographic Designers of Canada. 1958–64. *Typography / Typographie*. 6 vols. Exhibition catalogues. Toronto & Montreal: Rolland Paper. ✱ Individual volumes are titled with a two-digit date (*Typography 58, Typography 60*, etc), but there was no volume for 1963. The Society of Typographic Designers of Canada (TDC) mutated into the Society of Graphic Designers of Canada (GDC) in 1968.

Solomon, Michael. 2003. "Publishing Children's Picture Books: The Role of Design and Art Direction." Pp 191–218 in *Windows and Words: A Look at Canadian Children's Literature in English*, edited by Susan-Ann Cooper & Aïda Hudson. Ottawa: University of Ottawa Press.

Sowby, Joyce, & Randall Speller. 2002. "A History of Rous and Mann Limited, 1909–1954." Erin, Ont.: *D A: A Journal of the Printing Arts* 51: 2–36.

Speller, Randall. 1999. "Frank Newfeld and the Visual Awakening of the Canadian Book." Erin, Ont.: *D A: A Journal of the Printing Arts* 45.

———. 2003. "Arthur Steven at the Ryerson Press." Toronto: *Papers of the Bibliographical Society of Canada / Cahiers de la Société Bibliographique du Canada* 41.2: 7–44.

———. 2005a. "Frank Newfeld and McClelland & Stewart's *Design for Poetry* Series." Erin, Ont.: *D A: A Journal of the Printing Arts* 56: 3–36.

———. 2005b. "The Secret History of Dust Jackets: What They Tell Us about the Cultural Life of Our Country." Toronto: *Quill & Quire* 71.4: 20–21.

———. 2007. "Thoreau's Own Walden." Erin, Ont.: *D A: A Journal of the Printing Arts* 60: 28–49.

Stacey, Robert. 1996. *J.E.H. MacDonald, Designer: An Anthology of Graphic Design, Illustration and Lettering*. Ottawa: Archives of Canadian Art.

———. 2000. "Graphic Art and Design." Pp 1004–8 in *The Canadian Encyclopedia*. Toronto: McClelland & Stewart.

Steeves, Andrew. 2005. "A Brief History of the Anchorage Press: The First Twenty Years." Erin, Ont.: *D A: A Journal of the Printing Arts* 54: 2–13.

———. 2007. "Pretty Pictures and the Design of Poetry Books." Montreal: *Canadian Notes & Queries / Questions et reponses canadiennes* 72: 66–68.

———. [in press for 2009]. *Smoke Proofs: Notes toward an Aesthetic of Literary Publishing & Design.* Kentville, N.S.: Gaspereau.

Stillman, Terry. 2005. *Thoreau MacDonald: Canada's Foremost Book Illustrator.* Vancouver: Alcuin Society.

Tayler, Anne H., & Megan J. Nelson, ed. 1986. *From Hand to Hand: A Gathering of Book Arts in British Columbia.* Vancouver: Alcuin Society.

Taylor, Insup, & David R. Olson, ed. 1995. *Scripts and Literacy: Reading and Learning to Read Alphabets, Syllabaries and Characters.* Dordrecht: Kluwer.

Toye, William. 1961. "Frank Newfeld, Book Designer." Toronto: *Quill & Quire* 28.2: 18–21.

———. 1963. "Book Design in Canada." Vancouver: *Canadian Literature* 15: 52–63.

Tremaine, Marie. 1934. *Early Printing in Canada.* Toronto: Golden Dog Press.

———. 1952. *A Bibliography of Canadian Imprints, 1751–1800.* Toronto: University of Toronto Press. ✳ *See also* Fleming & Alston 1999.

Updike, Daniel Berkeley. 1937. *Printing Types: Their History, Forms and Use.* 2nd ed. 2 vols. Cambridge, Mass.: Harvard University Press.

[Van der Bellen, Liana]. 1981–90. *Made in Canada: Artists in Books / Livres d'artistes.* 6 vols. Exhibition catalogues. Ottawa: National Library of Canada.

Vervliet, Hendrik D.L. 1972. *The Book through Five Thousand Years.* London: Phaidon.

Walker, George. 2000. *The Inverted Line.* Erin, Ont.: Porcupine's Quill.

Warde, Beatrice. 1955. *The Crystal Goblet: Sixteen Essays on Typography,* edited by Henry Jacob. London: Sylvan Press.

Warkentin, Germaine. 1999. "In Search of 'The Word of the Other': Aboriginal Sign Systems and the History of the Book in Canada," University Park, Pennsylvania: *Book History* 2: 1–27.

Whiteman, Bruce. 1991. "Contact in Context: The Press and Its Time." Burnaby, B.C.: *West Coast Line* 5: 11–27.

Wilcox, Michael, & Richard Landon. 1998. *In Retrospect: Designer Bookbindings by Michael Wilcox.* Exhibition catalogue. Toronto: Thomas Fisher Rare Book Library.

Winterson, Jeanette. 1995. *Art Objects: Essays on Ecstasy and Effrontery.* London: Jonathan Cape.

Woodcock, George, ed. 1967. "Publishing in Canada." *Canadian Literature* 33. [First special issue on publishing.] Vancouver.

———. 1973, "Publish Canadian." *Canadian Literature* 57. [Second special issue on publishing.] Vancouver.

Woodsworth, Glenn. 1998. *Cheap Sons of Bitches: An Informal Bibliography of the Publications of William Hoffer, Bookseller.* Vancouver: Tricouni Press.

[Woon, Wendy, et al.]. 1990. *Learn to Read Art: Artists Books.* Exhibition catalogue. Hamilton, Ont: Art Gallery of Hamilton.

Academica Sinica, Taipei 19
Ahenakew, Frieda 144–45
Air 152–53
Albahari, David 184–85
Alcuin Awards 13, 207–26, 228
Algonquian 16, 17, 18, 19, 20, 141
Aliquando Press 49
Alison's Fishing Birds 90–91
Allen, Dean 148–51, 228
Alphabetical Cosmologies 139
American Museum of Natural
 History 34–37
Anansi, House of 200–201
Angilirq, Paul Apak 174–5
Annick Press 190–91
Apikoros Sleuth 98, 202–3
Ark of Koans 168
Atanarjuat: The Fast Runner
 174–75
Athapaskan 16, 19–21, 28, 30, 39
Atmospheres Apollinaire 114–15
Atwood, Margaret 98
Ayaruaq, John 79

Balthazar and Other Poems 117
Bantock, Nick 99, 124–25
Baraga, Friderik 17, 18, 26–27
Barbarian Press 96, 132–38
Barbeau, Marius 78
Baroque letterforms 37
Barwin, Gary 191
Baskerville, John 46, 51, 66, 84,
 86, 88–89, 149
Beauchemin & Valois 26–27
Beaver (Dunneza) 16, 19, 39
Beaver Texts 39
Béja, Philippe 192
Bell, Moses 32
Benton, Morris Fuller 48, 64,
 117, 155
Bevington, Stan 96, 97, 172–75
Bill Reid 104–5
Bissett, Bill 92, 97, 98
Blackfoot syllabics 19
Blais, Marie-Claire 54–55, 98
Blakeley, Gary 159
Blewointment Press 92
Blodgett, E.D. 168
Bloomfield, Leonard 42–43
Blue Roofs of Japan 132–33
Boas, Franz 32–37
Borderlands 160–61

Brault, Jacques 168
Brick Books 94
Bringhurst, Robert 102–3,
 132–33, 178–79
Brownoff, Alan 97, 166–71, 228
Bulmer 48, 72, 204
Bureau of American Ethnology
 32–33, 35–39
Butterflies of British Columbia 159
Butterfly on Rock 84
By a Thread 194–95

Caledonia 57, 59, 61, 201
Campbell, Grace 46
Canadian Centre for Architecture
 110–11
Carmichael, Franklin 46, 48
Carrier Prayer Book 30–31
Carroll, Lewis 193
Carson, Anne 98
Carter, Matthew 142, 201
Cartier 50, 51, 77, 96, 175
Chaplin, Robert 197
Chequered Shade 58–59
Chipewyan 16, 19, 21, 22–25, 28
Chipewyan Texts 22–25
Clarke & Stuart 48
Click 120–21
Coach House Press 96, 97,
 116–17, 172–75, 177, 204–5,
 228
Cocking, Peter 97, 182–86, 228
Cohen, Leonard 56–57
Collected Poetry of Malcolm Lowry
 158
Collins, Toronto 46
Colophon Books 90–91
Contemporaries of Erasmus 85
Conway, John 170–71
Cooper & Beatty 48
Coppens, Carle 146–47
Cover to Cover 100–101
Cree 16, 17, 18–19, 20, 21, 26, 28,
 42–43, 51, 141, 142, 144–45
Crosbie, Lynn 120–21
Crows 165

Dair, Carl 50, 51, 76–77, 96, 175
Dakelh 16, 19–20, 30–31
Daniells, Roy 58–59
Dayodakane 35
Debbie 150–51
deBeyer, Michael 176–77
Department of Mines 42–43
Department of Northern Affairs
 & Natural Resources 78
DePol, John 136–37

Derreth, Reinhard 104–5
Design with Type 76–77
*Dessins d'architecture de l'avant-
 garde russe* 110
Dewinetz, Jason 97, 198–99
Dickens, Ned 194–95
Douglas & McIntyre 102–105,
 128–31, 162–63, 182–86, 228
Downe, Lise 122–23
Dragland, Stan 94
Drumbolis, Nick 196–97
Dwiggins, William Addison 48,
 54, 57, 59, 61, 167, 201

Economic Atlas of Ontario 80–81
ECW Press 122–23, 165–67, 228
Éditions Erta 49
Electric Language 154–55
Elsted, Crispin 96, 132–38
Elsted, Jan 132–38
End Grain 134–35
Erickson, Arthur 128–31
Ethnology of the Kwakiutl 36–37
Euphemia 20
Evans, James 18–19, 20

Faces on Places 200–201
Fairley, Barker 82–83
Faraud, Henri 19
Faust 80–81
Fifth House 144–45
Firefly Books 187
Fleming, Allan 49, 51, 82–83
Frascara, Jorge 106–7
Frutiger, Adrian 80, 107
Frutkin, Mark 114–15

Garamont, Claude 48, 115, 152,
 162
Garneau, Hector de Saint-Denys
 66–67
Gaspereau Press 97, 176–81, 228
Giampa, Gerald 95
Giguère, Roland 49
Gill, Eric 48, 52, 110, 135, 137
Goddard, Pliny E. 39
Goethe, J.W. von 82–83
Goluska, Glenn 96, 98, 108–11,
 166
Gotlieb, Phyllis 60–61
Goudy, Frederic 48, 90, 95, 152
Graham, Arifin 158
Gramsci × 3 106–7
Granjon, Robert 48, 142, 162
Grave Sirs 64–65
Greenboathouse 198–99
Greystone Books 165, 228

Groot, Lucas de 159, 164, 170
Grouard, Émile 19
Group of Seven 48
Gustafson, Linda 187, 228
Gustafson, Ralph 52–53
Gutenberg Galaxy 62–63
Gyldendal 44

Haida 16, 38
Haida Texts and Myths 38
Haig-Brown, Roderick 90–91
Hébert, Anne 66–67
Herald Press 48
Hewitt, J.N.B. (John Napoleon
 Brinton) 18, 35
hieroglyphs 15
Hippolyte's Island 126–27
Hobart, Elizabeth 228
Hodgson, Barbara 99, 104–5,
 126–31, 228
Hoffer, William 108–9
Holgate, Edwin 48
Horden, John 19
Howard, Barbara 112–13
Hudson, John 96
Hunt, George 34–37
*Huron-Wyandot Traditional
 Narratives* 78

Iglulik and Caribou Eskimo Texts
 44
Imprimerie Dromadaire 166
Inishbream 136–37
Inkster, Tim 96, 112–15, 228
Inuktitut 16, 19, 20, 28, 40–41,
 44, 79, 174–75
Iñupiaq 40
Iroquoian Cosmology 35
Isuma Productions 174–75
Ivaluardjuk 44

Jabberwocky 193
James, Geoffrey 102–3
Jannon, Jean 48, 152
Jenness, Diamond 40–41
Johnston, Edward 48, 94
Jones, Douglas G. 84, 117
Jones, Randy 82–83
Jorisch, Stéphane 191, 193

Kâ-kîsikâw-pîhtokêw 43, 179
K'atchodi, Lizette 28
Kegg, Maude 142–43
Keller, Martina 156–57
Kennedy, Bill 204–5
Keziere, Russell 102–3
Kids Can Press 193, 228

King Jammy's 156–57
King's Printer (Ottawa) 40–41
Kishkan, Theresa 136–37
Kiskatinaw Songs 88–89
Klanak Press 66–67
Kluckner, Michael 148–49
Kôhkominawak otâcimowiniwâwa
 144–45
Krimpen, Jan van 95, 133, 192
Kroetsch, Robert 94, 98, 166–67
Kurschenska, Harold 49, 62–63
Kuthan, George 49
Kwakiutl Texts 34
Kwakwala 16, 34–37, 38

Lambert, Lucie 152–53
Lande, Lawrence 72–75
Latimer, Philip 32
Laurentia 59
Laurentian 96
Lauzon, Andrée 191
Lavdovksy, Alexander 97, 139
*Lawrence Lande Collection of
 Canadiana* 72–75
Ledger, The 94
Lee, Dennis 98
Leech, Bev 51, 86–89
Lesser, Beth 156–57
letterpress 13, 49, 51, 89, 133
Lǐ Fānggùi (Fang-kuei Li) 21–25
Lička, Zuzana 149, 191
Liebhaber's Wood Type 98, 166
Lingner, Antje 49, 84, 85
Linguistic Society of America 45
Lino 99, 188–89
Longspoon Press 106–7
Lowry, Malcolm 158

McClelland, Jack 49
McClelland & Stewart 49, 52–61,
 228
McDonagh, George 49
MacDonald, J.E.H. 48
MacDonald, Thoreau 48
McDonald, Rod 96
Macfarlane Walter & Ross
 120–21
McGill University Press 70–71
McKay, Don 98
McLean, Eric 70–71
McLuhan, Eric 154–55
McLuhan, Marshall 51, 62–63
Magic Mustache 191
Majzels, Robert 98, 202–3
Malahat Awards 13, 227, 228
Maliseet 16, 140–41
Man in Love 110–11

Mandeville, François 21–25
Mardersteig, Giovanni 95, 109,
 176, 178
Matthews, Geoffrey J. 80–81
Mélançon, Robert 152–53
Mercury Press 118–19, 228
Michaels, Anne 98, 116
Micmac-Maliseet Institute
 140–41
Mills, W. Ross 20, 96, 178
Mitchell, Lewis 140–41
"Modern" types 26, 37
Mohawk 16, 35
Moosomin, Louis 43
Morice, Adrien-Gabriel 19–20,
 30–31
Morison, Stanley 95
Morriss, Charles 51, 66, 86–89
Moveable Inc. 202–3
Murray, Terry 200–201
Musebook 86–87
Musgrave, Susan 88–89
Myth as Math 196–97

Nâh-namiskwêkâpaw 43
Naked Poems 68–69
National Gallery of Canada 48
National Library of Canada 48
Native Canadian languages
 16–45
Neoclassicism 37, 46, 84, 89, 201
Neuman, Shirley 106–7
New, W.H. 160–61
New Star Books 150–51
Newfeld, Frank 49, 50, 51, 52–61,
 228
Newhouse, Seth 35
Newlove, John 64–65
Nichol, bp (Barry Phillip) 118–19
Nichols, John D. 142–44
Nisgha 16, 32–33
Nootka Texts 45
Noroît, Éditions de 146–47
Nova Scotia College of Art &
 Design 100–101

Ogg, Arden C. 144
Ojibwa 16, 17–18, 26–27, 142–43
"Old Style" types 37
Ombre du doute 189
Ondaatje, Michael 98
oral literature 11–14, 20–21, 51,
 93
Orca Publishers 194–95
Organon vocis organalis 172–73
O'Rourke, Lynn 194–95
Our Grandmothers' Lives 144–45

Outlands 196–97
Outram, Richard 112–13

Page, P.K. 139
Passé vivant de Montréal 70–71
Paulson, Ingrid 96, 200–201
Peck, Edmund 19
Pedlar Press 228
Periwnkle Press 64, 68–69
Peter, Friedrich 96
Petitot, Émile 17–18, 28–29
Pharos Press 86–89
Phillips, Walter J. 48
photo-offset printing 50, 52, 82
Poèmes 66–67
Poèmes contre la montre 146–47
Poon, Joanne 142–43
Poppy Press 139
Porcupine's Quill 96, 97, 112–13, 177, 228
Portage Lake 142–43
Power, Karen 193
Premium Beer Drinker's Guide 187
Prud-Homme, Claude 146–47
Publications de l'avant-garde soviétique 110
Pullet Surprise 148–49

Queen's Printer (Ottawa) 79
Q'iẋitasu' 34–37
400 Coups, Les 188–89, 192

Raincoast Books 124–27, 148–49, 228
Rasmussen, Knud 44
Rawlings, Angela 98, 204–5
Recalling Early Canada 169
Red Deer College Press 228
Reid, Robert R. 49, 51, 64–65, 70–75
Reine rouge 192
Remski, Matthew 172–73
Renaissance typography 47, 70, 77, 89, 109, 121, 172, 176
Renault de Broise 28–29
Report of the Canadian Arctic Expedition 40–41
Rhodes, Shane 198–99
Richardson, Scott 228
Rimmer, Jim 50–51, 90–91, 95, 152
Rivers among Rocks 52–53
Roberts, Jim 202–3
Robertson, Gordon 96, 116–23, 228
Robertson, Lisa 150–51

Roger Ascham Press 49
Rogers, Bruce 48, 88
Romanticism 26, 29, 37, 155, 201
Ross, Graham 194–95
Rous & Mann 48
Roy, Indrapramit 190
Rueter, Will 49
runes 15
Rural Night Catalogue 176–77
Růžička, Rudolph 169, 184
Ryan, Allan J. 164

Sabine's Notebook 124–25
Sacred Stories of the Sweet Grass Cree 42–43
Sapir, Edward 45
Saskatchewan: Uncommon Views 170–71
Savage, Candace 165
Saveur du vide 188
Scollon, Ron 21–25
Scotch Roman 59, 201
Scott, Frank R. 66–67
Seven Journeys: The Sketchbooks of Emily Carr 182–83
Shadbolt, Doris 102–3, 182–83
Sibner, Herbert 86–87
Sibum, Norm 108–9
Siebner, Herbert 86–87
Simply Read Books 228
Skelton, Robin 13, 86–87
Slimbach, Robert 139, 162, 165, 167, 172, 197, 199
Snow, Michael 98–99, 100–101
Snow Man 184–85
Soft Signature 122–23
Solomon, Michael 228
Soul Arrow 92
Spice Box of Earth 56–57
Steeves, Andrew 97, 176–81, 228
Stoddart 154–55, 228
Sullivan, Jessica 97, 165, 228
Susan Point: Coast Salish Artist 162–63
Swadesh, Morris 45
Swanton, John Reed 16–17, 38

Tait, Douglas 88–89
Tanabe, Takao 49, 64–69
Ten Counting Cat 197
Ten Poems 108–9
Tengo sed 198–99
Tête blanche 54–55
Theoretical and Practical Grammar of the Otchipwe Language 26–27
Thorn-Apple Tree 46
Tims, John 19

Tiro Typeworks 96
Traditions indiennes du Canada nord-ouest 28–29
Trickster Shift 164
Trump, Georg 95, 109, 117, 157
Truth: A Book of Fictions 118–19
Tschichold, Jan 95, 115, 158
Tse Yim (謝琰) 132–33
Tsimshian Texts 32–33
Twenty-One Small Songs 138
Typographic Quest 76–77

UBC Press 158–61, 164, 228
University of Alberta Press 97, 142–43, 166–71, 228
University of Toronto Press 60–61, 76–77, 80–85
Updike, Daniel Berkeley 94–95
Ursa Major 178–79

Vaitkunas, George 96, 160–64, 228
Vancouver Cooks 186
Very Hungry Lion 190
Villalonga, Jesus Carles de 146
Virgo, Séan 88–89
Visions: Contemporary Art in Canada 102–3

Waddell, Malcolm 154–55
Walenta, Tomasz 188–89
Wapapi akonutomakonol 140–41
Watkins, Edwin A. 19
Watson, Wilfred 106–7
Webb, Phyllis 68–69
Weight of Oranges 116
What the Crow Said 166–67
Wide Slumber for Lepidopterists 98, 204–5
Wiḣa'is 45
Wilson, Richard D. 70–71
Winterson, Jeanette 93
Wisdom and Metaphor 180–81
Within the Zodiac 60–61
Wolf, Gita 190
Wolfart, H.C. 144–45
Wrigley, Roy 48
Wyatt, Gary 162–63

Zab Design 228
Zapf, Hermann 52, 80, 82, 85, 95, 103, 109, 116, 141, 144, 183, 197
Zwicky, Jan 138, 180–81

⌘ The main text of this book is set in LAURENTIAN BOOK, a type designed in Toronto in 2002 and revised at Lake Echo, Nova Scotia, in 2007 by Rod McDonald. The chapter titles and ornaments are CARTIER BOOK, refined and adapted by Rod McDonald from preliminary designs made by Carl Dair in Toronto and in the Netherlands between 1957 and 1967. ✤ All passages in Canadian Syllabics are set in W. Ross Mills's EUPHEMIA, designed in British Columbia and Nunavut between 2002 and 2004. ✤ The captions are set in CASPARI, a face designed in the Netherlands in the early 1990s by Gerard Daniëls. ✐ ARNO, designed by Robert Slimbach in California, is used for François Mandeville's Chipewyan text and its English translation. The Cyrillic font is Slimbach's MINION. ✒ The main Chinese font is Monotype KAĬTĬ (楷体), designed in Hong Kong. ✽ The book itself was designed and set in British Columbia by Robert Bringhurst and printed and bound in Altona, Manitoba, by Friesens Corporation. ❧ The paper is Garda Silk from Cartiere del Garda, Riva del Garda, Trentino, Italy. It is wood-free, acid-free, and of full archival quality.